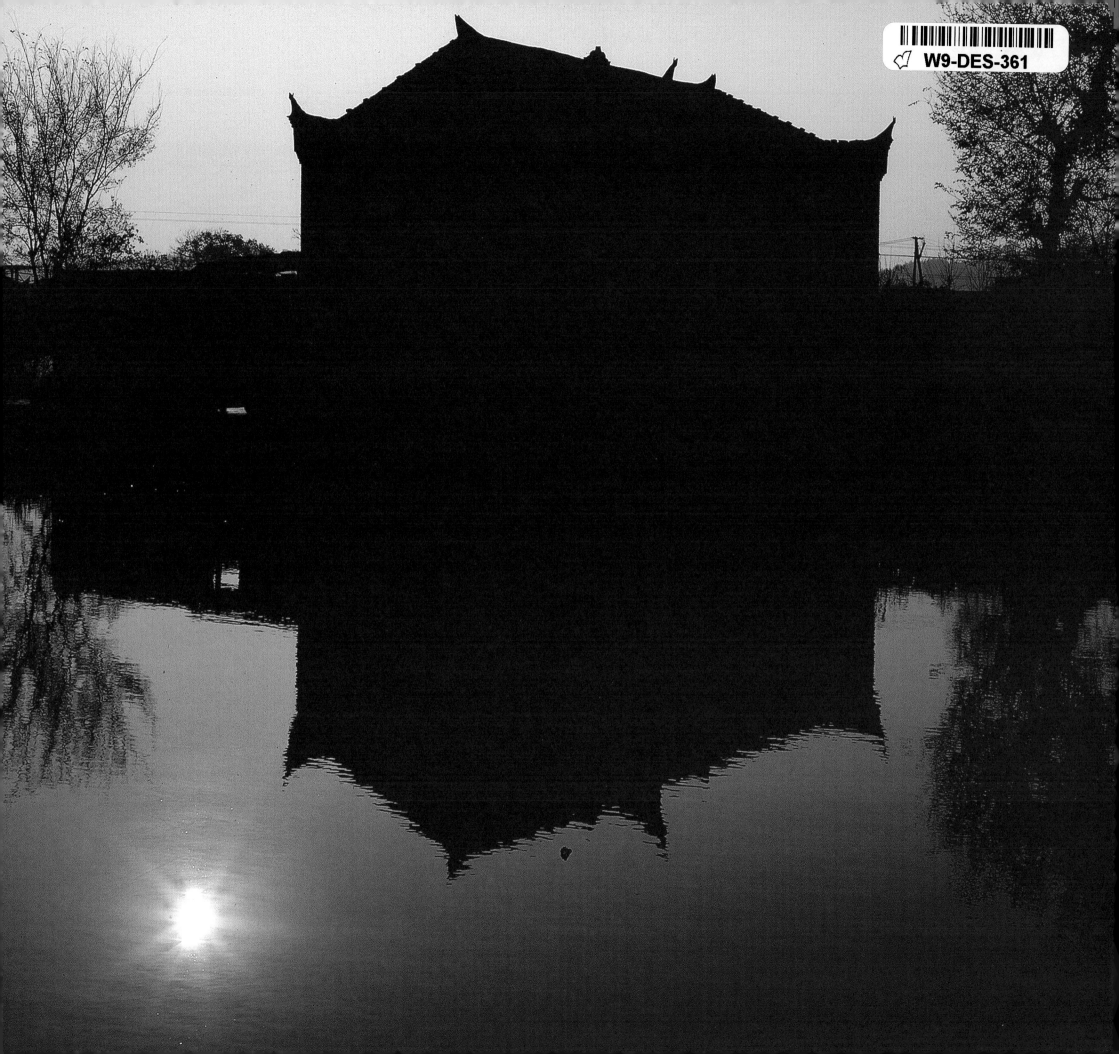

BOOKS by ELIZABETH GILL LUI

Spirit and Flight
A Photographic Salute to the United States Air Force Academy
1996

Closed Mondays
1999

Building Diplomacy
The Architecture of American Embassies
2004

OPEN HEARTS OPEN DOORS

明心啟扉

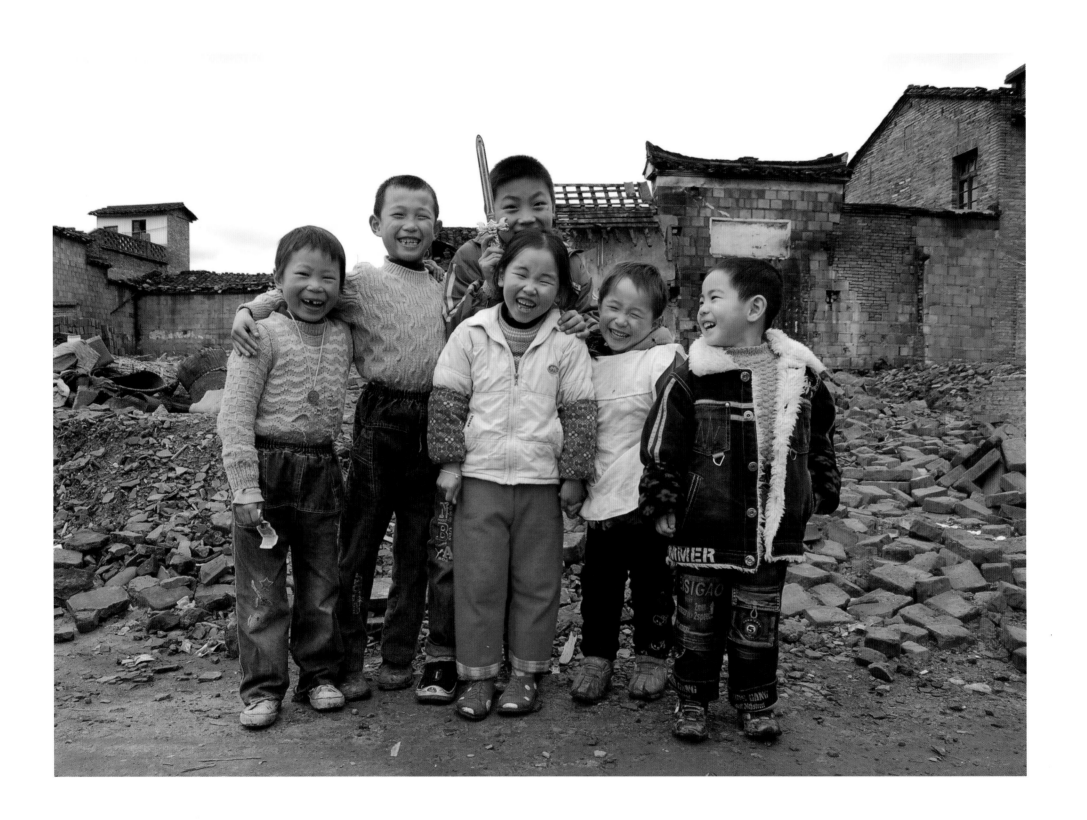

For the children of the People's Republic of China, so that they may be inspired to embrace their past and work for the preservation of their rich cultural legacy.

獻給中華人民共和國的孩子，藉此或可啟發他們珍惜自己的歷史，並為保存他們豐富的文化遺產而努力。

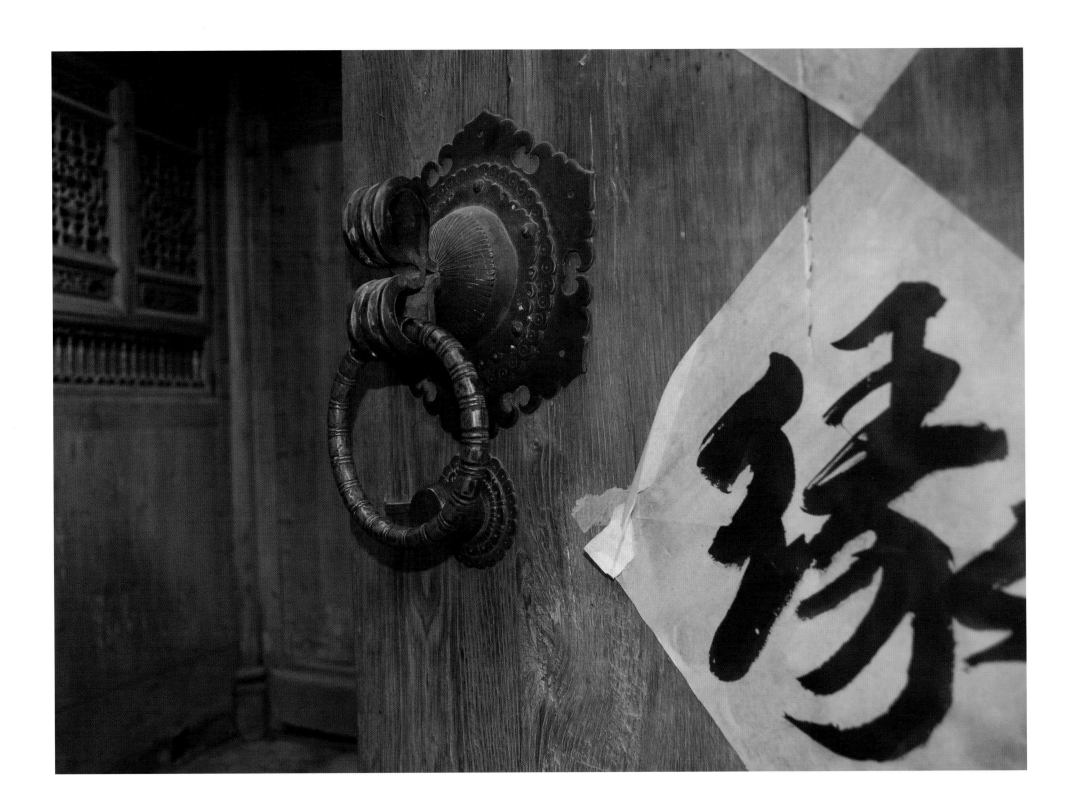

OPEN HEARTS OPEN DOORS
明心啟扉

The translation of the title OPEN HEARTS OPEN DOORS is classical and poetic.
Literally, 明心 *mingxin* is a bright or clear heart.
Its philosophical meaning is from a Buddhist maxim, 明心見性 *mingxinjianxing*
"enlightening the heart to see into the nature of mind."
In a broad sense, it connotes the meaning of opening your heart.
啟扉 *qifei* is opening doors. *Qi* is open. The Chinese word *fei* is rich in meaning.
It primarily means a physical piece of door. *Fei* is an old word, not very often used in
contemporary parlance except for forming a compound noun with the word *xin* (heart).
Xinfei is the innermost part of the heart and can also be interpreted as the door of the heart.
Fei also refers metaphorically to a house, usually a cottage or a hut in the country,
and it lastly means the title page, which is usually the first page of a book.
Such is the beauty and richness of the Chinese language!

「明心」按字面意思是明亮的心。佛家所說「明心見性」，則指究明本心而徹見
本性。廣義而言，明心有敞開心胸的含義。

「啟扉」意思明顯。扉是門閫、門扇。扉字今已少用， 如與心字相合, 是為扉，
即人的內心。但何不亦解作人心的門扉？扉也借指屋舍；荊扉、柴扉、野扉，都
是村門陋戶。扉頁就是書刊封面內印着書名和作者名等資料的一頁，通常是書刊
的第一頁。

此為OPEN HEARTS OPEN DOORS 譯作「明心啟扉」的由來。

The diversity of cultures and heritage in our world is an irreplaceable source of spiritual and intellectual richness for all humankind. The protection and enhancement of cultural and heritage diversity in our world should be actively promoted as an essential aspect of human development.

The Nara Document on Authenticity, 1994

在我們的世界，文化和遺產的多樣性，是全人類精神和知識財富不可替代的源泉。
保護及增強文化和遺產的多樣性，應積極提倡為人類發展的重要層面。

奈良原真性文件 1994

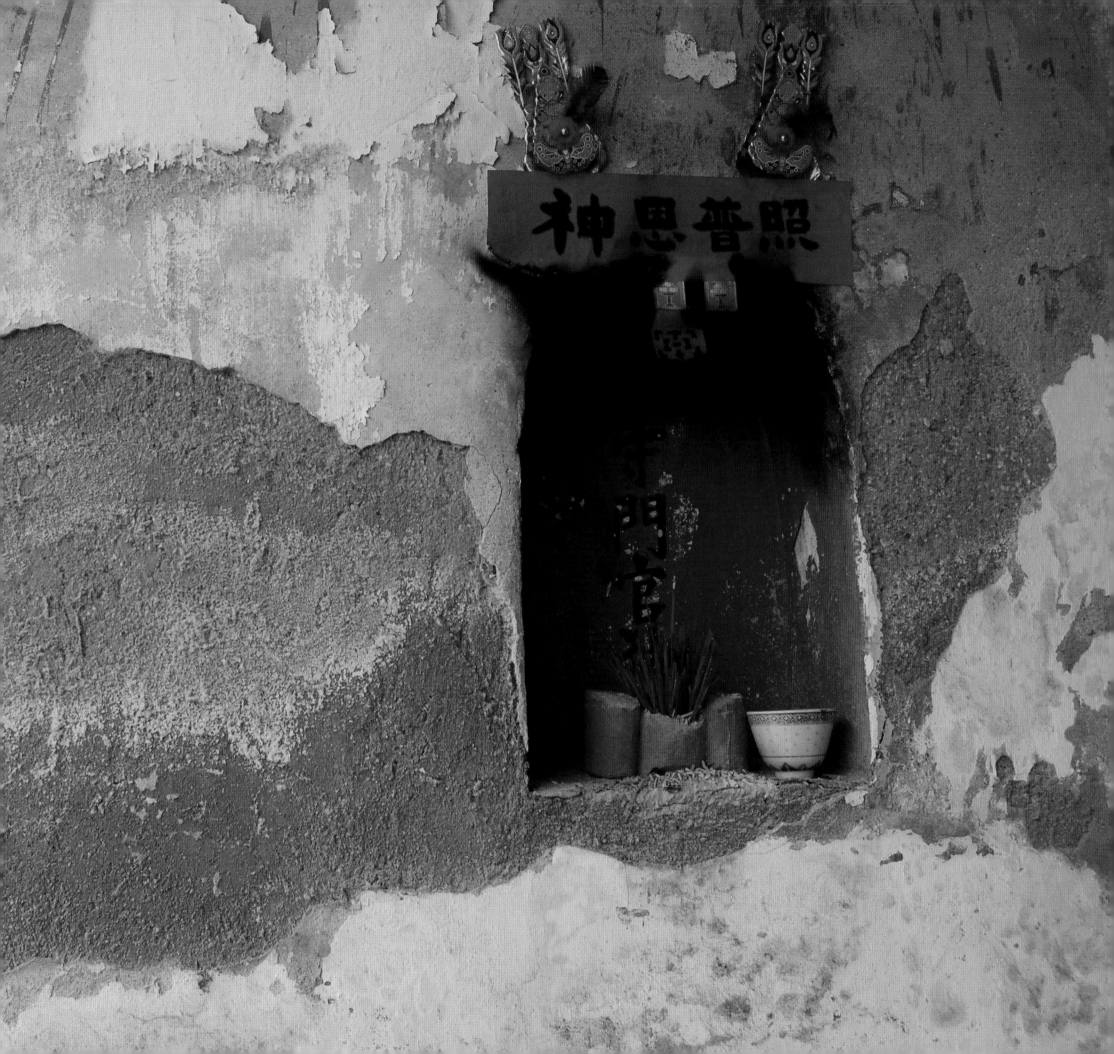

OPEN HEARTS OPEN DOORS

REFLECTIONS ON CHINA'S PAST & FUTURE

明心啟扉

鏡看中國的過去與未來

Elizabeth Gill Lui

F-STOPS PRESS

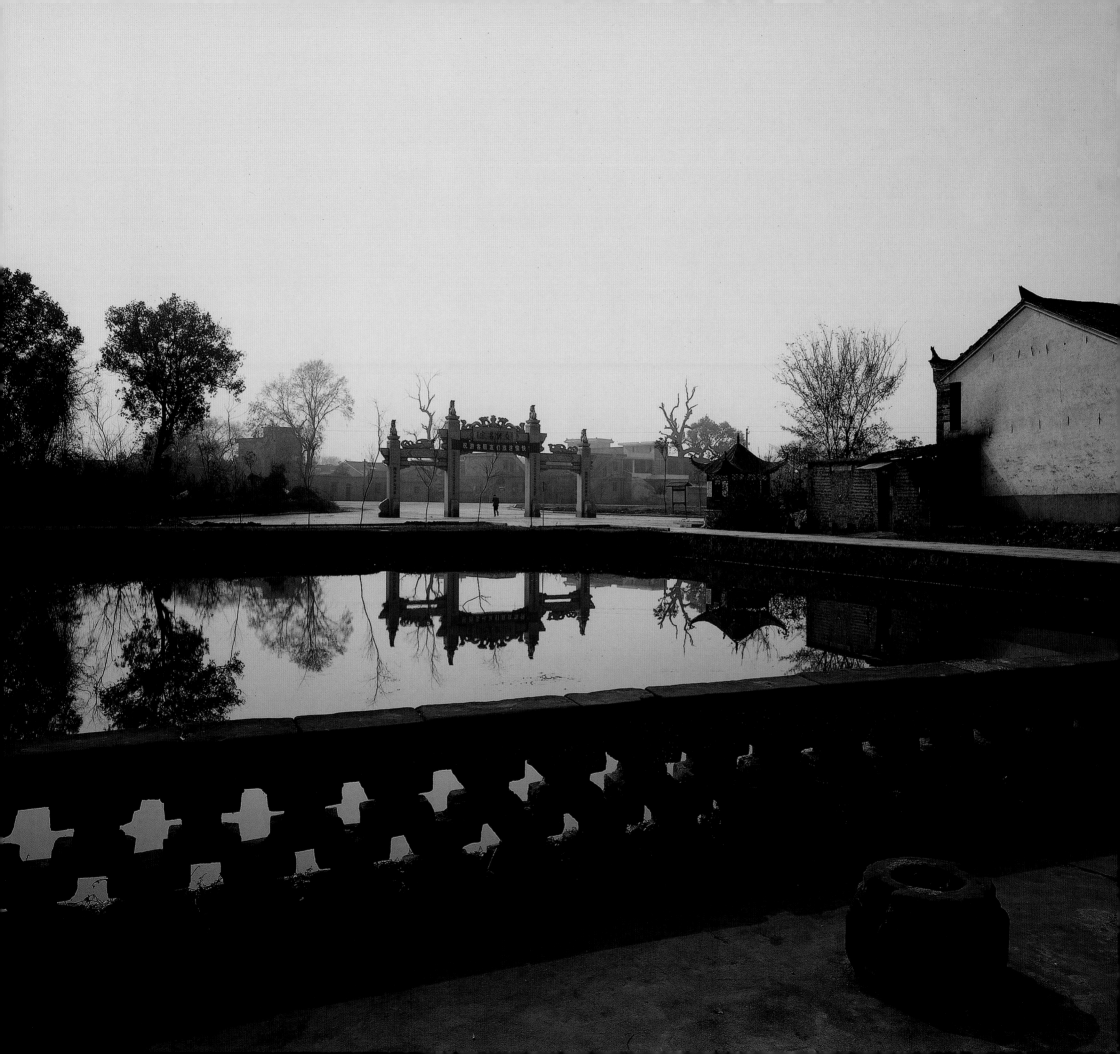

WITH SPECIAL CONTRIBUTIONS *by*

Puay-Peng Ho
何培斌

*Chairman, Department of Architecture,
and University Dean of Students,
The Chinese University of Hong Kong*

I. M. Pei
貝聿銘

Founder, Pei Cobb Freed & Partners, New York

Zheng Shiling
鄭時齡

*Director, Institute of Architecture and Urban Space,
Tongji University, Shanghai*

VISION STATEMENTS

Beijing Cultural Heritage Protection Center
北京文化遺產保護中心

The Getty Conservation Institute
蓋提文物保護中心

The Rockefeller Brothers Fund
洛克菲勒兄弟基金會

REFLECTIONS ON CHINESE HERITAGE PRESERVATION

Chan Yuen-Lai, Winnie 陳婉麗

Jeffrey Cody

Martha Demas

Enrico d'Errico

Angus Forsyth

Hui Mei Kei, Maggie 許美琪

Ethel Emerson Hutcheson

Keya Keita

Liu Xiaoguang 劉曉光

Vincent H. S. Lo 羅康瑞

Christine Loh 陸恭蕙

Donovan Rypkema

Alexander Stille

Peter H. Y. Wong 黃匡源

Benjamin T. Wood

Paul Zimmerman

TRANSLATION

Chor Koon-Fai 左冠輝

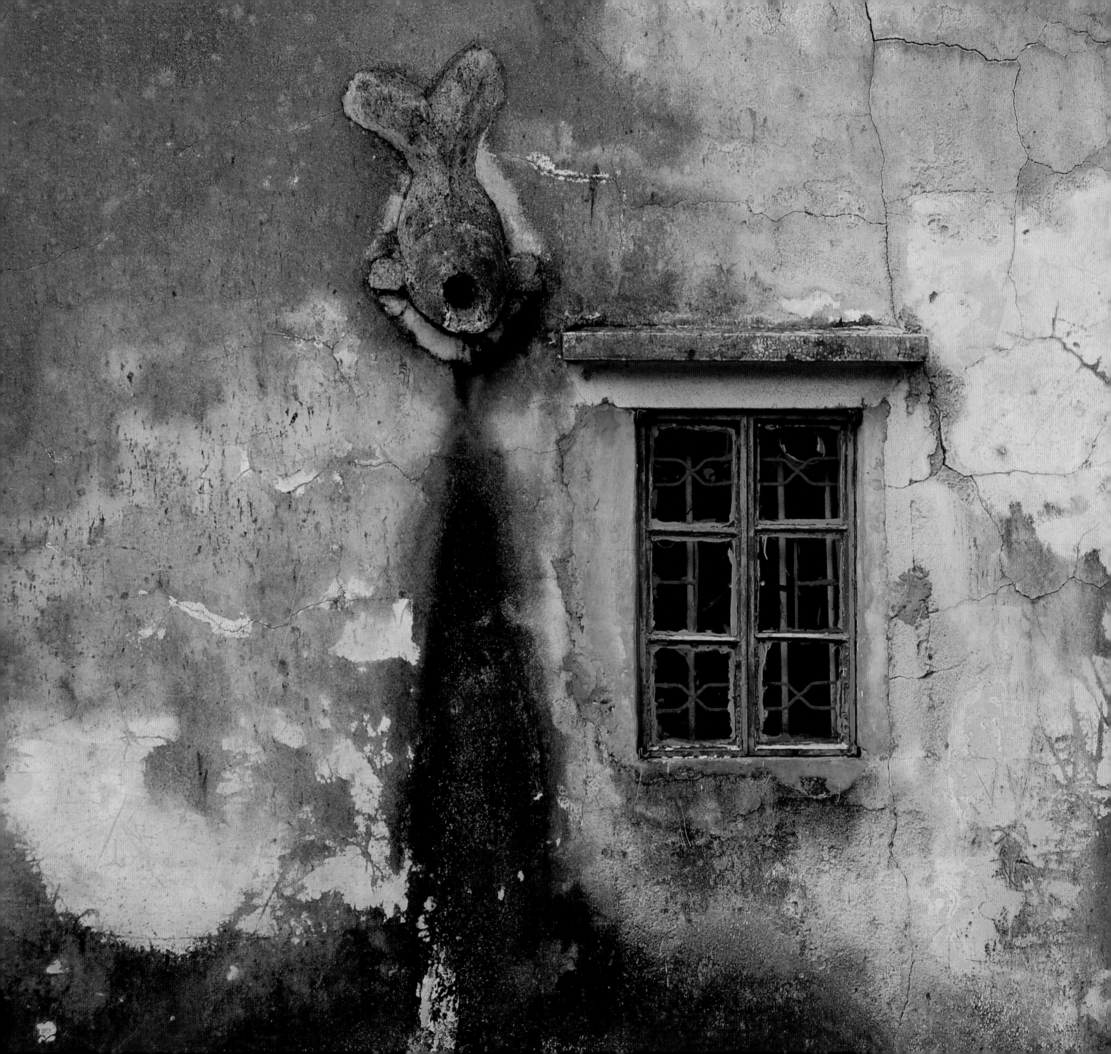

Imbued with a message from the past, the historic monuments of generations of people remain to the present day as living witnesses of their age-old traditions. People are becoming more and more conscious of the unity of human values and regard ancient monuments as a common heritage. The common responsibility to safeguard them for future generations is recognized. It is our duty to hand them on in the full richness of their authenticity.

The Venice Charter, 1964

世世代代的歷史遺迹記載了過去的信息，留存至今天，是古老傳統的活見證。人愈來愈注重整體的人類價值觀，而且視古代遺迹為共同的遺產。大家都明白，為後世人保護這些遺迹是我們的共同承擔。我們有責任把這些遺迹的豐富原真性完整保存，交給下代。

威尼斯憲章 *1964*

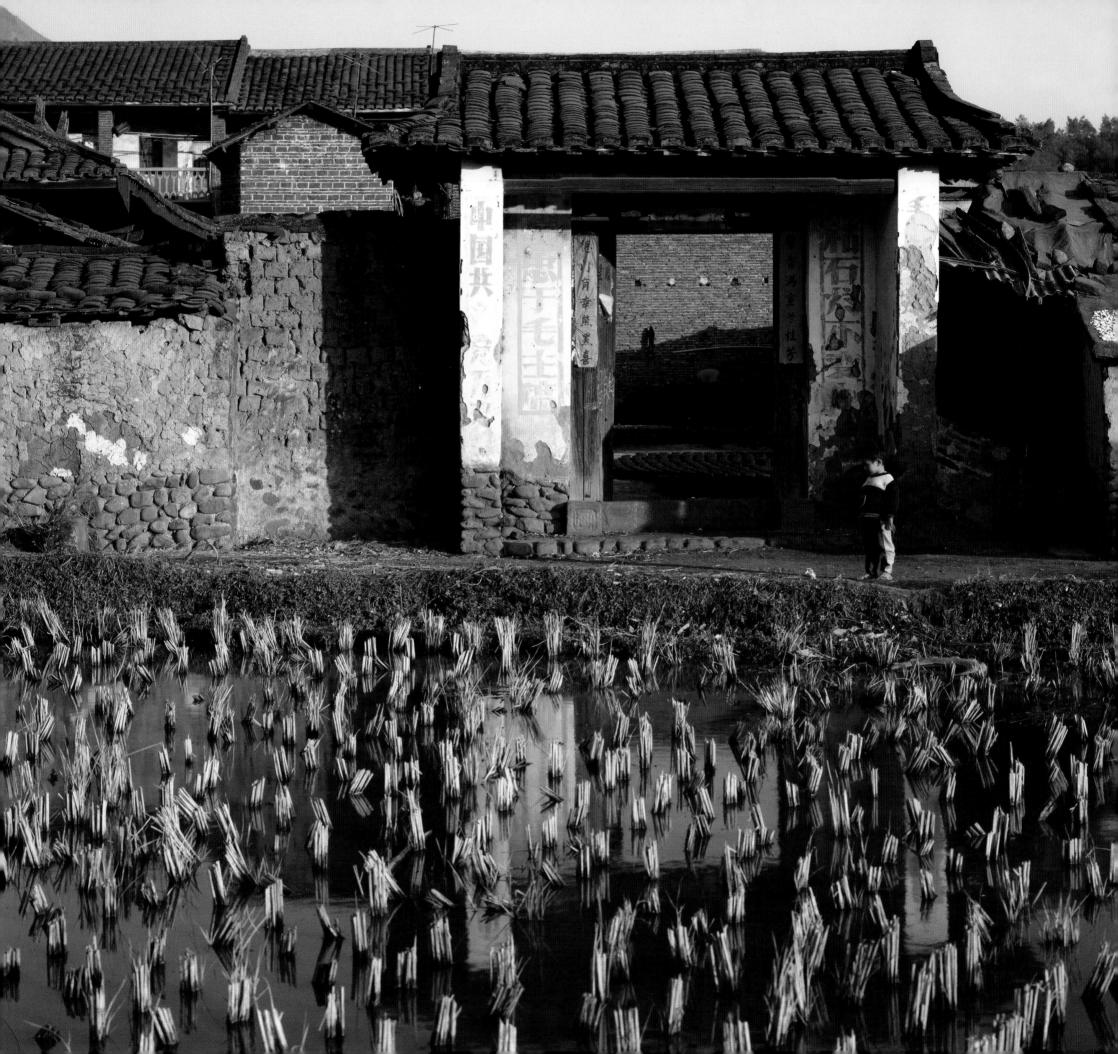

CONTENTS
目錄

*Quotes presented throughout from The Venice Charter, 1964, and
The Nara Document on Authenticity, 1994*

*Chapter headings are taken from the I Ching, or Book of Changes, the oldest of the Chinese
classic texts. The characters read as metaphors for man's place in the natural order.
The version used here is taken from the authoritative translation by Richard Wilhelm.*

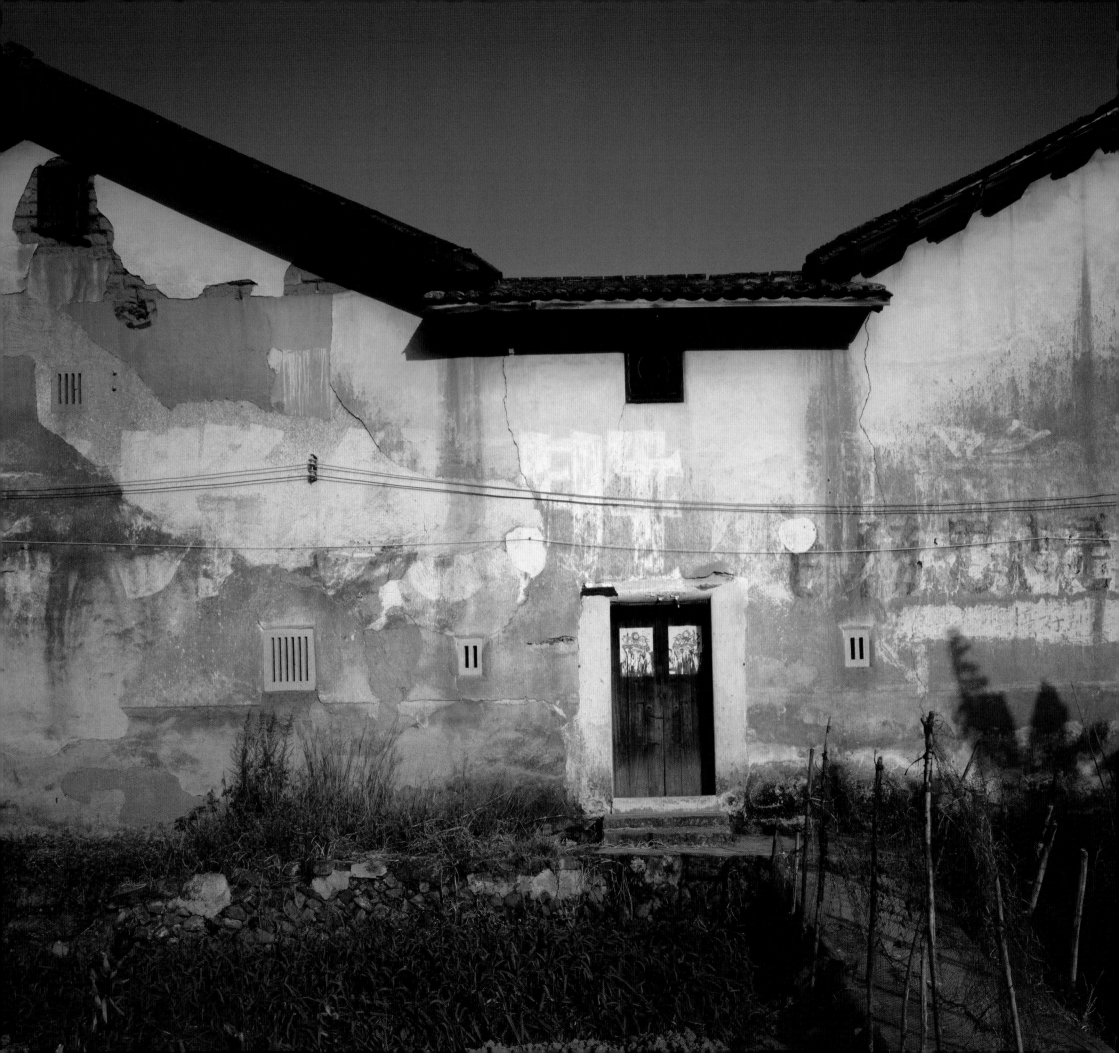

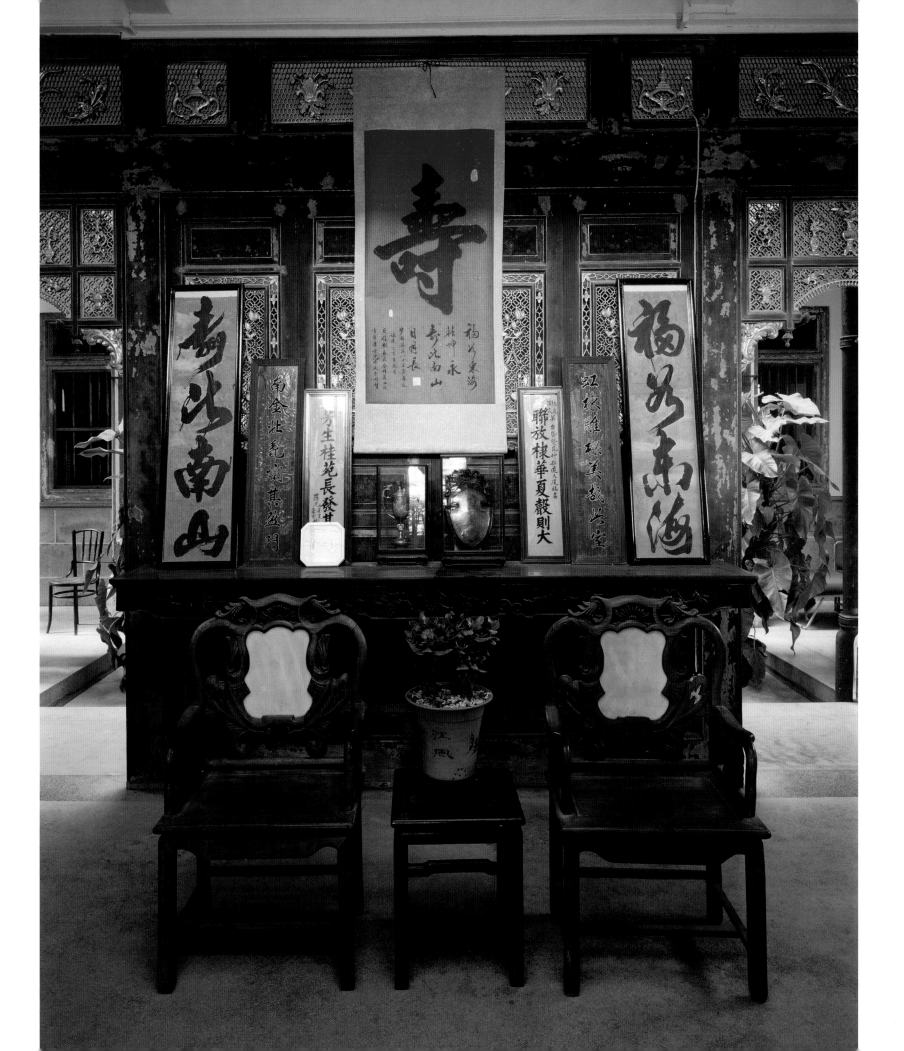

In a world that is increasingly subject to the forces of globalization and homogenization . . . the essential contribution made by the consideration of authenticity in conservation practice is to clarify and illuminate the collective memory of humanity.

The Nara Document on Authenticity, 1994

在愈來愈受全球化和同質化影響的世界裡 … 遺產保護工作對原真性的著重，其最實質的貢獻是澄清及闡明了人類的共同回憶。

奈良原真性文件 1994

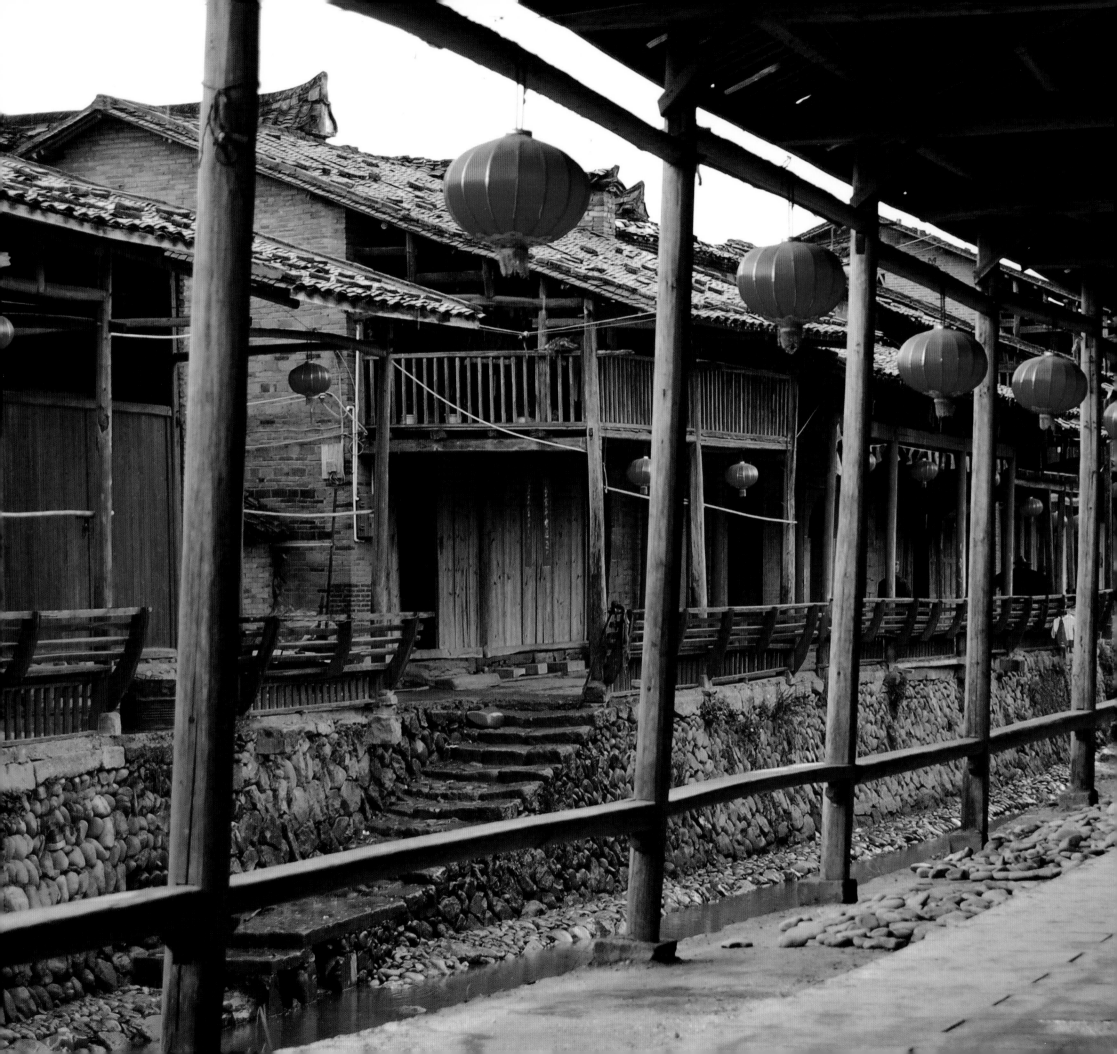

foreword

GROWING CULTURE

Keya Keita

In the fire-lit caves of our ancient ancestors there was no culture, only tools and methods, tasks and manners. History was ground from the stone wheel of time, and eventually, ways became habits, habits became customs, and customs solidified into an organism of culture, created only from life perpetuated over the ages. Our present cultural identity is only the culmination of all culture that has congealed before now; it relies on the preservation of what has been and the persistence of new works. It does not exist isolated from life, evolution, revolution, or time. In truth, culture and time have a symbiotic relationship—culture feeds on time, and in turn, time yields culture.

We are the products of both our past and visions for the future; our cultural identity is formed by this tug of time, this ever-expanding bridge. To freeze the past in skeletal memories stops organic progression, terminates our ability to relate to history, and dictates cultural bankruptcy.

It is a misconception that culture creates art and architecture. Instead, it is crucial to the sustainability of creative heritage to realize that art and architecture create culture. If this premise is embraced, there can be no fear of the diminution of culture, for it follows that the only way to ensure survival is to keep living, growing, changing.

Therefore, it is the momentous charge of all living creators—artists, designers, and builders—to integrate everything that has been with everything that may be.

Never repeat, never forget, never stop growing culture.

序言
耕耘文化

Keya Keita

在我們遠古祖先火光照明的洞穴裡，沒有文化，只有器具和方法、工作和方式。時間的石輪輾出歷史，最後方法變成習慣，習慣成為習俗，而習俗結晶成為文化的有機組織，經過千百萬年的蘊釀始出現。我們現在的文化認同，不過是之前所有文化凝結後累積得來；這種認同有賴保存既有和持續創新。文化認同並非獨立於生活、演化、變革或者時間以外。其實，文化和時間有共生的關係 —— 文化從時間攝取養份，而時間則反過來生出文化。

我們既是過去的成果，也是對未來憧憬的產物；我們的文化認同，就由這種過去和未來的相持，一條不斷擴展的橋樑所形成。把過去留在只有梗概的回憶裡，停止了有機的生長，我們也失去了和歷史關聯的能力，文化淪喪由此而來。

文化創造藝術和建築這個論點是個誤解。相反，文化遺產可否持續下去，關鍵在於大家明白到文化是藝術和建築創造的。接受這個前題的話，文化縮減的現象並不可怕，因為要幸免被淘汰，唯一的方法是繼續生存、成長和改變。

因此，所有今天的創作者 —— 藝術家、設計師和建築師 —— 都身負重任，他們必須把一切已有的和會有的東西結合。

永不重複，永不忘記，也永不停止耕耘文化。

Cultural heritage diversity exists in time and space, and demands respect for other cultures and all aspects of their belief systems. In cases where cultural values appear to be in conflict, respect for cultural diversity demands acknowledgment of the legitimacy of the cultural values of all parties.

The Nara Document on Authenticity, 1994

文化遺產的多樣性存於時間和空間之中，以尊重其他文化及其信仰體系的所有層面為要旨。若不同的文化價值出現衝突，對文化多樣性的尊重，即承認不同群體的文化價值各有其統。

奈良原真性文件 1994

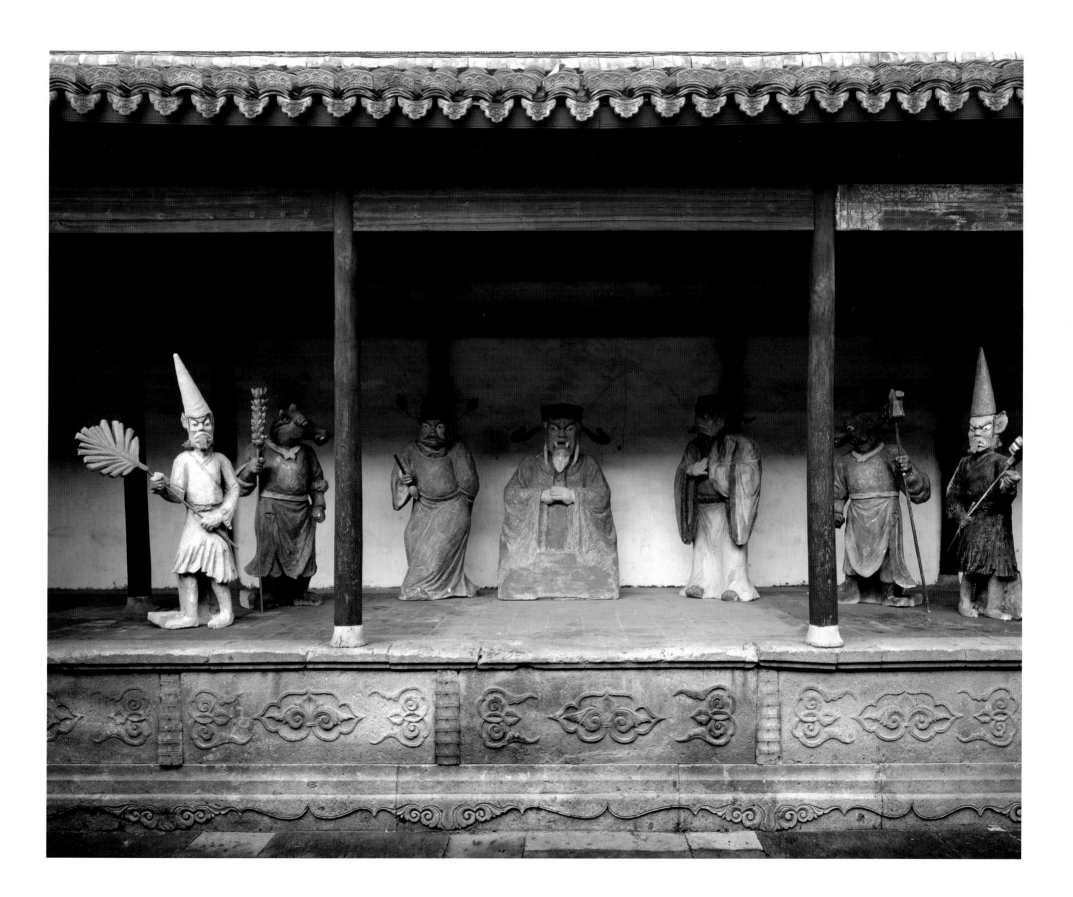

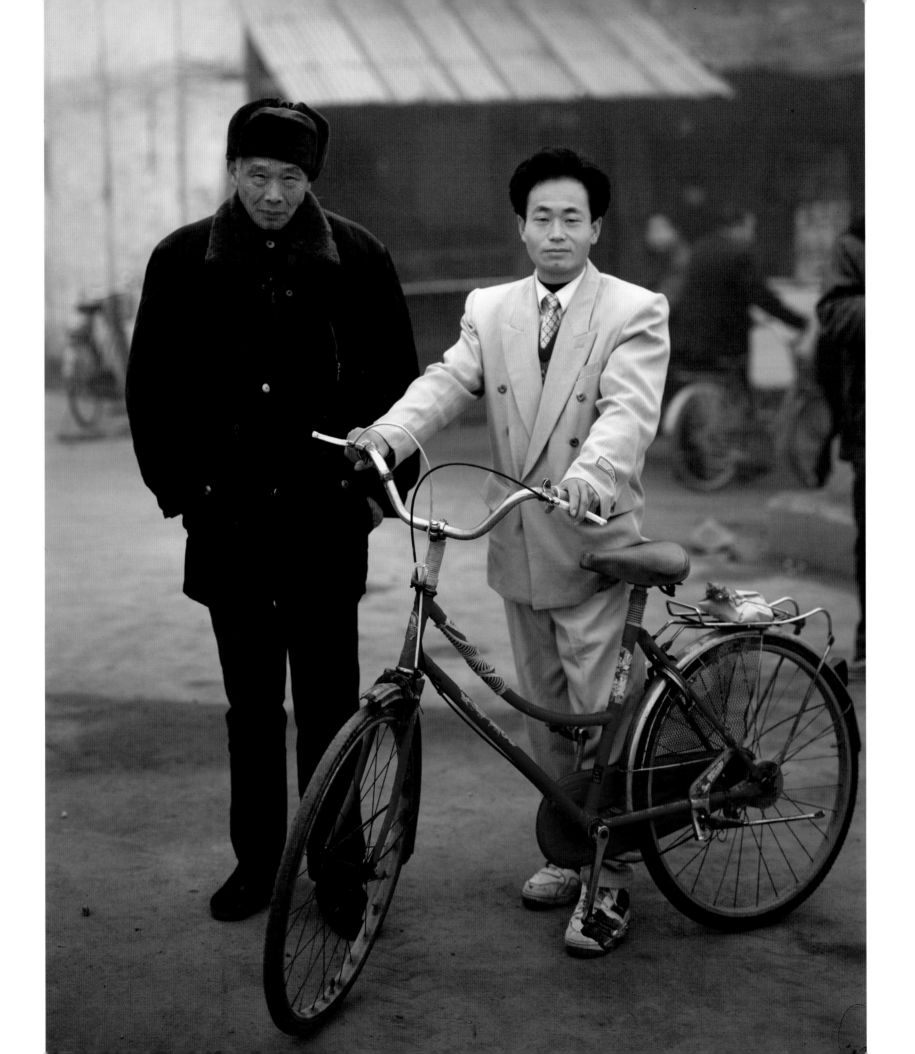

WITH ONE HEART, PROTECT OUR HERITAGE

Zheng Shiling, Tongji University, Shanghai

The future of China's patrimony is in the hands of the Chinese people. While there are many parties who lend us their expertise and passion, it is truly the Chinese people who will move forward on these terribly important initiatives. There are many among us who are dedicated to and concerned about working toward the best approach to heritage protection. These efforts have been an ongoing commitment for individuals in academia, government, and the citizenry for decades. The challenges are daunting at times, but the effort of many has begun to bear fruit. Hard work is still ahead, but there is dialogue, analysis, and action, and all of this sheds a hopeful light on our prospects for success in the future. Amid the multitude of changes going on in the People's Republic of China, there is also a groundswell of sentiment for the preservation of our cultural landscape. For those of us who have been involved for some time in these efforts, this awareness is encouraging.

In many regards, Shanghai is like other international cities that have undergone dramatic modernization, although the accelerated pace with which it and all of China is progressing is relatively unparalleled. In Shanghai, as in many of the world's most vibrant cities, the nationalistic and religious significance of buildings has saved them from demolition. Across China, buildings and monuments are often designated for preservation based on their historical significance to the archaeological, dynastic, and Communist eras rather than their purely aesthetic or artistic value. This practice has thus protected many important structures in our nation. It has also helped maintain much of the urban fabric of Shanghai, despite the destruction or alteration of numerous historic areas.

The city of Shanghai, for better or worse, has always been the leader in cultural and intellectual influence for China as a whole. We have learned both from her successes and mistakes. Since 1994 in Shanghai alone over thirty million square meters of historic infrastructure, comprised of countless old buildings, have been demolished. Despite the existence of government mandates to protect historically important areas, there is scant enforcement of these laws, nor are there economic tax incentives that encourage the successful protection of heritage properties.

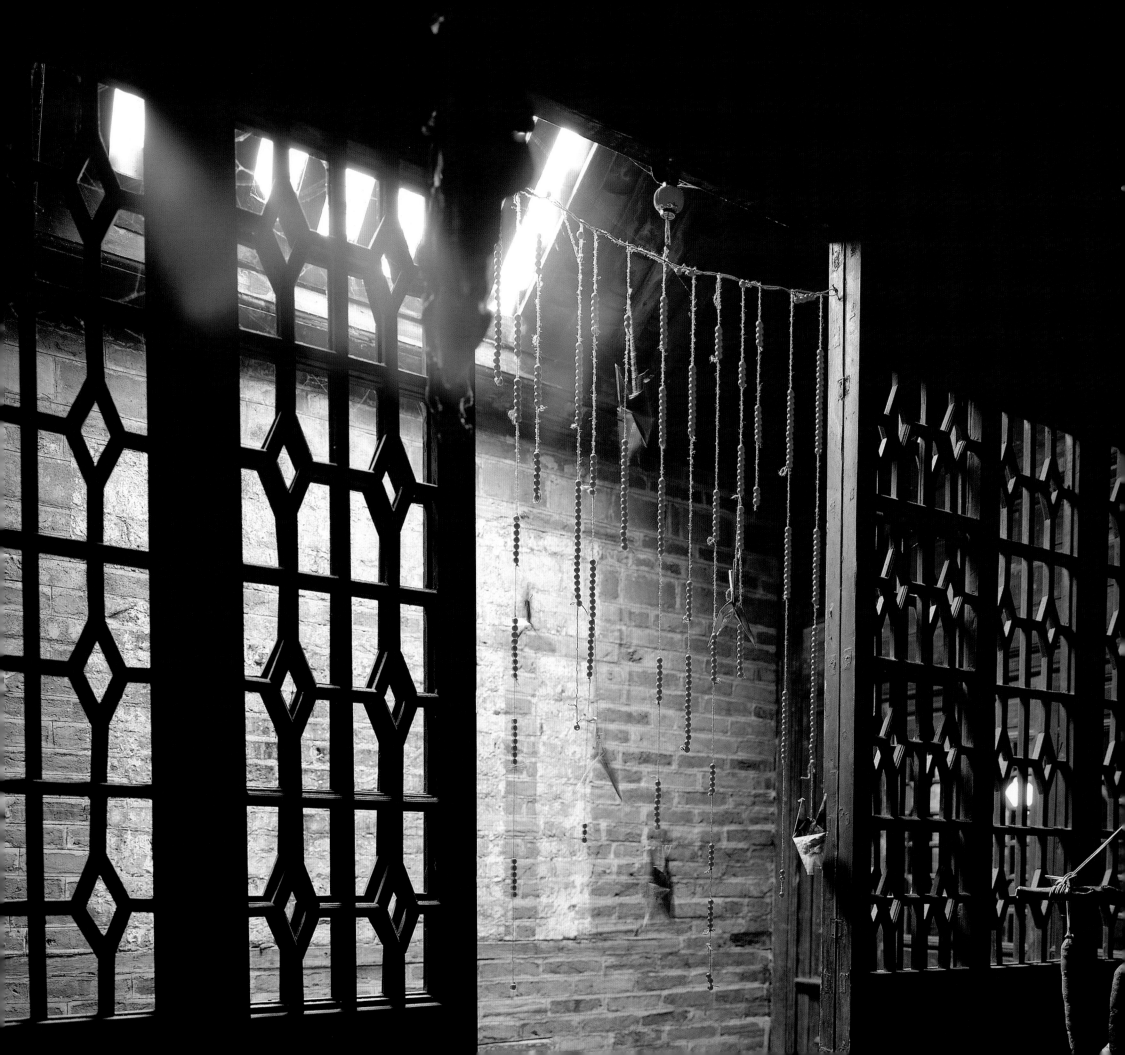

In identifying buildings that are candidates for preservation, many complex issues are involved. It must be remembered that most houses that existed before the modern era were built to provide housing for single extended families with many members. During the twentieth century public acquisition of these properties meant that they were adapted for a style of habitation for which their original design was not suited. Preserving a way of life as an inherent component of heritage conservation is difficult when traditional lifestyles have already been altered many times over. Determining how to do justice to the original intention of historic buildings is therefore part of the challenge with which we are faced.

Beyond the challenges of restoring architectural structures themselves, it is also of primary importance to consider the desire of the residents who live in these traditional settings. In the early years of economic development many people were very pleased to be relocated to more-modern living situations where crowding was alleviated and contemporary conveniences were provided. As the expense of living has increased with the improved economy, it has now become more of an issue of providing adequate compensation to those who must seek new living environments, often far from the central areas of the city. Transportation costs must be factored in to these new arrangements, along with the availability of commercial amenities that make what is still subsistence living possible. Providing more than just a new apartment is essential if relocation is to be considered a desirable alternative to the communal lifestyle that was natural to inner-city living in old neighborhoods.

A multidisciplinary approach to addressing the issues of heritage preservation has most recently been advocated at the May 2005 conference of the Chinese Academy of Sciences. Because cultural identity and the valuation of the past were greatly compromised during the Mao era, there is concern that a general identity crisis is contributing to the lack of initiative of protecting Chinese heritage. Scholars from the social sciences, the humanities, the arts, and the physical sciences are now lending their voices to this discussion with the hope of bringing a more-holistic approach to this very important and pressing issue.

China and her people will not remain in the past. With resolve and dedication we will see a better future in which the wisdom and the treasures of our great heritage play their part in making our nation one among the many that embrace the past, present, and future.

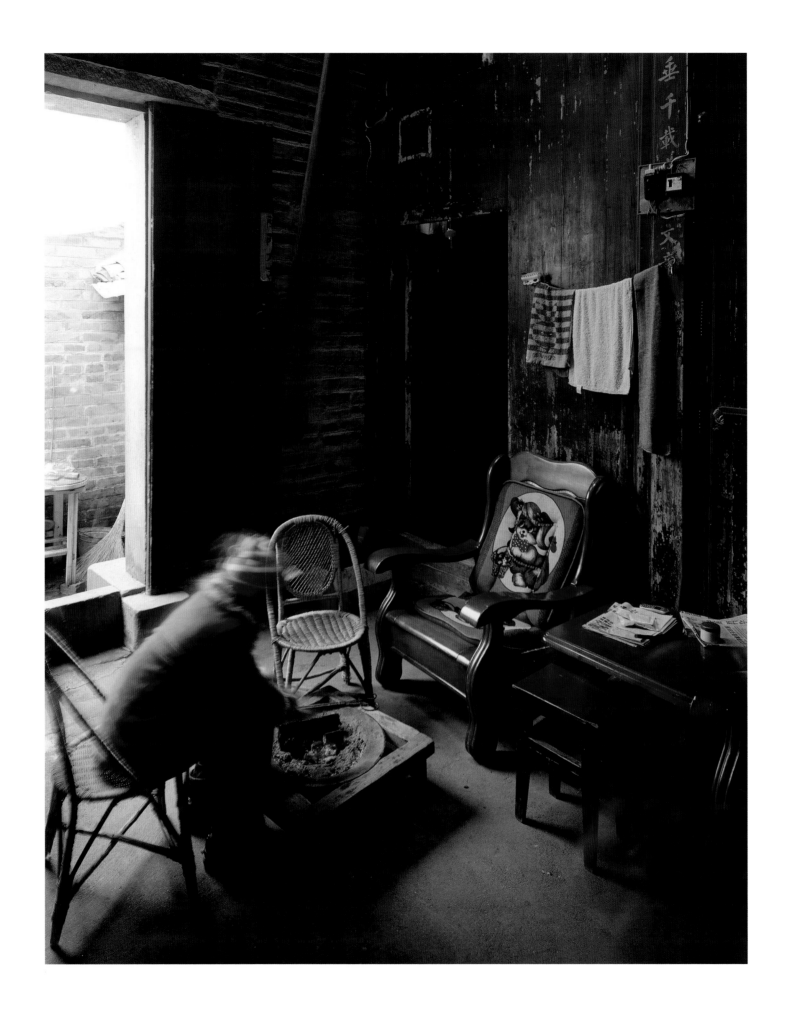

前言
同心協力保護我們的文物
鄭時齡，上海同濟大學

中國的祖傳財產前途就在中國人手裡。海外研究及醉心中國事物者大有人在，但保護祖傳財產的要務，畢竟要中國人自己同心協力肩負。我們不乏關心這個問題的有心人，他們都在致力保護文物的工作。這項要務需要學者、政府和人民數十年不斷努力的承擔。箇中的挑戰有時候頗為嚇人，不過很多耕耘已開始有收穫。要做的工作仍然艱巨，但對話已建立，分析有了，行動也有了，可以說前路是光明的。在中國千態萬狀的變化裡，主張保護文物建築的呼聲也愈來愈高。對我們這些孜孜工作已一段時間的人來說，這個醒覺是一種鼓舞。

上海和其他經歷急劇現代化的國際都會在很多方面都相似，但這個城市以至全中國的前進步伐之速，相對而言是無例可援。在上海，正如在世界上其他充滿活力的城市一樣，對國家有紀念價值或者宗教上有特殊意義的建築物都得以保留，幸免被拆毀。在中國各地，政府指定必須保存的樓宇和紀念建築，往往是因為有考古作用，或者是屬於歷朝遺蹟以及建國前後時期的表徵，與純美學或藝術價值無關。無數重要的建築物因此得以保存，雖然很多歷史性的地區被拆毀或改動了，上海大部份的市容風貌仍然保留了下來。

不管怎樣，上海一直以來都帶領着中國的文化和知識潮流。上海是對是錯，我們都可以借鏡。自1994年起，單是上海一地，已經有超過三千萬平方米具歷史意義的基礎結構被拆掉，其中包括無數古老建築物。政府雖然三令五申要保護重要歷史地區，但執法上仍未見成效，而且也沒有甚麼經濟誘因，足以驅使人們保存屬於文化及歷史遺產的建築。

要決定建築物是否符合受保存的條件，牽涉很多複雜的問題。大多數建於現代以前的房子，設計上只供家庭成員眾多的一房人居住。到了二十世紀，這些房子成為公開買賣的物業，原來的設計已經不能配合新的居住型式。傳統的生活方式已經變得面目全非，要保存一種生活方式，以作為保護文物建築不可缺的部份，真是談何容易。我們面對的其中一項挑戰，就是如何客觀評價歷史性建築物的原來用途。

修復建築物結構的艱巨工作固然重要，照顧在這些傳統環境裡生活的居民的期望也不容忽視。在經濟發展的初期，很多人都樂意遷到比較現代化的環境居住，因為既不用受人口擠迫之苦，也可以享受各種方便設備。不過經濟愈改善，生活費用隨之上升，現在問題是居民得到的補償，是否足夠讓他們找到新的生活環境，而這些環境往往都距離市中心甚遠。新的安排必須把交通費計算在內，還有基本生活所需的商業設施配套也不可少。要習慣了城內舊區社群生活的居民搬遷，需要其他吸引的條件，單靠提供一處居所並不足夠。

中國科學院最近在2005年5月的會議上，提出跨學科的方法以處理保護文物建築的問題。毛澤東時期對文化認同和過去評價曾經有非常大的妥協，現在對保護文物建築的冷漠，恐怕即源自一種普遍的身份認同危機。現在社會科學、人文學科、文科和自然科學的學者正在討論，提出他們的意見，希望有一套整體的辦法處理這個重要且急切的課題。

中國和中國人不會停留在過去。我們只要有決心和獻身精神，前景將會更美好，我們偉大的文化和歷史遺產，將以其蘊含的知識和珍貴的價值，發揮作用，使我們與眾多其他國一樣，繼承過去，立足現在，開創未來。

The intention in conserving and restoring monuments is to safeguard them no less as works of art than as historical evidence.

The Venice Charter, 1964

保存和修復遺迹的意義，在於保護的不單是藝術品，也是歷史的憑據 。

威尼斯憲章 *1964*

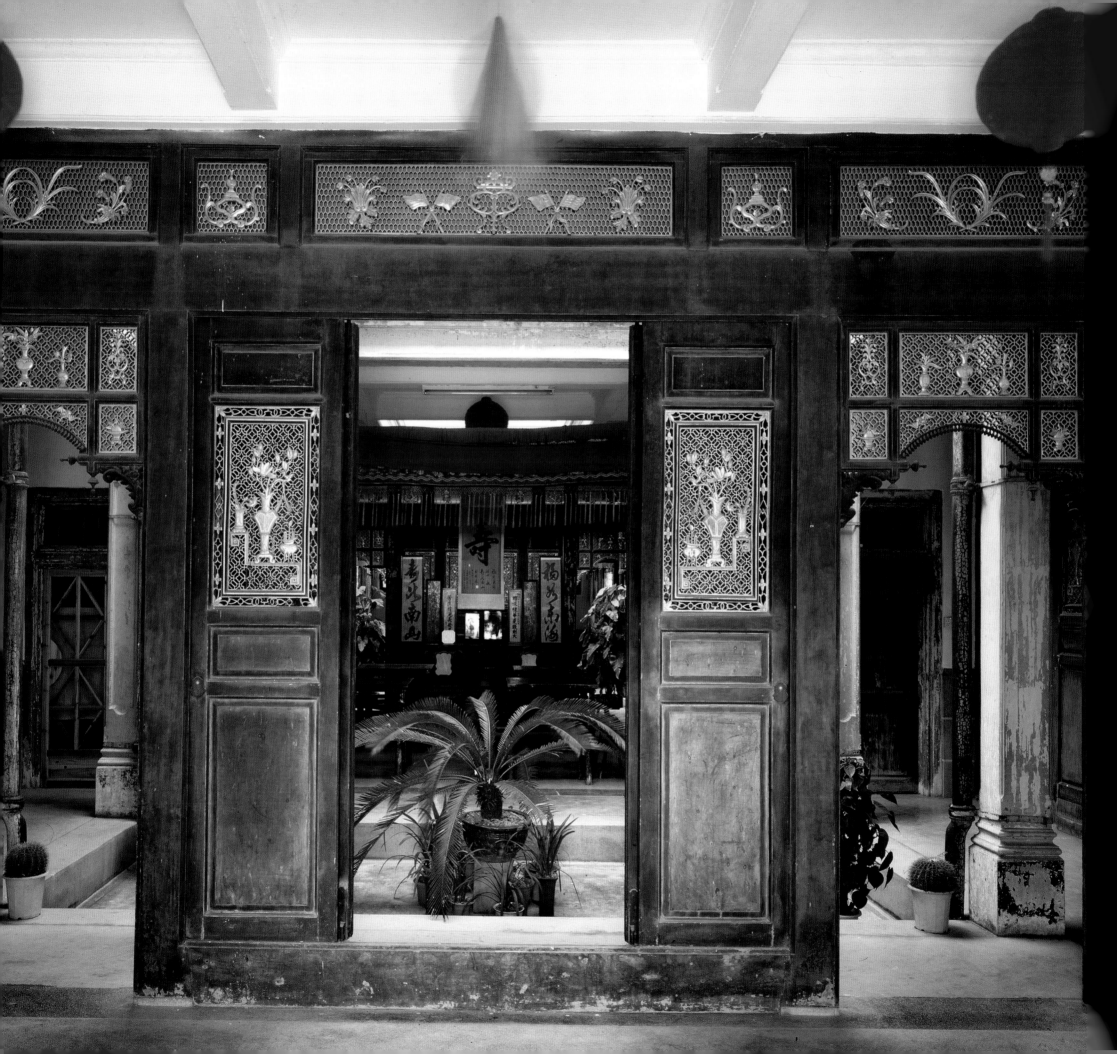

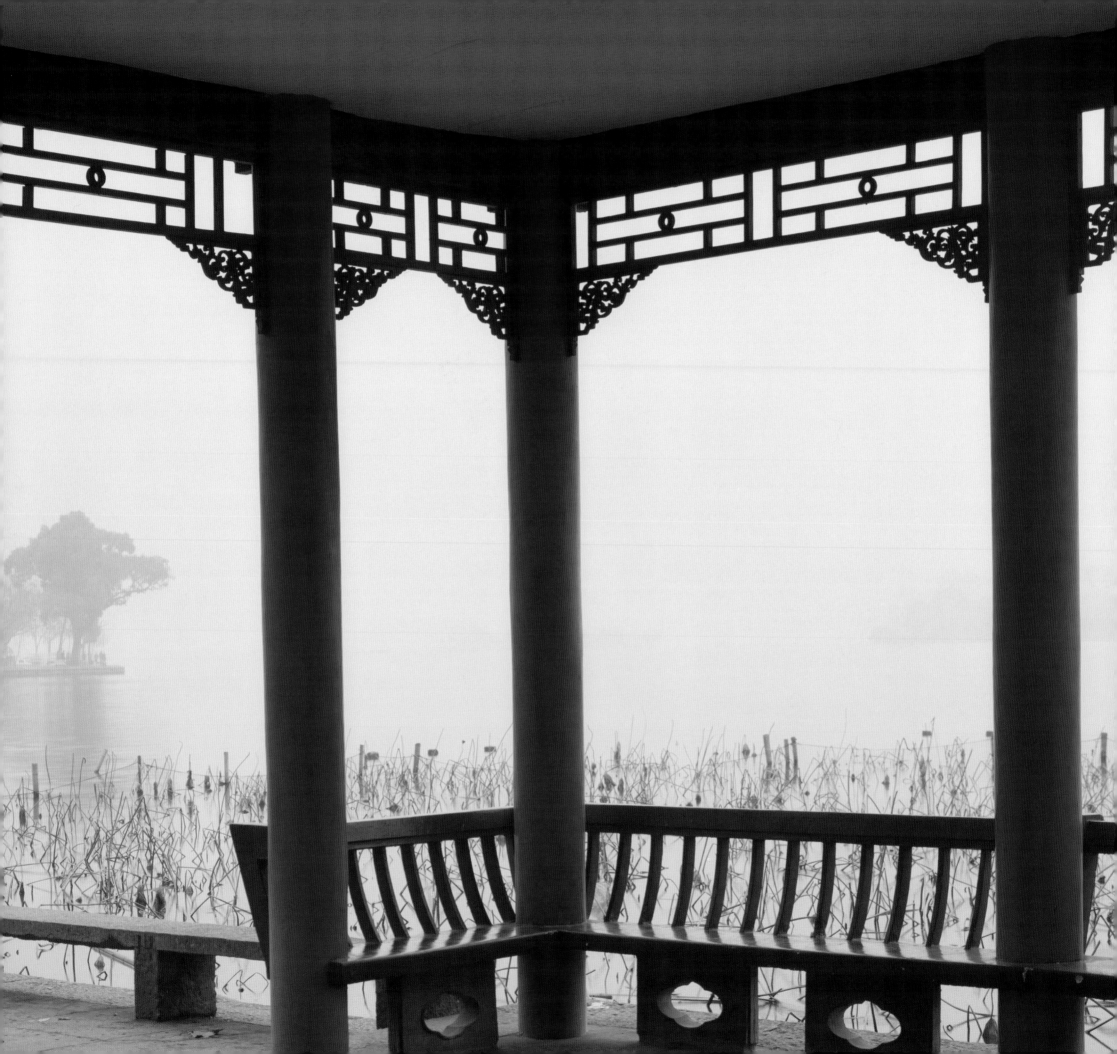

prologue
WHY PRESERVE THE PAST?

Compared to many, I was not an early visitor to China. Yet it has fascinated me from my first trip there in 1995 to my more-recent visits in 2007. Over that decade I have been witness to a dramatic transformative period in China. I admire the amazing progress of the building of new cities as much as I appreciate the nation's historical legacy. However, as China came to fascinate and surprise me, to this moment it raises more questions in my mind than answers. This book is my effort to sort through these issues and make sense of the complexity of what China has come to mean to me.

In this age of globalization we know that the world grows smaller and the ways of life more similar. With this knowledge, I am concerned as much about the fate of the natural environment as about the people who inhabit our shrinking world. A rich diversity appeals to me, and I believe it is essential to humankind's survival. Homogeneity is a force we now struggle to balance with our desire for unique cultural identities. For this reason, where possible, the preservation of diversity is of greater importance than ever. Cultural history forms the core of this diversity.

The building of culture is a work in progress, in China as elsewhere. Every age creates and has the right to insist upon its own synthesis of elements that make up its culture. As much as we value the past, it can never be what it once was, but when it finds its rightful place in the present, it enriches and informs. In the case of China's history, its treasures and historical artifacts are certainly not here merely for our entertainment. They compose the bedrock upon which new culture is based.

In the study of China those things that have survived the trudging complexities of history are of inestimable value. The immediate task at hand is to protect what has come to us intact. Thus, to the caretakers is transferred a sobering responsibility, for beyond saving tangible artifacts, preservation is a means of keeping memories alive. Profiting from our historical knowledge, hybrids of the past and present come into being. Our present can be built on the foundation of the past, but only if we have acted to protect this inheritance.

Fortunately it is within our power to preserve the human legacy that preceded us. Some may disagree with this. There are those who dismiss the preservation imperative when economic progress and development is paramount. It is often argued that preservation is an option too luxurious to entertain. But many professionals believe, and such voices will be raised in this volume, that there are viable economic models that show the benefits of preservation and adaptive reuse.

We might wonder why we should preserve the past at all. Really, why bother? For those who are immersed in these efforts, the question seems ignorant, if not insulting. We act in the art and academic worlds as if this value is a given. The simple truth is that humanly created things are precious. Those that are exceptional are few and far between, and when they are gone, they are gone forever. In our own time we are completely incapable of replicating what the past was able to achieve. So because we cannot re-create it, we must preserve it.

The creative output of mankind tells us of our deep humanity. It is a tribute to the life-affirming urge we have to live with honor and beauty in this finite world. Through the preservation of these cherished things we keep alive the record of the creative and intellectual expression of the people who came before us.

Plainly, this legacy is too precious to sacrifice on the altar of progress and economic expedience. To persevere in its protection is to honor the human spirit that calls to us from both the past and the future.

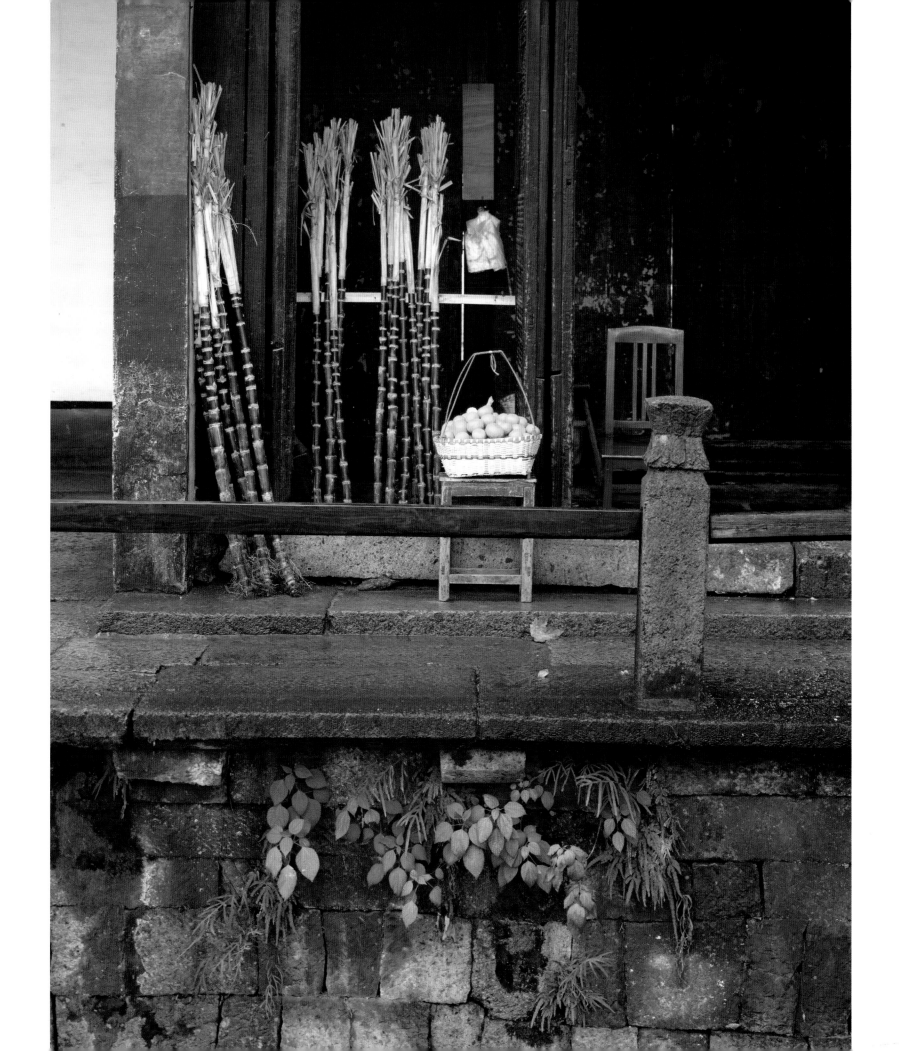

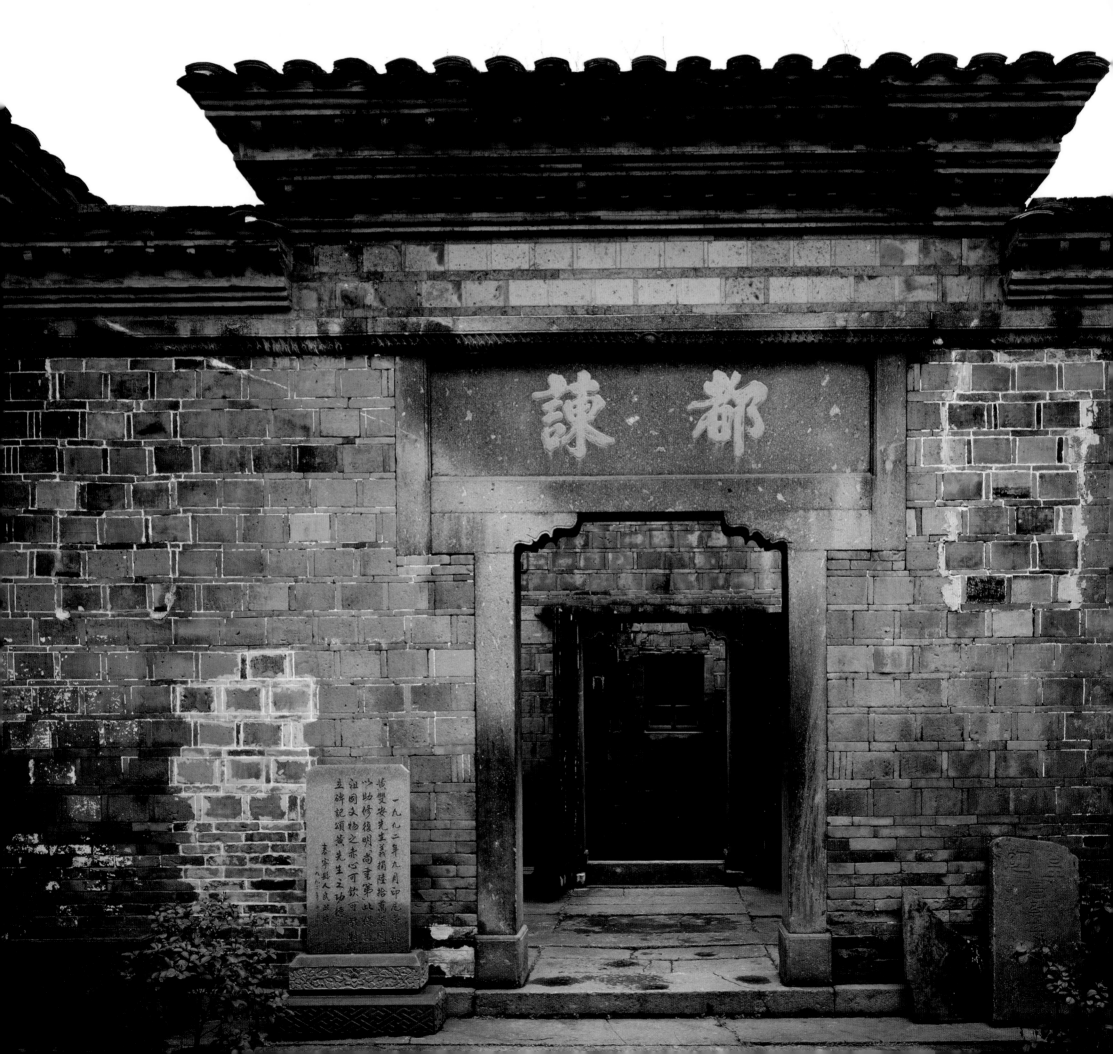

為甚麼保存過去？

和很多人相比，我算不上是中國的最早訪客。不過自我1995年首次到中國，以至2006年最近的一次，每一次中國之行都令我入迷。那十年內，我目睹中國翻天覆地的變化。我既贊歎中國的新城市以驚人速度建立，也極為欣賞中國的歷史遺產。可是，中國令我贊之歎之的同時，也令我想到不少問題，而到今天為止，這些問題很多還未有答案。這本書是我對這些問題的整理，中國於我的意義極為複雜，我要理出頭緒。

在這個全球化的時代，世界變得小了，原來不同的生活方式也變得愈來愈相似。在這個情況下，我對自然環境的命運，以及對棲居在我們這個日漸縮小的世界的人，關心如出一轍。我喜歡豐富的多樣性，而且相信那是人類賴以生存的關鍵。我們現在要抗衡的是同質性的影響，靠的就是對獨特文化認同的渴求。正因如此，保存多樣性以在今天的意義最大。多樣性的核心就是文化歷史。

文化的建構是永無休止的過程，在中國如此，在其他地方也一樣。每一代人都在創造文化，而且有權堅持以其方式及元素建構屬於他們那一代的文化。我們珍惜過去，但不能重拾過去，過去在今天受到正視，今天將更充實和得著。中國歷史裡，歷代的文物珍品絕非純粹為消閒娛人而出現。這些珍貴的物件構成了新的文化基礎。

在中國，那些歷盡千百年歷史洗禮後幸存的文物都是無價寶。當前的要務是把現有的文物好好保存。這是發人深省的責任，因為所保存的已經超越了實在的物件，而是我們的回憶。了解歷史的最大得益，是過去和現在得以交織呈現。現在以過去為基礎，所以我們必須保護過去留下來的遺產

我們幸好有能力保存人類的文化及歷史遺產。也許有人不同意。發展經濟成為大前題的時候，有些人會認為保存文物沒有必要，可有可無。常見的論點是保存文物是奢侈的玩意。不過，很多專業人士認為，我們其實可從保存文物和改造性再用之中得益，而且有例可援，切實及行得通的經濟模式並非子虛；這些意見已收納本書之內。

我們也許會有疑問，保存過去究竟所為何事。是的，何必費事呢？對那些埋首於保存文物工作的人來說，這個問題就算是無意冒犯，也是有點無知。我們這些藝術和學術界中人已經視這些工作為理所當然。事實是人類創造的東西都可貴，其中有些更彌足珍惜，一旦失去便無法補償。過去的事物，我們現在沒有這樣的能力複製出來。正因為我們不能再創造過去的事物，我們必須把這些事物保存。

人類的創造物表達了深層的人性。那是向肯定生命價值的推動力致敬，在這個有限的世界裡，我們應以尊重及美善之心體驗這股力量。藉着保留這些珍貴的事物，前人創造性和智性表達的紀錄亦得以長存。

這些遺產真的不可以奉獻在發展和經濟的祭壇上。

擇善固執保存文物，是對過去和未來向我們呼喚的人類精神表達我們的敬意。

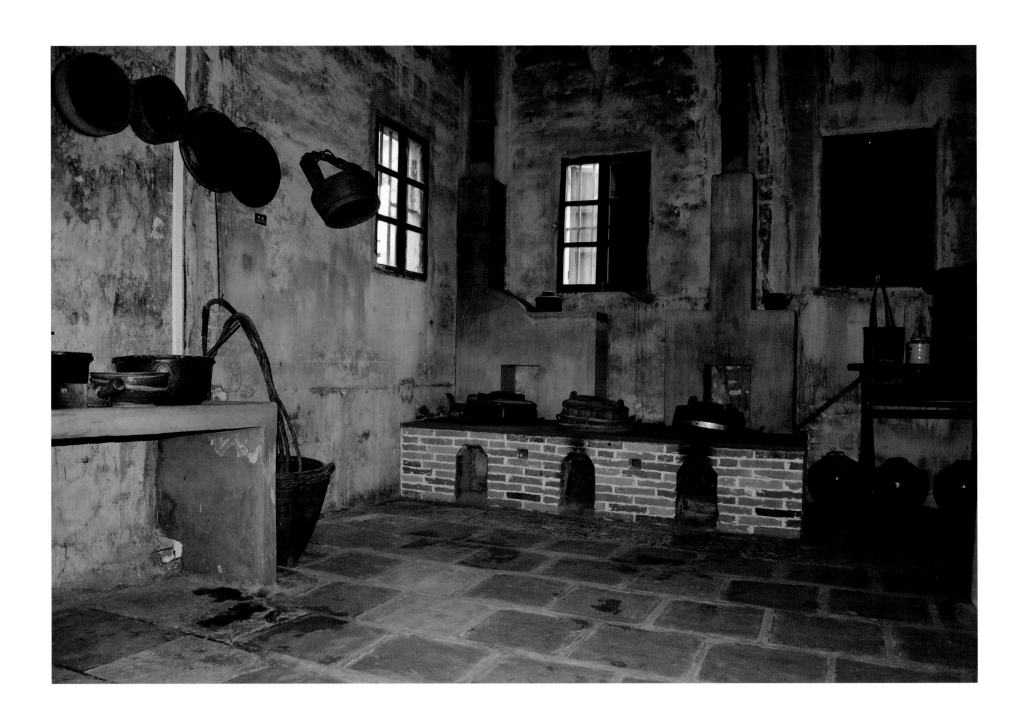

The concept of an historic monument embraces not only the single architectural work but also the urban or rural setting in which is found the evidence of a particular civilization, a significant development or an historic event. This applies not only to great works of art but also to more modest works of the past which have acquired cultural significance with the passing of time.

The Venice Charter, 1964

歷史遺迹指的不只是單一的建築，亦指城市或村落的環境布局，而從中可以找到證據，證明某個社會和生活方式，或者某件歷史事件的重要發展。這個定義不但適用於偉大的藝術作品，也適用於從前較為普通但因為年代久遠而變得有文化意義的事物。

威尼斯憲章 *1964*

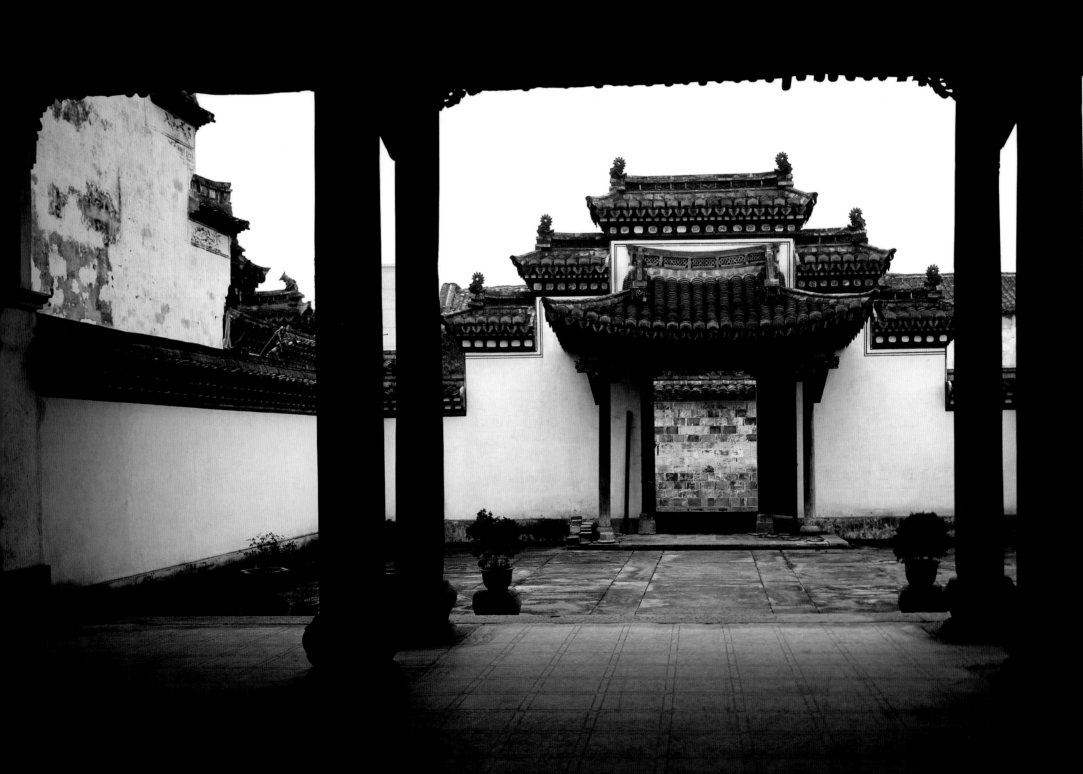

introduction

CHINESE WALLS
facing the challenges of cultural heritage preservation

What is culture? The answers to this question are as diverse as the people on this planet. In its essence, culture is not static, nor locked in the past, nor separate from the human condition. Culture is organic and alive, thus ever changing and evolving. As our world moves toward the future, expressions of who we are, what we feel and think, what we know and honor, and what we create, move with us. They are vital parts of what makes us human. This is culture.

Language is an essential aspect of culture. It plays a central role in our perception of reality. As language shows, cultural identity is tied not only to humanly created things but also to the living spirit and the collective memory of a people. Culture, with its many aspects, is thus very specific to time, place, and person.

China is indeed a unique culture, both in its past and present. To many people in the world it is a mystery and a curiosity. One could reasonably say that the world looks at China with a combination of wonder and guarded expectation. As China enters the twenty-first century, it is, as never before, embracing the tenets of modernity while changing at an accelerated rate.

Basic principles in the modern era recognize that history is linear, moving from the past, through the present, and toward the future. Unlike the cycle of eternal recurrence that characterized the dynastic periods of China, the modern age has brought with it a pace of change for China unparalleled in the West.

Other developed countries had more than a century, perhaps even two, to embrace the trappings of industrialization, communication, and globalization. In the case of China, these earth-shattering changes have been woven into the fabric of its culture within a scant few decades. To touch on all the repercussions of this transformation is not my desire here, or within my ability, yet I venture that no one denies the magnitude of the awakening of the sleeping giant.

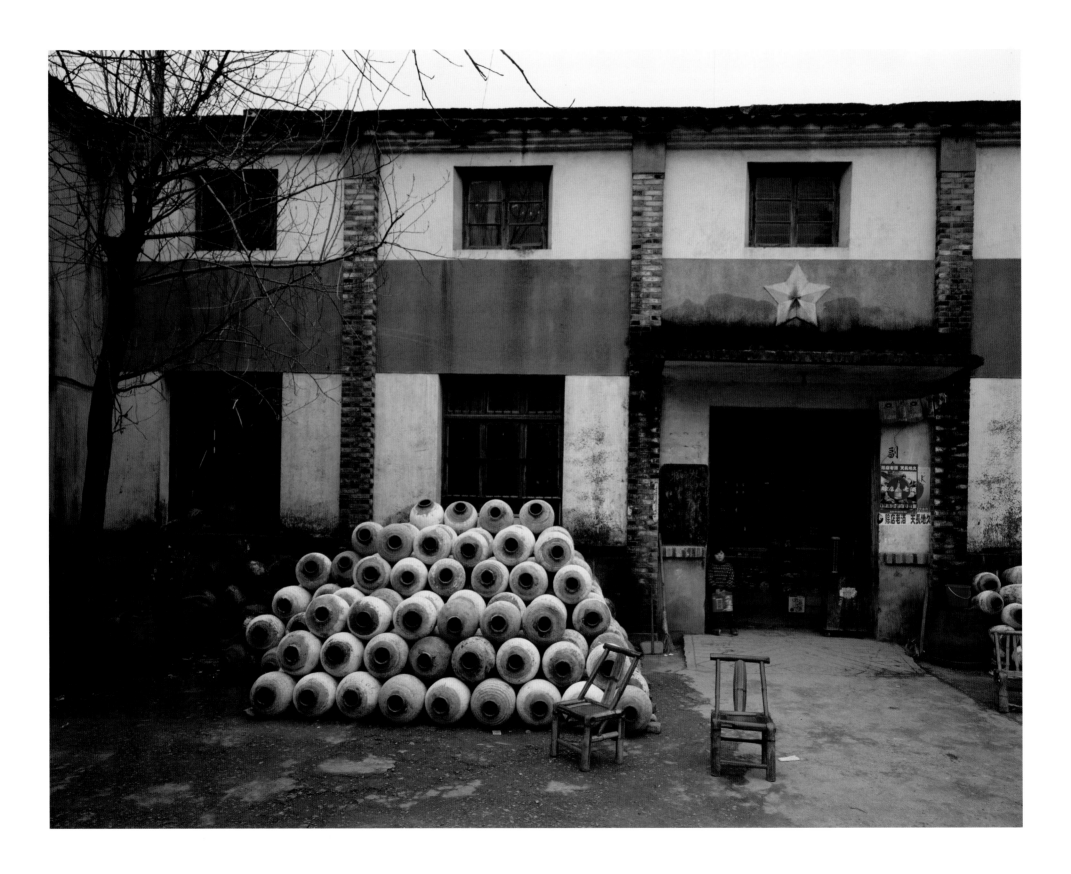

In times past China also captured the world's imagination, from nomadic explorers, to Arab traders, to Marco Polo, to the first navigators that made their way to China by sea. Over centuries China created one of the richest repositories of art, architecture, artifact, and tradition that had ever existed. The riches China had to offer the earliest Western explorers were as exquisite as the finest possessions enjoyed only by the royal and aristocratic elite of European and New World capitals of the day.

Despite its efforts to the contrary, China was to be transformed once navigation forced open its shores to visitors from afar. From tea, to silk, to porcelain, the hunger for Chinese treasures caused, as it so often and so tragically does, conflict and war. As centuries of a way of life unraveled, China faced new challenges socially, politically, and culturally.

China incurred many tragic losses in the nineteenth century, from the Opium Wars to the Boxer Rebellion. In adapting to these cataclysmic changes, aspects of China's lifestyle and governance were left behind. For those who embrace the ideals of progress, and I will go on record here as being one who does, this transformation of Chinese society is still to be viewed with a combination of resignation and regret. Much was lost, but then how could it not have been so?

To imagine that the Qing dynasty was still much intact for our immense enjoyment and admiration is a utopian alternative to the hard history of twentieth-century China. In retrospect, it is only too easy to criticize the abbreviation and loss of what was one of civilization's greatest artistic and cultural eras. But the world is not a museum. It is a place where humans must first secure their survival.

Nostalgia for an idyllic past, always more imagined than real, often collides with reality when a nation-state must contend with cultural stagnation and social turmoil. It is much easier to love a dysfunctional past once it has disappeared. Because centralized power had fostered corruption in the late stages of the Qing dynasty, a revolution in China's socioeconomic structure was predictable. China tumbled blindly into a new century that was reinventing history in ways that no one, least of all the Chinese, could have predicted.

China was faced with the challenge of creating itself anew from the ashes of an antiquated past. Few options were in sight. Using a Western political and economic model was far from being an exact fit for China's needs. The excruciating transformation demanded of China presented few political alternatives. There were no easy solutions for how it might make such a massive historical leap forward.

This is not a historical primer, but a work that is meant more as poetry than prose. The study of China's history is available to anyone who is conscientiously interested in global geopolitics. For my purpose here I will only summarize by saying that without question the Chinese people made untold sacrifices in the name of progress. These costs were the birth pangs of a nation. They were also the means of feeding the masses of Chinese left hungry and homeless after decades of hostile foreign intervention and domestic social upheaval.

The ensuing brutalities that characterized the fight for political control and the violence and destruction that were endemic to the Cultural Revolution are rightly looked upon with sorrow and regret, and even denial. However, it is difficult to imagine that conditions would have been otherwise, since China had entered the twentieth century in a state of political chaos. For those who lived through that tumultuous time, it is still too painful to reignite those memories, and many years must pass before the scope of that nightmare can be fully analyzed. I am in no way an apologist for the Cultural Revolution, or man's inhumanity to man in any case, but the number of nonviolent revolutions in human history is certainly more an aberration than a rule.

Political history aside, the repercussion that is of concern to us here was the wanton destruction of so much of China's cultural patrimony during the last century. I feel justified in calling such misguided annihilation of historical relics a crime against humanity. By choosing now to stop the ongoing destruction of its cultural history, China would set a new course for preserving its cultural inheritance. We cannot undo the past. We can, however, act to create a better future.

As we move away from mourning the past that was destroyed, we are witnesses to a basic truth about the evolution of culture. The nature of civilization is organic because it is human. People and the means by which they exist are never static, but always changing. Things happen, things are lost, new things emerge. This is true whether we like it or not—and for modernity, it is embraced. That anything survives at all is the true miracle. All that was (whether it exists now or not) and all that is new combine to define a people culturally.

So what is it of the past that can be preserved? No one now lives who can share with us tales of direct experience of the Forbidden City or the building of the Great Wall or emperors' tombs. We must look, therefore, to the ciphers that are left to us of other times. These markings—glorious fragments of cultural history—are all that we have, and surprisingly, we can claim that we do know a lot about the past. There is a strong tradition of scholarship that has made this possible.

About China's past there exists an artistically prolific tradition of written and tangible artifact. This grand collection constitutes a long and continuous cultural record from which a sublime picture emerges. China's cultural greatness attracts the admiration of Sinophiles as much, if not sometimes more, as it does the Chinese themselves. But it must be as sovereignty dictates, on China's terms, that its past is preserved and its future secured. From all those with an interest, vested or voyeuristic, there is unequivocal support for this approach.

We pull from the past those things that reflect the image we have of another time. Among those things on which we place cultural significance are places, objects, art, architecture, literature, language, traditions, myths, legends, philosophy, religion, societal constructs, and anthropological and archaeological evidence. In the work of preservationists, these are fundamental examples of human existence, which are valued as being worthy of study and protection.

We should preserve the tangible relics of our past, as we are able. Beyond the physical, there are also intangible aspects of the human experience that are in need of our protection. There is sanctity in the human spirit that makes cultural enlightenment possible in any given time and place. And I believe, as a living artist (so this is my bias), that as we work to protect the past, we also support the creation of new lines of thought, art, and cultural expression.

China is currently in a period of prolific artistic creativity. This is an exciting time in the Chinese contemporary art world. Artists help articulate a vision of a society that was once something else and is becoming something new. These efforts will necessarily include hybrids of the past and present. In this way they contribute, through the wealth of new work, an understanding of China's past. Such is an enduring example of culture's tenacity and continuity.

Humanity stands at a crossroads. This is all we have—a present in which to act. As it applies to China's cultural inheritance, it is my belief that the entire world looks to this great nation with the most sincere hope that its rich heritage be protected. We can choose to do things so they may endure, even in the commodity-driven times in which we live.

China is the caretaker of a treasure of human history that is unparalleled. For myself and on behalf of my colleagues, who have so generously engaged in the discussions that led to this book, I appeal to those in positions of influence in China that action be taken to protect their nation's *patrimony.* In a country where familial lineage is of such significance, this term should resonate in a specific way, as it is defined as "those things one generation has inherited from its ancestors."

By taking this bold and courageous course, China will enhance not only its own cultural identity but also that of humanity writ large, with the wealth that only the perpetuation of one of the world's greatest cultural legacies can provide.

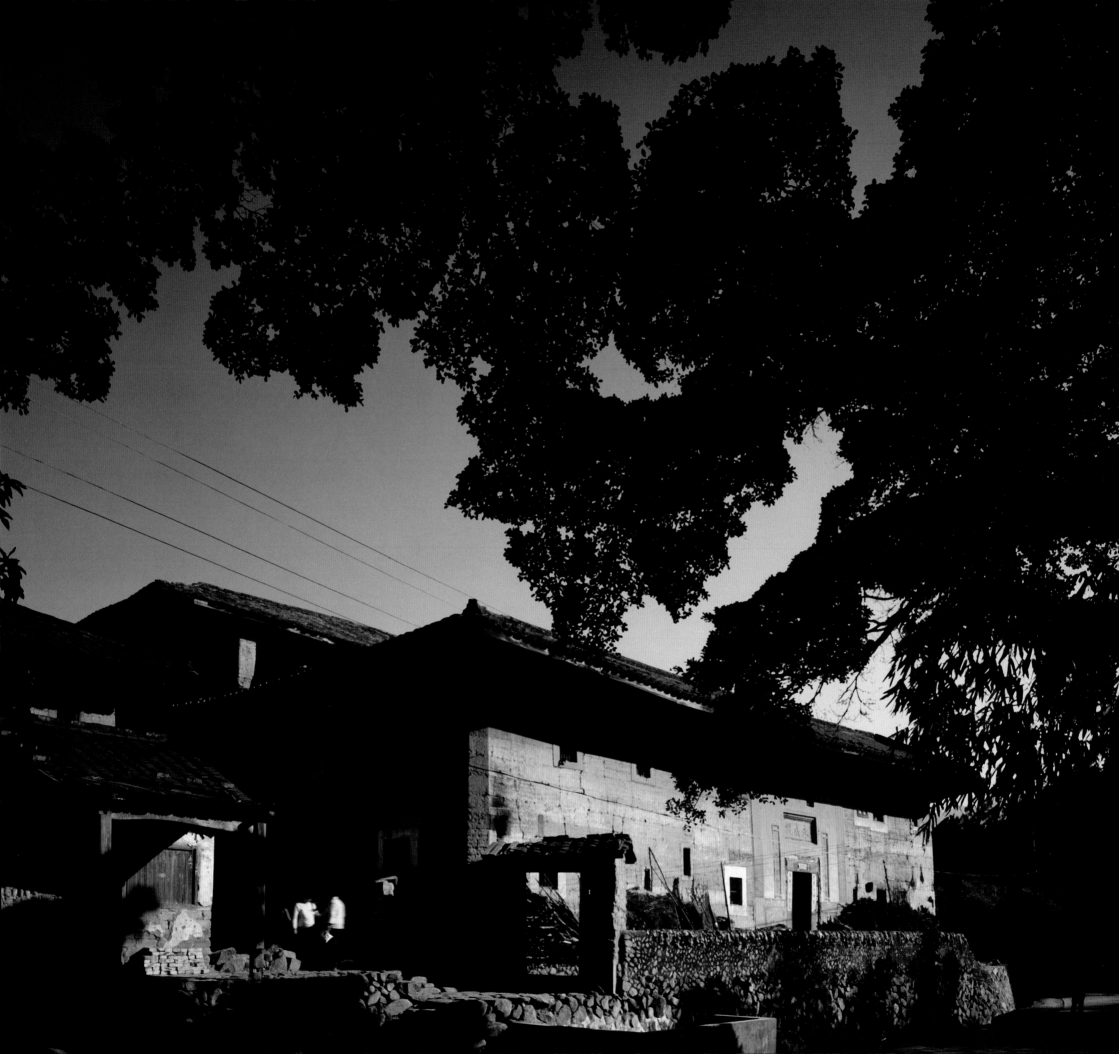

導言
「中國牆」
正視保存文化遺產的挑戰

文化是甚麼？這個問題的答案，有如地球上諸色人等一般多樣。本質上，文化並非靜態，亦不會滯於過去，更不會脫離人的環境。文化是有機和有生命的，所以不斷變化，不停發展。我們的世界往未來移動的時候，我們是誰；我們所感所想；所知所尊；我們所創造的，這種種思想和感情的表達，也隨着我們轉變。這些是我們作為人的重要構成部份。這就是文化。

語言文字是文化的主要層面。我們對事實的感知有賴語文。按語文所顯示，文化認同所繫者，並非單是人類創造的事物，亦關連一個民族的精神現狀和共同回憶。文化，以其多樣面貌，因此亦隨時、地和人而各異。

中國文化真的非常獨特，古今皆然。世界上有很多人覺得中國神秘及奇妙。可以這樣說，世人看中國的眼光混合了驚嘆和有保留的期待。中國邁進二十一世紀的時候，前所未有地全面迎接現代化，以加快的速度轉變。

現代的基本理論認為歷史是綫性的，從過去發展到現在，再推向未來。中國歷史裡，朝代興替循環，但現代為中國所帶來的轉變，步伐之速是西方無法比擬的。

別的發達國家有超過一百年，甚至兩百年的時間發展工業、通訊和接受全球化。中國卻得在幾十年間，把這些翻天覆地的轉變和自身的文化融合。我無意，亦沒有能力，在這裡論說這些變化的影響，不過我可以大膽說，沒有人會感覺不到這個沉睡巨人醒來後的震撼。

中國從前也是世人憧憬的國度。遊牧探險家、阿拉伯商人、馬可勃羅，以至首位覓路至中國的航海家，中國都是他們的目的地。千百年來，中國創造了燦爛的文化，藝術、建築、工藝和傳統，內容之豐富無與倫比。最早來到中國的西方探險家也最幸運，他們接觸到的中國珍寶，與當時只有歐洲和新世界王室貴胄才享受到的珍品不遑多讓。

中國雖然極力抗拒，但外國的海上力量強行打開了海岸，遠方來客登陸，中國被迫改變。茶葉、絲綢、瓷器，西方對中國商品的渴求愈來愈大，經常而且悲劇性地引起糾紛及戰爭。世世代代的生活方式一下子解體，中國面對着社會、政治和文化上的新挑戰。

中國在十九世紀經歷了鴉片戰爭和義和團等動亂，損失慘重。在適應這些災難性的轉變時，中國的生活方式和管治層面遠遠落後了。對那些信奉發展和進步的人來說（先此聲明，我是其中一員），今天回顧中國社會的這個改變，仍然令人感到無可奈何和惋惜。失去的太多了，但又怎麼可以不是這樣呢？

二十世紀的中國歷史荊棘滿途，奢望滿清一代仍可以完整地供我們沉浸其中細味欣賞，是逃避那段歷史的空想。回顧過去，對人類文明其中一段最光輝的藝術和文化時期竟然輕視如斯，我們很難不會不批評。但世界不是一座博物館。人生世上首要是確保生存。

對過去如詩如畫歲月的緬懷，往往是想像多於真實，而國家窮於應付停滯不前的文化與社會動盪時，懷舊和現實便水火不容。過去怎樣不濟，一旦成為過去，便很容易令人懷念。晚清政治腐敗，一場中國社會經濟結構革命正風雨欲來。中國跌跌撞撞進入一個新的世紀時，歷史正以另一種方式改寫，誰也預料不到，更不要說中國人了。

中國面臨的挑戰，是從古老過去的灰燼裡重生。眼前沒有甚麼選擇。　西方的政治及經濟模式於中國並不完全適用。變化之急劇，中國可以取捨的政治選擇無多。這是歷史性的向前猛躍。如何做得到？沒有容易的方法。這可不是歷史的初階讀本，而是一份詩詞多於散文的作業。任何對全球地緣政治學真正有興趣的人都可以研究中國歷史。我只想概括地說，中國人確實在發展的名義下作了數不清的犧牲。所付的代價是國家出生時的陣痛。還有必須千方百計養活飽受外憂內患摧殘後的哀哀黎民。

文化大革命的殘酷暴力及破壞，令人感到悲哀和痛惜，甚至難以接受。對那些經歷過那段動盪歲月的人來說，到現在仍然是不堪回首，要充份了解那場惡夢究竟有多可怕，應該是多年後的事了。不管怎樣，我絕對無意為文化大革命辯解，亦不認為人類自相殘害是無可避免，但非暴力革命肯定只是人類歷史的特殊例子，並非常規。

撇開政治歷史，我們關注的是上世紀中國文化遺產被大量恣意破壞所造成的影響。這種誤導性的毀滅歷史遺跡，我認為可以稱之為違反人性的罪行。中國現在停止再損毀文化歷史，可以立下不再重蹈覆轍的榜樣。逝者已矣，但我們可以創造更美好的未來。

我們為毀掉的歷史惋惜之餘，眼前就是真實的文化蛻變。文明的本質是人，所以是有機的。人及其生存的方式從來不是靜態，而是不斷變化。生生滅滅，推陳出新。我們愛也好恨也好，這是事實 — 而這正與現代性契合。沒有被淘汰的東西才是真正的奇蹟。所有新與舊（無論是否還存在）的結合構成一個民族的文化定義。

那麼過去有些甚麼是可以保存的呢？今天沒有人會告訴我們紫禁城內生活的親身經歷，遑論萬里長城或者帝王陵墓的建造經過。我們必須解讀留傳到我們手上的東西。這些標記— 文化歷史的輝煌片斷 — 是我們僅有的了，出人意表的是，我們的確對過去有頗深的認識。所以如此，有賴堅實的學術傳統。

中國的過去從其多彩多姿的藝術傳統可見一斑。中國的書畫和手工藝品數量極為豐富，構成一個悠長綿延的文化紀錄，呈現出一幅令人目眩的圖畫。中國文化的偉大，中國人固然贊歎，仰慕中華的外國人亦深受吸引。不過從國家的立場來說，歷史要保存，未來也要安全無憂。所有利害攸關者，切身也好從旁伺機也好，對這個取向都不會有異議。

從過去的事物裡，我們可以想像另一段時間的情景。這些蘊含文化意義的事物指的是地方、物件、藝術、建築、文學、語言、傳統、神話、傳說、哲學、宗教、社會結構，以及人類學和考古學的發現。對文物保存者的工作來說，這些是人類存在的基本例子，值得研究及保護。

我們應該保存歷史的有形遺迹，而且也做得到。除了實質的事物外，人類文化的非物質部份也需要受到保護。人文精神的可貴之處，在於任何時空裡均可以達到文化的覺醒。作為今天的藝術家（所以有我的偏見），我相信我們在保護過去的同時，也在支持創建思想、藝術和文化表達的新路線。

中國現時處於藝術創意的高峰期。這是中國當代藝術世界裡令人感到興奮的時刻。藝術家有助表達社會的願景，那曾經是另一個樣子，而現在已面貌一新。這些努力必然包括過去和現在的融合。藝術家以其豐富的新作品促進了對中國過去的了解。文化的強韌和連貫性亦由此可見。

人類正處於十字路口。當下是坐言起行的時候。說到中國的文化承傳，我深信，全世界都竭誠希望這個偉大國家的遺產受到保護。我們可以選擇做些事情，讓這些遺產在這個受商品左右的世界裡也得以長存。

中國守護着人類歷史裡無雙的寶藏。我謹向在中國居於有影響力的地位者呼籲，也代表以他們坦誠的討論而促成此書的同行這樣做，必須採取行動保護他們國家的祖傳遺產。在一個重視家族世系的國家，這應該會引起共鳴。

「世上無難事，只要肯登攀」。保護一項世界上最偉大的文化遺產，使其不朽，從中的增益，不單是中國自身，而是人類整體的文化認同。

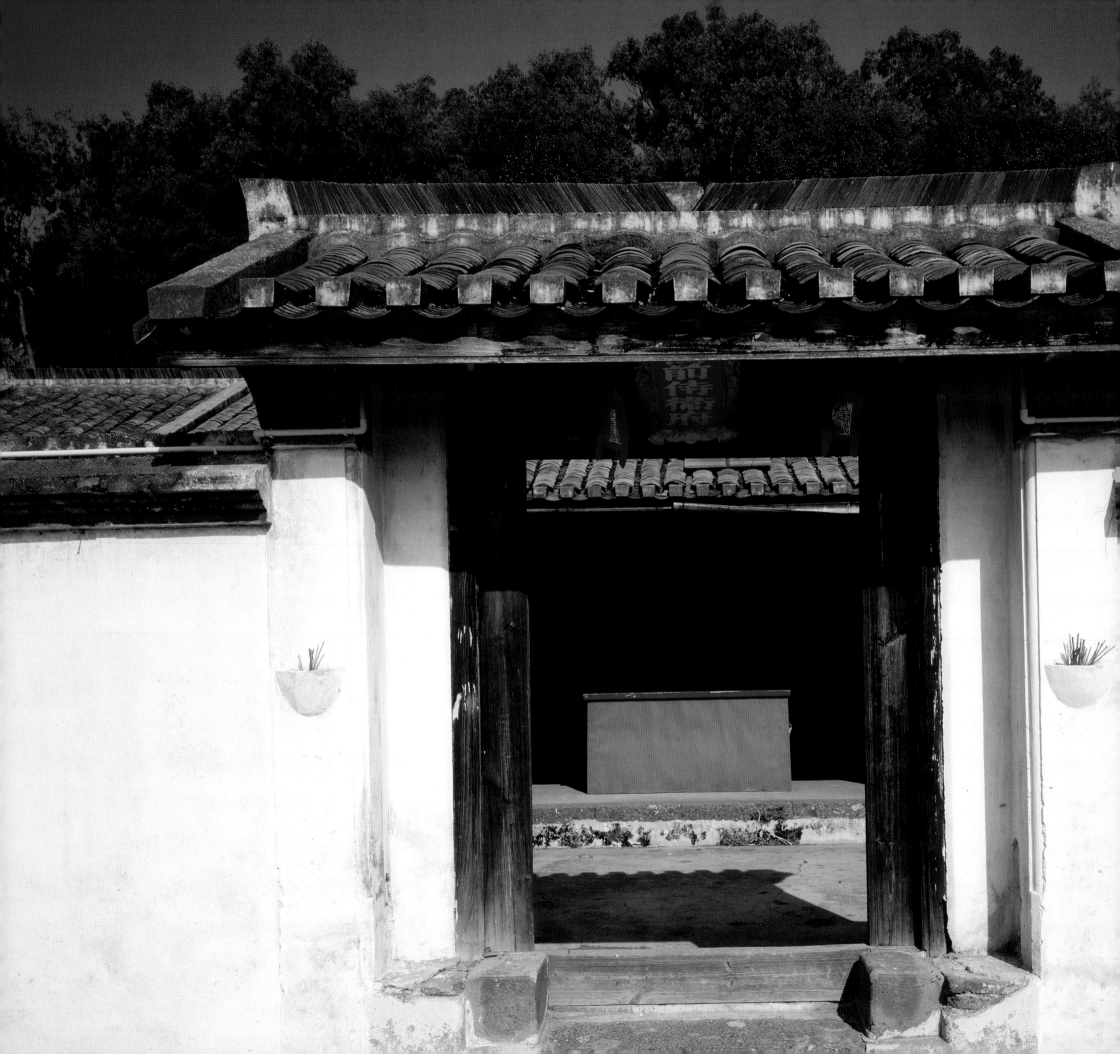

All cultures and societies are rooted in the particular forms and means of tangible and intangible expression which constitute their heritage, and these should be respected.

The Nara Document on Authenticity, 1994

所有文化與社會，都根植於其實質和非實質體現的獨有存在形式和方法，由此構成其遺產，理應受到尊重。

奈良原真性文件 1994

holding together

pi

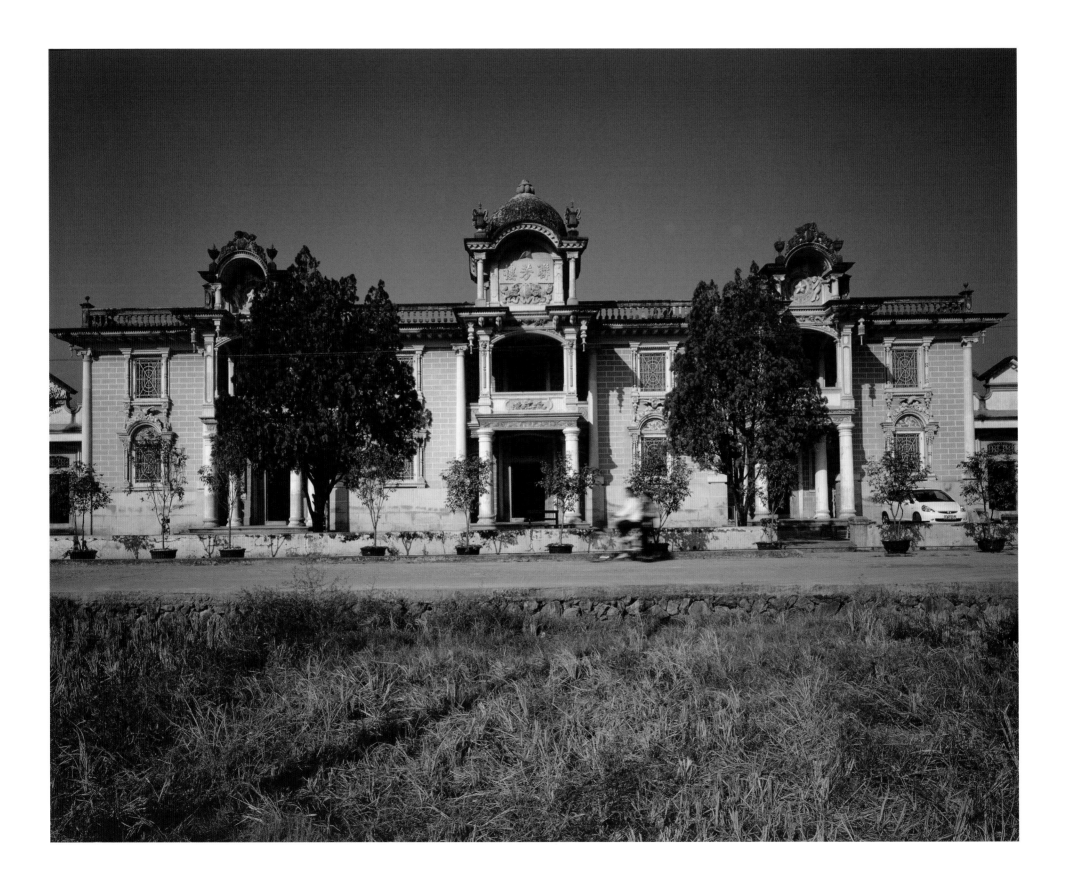

jianzhu

tradition 傳統

ANGUS FORSYTH

China can claim more than a six-thousand-year continuum of
the same people working the same land. Its culture has evolved and developed
into the present day, sometimes absorbing and sometimes rejecting foreign influence.

中國可稱六千多年來由同一民族在同一土地上勞動。
中國文化蛻變及發展至今天，時而融合時而排斥外來影響。

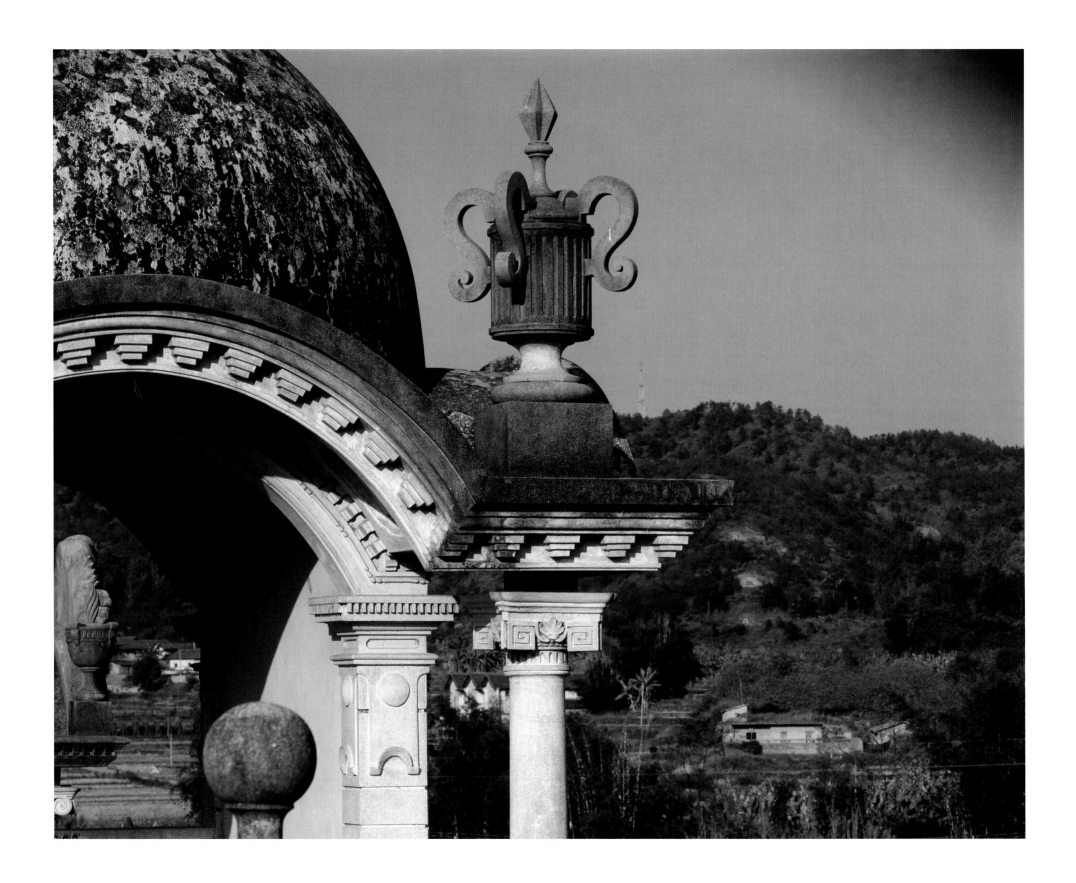

The good news is that in today's climate many people of conscience are working to protect historical artifacts, understanding that our surroundings from the past provide the backdrop that enables us to appreciate—or decry—the present.

好消息是，在今天的氣候裡，很多有良知的人都參與保護歷史文物的工作，他們明白，從過去留下來在我們身邊的事物，為我們提供了一個背景，讓我們可以欣賞 — 或者批判 — 現在。

But sadly we are also witness to the widespread blight of development motivated solely by profit. In all centers of population the protection of Chinese cultural heritage is at greater risk than ever before. The problem is urgent. There is no time to waste in attempting to save the last vestiges of China's historical legacy.

可惜的是，我們也目睹純粹為了利益而發展所造成的廣泛破壞。在所有人口稠密的地方，對中國文化遺產的保護，從未有像現在那樣的岌岌可危。問題非常嚴峻。救救殘存的中國歷史遺產，時間無多了。

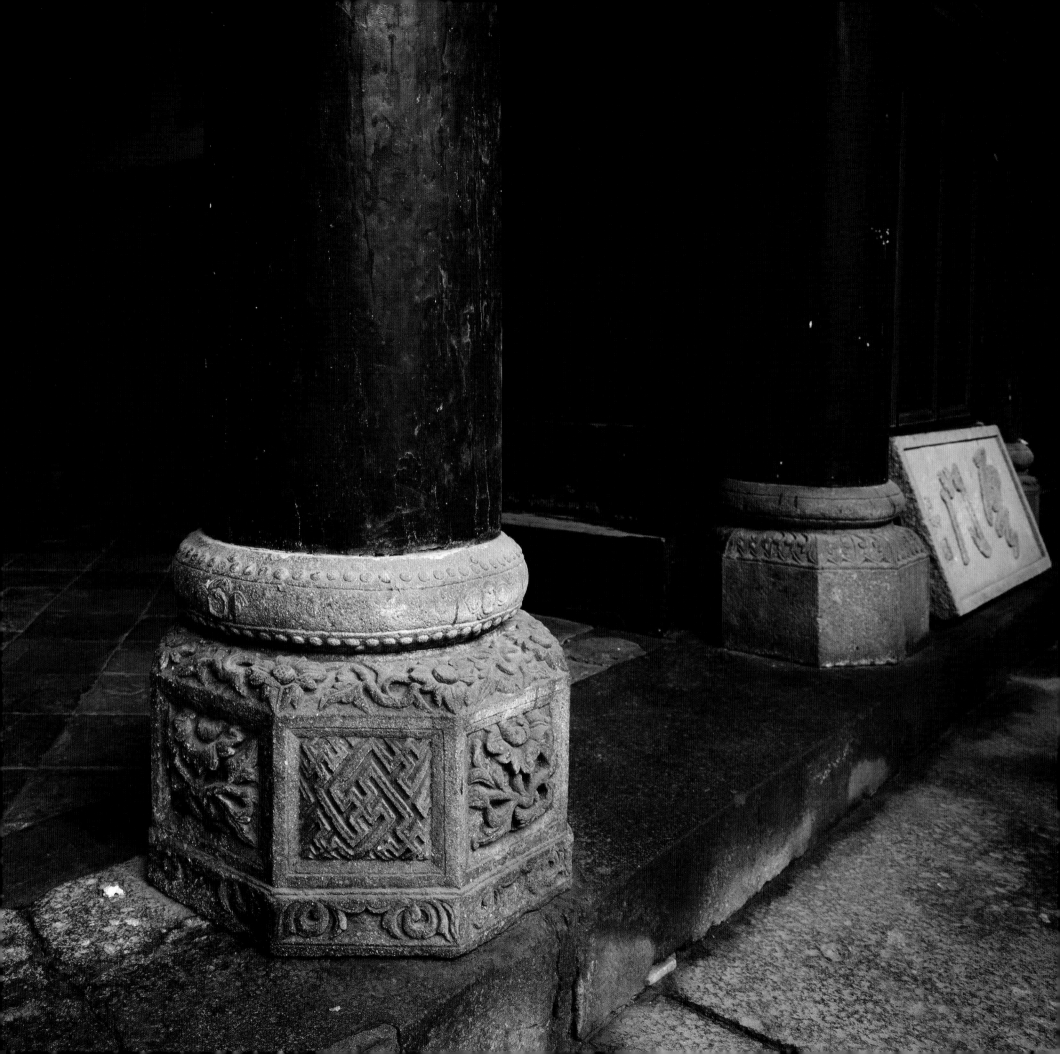

保護 *baohu*
conservation

THE GETTY CONSERVATION INSTITUTE
蓋提文物保護中心

China is a unified country of many ethnic groups; it is a vast country with a long history and an unbroken cultural tradition. The large number of surviving heritage sites affords a vivid record of the formation and development of Chinese civilization. They provide the evidence for an understanding of China's history and a basis upon which to strengthen national unity and promote sustainable development of the national culture.

中國是多族群的統一國家，幅員廣闊，歷史悠長，文化傳統綿延不斷。現存的大量文化和歷史遺產，即生動地紀錄了中華文明的形成和發展。這些遺產有助我們了解中國歷史，而且是國家團結的基礎，亦促進民族文化的可持續發展。

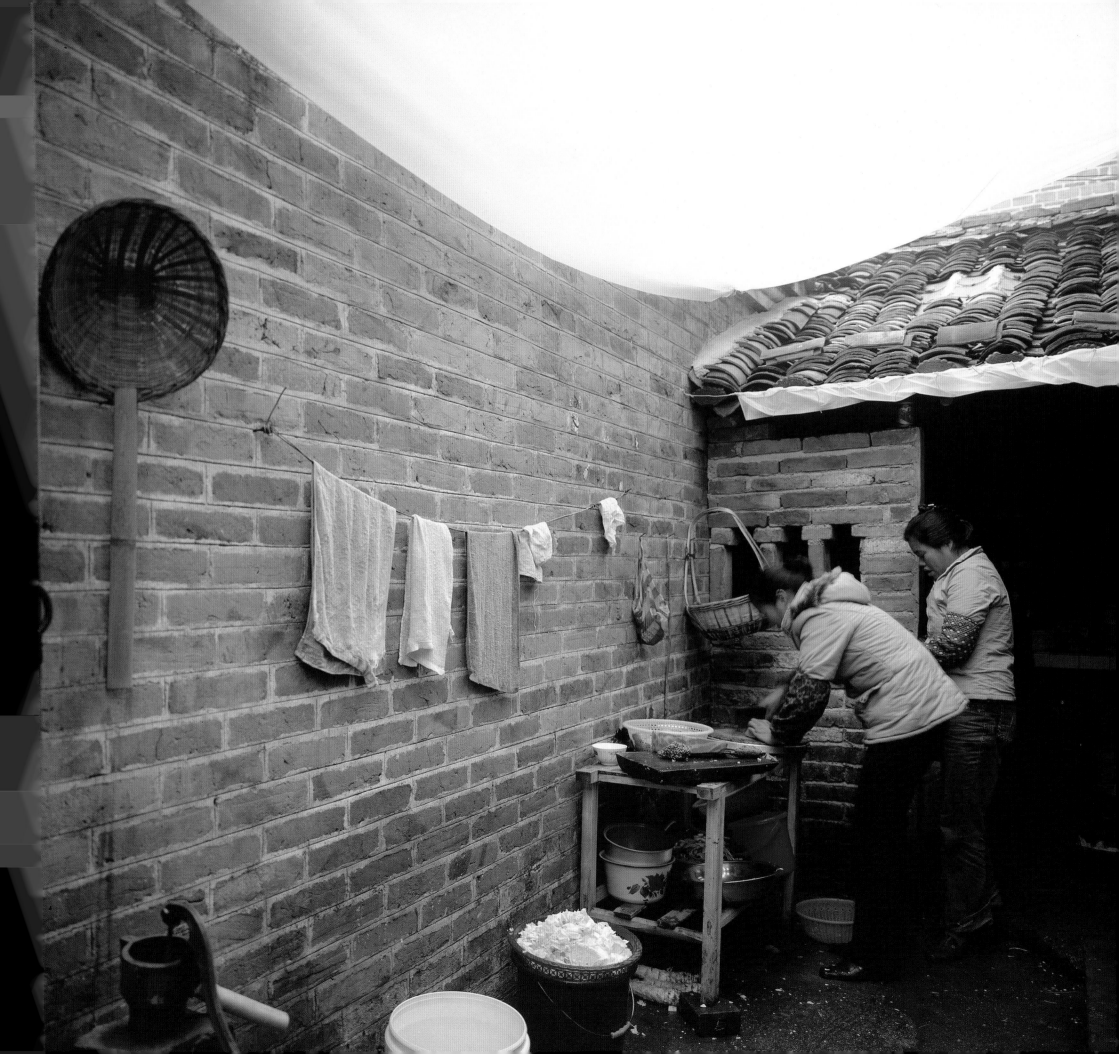

Peace and development are central themes in contemporary society.

當代社會以和平與發展為主題。

Mutual understanding of one another's heritage promotes cultural exchange among countries and regions and serves the interest of world peace and common development. China's magnificent sites are the heritage not only of the various ethnic groups of China but are also the common wealth of all humanity; they belong not only to the present generation but even more to future generations. Thus it is the responsibility of all to bequeath these sites to future generations in their full integrity and authenticity.

民族間互相認識彼此的文化和歷史遺產，可促進國家和地區的交流，有利世界和平及共同發展。中國歷史遺迹宏偉壯麗，不但是中國不同族群的遺產，也是全人類的共同財富，非今世所獨享，亦屬後來世世代代所擁有。因此所有人責無旁貸，必須完整及原真地保存這些遺迹，以傳給後世。

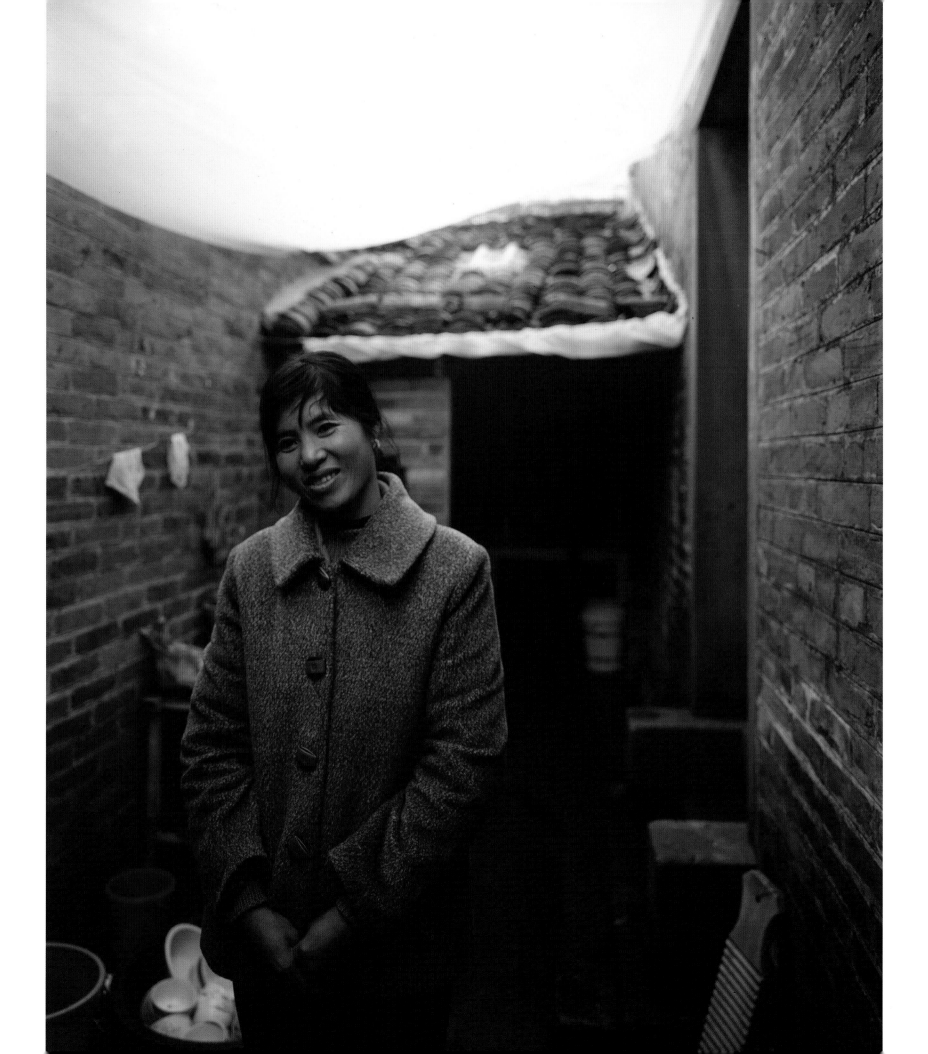

轉變 *zhuanbian*

change

MARTHA DEMAS

Amidst all the uncertainties about China's future, one thing is clear:
how people value the tangible link with their past will change.

所有關於中國前途的變數裡，有一件事清楚不過：
人們如何 評價 和過去的有形聯繫將會 改變。

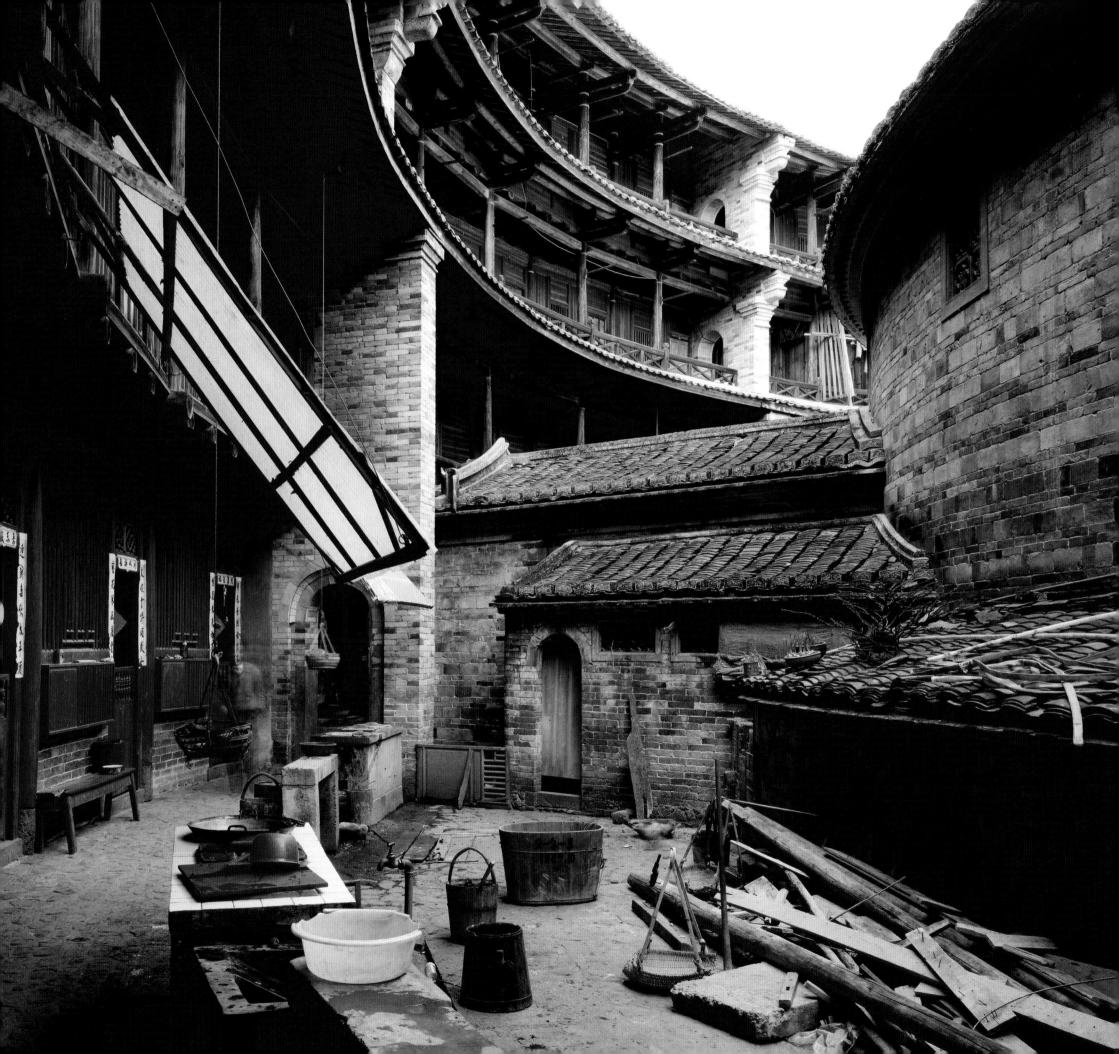

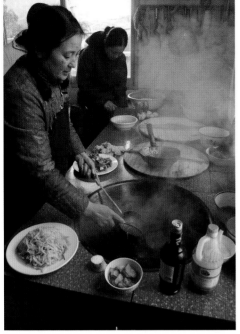

What might be acceptable today in terms of loss of the places that have shaped Chinese identity, in favor of relentless economic growth, will certainly be viewed with regret and disappointment in the future. There is already so much to regret as we contemplate the diminished landscape of China's material legacy, and despite the Chinese penchant for re-creating and replicating, loss of the authentic is irreversible and irretrievable.

經濟不斷增長，體現中國風貌的地方因為得讓路給發展而消失，今天可能覺得順理成章，將來肯定會後悔莫及。想想中國的物質遺產面目日漸模糊，已經足以令人沮喪；而儘管中國人偏好重塑及複製文物，但原真的物件失去了便不能挽回和還原。

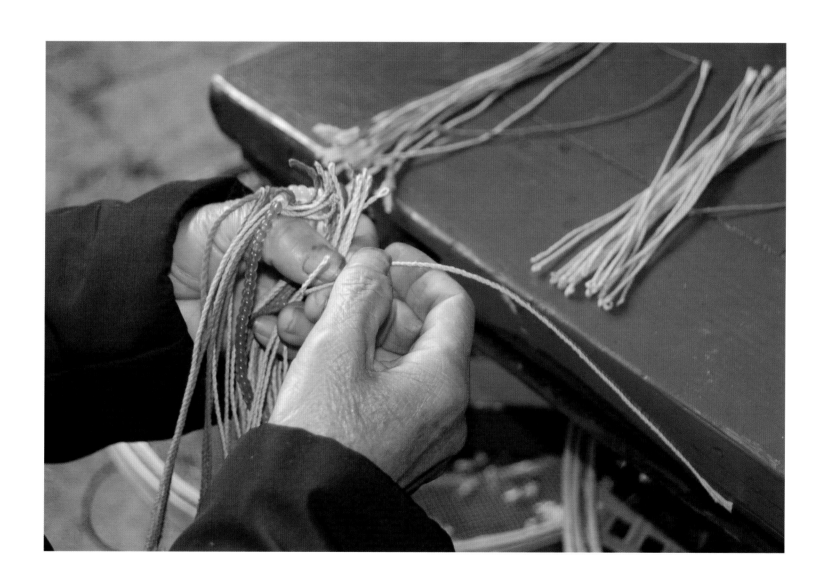

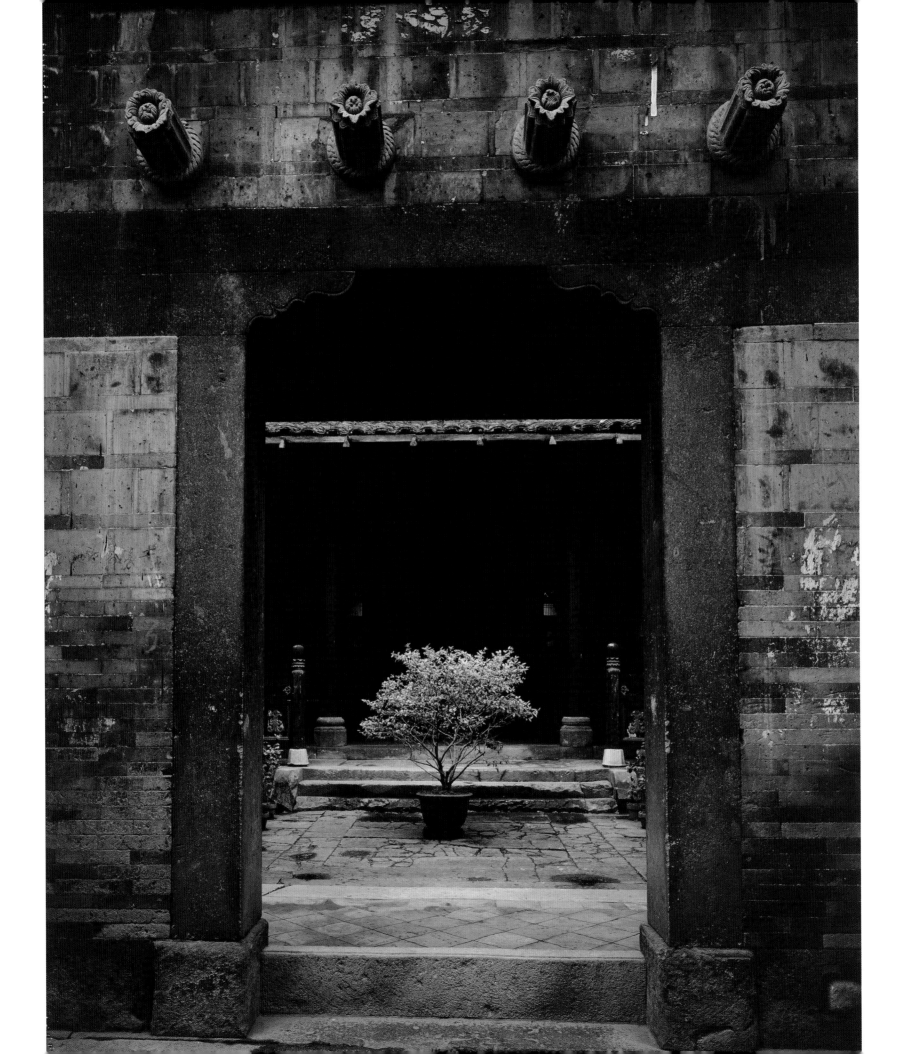

JEFFREY CODY

As China eyes its heritage sites in the context of their future value, one key question facing those Chinese who govern those sites' survival is what kind of values associated with those sites will prevail? If economic value trumps other kinds of values . . . then Chinese decision makers are making history pay.

中國人在衡量歷史遺迹的未來價值時，主宰這些遺迹命運者所面對的主要問題, 就是與這些遺迹相關的價值以何者為先？若果經濟價值重於一切，中國決策者無形中令歷史為文物的幸存付出高昂代價。

Opening up a series of actual dialogues with Shanghai's residents . . . might assist decision makers as they deal with hyper-development of a remarkable city, one rich in historical memories, but one at risk of erasing so many of the artifacts that reflect those memories in built form and space.

與上海的居民展開連串對話，對決策者處理這個大都會的極度發展時會有幫助。上海有豐富的歷史回憶，但很多以其建築形態和空間反映回憶的事物，正在有消失的危機。

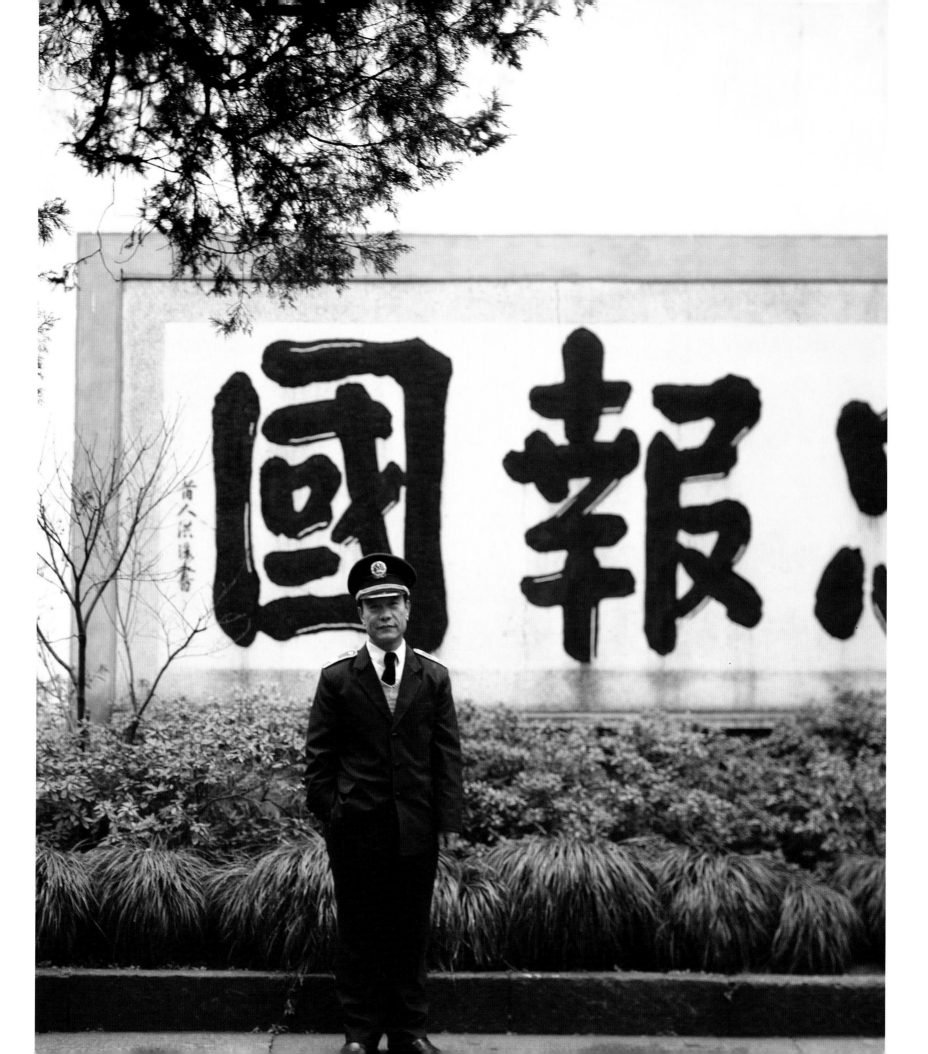

gradual progress

chien

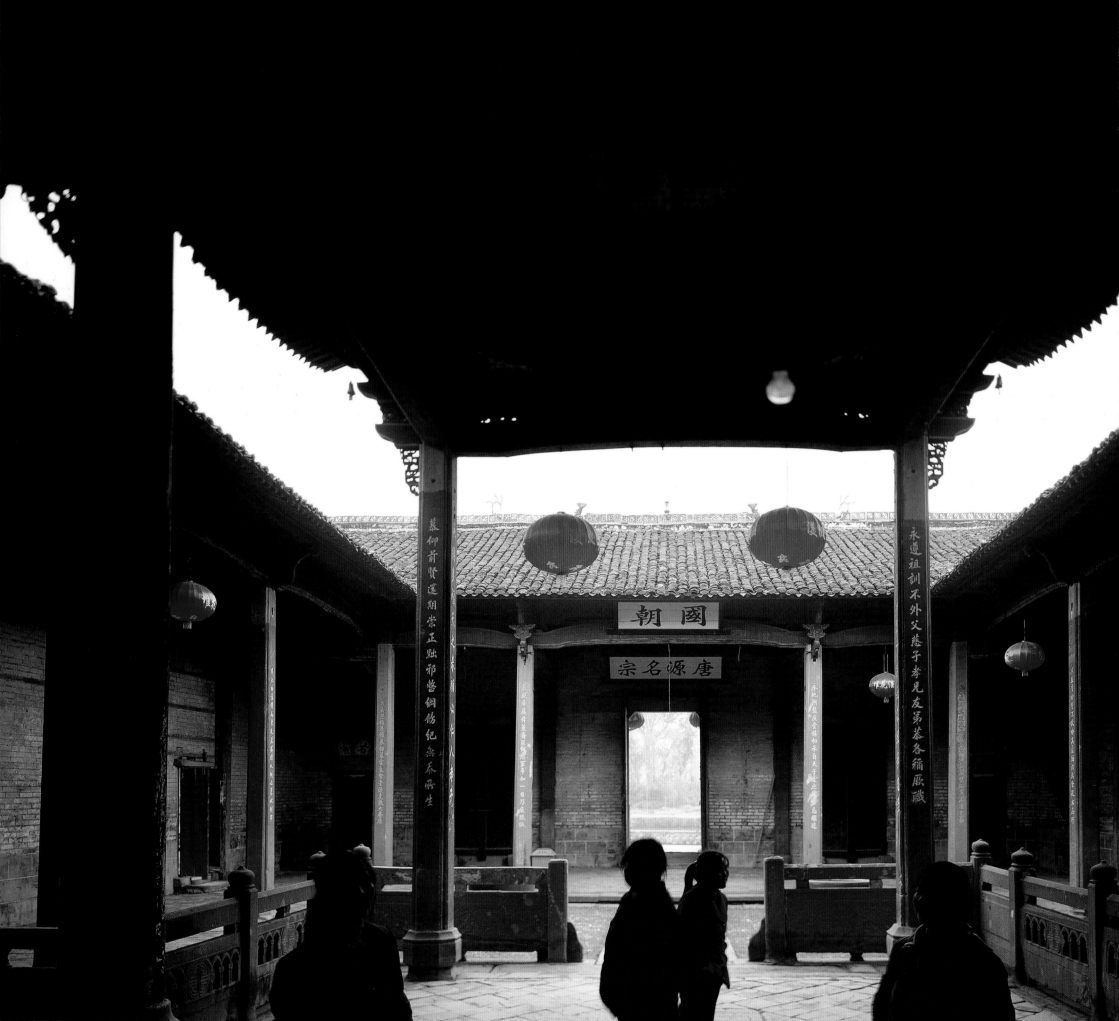

HUI MEI KEI, MAGGIE

許美琪

It is not difficult for one to see that wisdom and beauty exist in traditional habitats as they have taken form through years of evolution. Such traditional environments consist of built spaces that bear witness to the past and provide physical evidence of historical development and cultural identity.

不難看到，傳統的社群生態經過久遠年代的蛻變而成形，自有其智慧和美態。這些傳統的環境由建築空間組成，可作過去的明證，亦為歷史發展和文化認同提供實質憑據。

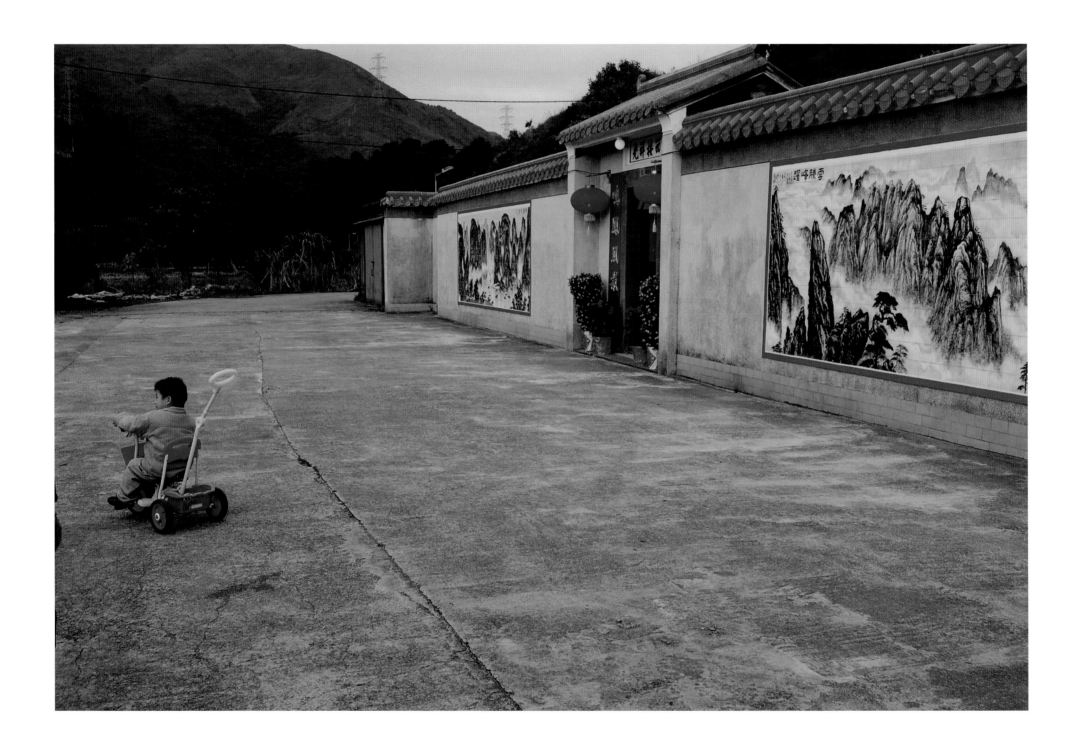

In our rapidly changing world, technologies are developing at such a fast pace that even the most remote villages are experiencing the effects of a shift in their environment, architecture, and lifestyle. This is an inevitable truth.

在我們這個瞬息萬變的世界，科技發展一日千里，就算最偏僻的村落也受到影響，環境、建築以至生活方式都要改變。這是不能規避的事實。

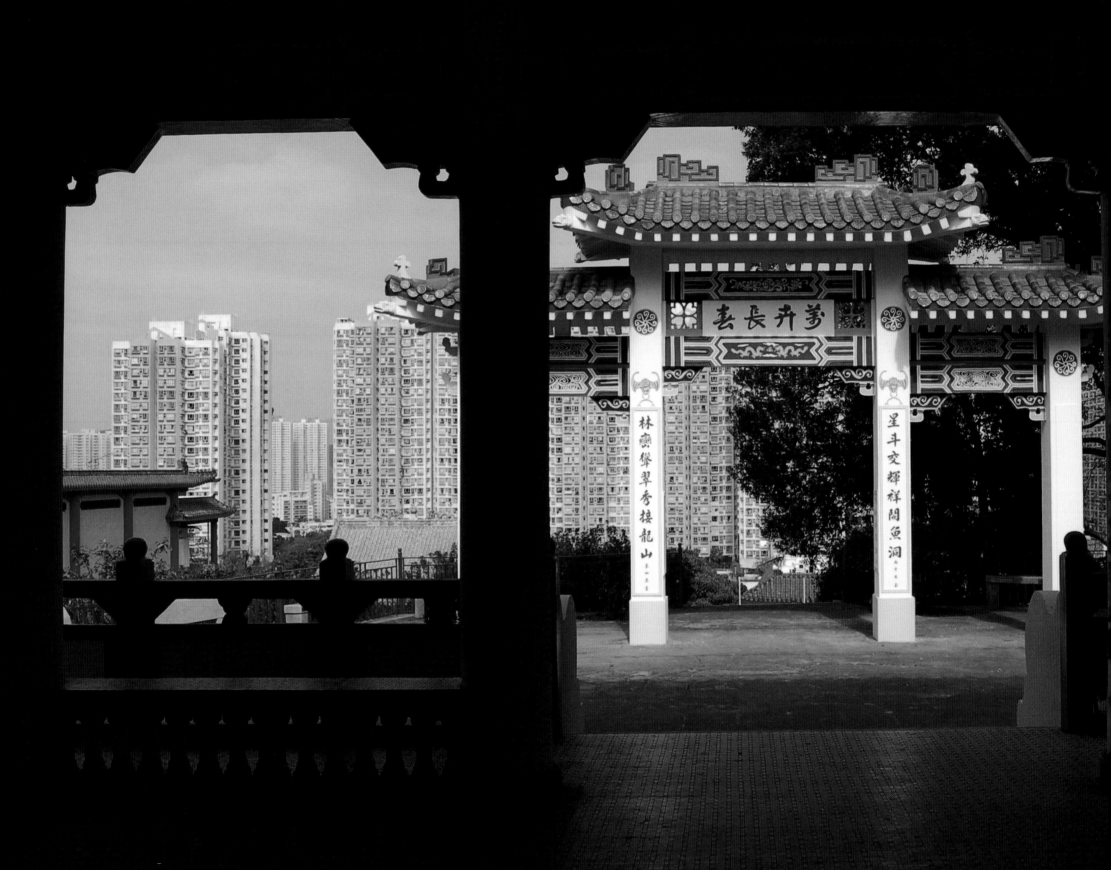

In my personal experience of studying and living in traditional and indigenous villages, the question that always presents itself is whether cultural identity, traditional habitat, and modern life can coexist and develop together. The critical question is, can material advancement be a substitute for the loss of cultural identity?

以我在傳統本地鄉村生活和讀書的經驗來說，經常思索的問題是究竟文化認同、傳統生態和物質進步（現代生活）能否並存及共同發展。關鍵是物質進步能否代替失去的文化認同。

Through its visual impact the built environment provides the most direct physical trace of cultural identity. Traditional habitat consists of the physical construct of built spaces, which are at the same time witness to the past and physical evidence of historical development.

建築結構環境透過其視覺上的影響力，為文化認同提供最直接的實質輪廓。傳統社群生態包括建築空間的實質結構，是過去的明證，也是歷史發展的實質憑據。

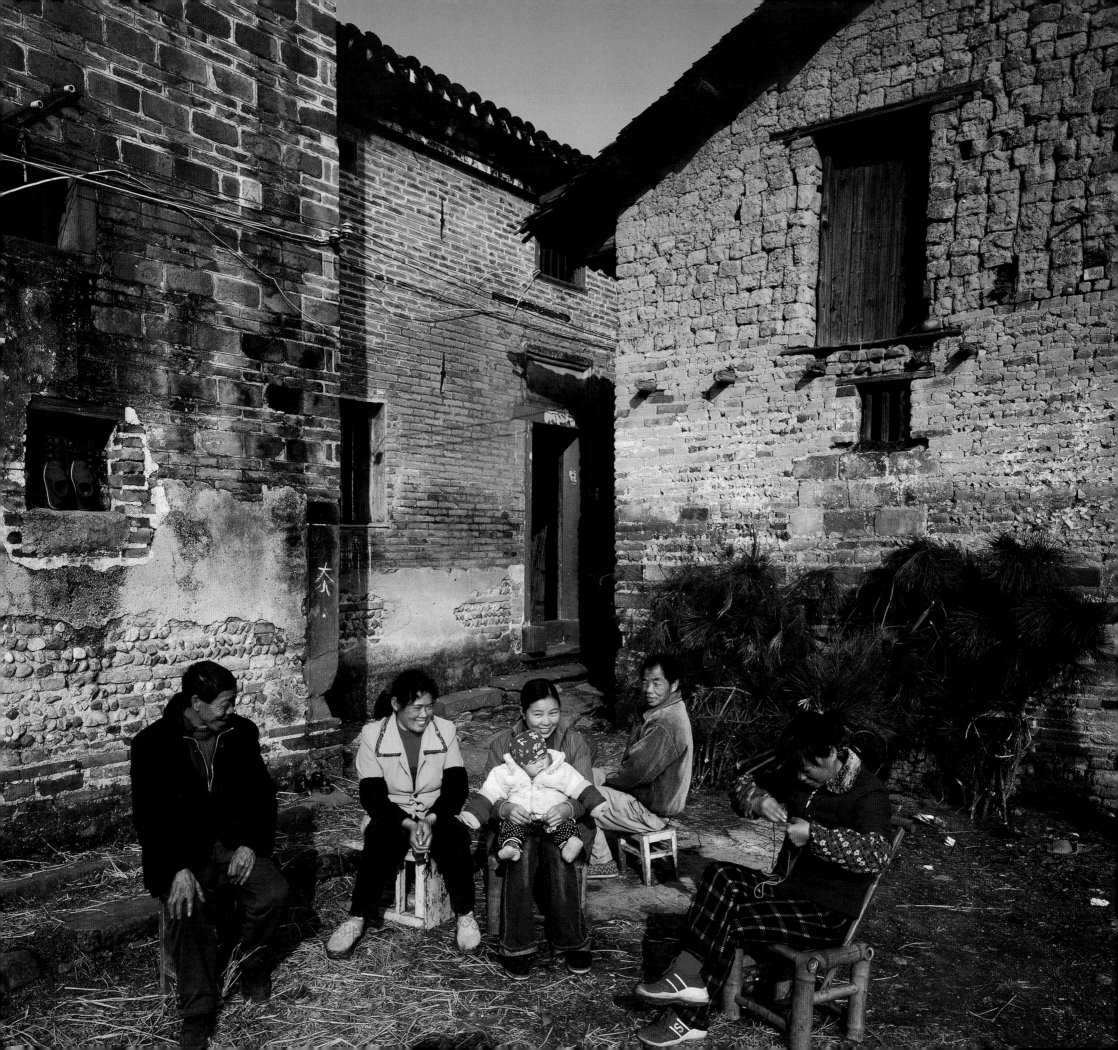

A vernacular environment can be read as an antique art form

or the vehicle for a continually evolving living culture.

鄉土環境可解讀為一種古老藝術，

或者是一個活文化的表達媒介，而這個文化是不斷蛻變的。

Therefore, if we view it as a practical container for everyday living, it has no choice but to adapt to new changes. To resolve how such change won't produce an overnight destructive force on cultural identity is the challenge. Perhaps the key lies with balance and negotiation and an involvement of local government with the people individually affected by such change.

所以如果我們視其為日常生活的實際容器，這環境除適應新的轉變外別無選擇。現在的挑戰是如何令這種改變不會在一夜間摧毀文化認同。也許關鍵在平衡與協商，以及地方政府和受影響民眾的溝通。

同質性

ETHEL EMERSON HUTCHESON

I see homogeneity as a thief in the night that is robbing us of our uniqueness, stealing the beauty and charm that draws us to explore other worlds. But I also recognize that my feelings reflect the thoughts of someone who has already lived more than two-thirds of her life and whose priorities and focus have changed during this life span.

我視同質性如夜盜，搶去我們的獨特性，偷走吸引我們探索其他天地的優美和魅力。但我也承認，我的感覺反映了一個已活了生命之三份二的人的思想，而在這段歲月裡，人生的輕重和焦點已經改變。

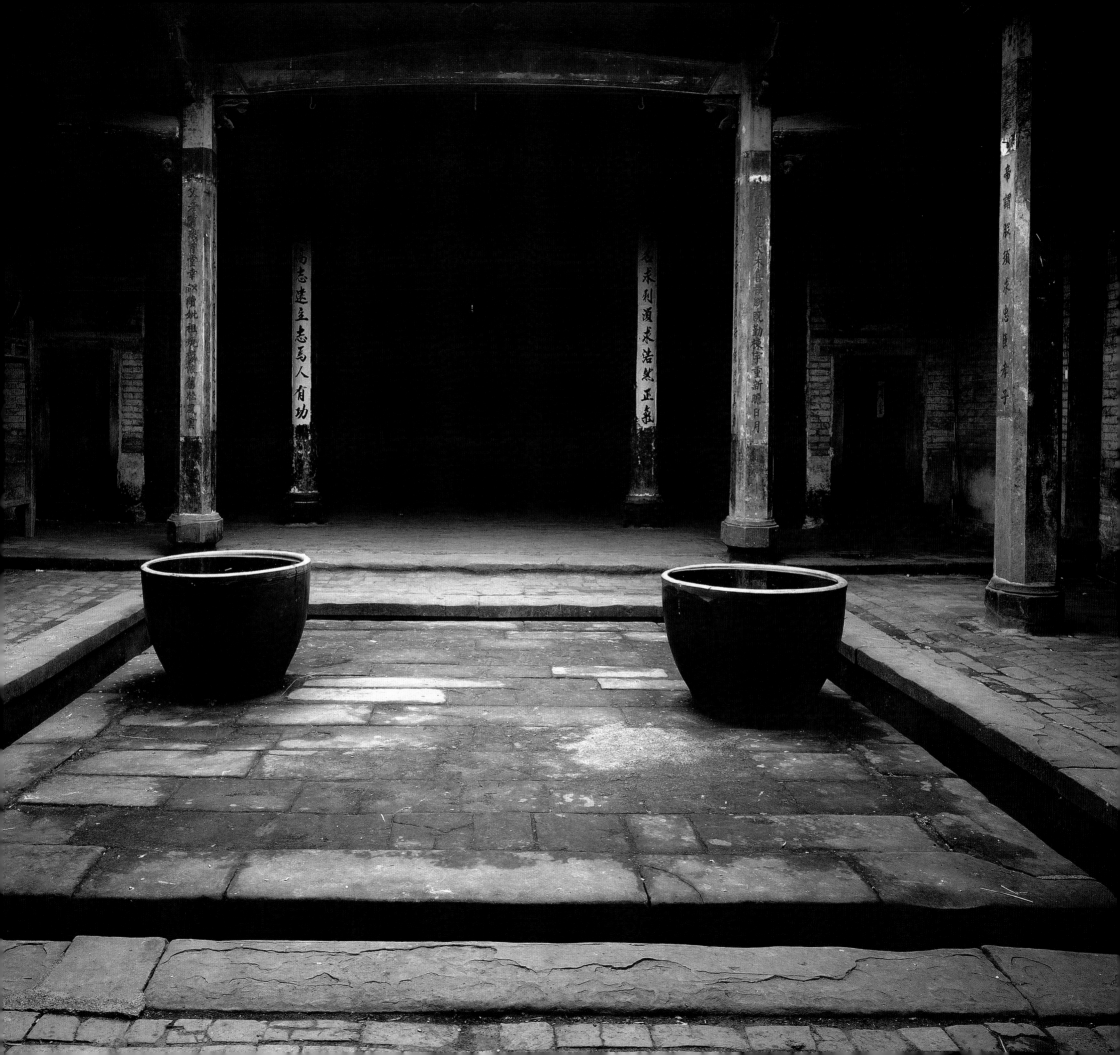

I understand that as instantaneous communication flattens our world, it is inevitable that the culture of younger generations around the world will naturally begin to be less and less unique. I can only hope that with more sameness will also come better understanding and perhaps less conflict.

我知道，在世界被即時通訊碾平的當前，年輕一代的文化自然難免變得愈來愈面目模糊。我只希望，大家愈來愈相似時會多些了解而少些衝突。

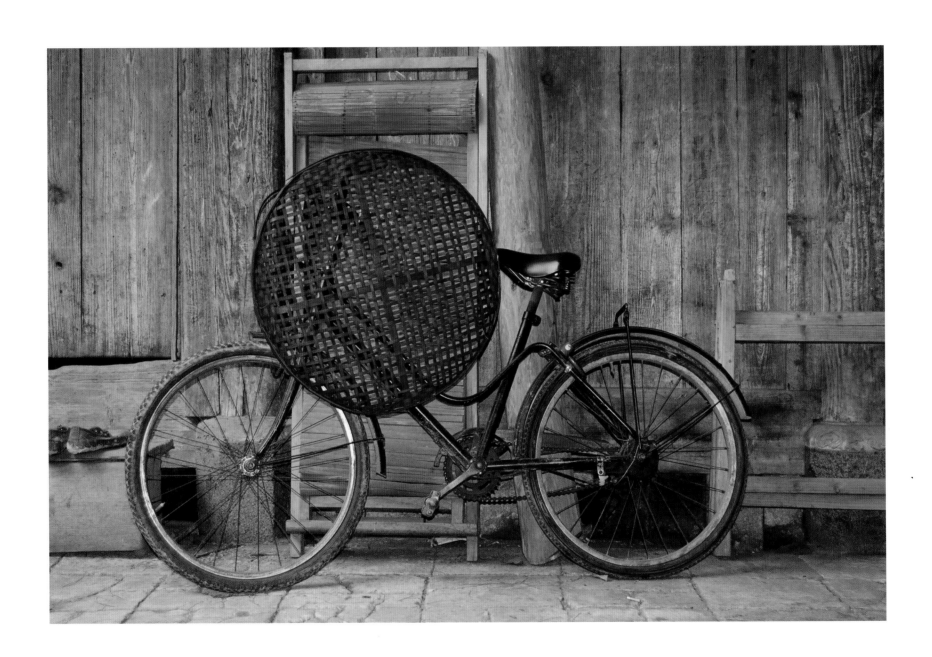

One thing will not change, however, and that is that
it will remain the responsibility of the elders of our societies,
who are saying farewell to the striving stage of their lives and entering the reflective stage,
to ensure that the essence of our former artistic, philosophical,
and spiritual culture will not be lost.

不過有一件事情將不會改變，就是社會上年長者的責任。

到了夕陽無限好的年紀，年長者有責任確保我們過去的藝術、

哲學和精神文化不會消失。

the creative

ch'ien

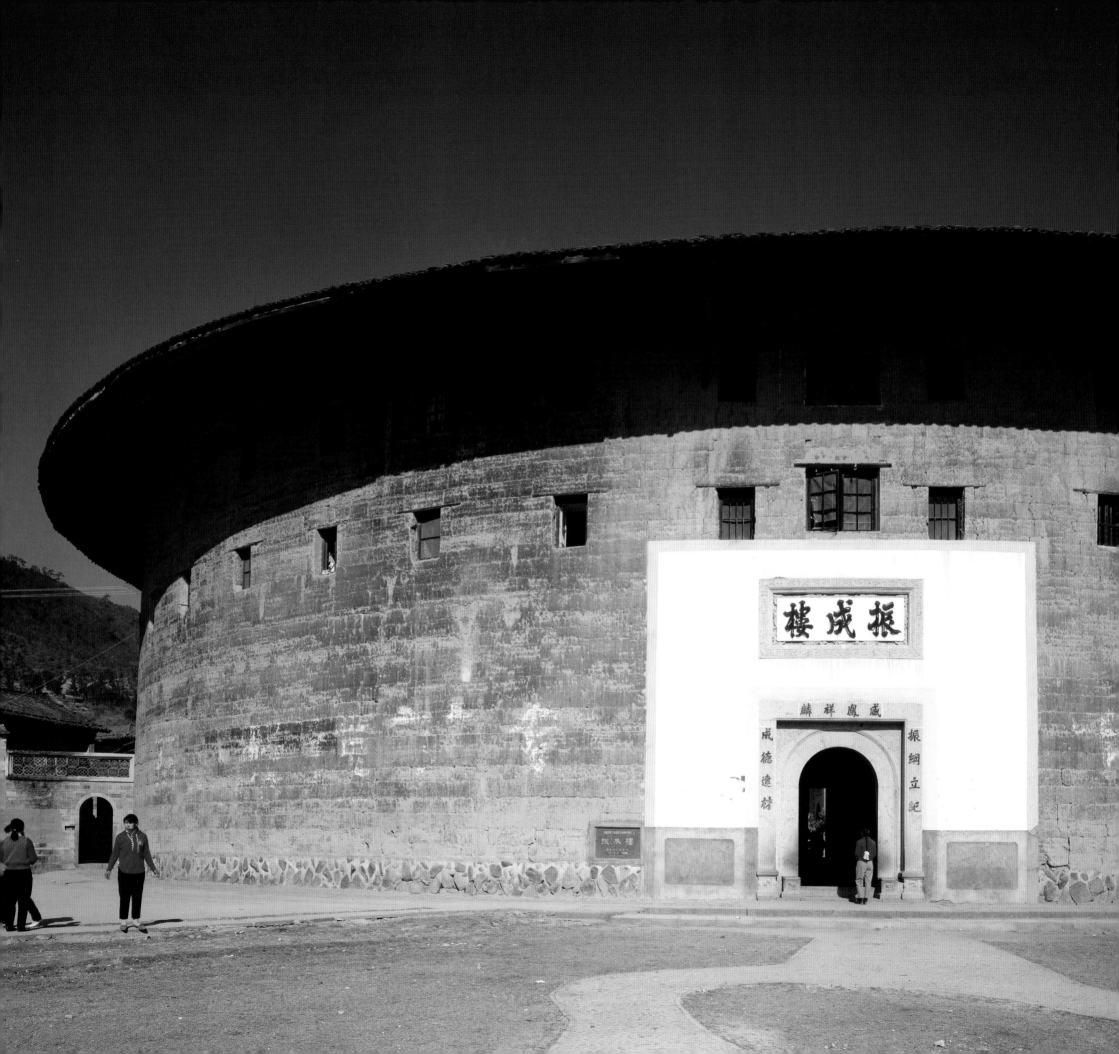

ALEXANDER STILLE

Beyond History and Memory
歷史與回憶以外

Conservation has often been conceived narrowly as the business of museum curators and the wealthy socialites who contribute to save Venice, which is all commendable. But the idea of seeing it as part of a much bigger and much more urgent global problem is extremely important. The cost benefits of seeing these problems in their interconnectedness yields enormous benefits.

文物保護一向被狹隘視為是博物館館長的工作，或者社交界富人的興趣，館長孜孜不倦和有錢人掏腰包拯救威尼斯，固然都值得表揚。但文物保護其實是一個更大及更急需解決的世界性問題其中一部份，意識到這點才最重要。了解這些問題的互相關聯處，得益無窮。

I would argue for this very broad, cross-disciplinary approach, and that flexibility and the willingness to go beyond the boundaries of disciplines is critically important. While we may be obsessed with the problem of preserving the past, we have to accept the reality of change and that change is often beneficial to the people that seek it out. . . . And so rather than thinking that we can preserve a static past, what we have is a creative dialogue between traditional cultures and the technologies that are more or less unstoppable.

我主張非常寬容和跨學科的方法，最重要是知所變通和不囿於學科。我們可以沉溺於保存過去，但必須接受改變的現實，而從改變中得益的，往往就是肯改變的人… 因此，與其以為我們可以保存靜態的過去，倒不如讓傳統文化和差不多是無法抗拒的科技有意義地對話。

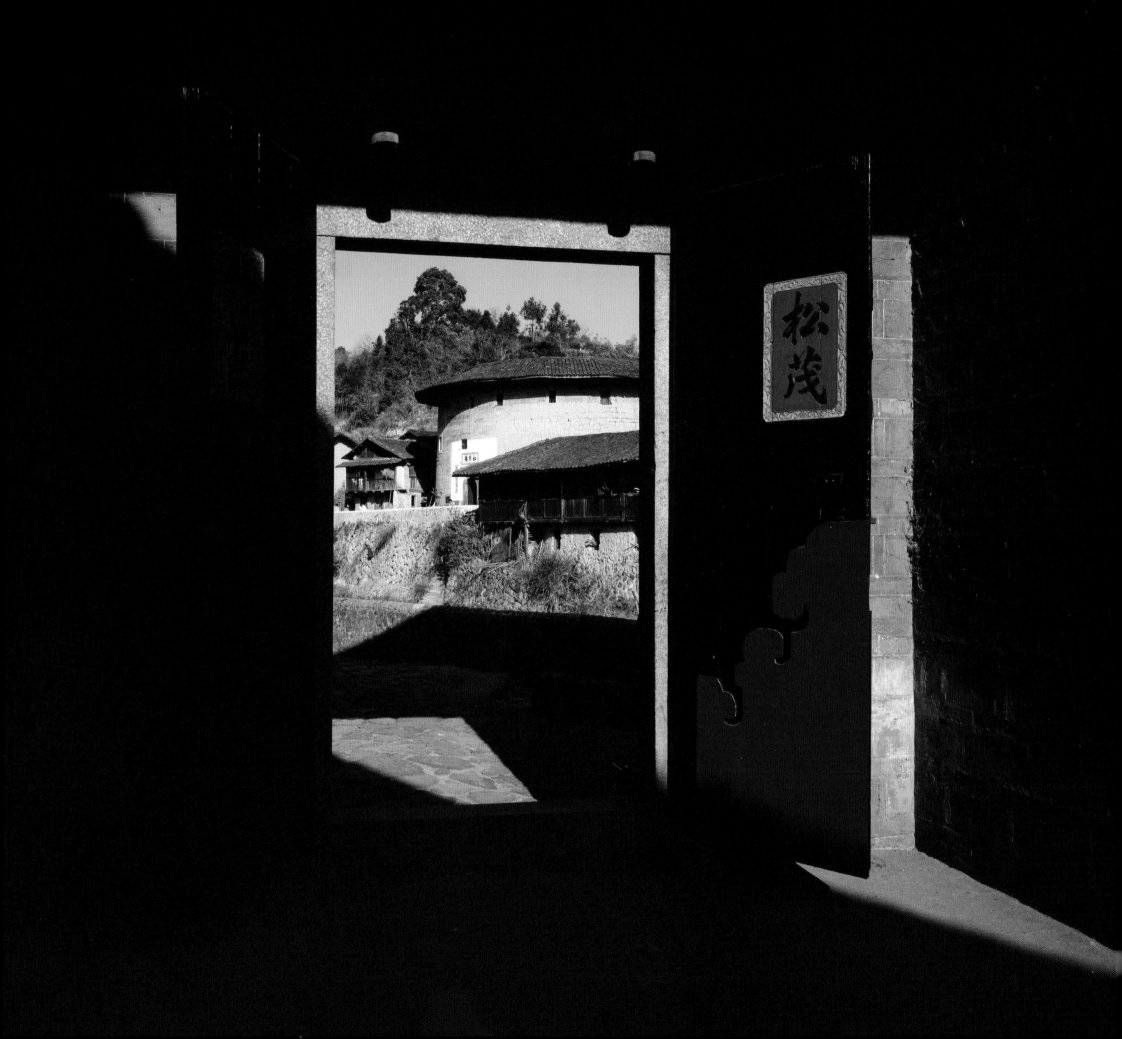

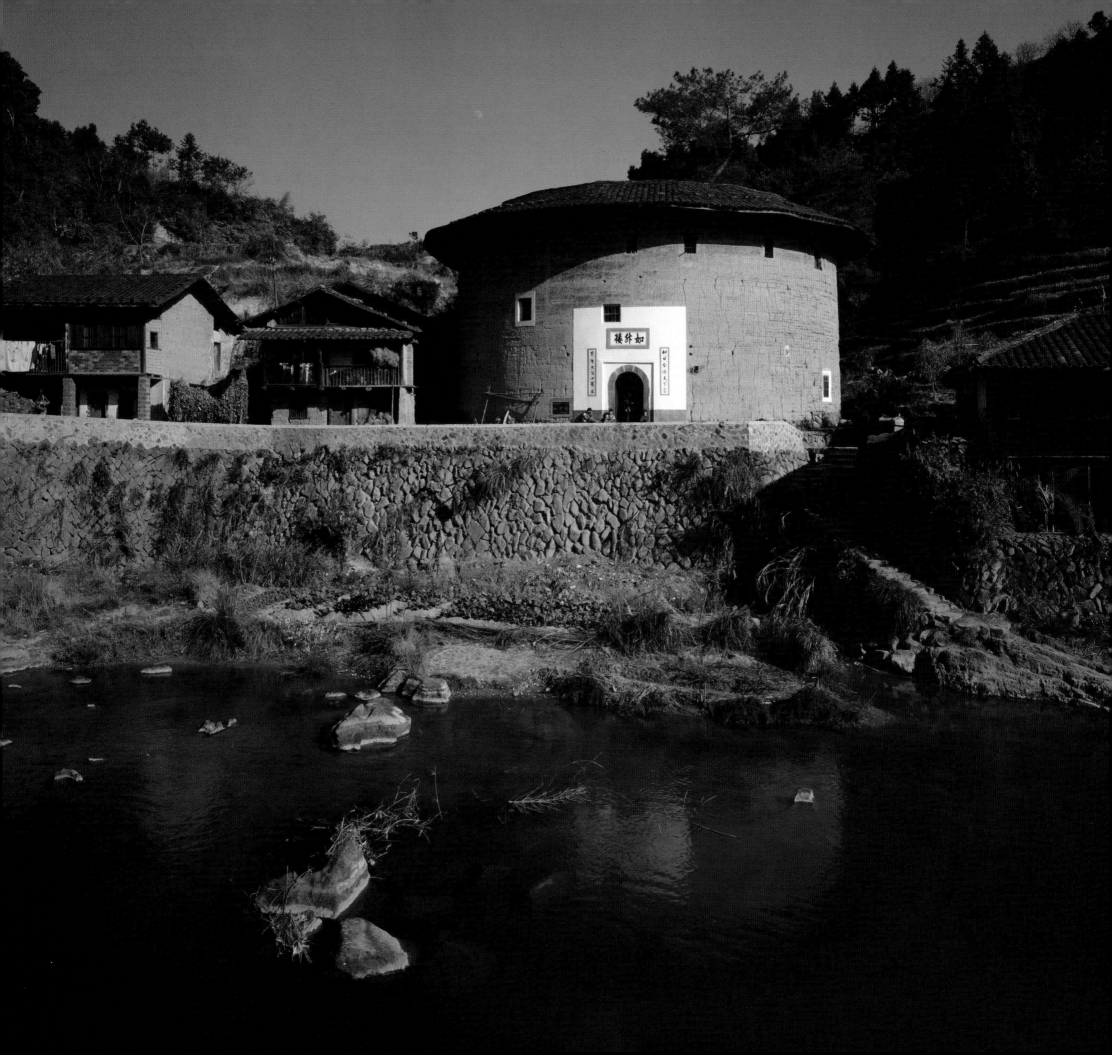

In the Chinese context, the idea of the ruin made little sense. Destroying and rebuilding ex novo fit China's cyclical yet seemingly unchanging world.

Up until about a hundred years ago, one could argue that the Chinese strategy of conservation was far more successful. While Western ancient architecture crumbled into ruins, to be replaced by successive styles, the basic forms of Chinese architecture remained remarkably unaltered for over two thousand years—even if none of the actual buildings remained.

遺迹的概念在中國意義不大。拆掉舊的，重建新的，符合中國循環不斷但似乎沒有改變的世界。

直至大約一百年前，中國的文物保護策略可以說是成功得多。西方的古老建築相繼崩頹的時候，中國建築的基本形態仍舊保存得很好，而且已有超過兩千年的歷史，儘管實質的建築物已經蕩然無存。

After the Communist Revolution of 1949. . . .
traditional artistic and artisan techniques that had
been handed down from master to apprentice for generations were lost.

中國一九四九年解放後…世代師徒傳授的
傳統藝術和工藝技巧已消失。

Just in the last several years, the Chinese have woken up to the fact that, unable to count on their traditional knowledge of arts and crafts, they will be left with precious little of their physical past if they don't also adopt Western strategies for conservation.

在剛過去的幾年，中國人醒覺了，傳統的藝術和工藝知識不可恃，再不採用西方的文物保護策略，過去留下來的東西將會所餘無幾。

"The Cultural Revolution not only destroyed our monuments,

it destroyed people's feeling for them," said a sensitive young architect. . . . "It killed off the sense of beauty."

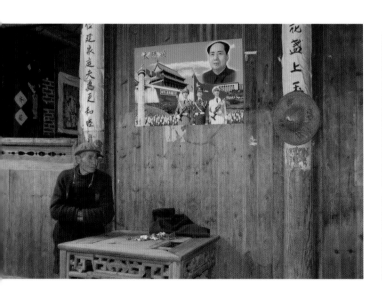

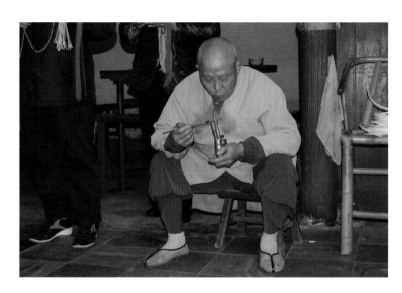 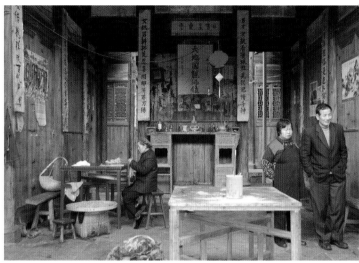

「文化大革命不但摧毀了我們的歷史遺迹，也摧毀了人們對這些遺迹的感情。」

敏感的年輕建築師說 ⋯ 「美的感覺被徹底消滅。」

保存

baocun

preservation

ENRICO D'ERRICO

Preservation is an act of conservation to protect elements, objects, handicrafts, and buildings from further decay. The objective is to have these historical assets transferred to future generations with their value intact, reflecting a record of the human development of civilization.

保存是文物保護的具體行動，是防止環境、物件、手工藝品和建築物不再腐朽下去。保存的目的是把這些歷史財產完整地傳給後世人，以作為人類文明發展的紀錄。

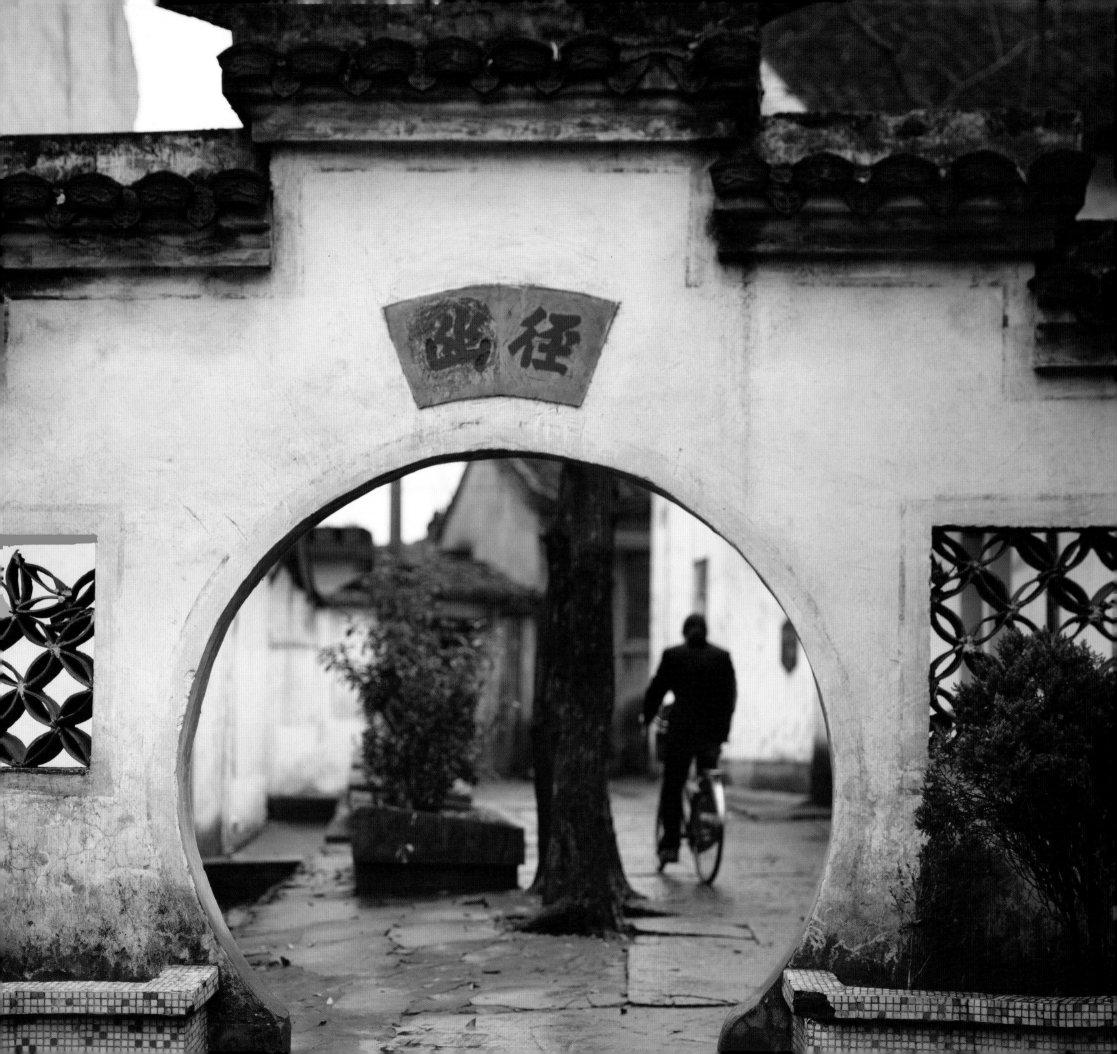

In every case, each monument has its own pathology, requiring a customized solution to its restoration. Every project must be carefully studied and evaluated on all its merits. One monument might be designated a ruin to be preserved as such, and another a building to be reused and adapted to a contemporary style of life.

不管怎樣，每個歷史遺迹的問題都不同，修復辦法亦各按情況而定。每個計劃必須根據事實小心研究及評估。某個遺迹可能需原封不動保存，某建築物則可以改動以配合當今生活方式而再用。

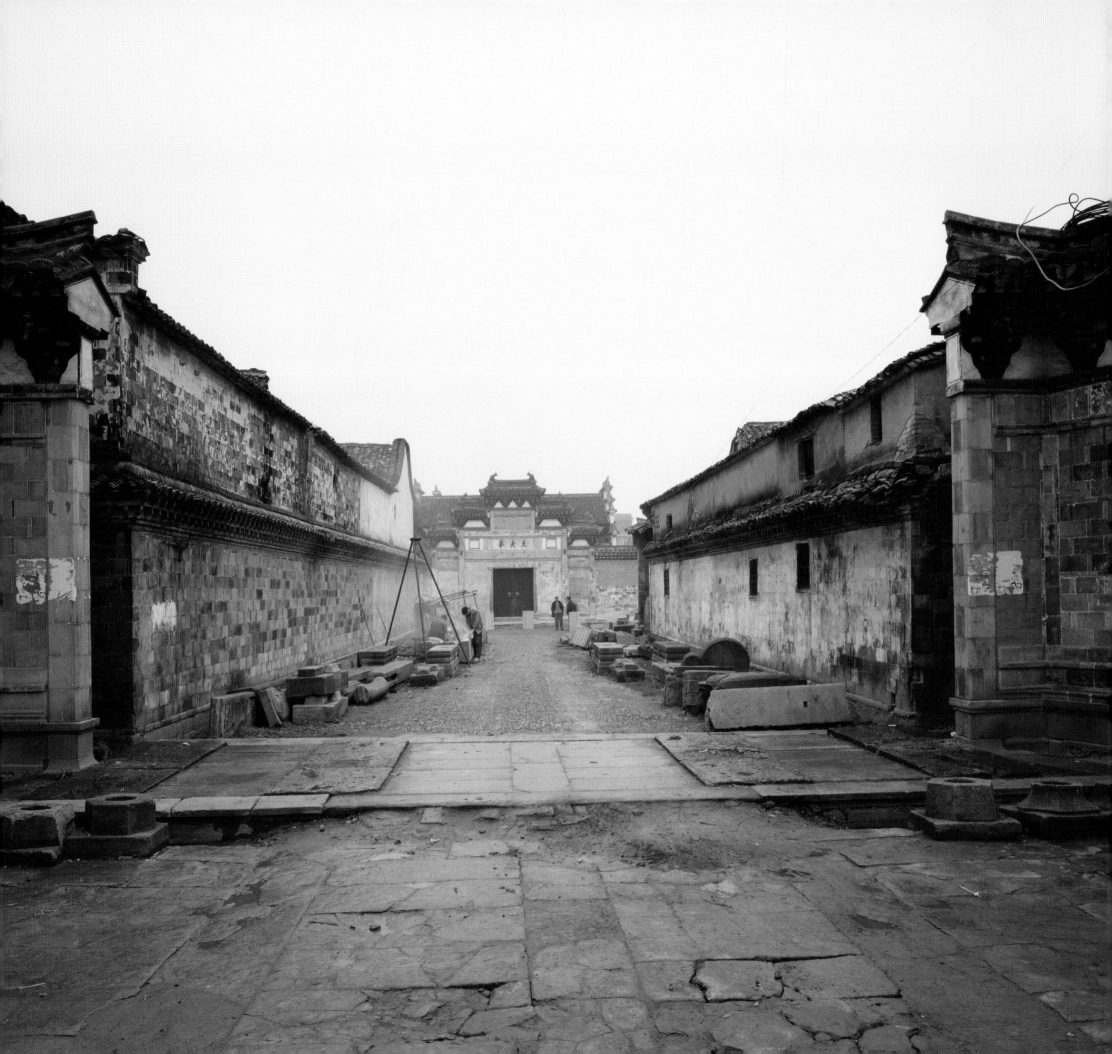

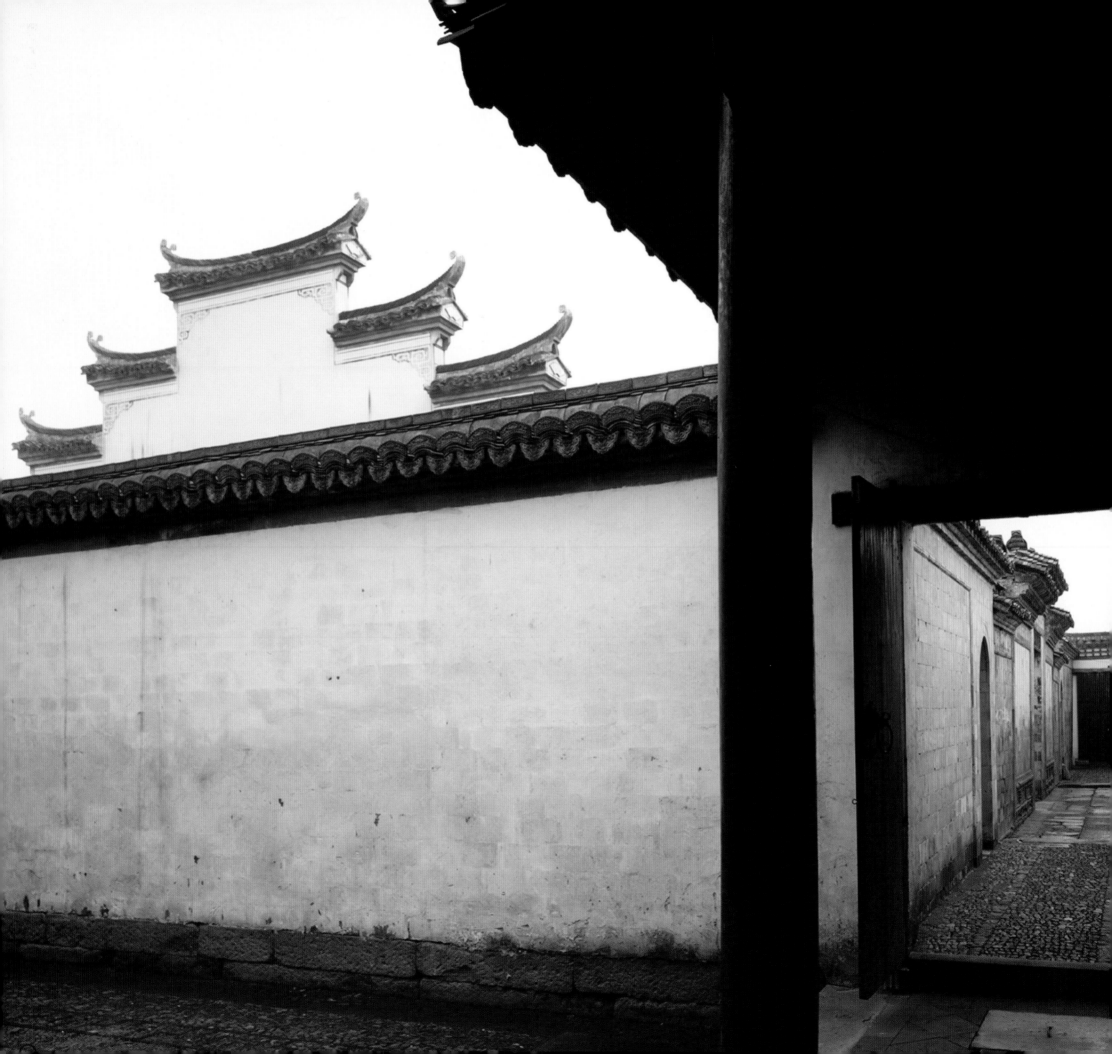

In the first case, minimum intervention to prevent further decay is the optimum solution, with as little alteration of the original as possible. In the second case, minor transformations are allowed, but always with the goal of avoiding hypothetical work that may compromise the historical form, design aesthetic, and authenticity of the original.

以第一個例子來說，最好的解決方法是盡量不動，以免其惡化下去，愈少改變原來的結構愈好。在第二個例子，輕微改動沒有問題，但應謹記不可作無謂的增減，以免破壞原來建築物的歷史形態、設計藝術和原真性。

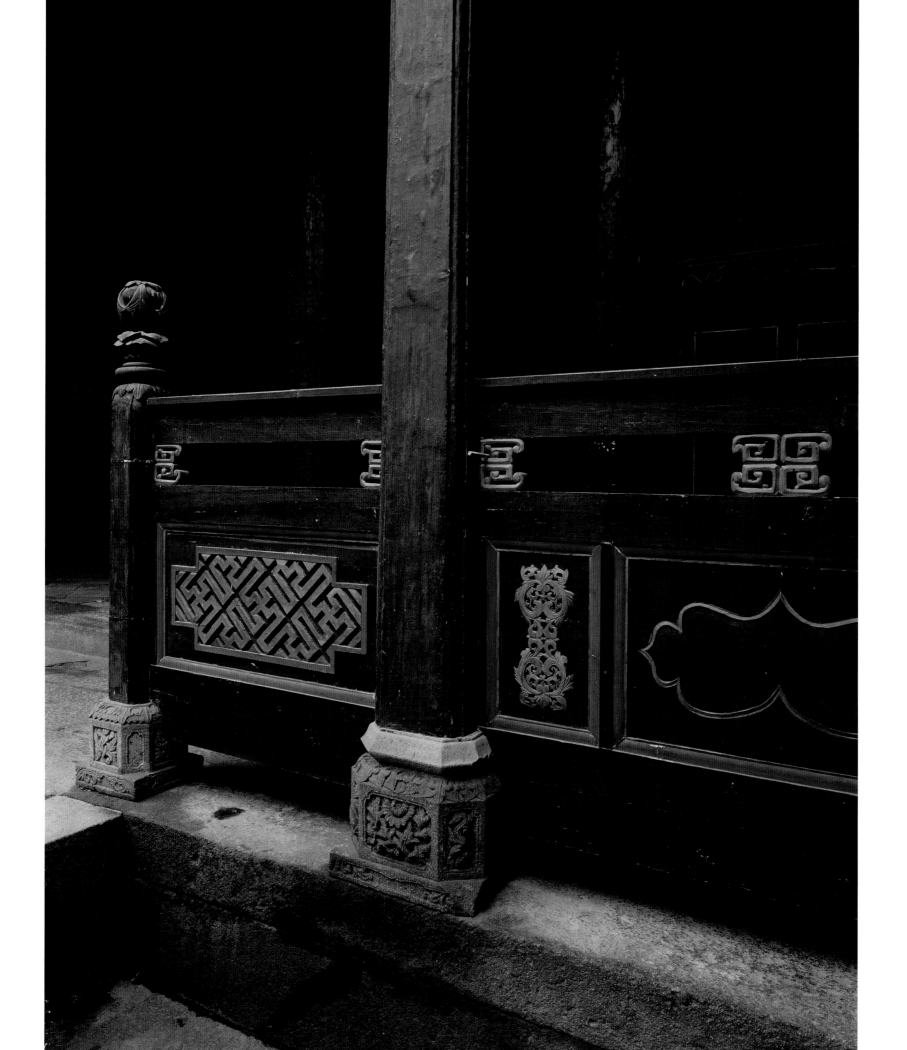

yuanzhenxing

authenticity

原真性

PETER H. Y. WONG

黃匡源

Most Chinese buildings have utilized wood as their main basis for structural support and facades. Even when treated with the ideal chemicals, decay of wood is inevitable. There can never be an authentic Chinese building over one hundred years old that has not been restored as a necessity for its most basic survival. We must be sensitive to this reality when we talk about the preservation of old Chinese buildings.

大多數中國房子都用木材作為結構支撐和外牆的基礎。木材就算處理得再好也難免腐朽。中國房子上百年歷史的很少會保持原真，要把房子保存下去便得定時修造。我們談保護古老中國房子時，必須正視這個事實。

Traditional local skills for crafting and constructing buildings or making implements have been lost. By focused retraining of local labor, we may be able to rekindle craft industries that in time will be able to restore buildings and artifacts, produce new highly prized objects, and provide for worthwhile employment opportunities throughout China.

傳統本地建造房子或家具的技術已失傳。集中再培訓本地工人，我們也許能夠令工藝行業死灰復燃，生產新的珍品，也在中國提供有價值的就業機會。

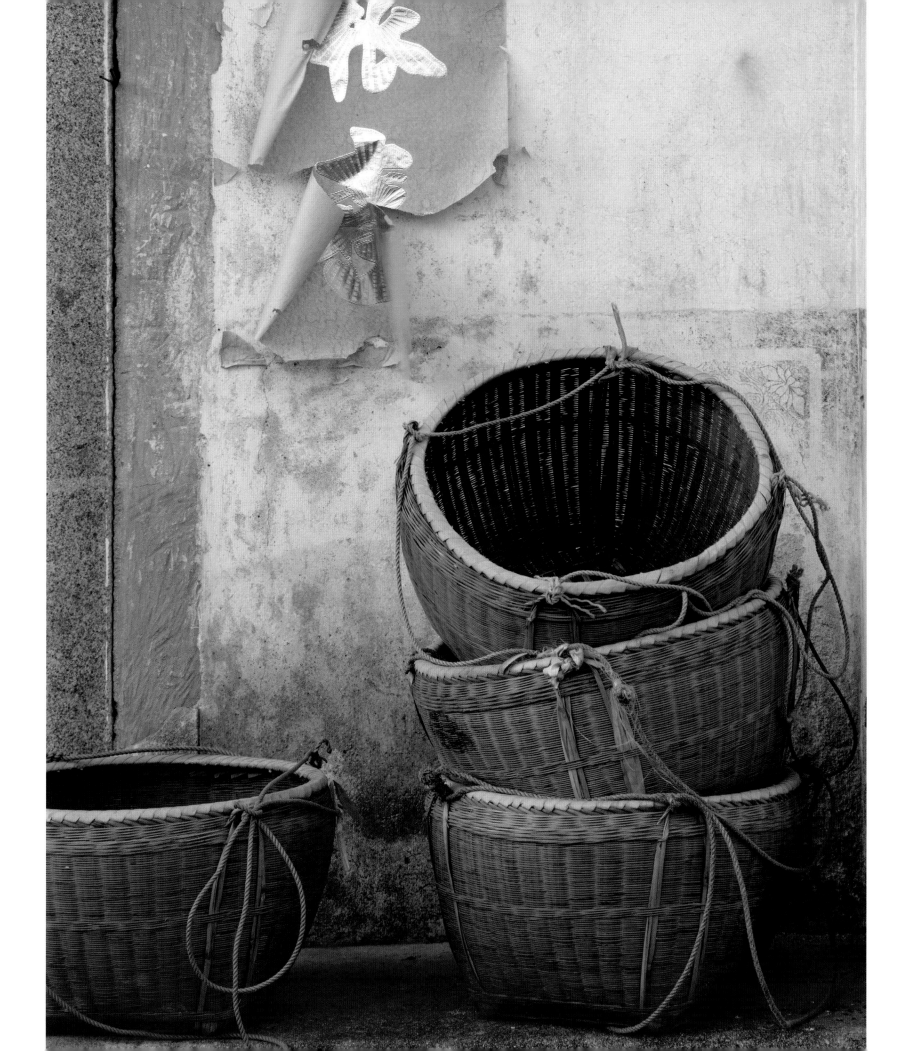

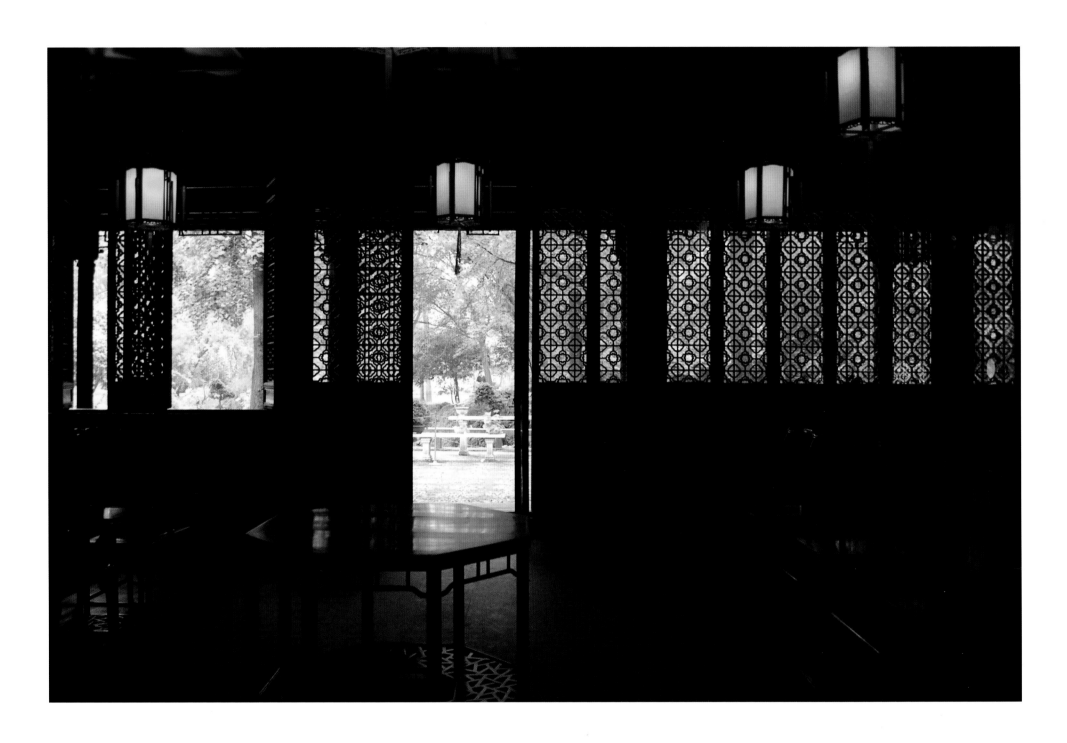

There are of course challenges in balancing preservation and historic authenticity with modernization.

保存文物及歷史原真性和現代化兩者要取得平衡，其中當然有挑戰。

If I have to live or work in a building, however old and prestigious, it has to be made habitable and protected against dry rot and decay. It must have safe electricity, proper ventilation, plumbing and clean water, and now, communication and Internet-access infrastructure. These changes have to be made. I cannot live or work in a museum that is a mausoleum of the past.

若果要我在一間房子裡生活或工作，這房子怎樣古老和出名也好，總得宜居才可以。房子需有安全的供電、適當的通風、防霉防腐、衛生設備系統和食水，還有現在的通訊和互聯網設施。這些是必需的改動。博物館是歷史陵墓，我不能在裡面生活或工作。

fellowship with men

t'ung jên

社群 *shequn*
community

BEIJING CULTURAL HERITAGE PROTECTION CENTER
北京文化遺產保護中心

At the grassroots level, local communities are in need of assistance to preserve tangible and intangible local culture. By providing training, building capacity, and cultivating respect and awareness of heritage conservation laws, there does exist a potential for success with conservation work in China.

基層的社區居民亟需協助，以保存物質和非物質的本土文化。民眾若能領悟文物保護法例，接受培訓，以及培養尊重及認識法例的觀念，中國的文物保護工作大有可為。

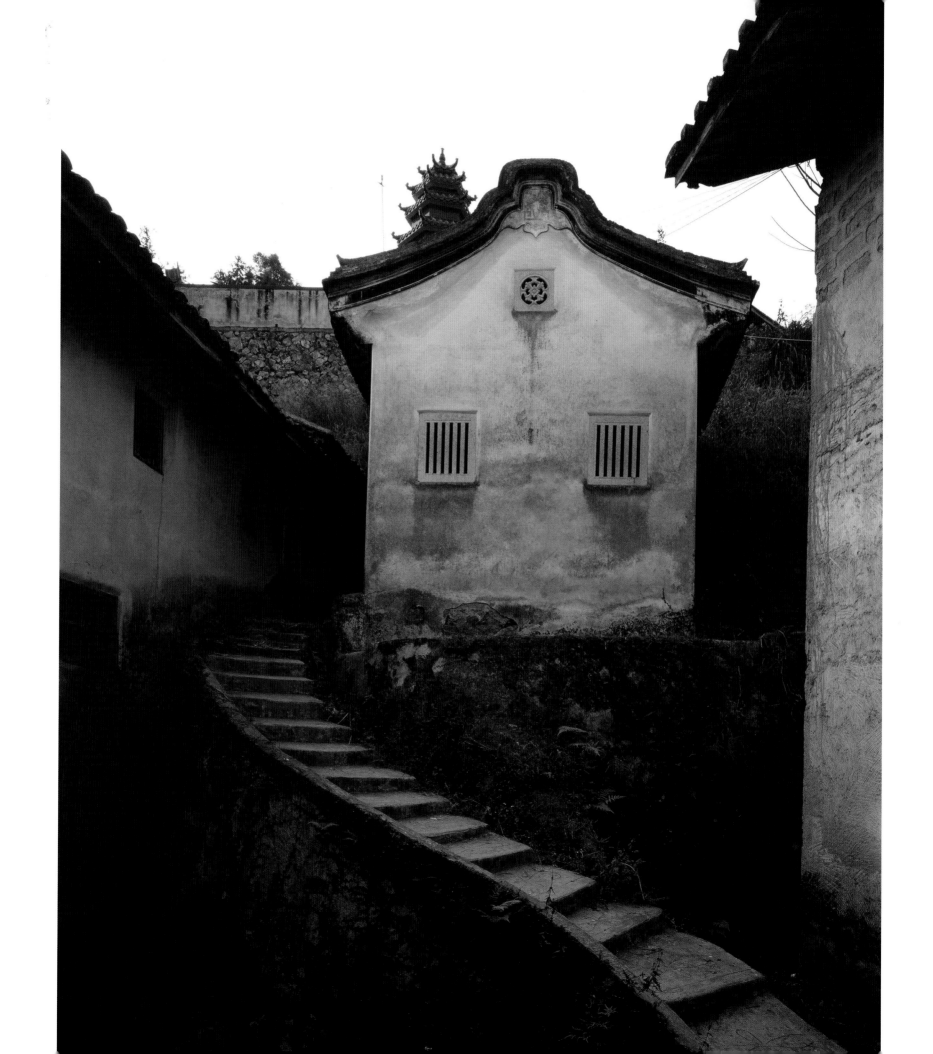

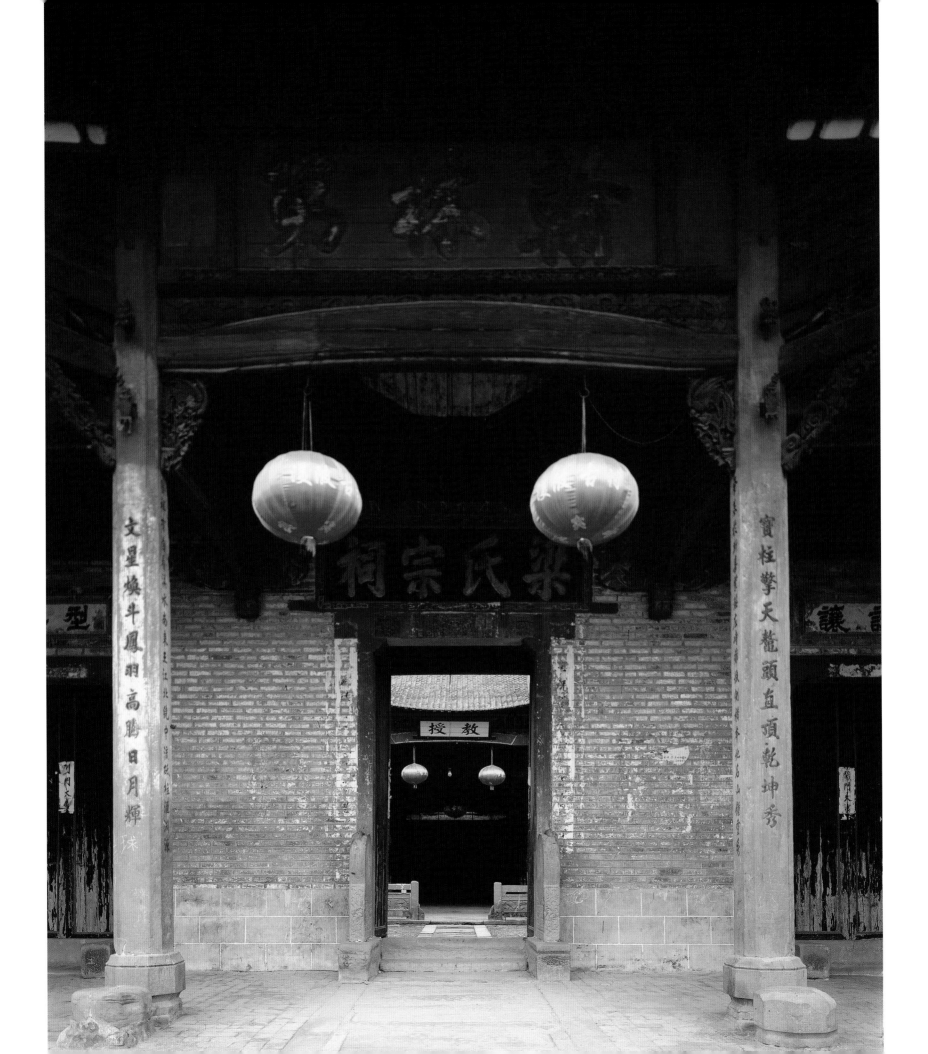

When stakeholders approach heritage protection in a constructive and nonconfrontational manner, the creation of a software of conservation becomes possible. In seeking to preserve the authenticity, essential historical character, and community life of historical sites and areas, and by encouraging creative adaptation to the needs of the twenty-first century, ersatz commercial replicas can be avoided.

利益攸關者若能放下己見，以建設性態度看待保護文物，不難建立相關工作的軟件。我們必須保存文物的原真性、重要的歷史特色、歷史遺迹和地區的社群生活，以及鼓勵有創意地適應二十一世紀所需，這樣才可避免文物成為合成的商業複製品。

Patience and commitment provide the bedrock for efforts that can achieve the goals of preserving the spirit and the form of China's traditional environments. Many people in China share in these goals. This is encouraging, for it means that with education, residents and local officials will come to value their neighborhoods and become aware that laws and regulations exist that protect both them and their environments.

要保存中國傳統環境的精神和物品，必須要有耐性和承擔，才可達到目標。中國有很多人都支持這些目標。這很令人感到鼓舞，因為意味着只需教育民眾和地方官員，他們會懂得珍惜自己的社區，而且對保護居民和社區環境的現存法例也更有認識。

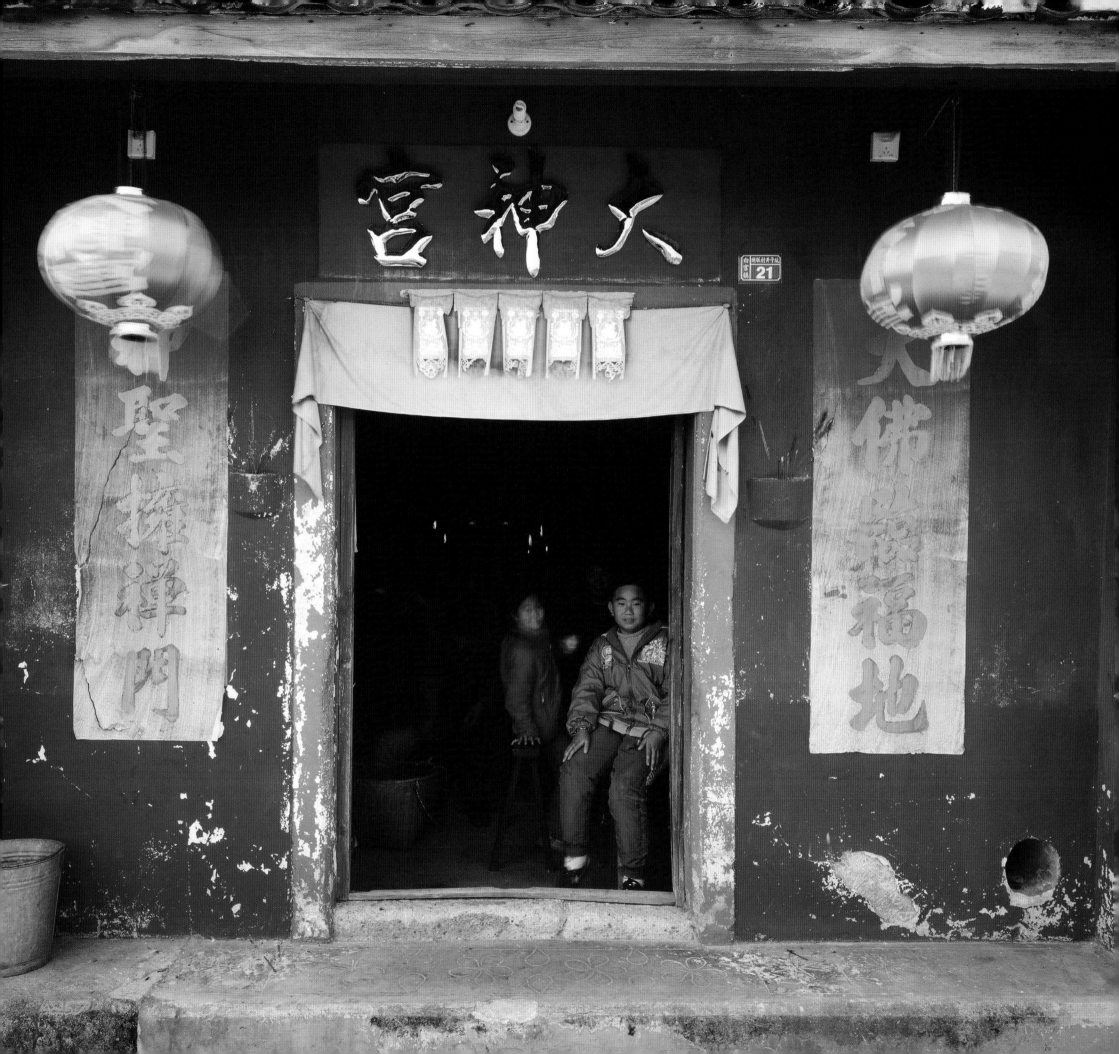

Building heritage trails in old areas of cities, providing residents with practical information on what can be done to renovate courtyards and neighborhoods, and collecting and recording oral histories of the actual experience of residents—all are examples of achievable and effective conservation efforts.

在城市的舊區開闢文物徑；向居民提供有用的資訊，讓他們知道可以怎樣翻新庭院和社區；收集和紀錄居民親身經歷的口述歷史 — 這些都是可行和有效的文物保護工作例子。

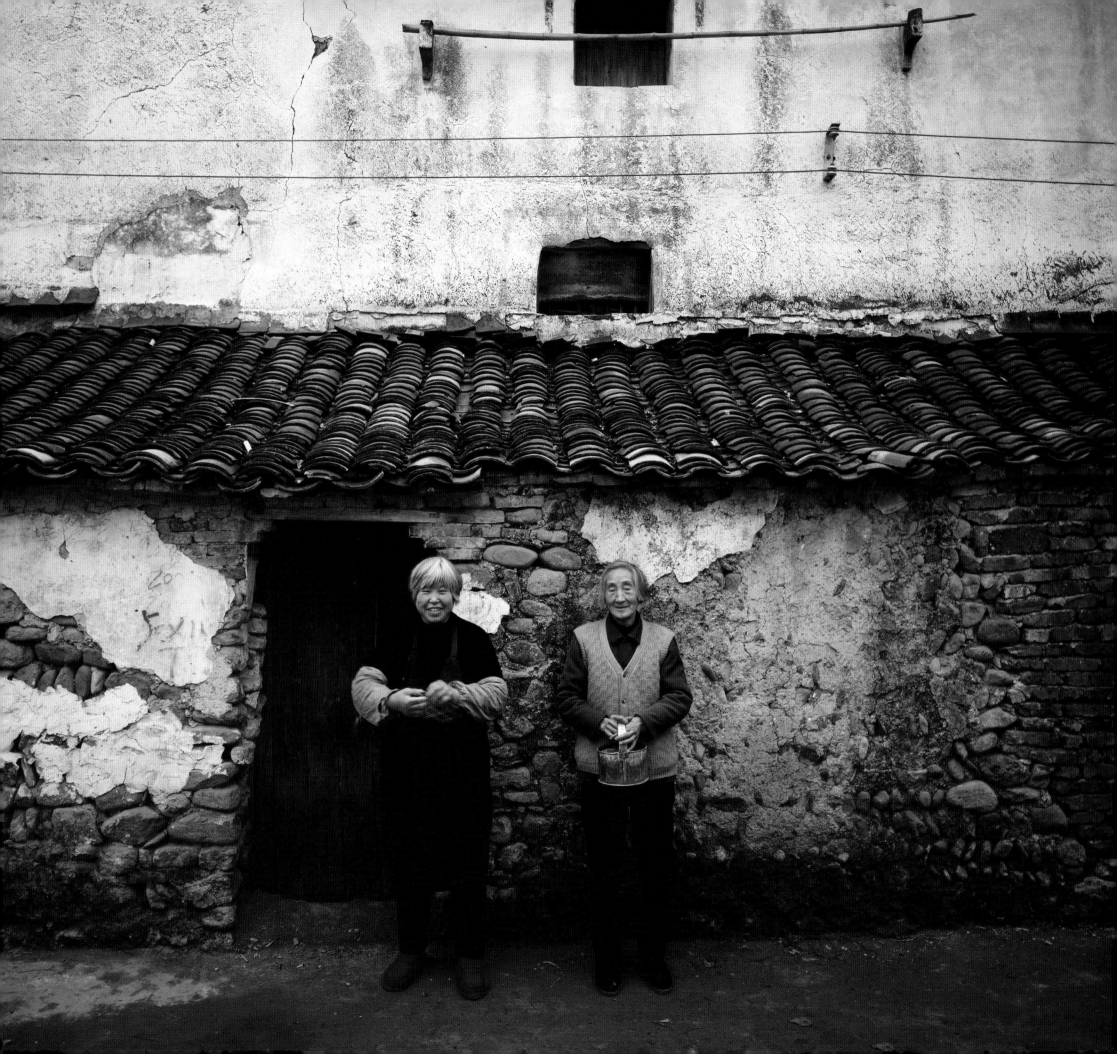

Preserving the historical qualities of our nation's built environment
is among the most pressing challenges of our era.

保存我國建築環境的歷史素質，是我們這時代其中一個最不容忽視的問題。

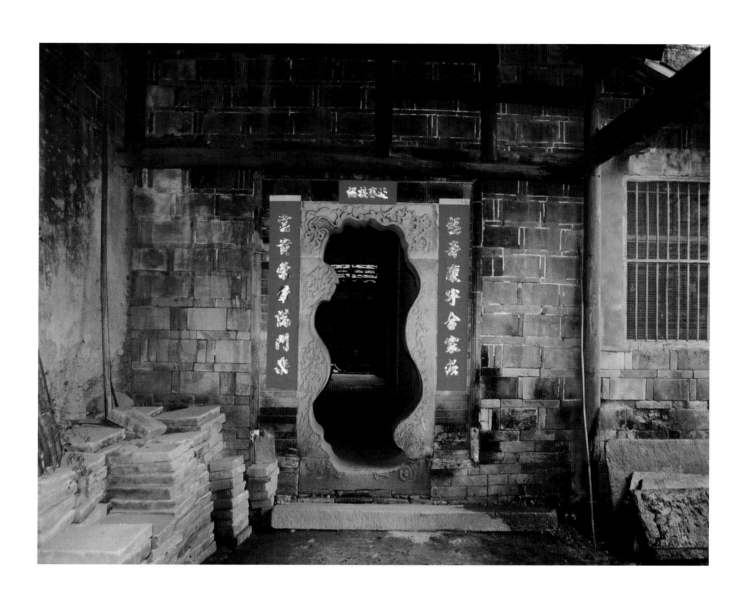

回 憶 *huiyi*

memory

CHRISTINE LOH

陸恭蕙

Living in Beijing in 1980, I was able to see and experience the extensive traditional *hutong* neighborhoods still standing at that time. I thought those treasures could be restored for the people living there and for the nation. This has not happened, and indeed most have been demolished. New boulevards seem "nice" to those who did not know what was there, as memories quickly fade once these heritage sites are destroyed.

1980年我在北京居住，當時傳統的胡同仍然有很多，我得以看到和體驗了這種古老的社區。我覺得這些社區很珍貴，為了居住其中的人，也為了國家，都應該予以修復。不過修復工作始終沒有出現，大部份的胡同反而被拆毀了。這些文化遺迹一旦被毀掉，很快從記憶裡消失，於是對那些從來不知道原址有些甚麼的人來說，新的大街看來「很好」。

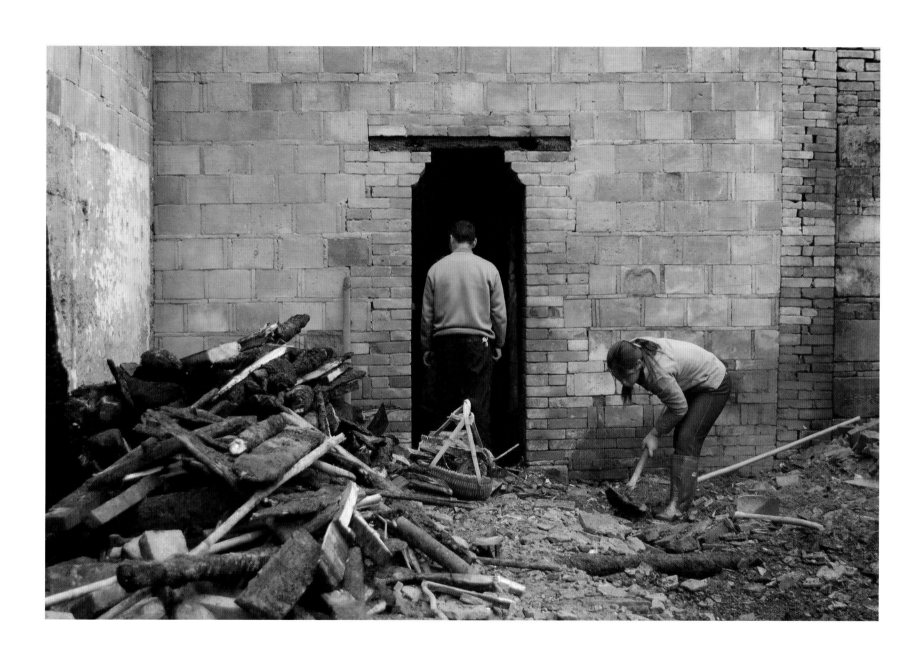

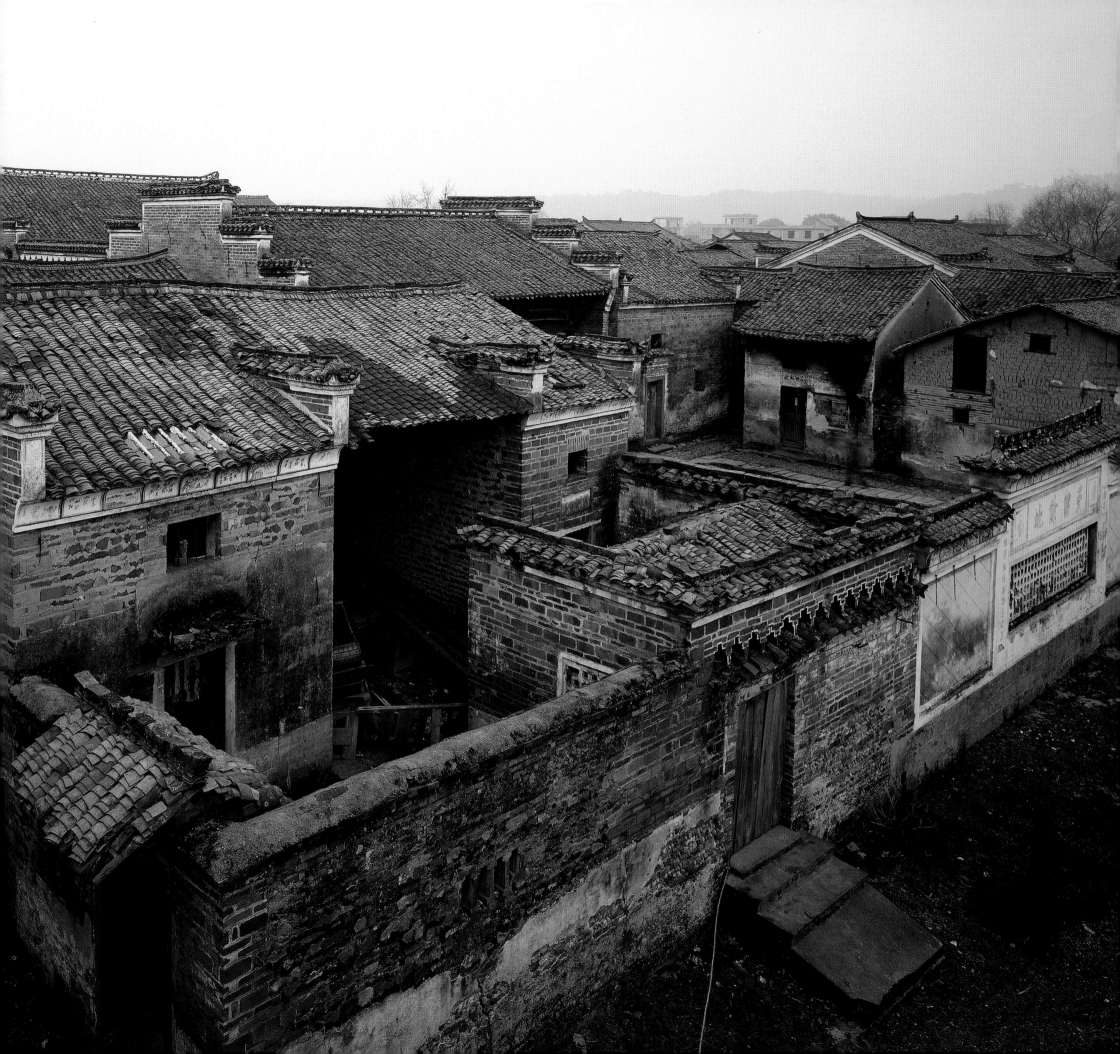

To remember the *hutong* of former times, we can now only catch a glimpse from
what little remains. We must reach into archives to understand
the history and evolution of traditional environments
so that the knowledge and memories of them can come alive.

我們現在只可從殘存的一鱗半爪裡捕捉胡同的舊時風貌。

我們得要從檔案裡了解傳統環境的歷史和變遷，

對這些環境的認識和回憶也因而不致湮沒。

Once structures and artifacts are gone, we are left only with archival records, if we are fortunate enough to find that these documents have been preserved.

建築物和文物一旦失去了，剩下的只有檔案紀錄，但視乎這些紀錄是否有幸得以保存下來。

Archival preservation of historical records should not be underrated and cannot be neglected. Even if architectural structures survive, we still need historical documentation that informs us of their evolution and details. I am passionate about this aspect of historic preservation, which, sadly, is often overlooked.

歷史紀錄檔案的保存不應被低估及掉以輕心。就算建築物幸存，我們也需要歷史紀錄去了解其演變及細節。我對保存這方面的歷史很感興趣，但可惜這個環節往往不受重視。

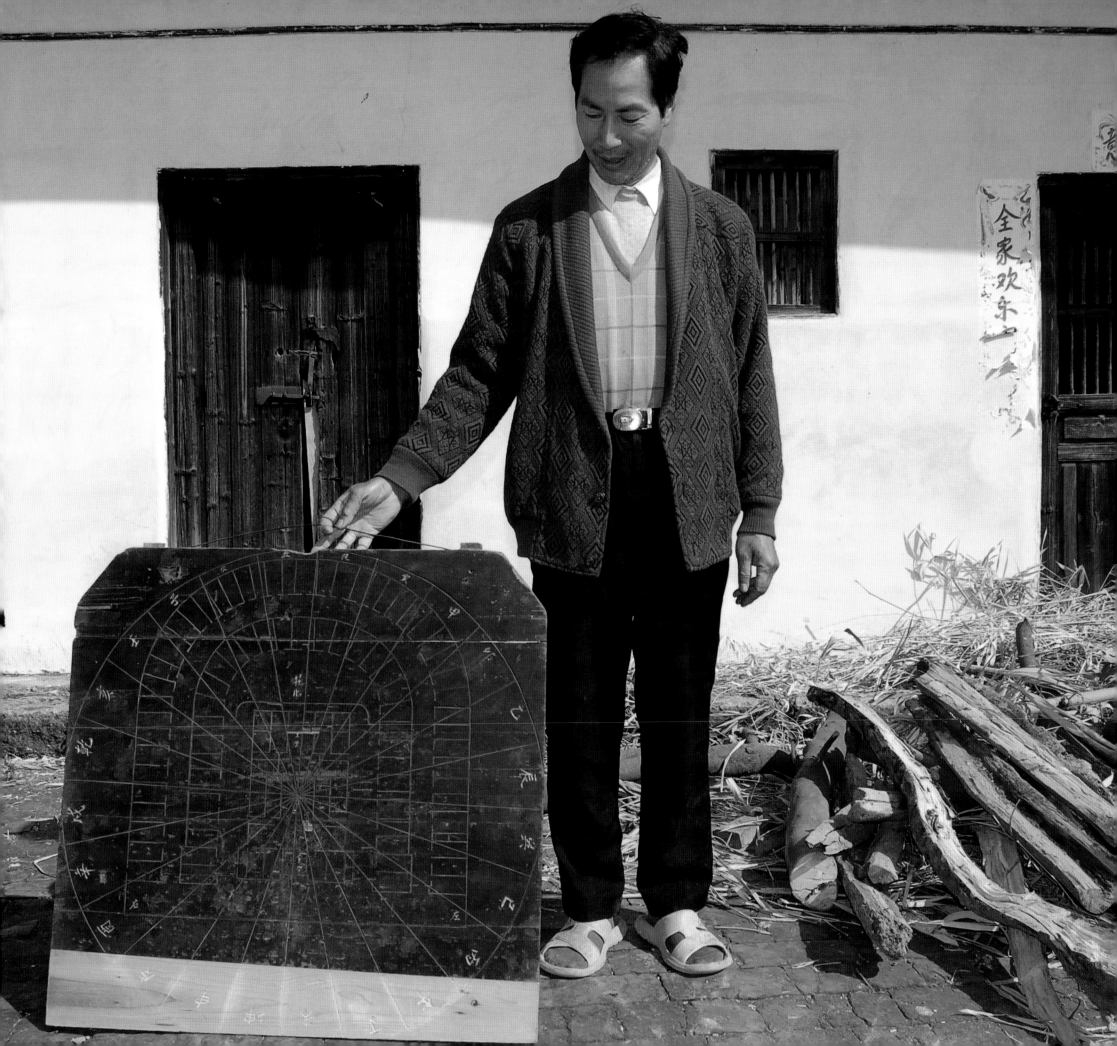

the taming power of the great

ta ch'u

ANGUS FORSYTH

文
化

cultural identity
wenhuarentong

認
同

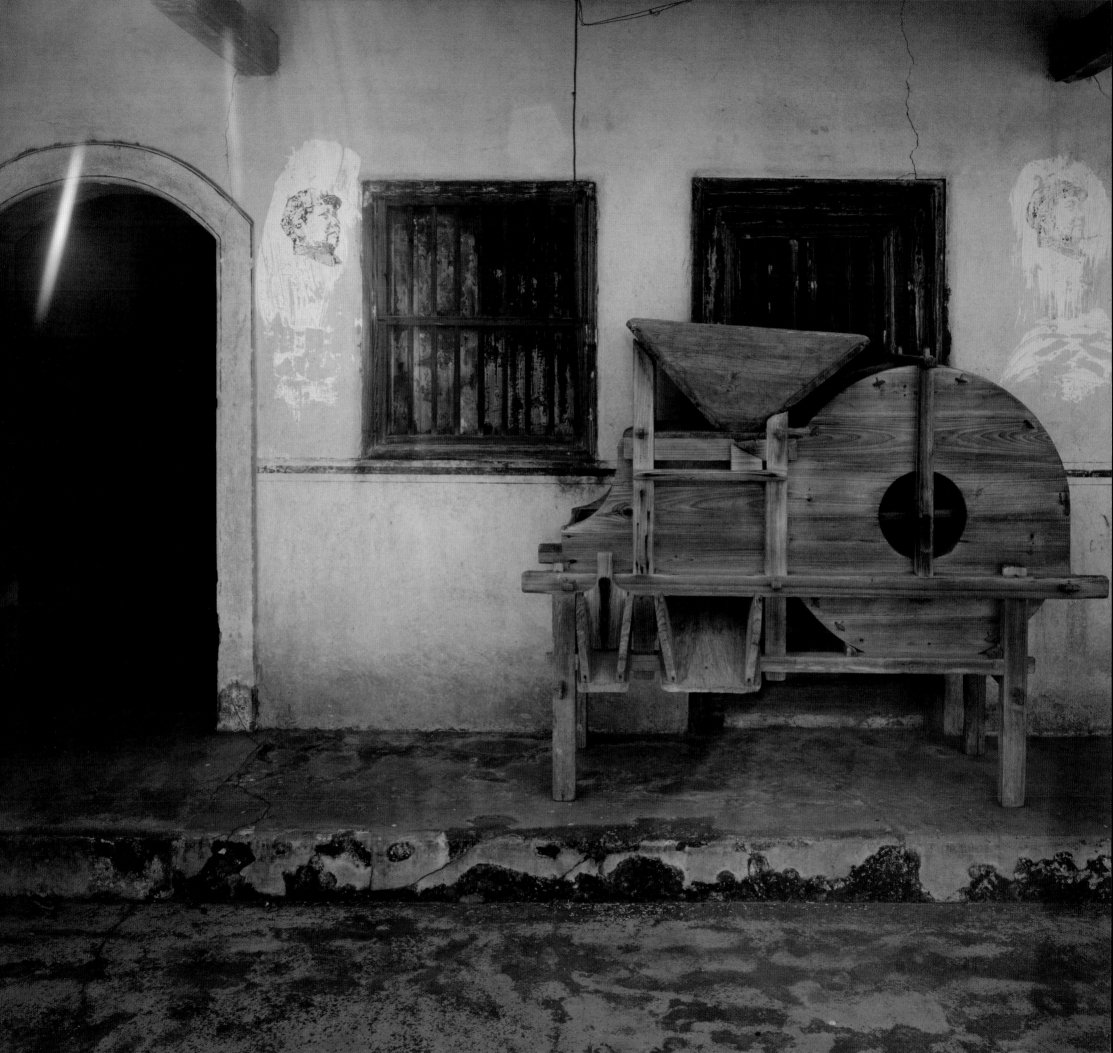

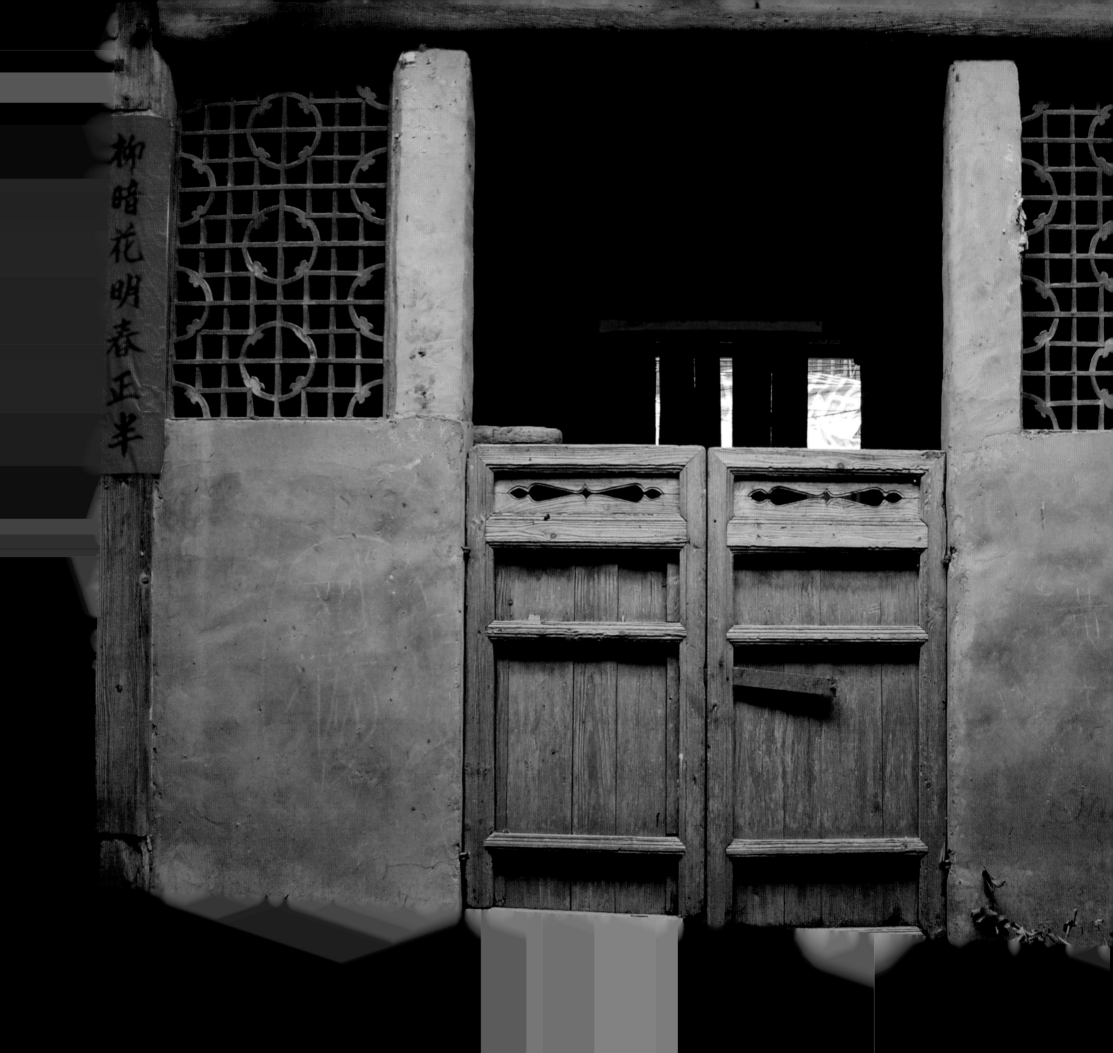

The Cultural Revolution was a major tragedy in its destruction of the physical cultural fabric of the country—something which, taken together with the dismantling of the walls of Beijing, leaves a huge hole in cultural awareness among the Chinese.

文化大革命是大悲劇，把國家的實質文化結構摧毀了；加上北京城牆的拆毀，中國人在文化意識上就出現了一個大洞。

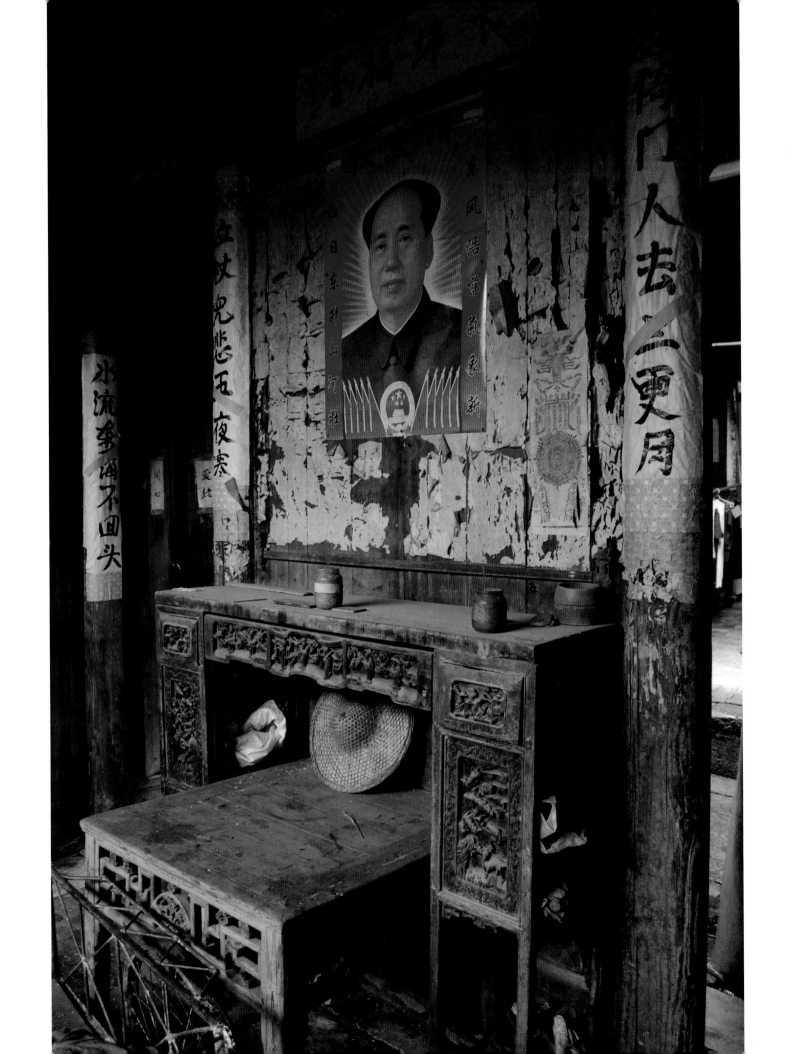

Over a decade (1966–76) the Cultural Revolution was the principal culprit in the destruction of China's artistic and architectural heritage. That tragic period was indeed a contradiction of the traditional Chinese value of pride in cultural identity enshrined in the Chinese classics and an uninterrupted dynastic history. It showed dramatically how vulnerable such values are even in a country like China, where tradition had long been held sacrosanct.

十年有多的時間 (1966–76)，文化大革命是毀滅中國藝術和建築遺產的元兇。這段悲慘的歲月事實上與傳統的中國價值觀相違，中國人的文化認同蘊含於經史子集和綿延不絕的朝代歷史之中，亦以此而自豪。

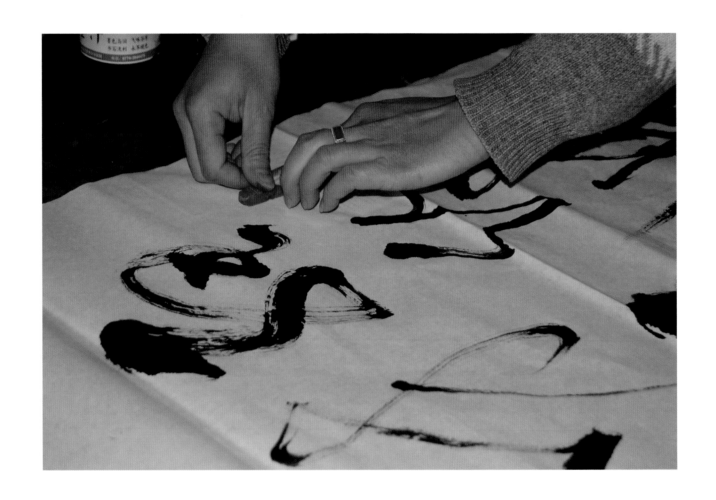

Multiple factors are needed to reverse these trends,
but to begin, an increasing swell of nostalgia for the past needs nourishing in China.

要扭轉這些趨勢需要多個因素，但首先得要在中國加強營造懷念往昔的氛圍。

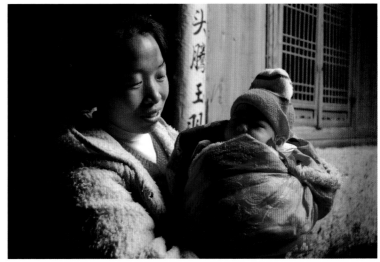

Most importantly, I believe that the basic will is there even if the political apparatus is lacking. We must have faith that as awareness increases, the means for action will appear.

我覺得就算欠缺政府的組織，基本的意願也不可少，這點尤其是最重要。我們必須有信心，公眾的認識增加了，行動的方法就隨之出現。

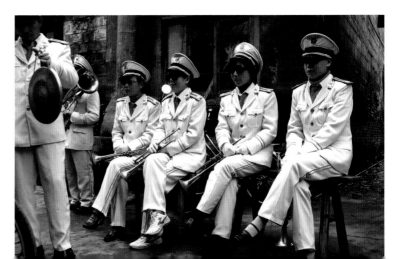

遺 產

yichan

heritage

PETER H. Y. WONG

黃匡源

One consequence of China's one-child policy is that for every citizen, he or she will be the collective memory for his two parents and four grandparents. Reaching out to this generation to instill in them a love for the legacy of the past should be central to any heritage preservation initiative.

中國每個公民將會是其雙親和四位祖父母的共同回憶，這是一孩政策的一個後果。任何文物保護計劃，都應該以這一代人為對象，培養他們對歷史遺產的愛護。

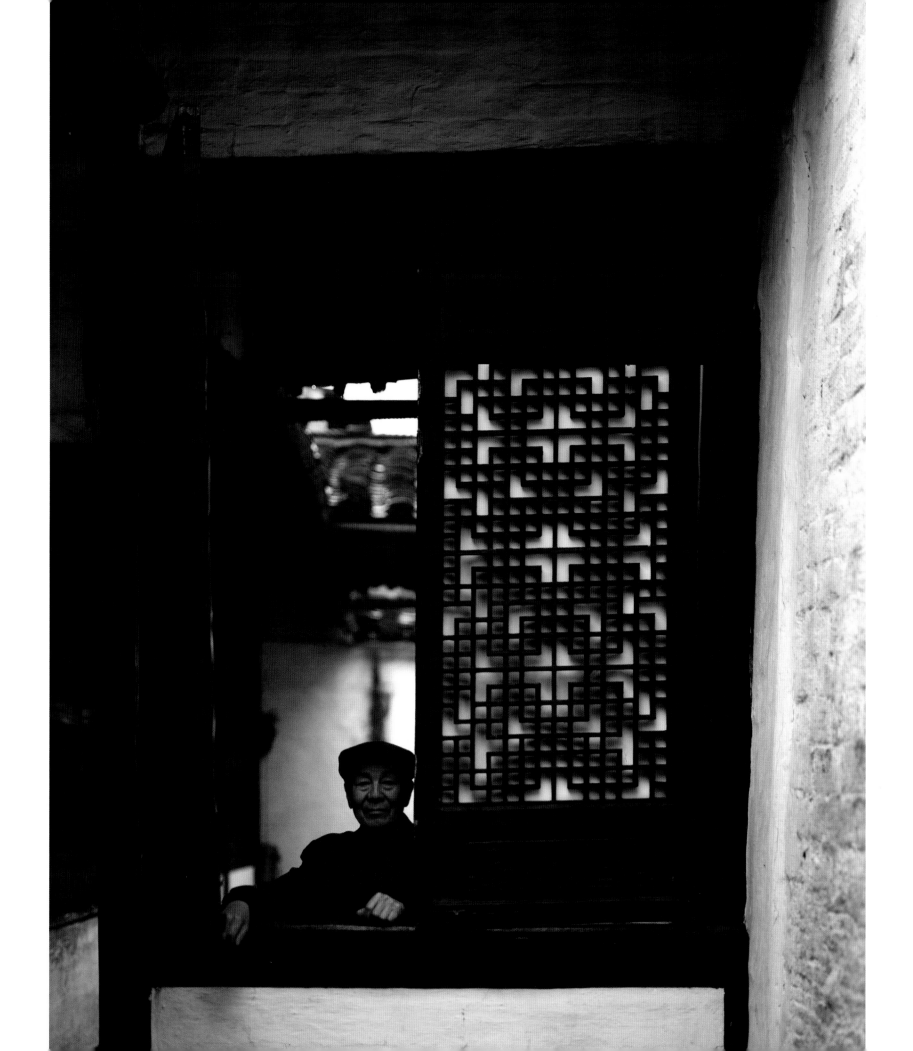

As China's economy grows, the younger generation will be faced with the consequences of accelerated development. Consumption per capita in China is still very low by developed countries' standards. However, the next ten years will see the rise of China as the motoring capital of the world. This headlong rush to prosperity in double-digit terms will mean that China will soon consume far more resources than most other countries. Smog and acid rain will accelerate the decay of historical artifacts and deter future tourism. Faced with this reality, every effort must be made to improve and protect the environment.

中國的經濟不斷增長，年輕一代將要面對高速發展的後果。以發達國家的標準來衡量，中國的人均消費仍然很低。不過，中國在未來十年將會冒升成為世界經濟的動力。這種以雙位數字一往無前衝向繁榮的勁，意味着中國很快會比大多數其他國家消耗更多資源。煙霧和酸雨會令歷史文物加速腐朽，桎梏未來的旅遊業發展。面對這個現實，必須盡一切能力改善和保護環境。

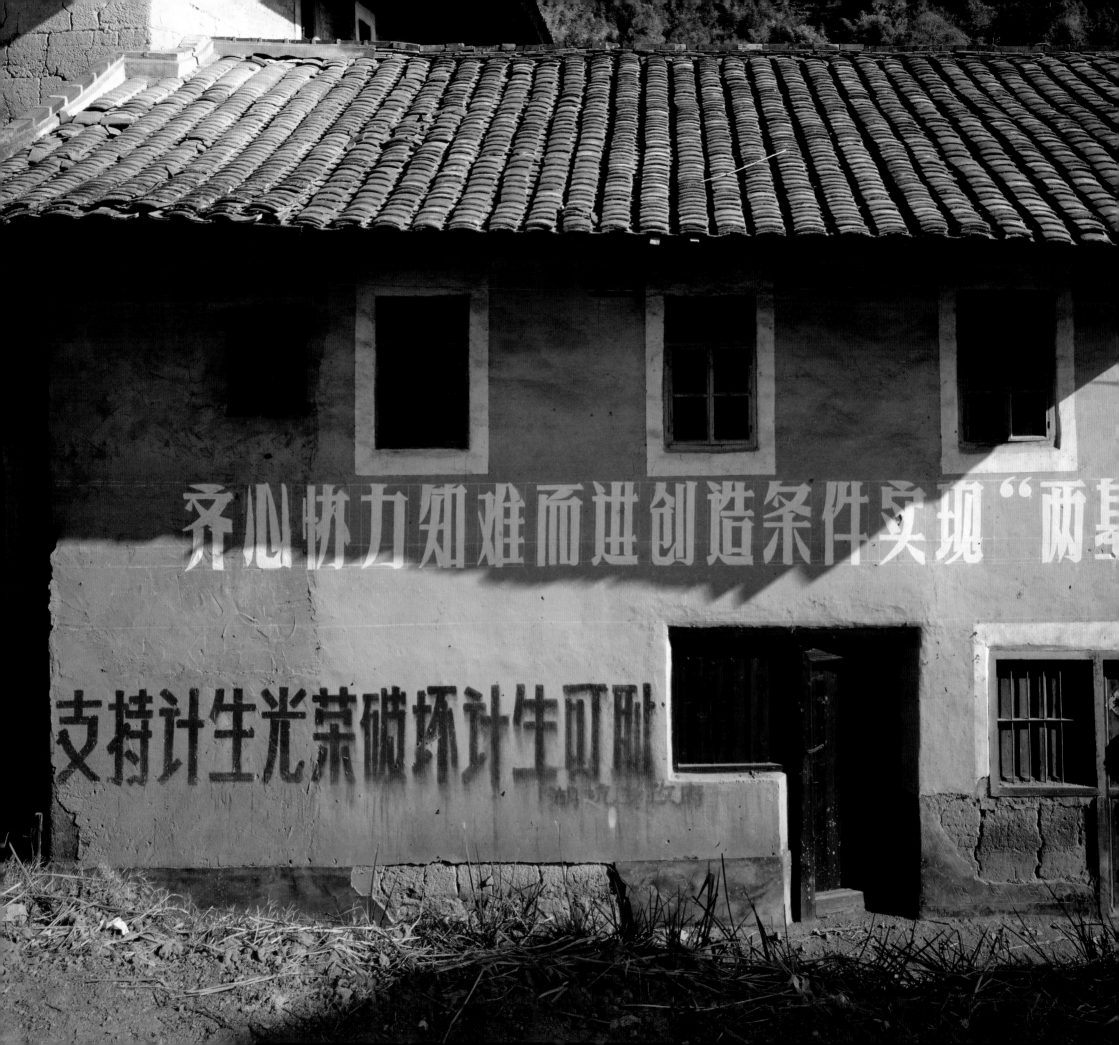

The pressing need to preserve existing heritage sites is critical. Unless we act immediately, we will be left with only the last remnants of our cultural legacy, which are rarely the best of what once existed. Lacking a cultivation of environmental and cultural awareness, "newer is better" will be the outcry, and China's rich heritage will be forgotten. Erasing the past is not an option for a civil society in the age of modernity.

保護現存的歷史遺迹刻不容緩，不能有失。若不坐言起行，我們那些屬於歷史上至珍至貴事物的文化遺產將所餘無幾。缺乏環境和文化意識的培養，「新即好」喊得最響，中國豐富的遺產將會被遺忘。忘卻過去不是現代文明社會的選擇。

duration

hêng

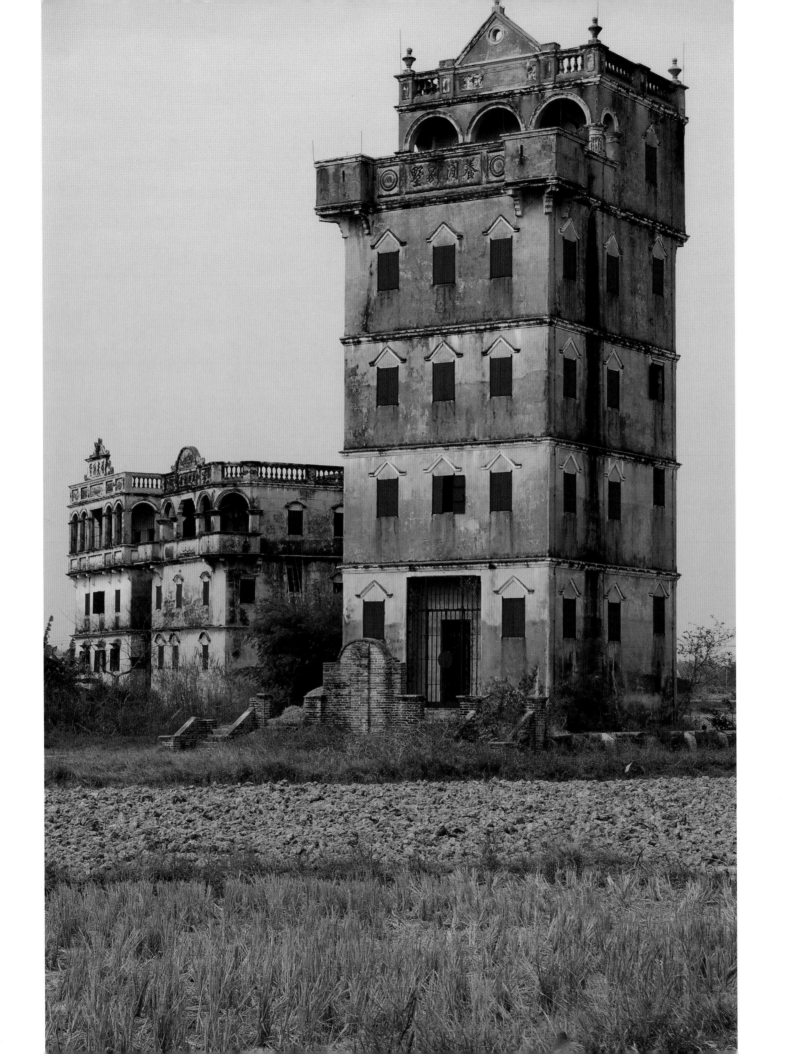

VINCENT H. S. LO

羅康瑞

vernacular architecture

minjianjianzhu

Architecture reflects history and culture. It truthfully tells of the lives, traditions, and living environment of our ancestors, which must be treated with respect. Much of Chinese vernacular architecture, though centuries old, possesses distinct characteristics of sustainability and aesthetic beauty, and these buildings should not be demolished in the name of development and modernization.

建築反映歷史和文化，如實地述說我們祖先的生活、傳統和生活環境，都是我們應該以尊敬之心看待的。大多數的中國民間建築，儘管已有幾百年歷史，在持續性和藝術美態上都極具鮮明的特色，不應以發展和現代化之名而拆毀。

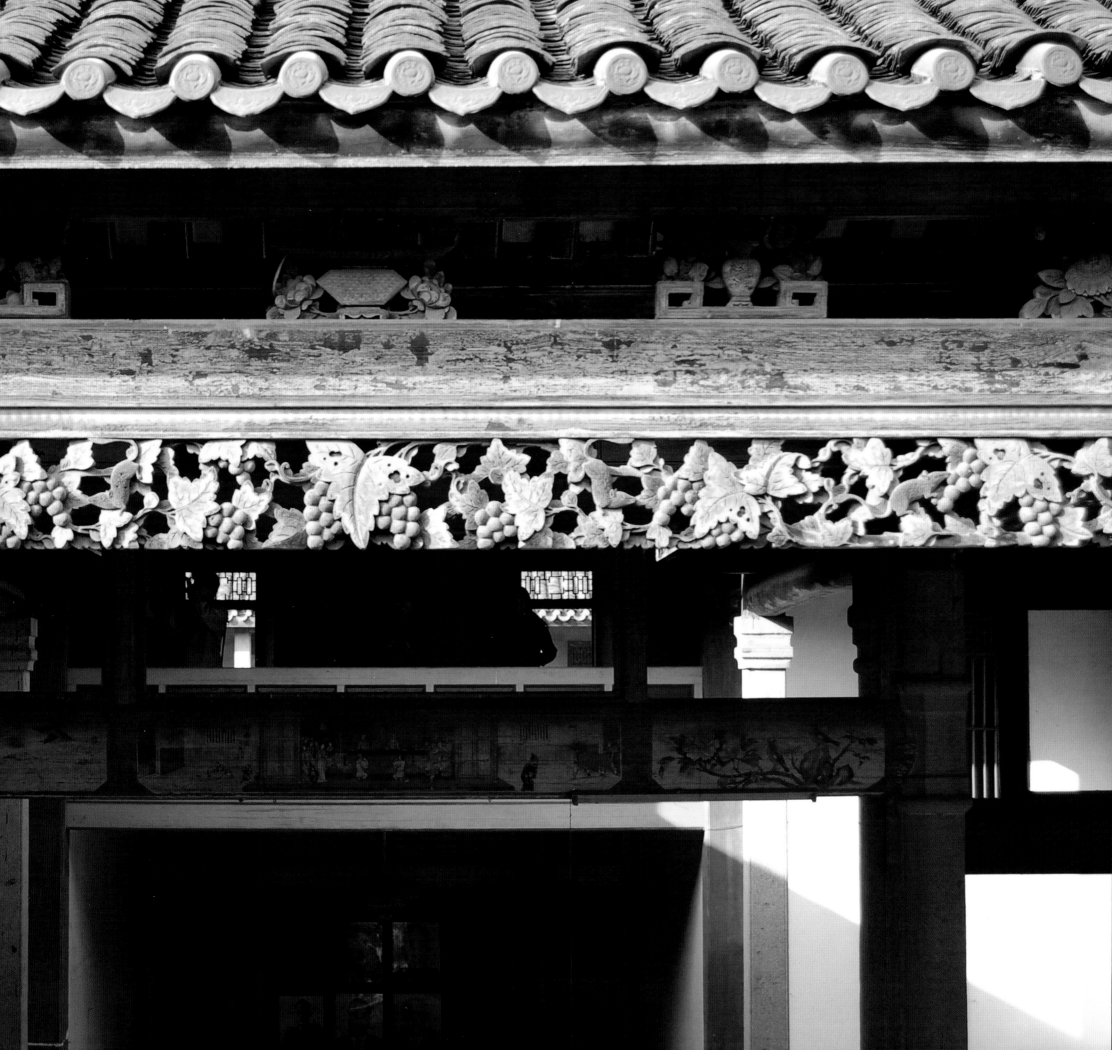

Realistically it is not economically feasible to preserve and turn every historic building into a museum piece, nor is it desirable. We must therefore look for other ways to approach saving China's heritage, and in this quest achieving balance is essential. In addition to the preservation of buildings of architectural and historic interest, buildings can be rejuvenated by giving them new life, new purpose, and new values. Adaptive reuse as an approach to preservation is one option that can provide both cultural and commercial success.

實際地看，把所有歷史建築物保存下來變成博物館的東西，經濟上並不可行，亦不可取。因此我們必須找出其他方法挽救中國的遺產，而在尋求的過程中最重要是不偏不倚，達致平衡。除了保存有建築學和歷史價值的房子外，還可以修復建築物，賦之以新生命、新用途及新價值。改造性再利用是保護文物的一種方法，是達致文化上和商業上雙贏的其中一個選擇。

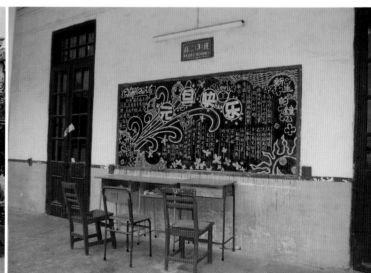

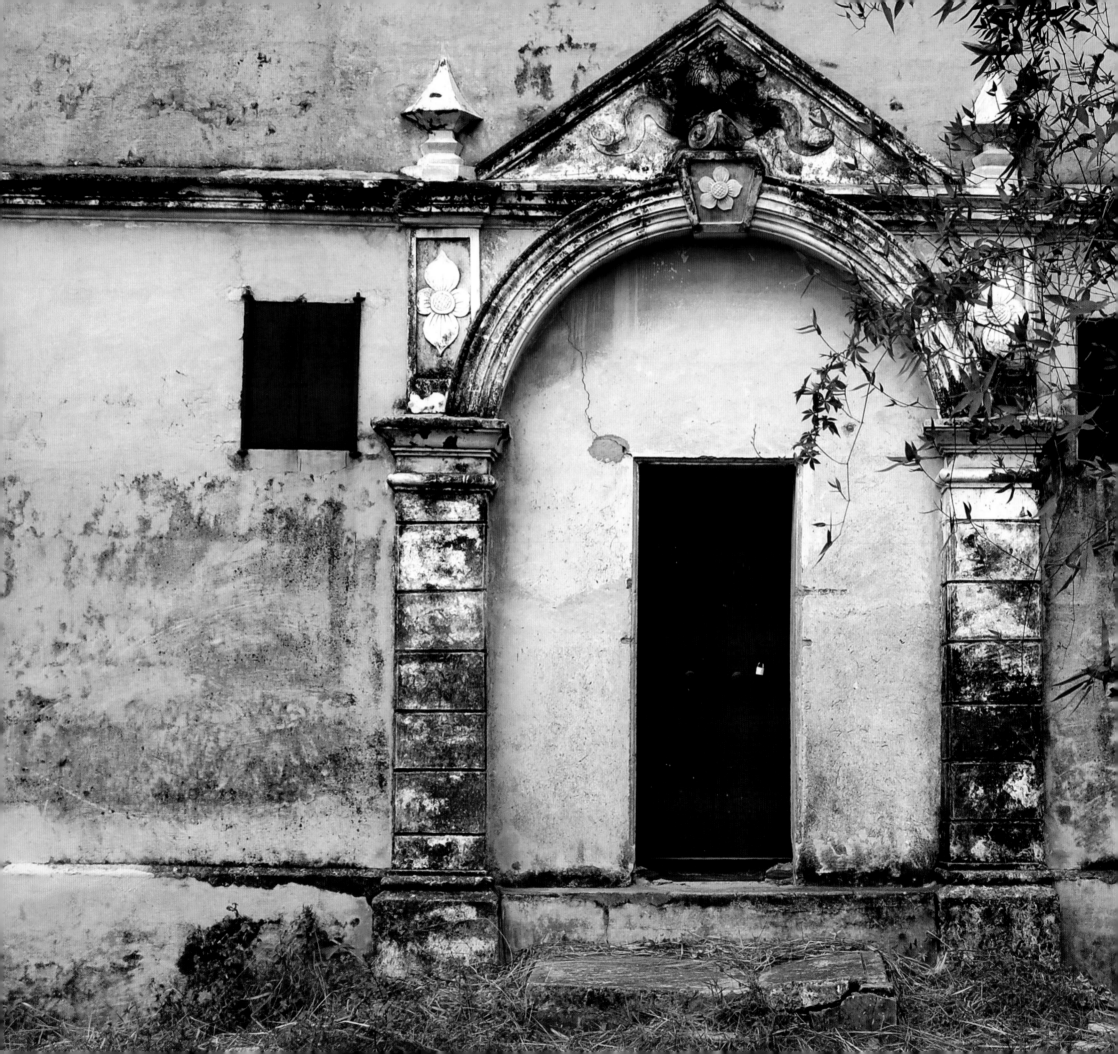

BENJAMIN T. WOOD

There are multiple factors influencing the resistance one confronts in trying to preserve historical architecture throughout China. As a result of political and social forces during the Cultural Revolution, the vast majority of Chinese have not been taught to appreciate their heritage. In this regard we now see that vernacular architecture is at risk because no one values it.

在中國，保存歷史建築所遇到的阻力，背後有很多因素。文化大革命的政治和社會暴力影響所及，大多數中國民眾沒有被教導去欣賞他們的文化和歷史遺產。由此之故，現時的民間建築處境不妙，因為大家都不珍惜這些房子。

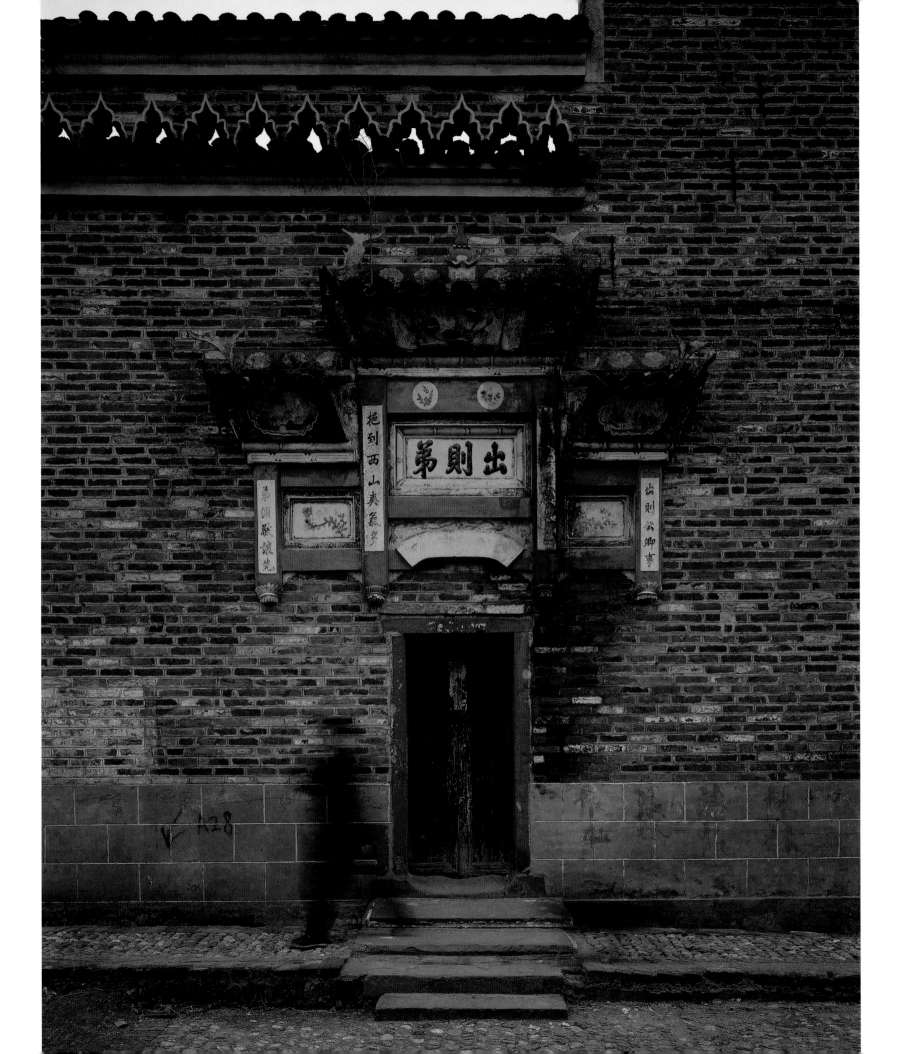

But equally influential is the fact that there have been very few successful models that have shown that preservation can be profitable. To refute this, I believe that a strong case can be made that there is a cost benefit to saving historic buildings. The good news is that there is an entrepreneurial spirit in China that will prevail, and when the Chinese see value in something, it will be accomplished.

再者，古老建築保存下來而有利可圖的成功例子聊聊可數，這影響亦不小。要反駁這點，我相信可以引用實例證明保存歷史建築物確有成本效益。好消息是企業精神在中國日盛，大家看到某事某物的箇中價值時，自然水到渠成。

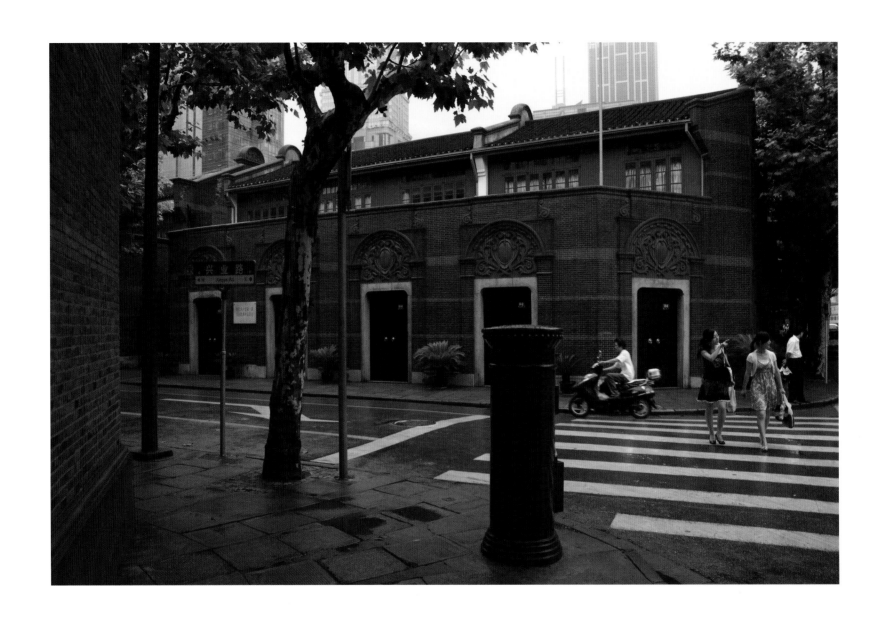

Like many countries, China has chosen to spotlight
historical significance as the defining motivation for preservation.

中國和很多國家一樣，以歷史意義來決定是否值得保存文化和歷史遺產。

In the case of the Xintiandi project in Shanghai, the focal point of the preservation district is the site of the First Congress Hall of the Communist Party (opposite). This is an example of how China has chosen to preserve monuments that are of historical significance, over preservation as an end in itself. As a factor that can motivate preservation efforts, this reality should not be overlooked and can be used to its obvious advantage.

以上海「新天地」為例，保存區的中心點是中共召開一大的所在地。這例子足證中國選擇是否保存有紀念價值的建築物時，是按其歷史意義而定，文物保存的最終目的反而是次要。要推動文物保存工作，不能漠視這個實際情況，反而應該善加利用。

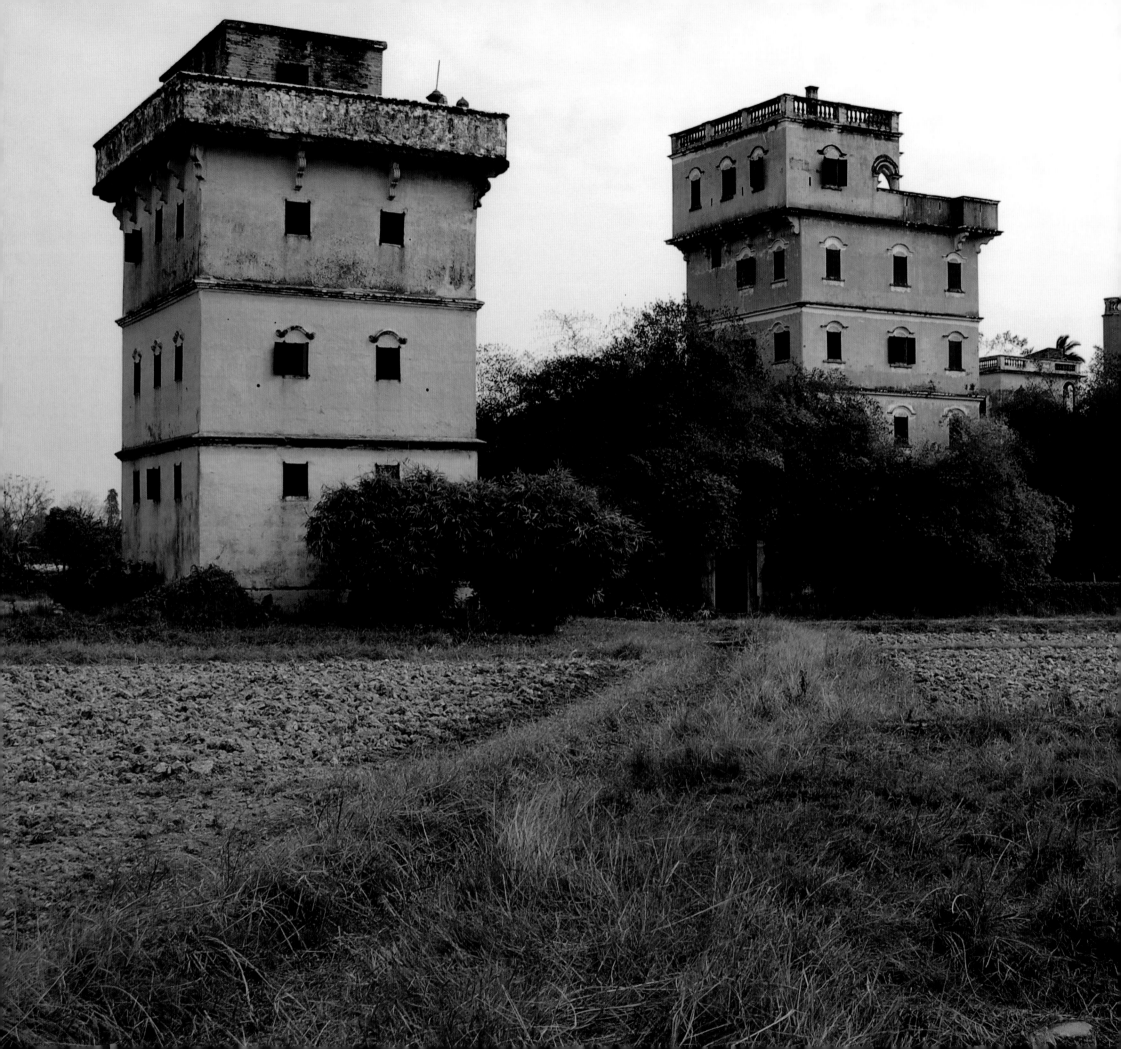

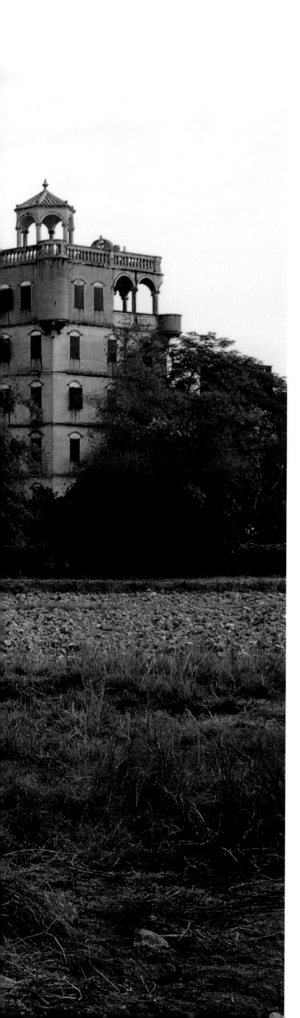

Once a restoration is accomplished, even if initially motivated by historical relevance, the added benefit of having saved a building, a neighborhood, or a village has been achieved. Once the beauty and value of this heritage is established, more of this legacy will be appreciated and then protected. The Chinese will become more sophisticated and appreciative of their past, of heritage properties, and of the natural environment. This may take time, but I have faith that this transformation is already occurring.

修復工作一旦完成，就算當初考慮的只是歷史意義，總算把一座房子、一個社區，或者一條村落保存了下來，已達到額外成效。只要確立了這項遺產的價值，更多相類的項目將會受到欣賞，從而得到保護。中國人對他們的過去，對遺產的特質，以及對大自然的環境將會更精於鑒別及欣賞。這可能需要點時間，但我相信轉變已經開始。

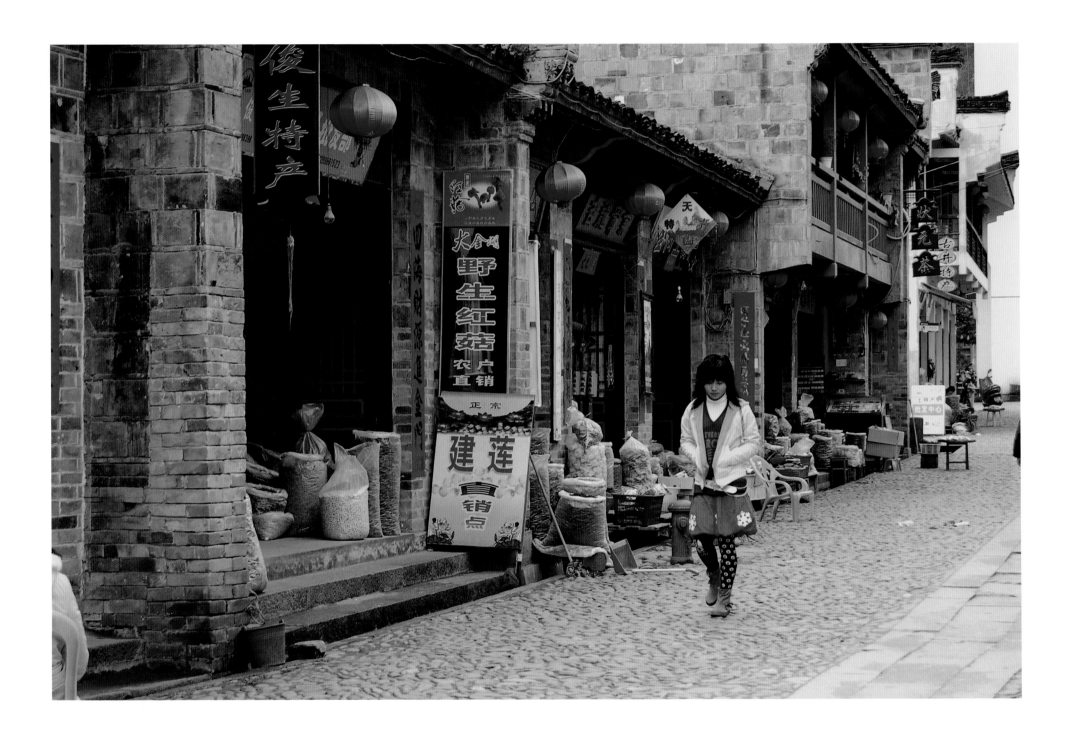

價值

LIU XIAOGUANG

劉曉光

In the Chinese context, so saturated with cultural heritage and tradition, it is almost impossible to design without some reference to the past. The real challenge is to design for the dynamic present alongside a seemingly uncompromising dilemma between preservation and development.

在中國這樣一個飽含了文化遺產和傳統的環境裏從事設計，要想完全撇開過去幾乎是不可能的。而真正的挑戰在於如何為今天而設計。事物在不斷變化，與此同時保護與進步之間的兩難矛盾似乎又水火不相容。

Although destroying and commercializing tangible histories are controversial, cities and buildings cannot be preserved merely as artifacts. They must be transformed one way or the other. However, resurrecting old values and mentalities in culture's name can be morally questionable and alarming. It has to be the architect's responsibility to be discreet and critical while working in this context.

儘管把物質遺產加以銷毀和商品化的行為富有爭議性，但城市和建築畢竟不能僅以器物的形式留存，某種方式的轉變是不可避免的。然而，以文化的名義復活舊的價值和理念可能引發道德上的疑問和警覺。在這個特定文脈中工作的建築師有責任保持謹慎的態度和批判精神。

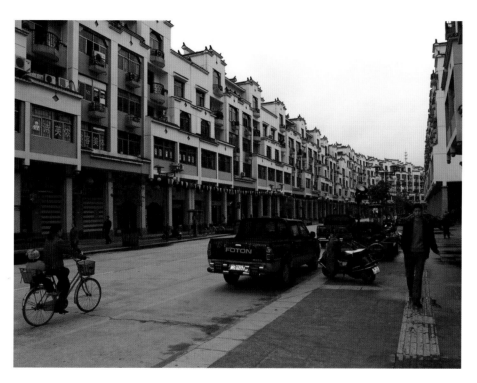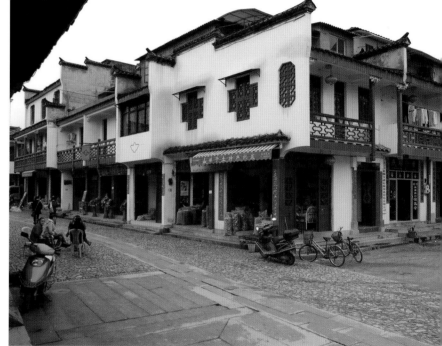

In the case of designing contemporary architecture for China, it is not my interest to develop a new vernacular or regional architecture. My attempt has been to engage Chinese philosophies and traditions not as nostalgic remarks but as active catalysts that may release potential universal values when interfaced with modern conditions.

談到為中國設計當代建築，發展某種新的鄉土或地方建築並不是我的興趣所在。在我的工作中,中國思想和傳統的角色不是懷舊的備註，而更像活性觸媒，在當代條件作用下可能催化和釋放出潛在的普世價值。

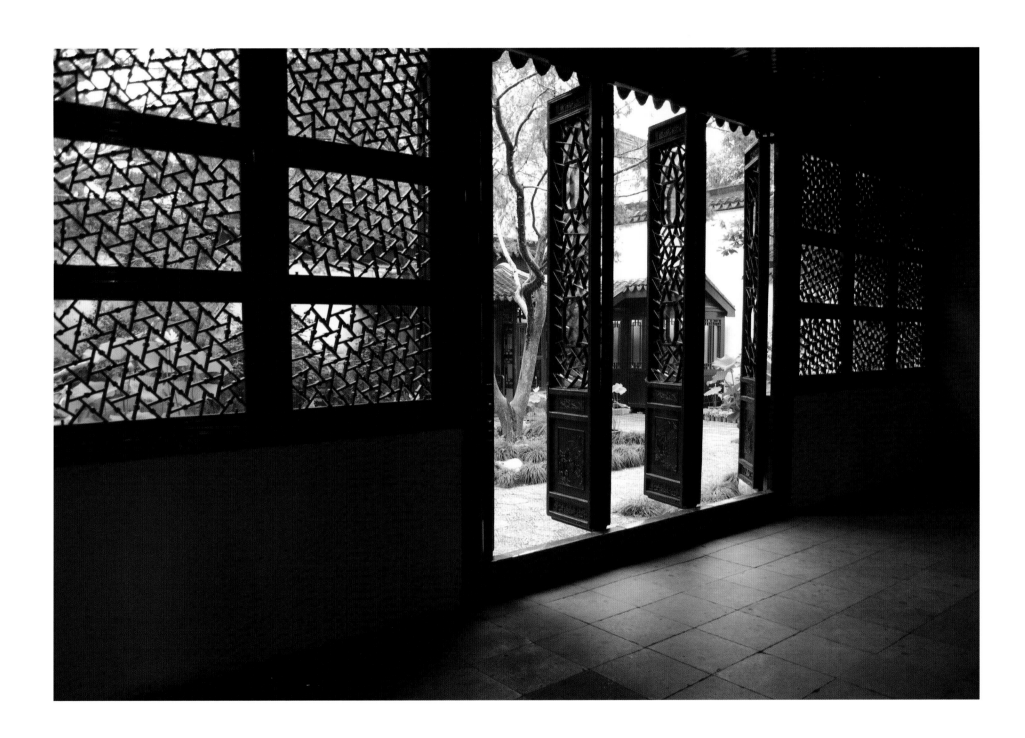

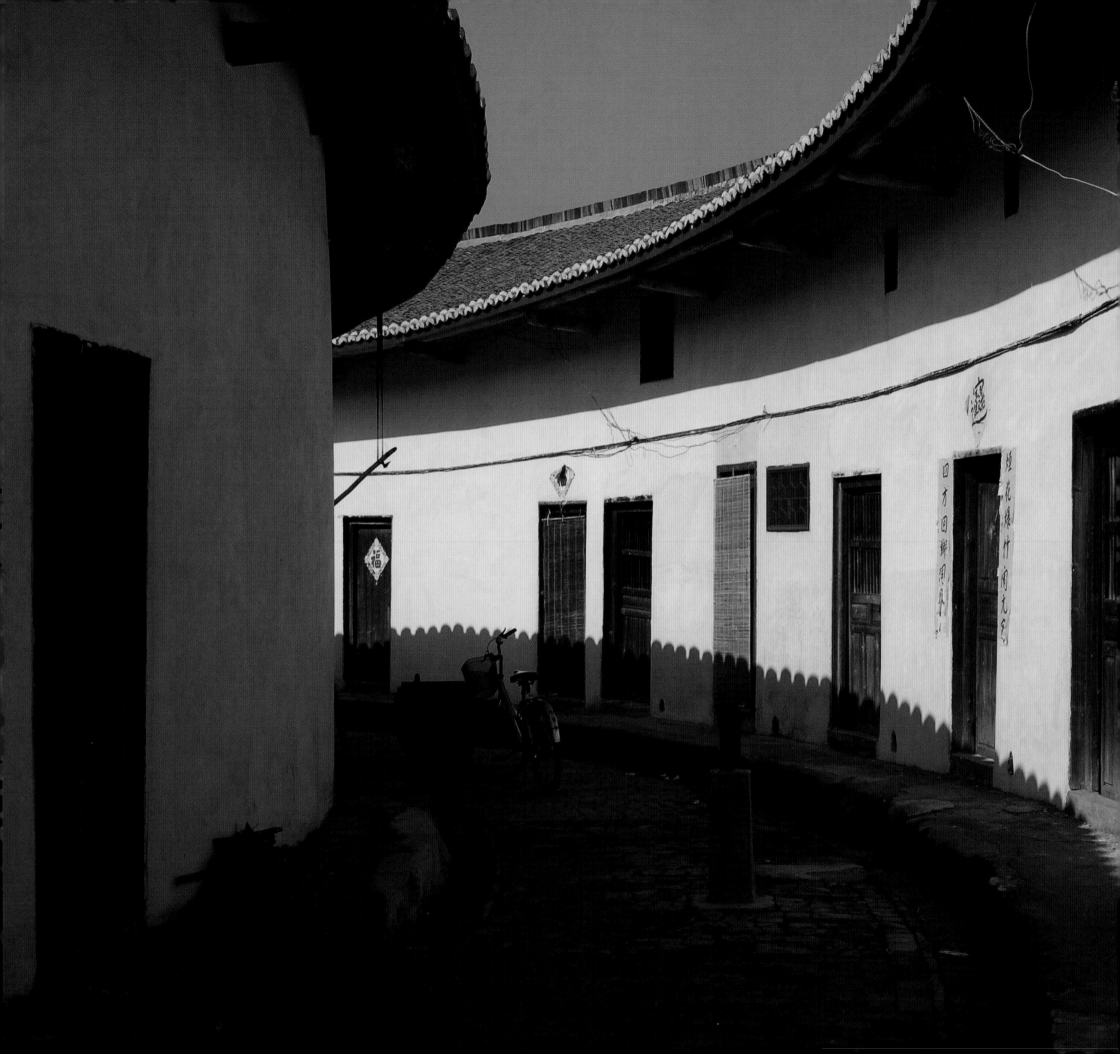

Architecture should have cultural genes. Any formal discourse on architecture cannot be sustained with an absence of core cultural values. Respecting a legacy should by no means be interpreted as submitting the new to the old. Established values and paradigms have to be subjected to constant and critical reevaluation in preparation for a real cultural renaissance.

建築需要有文化基因。離開了核心的文化價值，任何關於建築的形式探討都難以為繼。尊重傳統決不意味著新的要臣服於舊的。既有的價值觀和思維定式必須不斷接受批判和重估，才能為真正的文化復興做好準備。

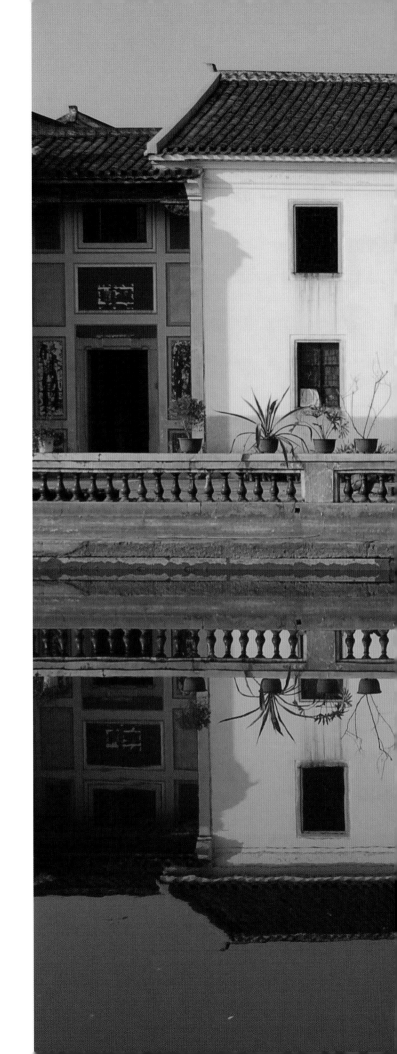

Until the social value structure can be stabilized
and cultural awareness is no longer relegated as secondary,
preservation for preservation's sake might be the best defense
for those places on the endangered list.

在社會價值結構塵埃落定，文化意識也不再無關痛癢之前，

為保護而保護恐怕是瀕危遺產最可靠的保障。

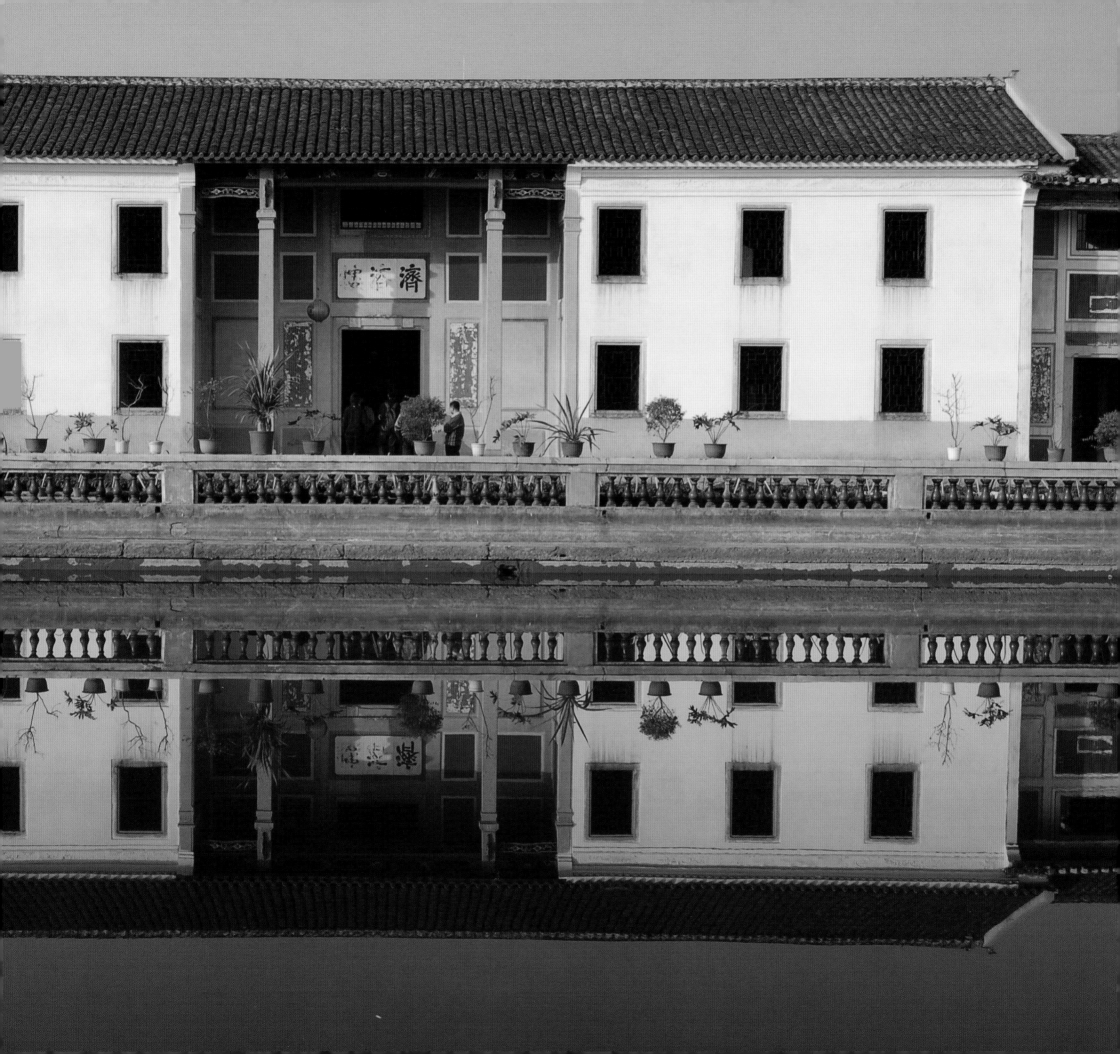

increase

i

都市化 *dushihua*
urbanization

PAUL ZIMMERMAN

Prosperity and the growth of a middle class in China has brought with it an awakening to the need for environmental protection and for the preservation of living and built heritage. Yet despite this new spirit, benefits such as preservation are being weighed against competing economic factors.

中國中產階層的成長和昌盛帶來覺醒，大家意識到有需要去保護環境和保留現存的建築遺產。可是儘管有這種新的精神，諸如文物保護的得益，仍免不了被相對的經濟因素比了下來。

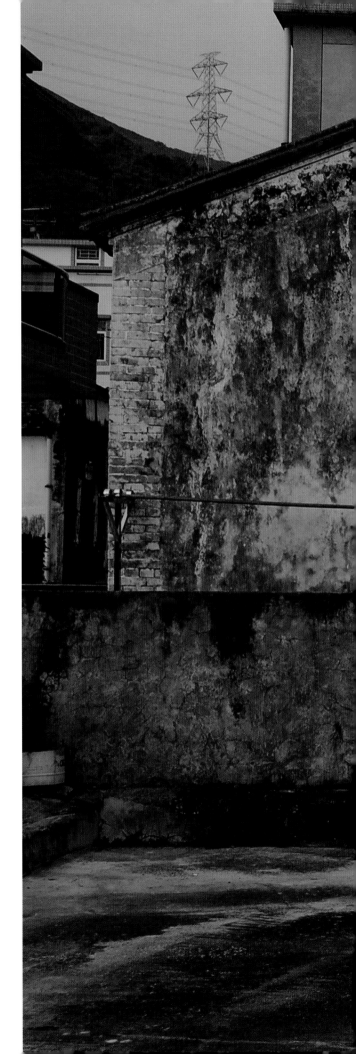

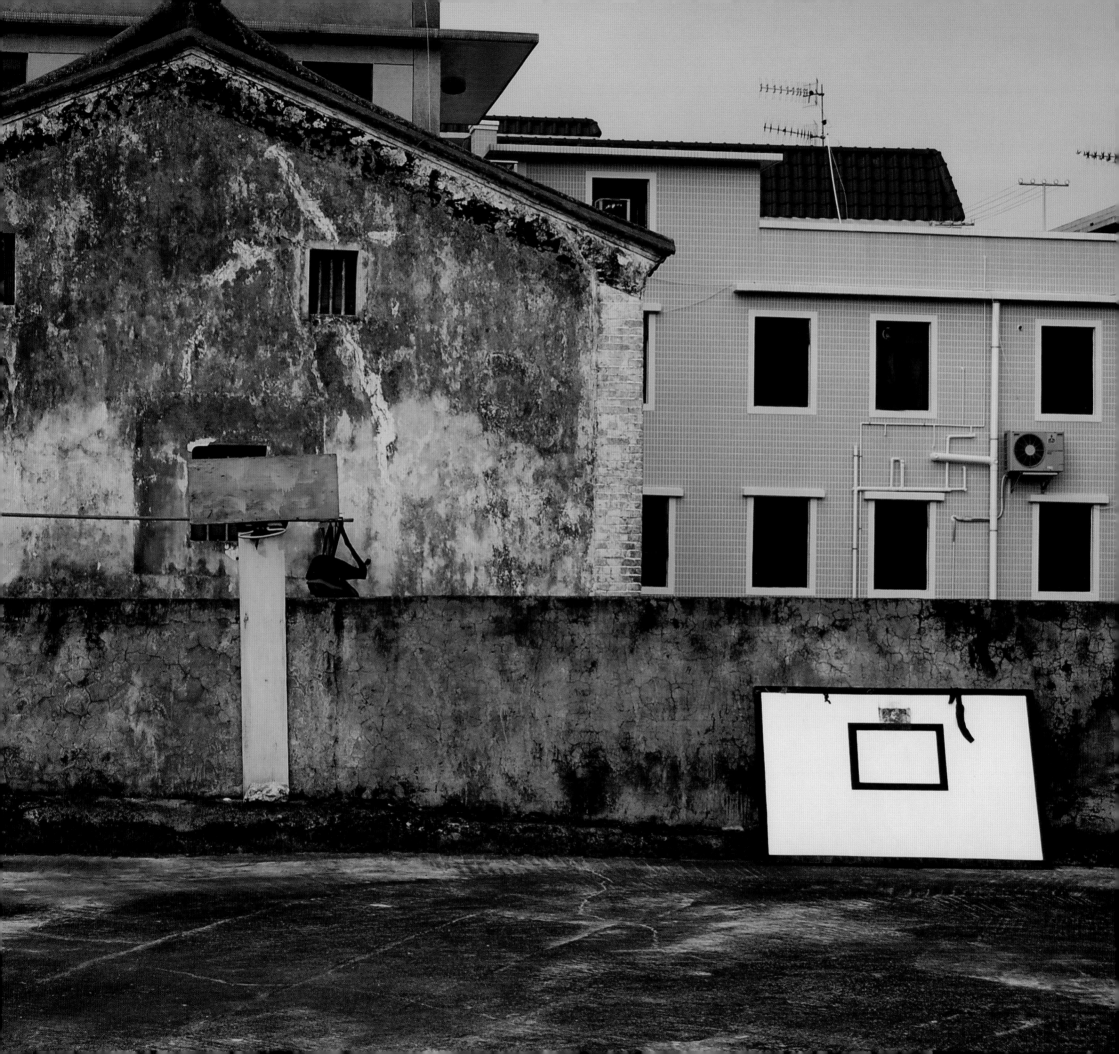

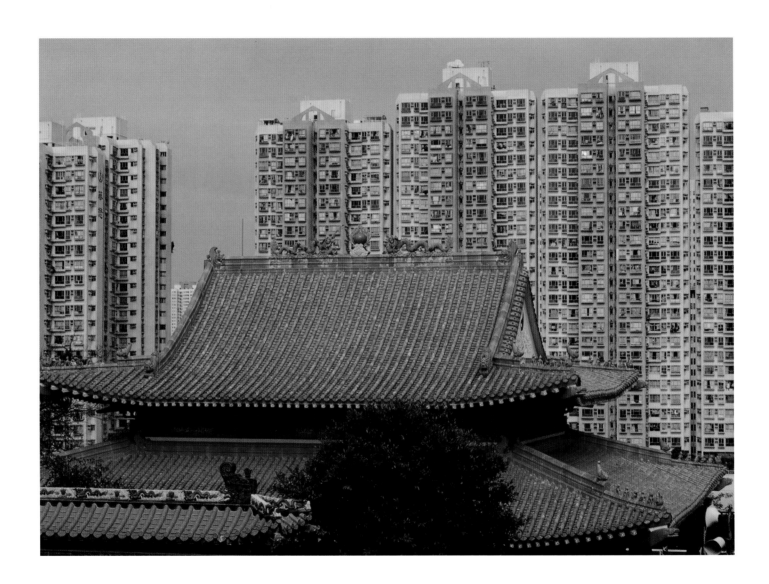

As China responds hastily to the need to absorb and facilitate its rural population into large cities, it faces threats to its cultural identity and its many significant heritage sites. The speed and scale of urbanization and a lack of private ownership of land offer serious challenges to successful heritage preservation.

中國中國在匆匆忙忙處理農村人口流向大城市的局面時，還要應付文化認同和重要遺迹所面臨的威脅。都市化既速且廣，土地亦無私人擁有權，為文化和歷史產遺的保存製造更大難題。

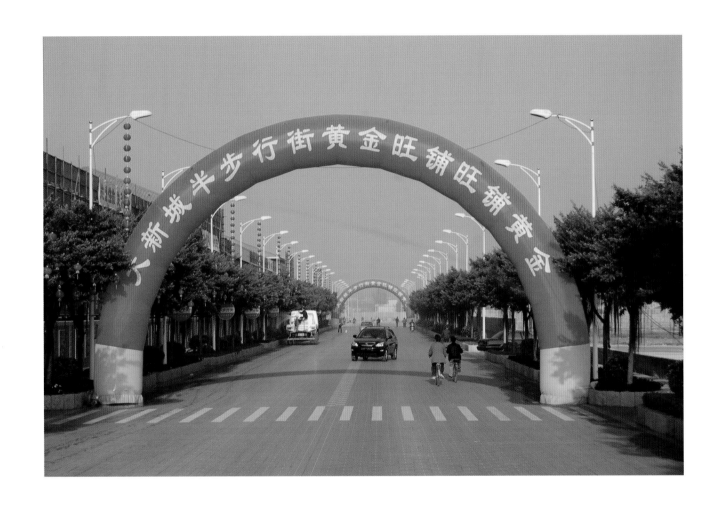

The incentive for local planning authorities has been to maximize land-related income, which complicates the reprioritization of development and conservation options. It is hoped that there is an early awakening and a growing respect for those in academia and the private and public sectors who have warned of the long-term costs to be paid for the dangerous and wanton destruction of heritage.

地方上的規劃部門一心盡量增加土地帶來的收入，令發展和文物保護孰輕孰重的次序更加複雜。學術界和公私人士都曾警告，悍然肆意破壞遺產會付出長遠代價，希望他們的說話受到尊重，大家及早覺醒。

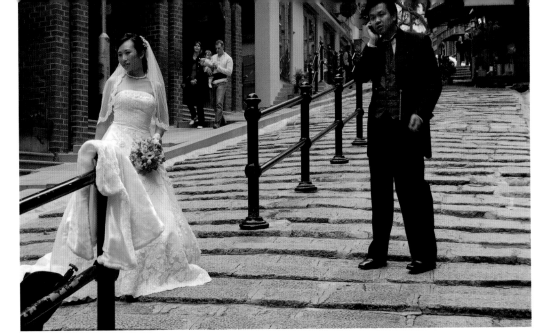

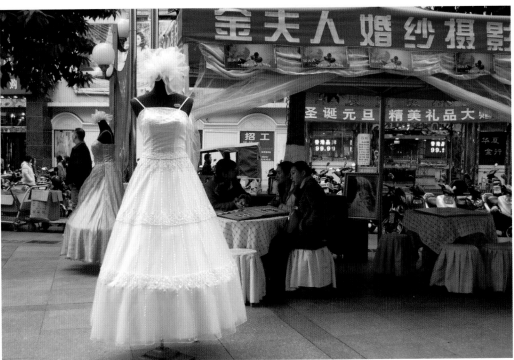

發 展 *fazhan*

development

DONOVAN RYPKEMA

It is the built environment that expresses, perhaps better
than anything else, a community's diversity, identity,
individuality, in short its differentiation.

建築環境也許比任何事物更能表達社群的多種多樣、
身份認同和個性特徵，簡而言之即社群的區分。

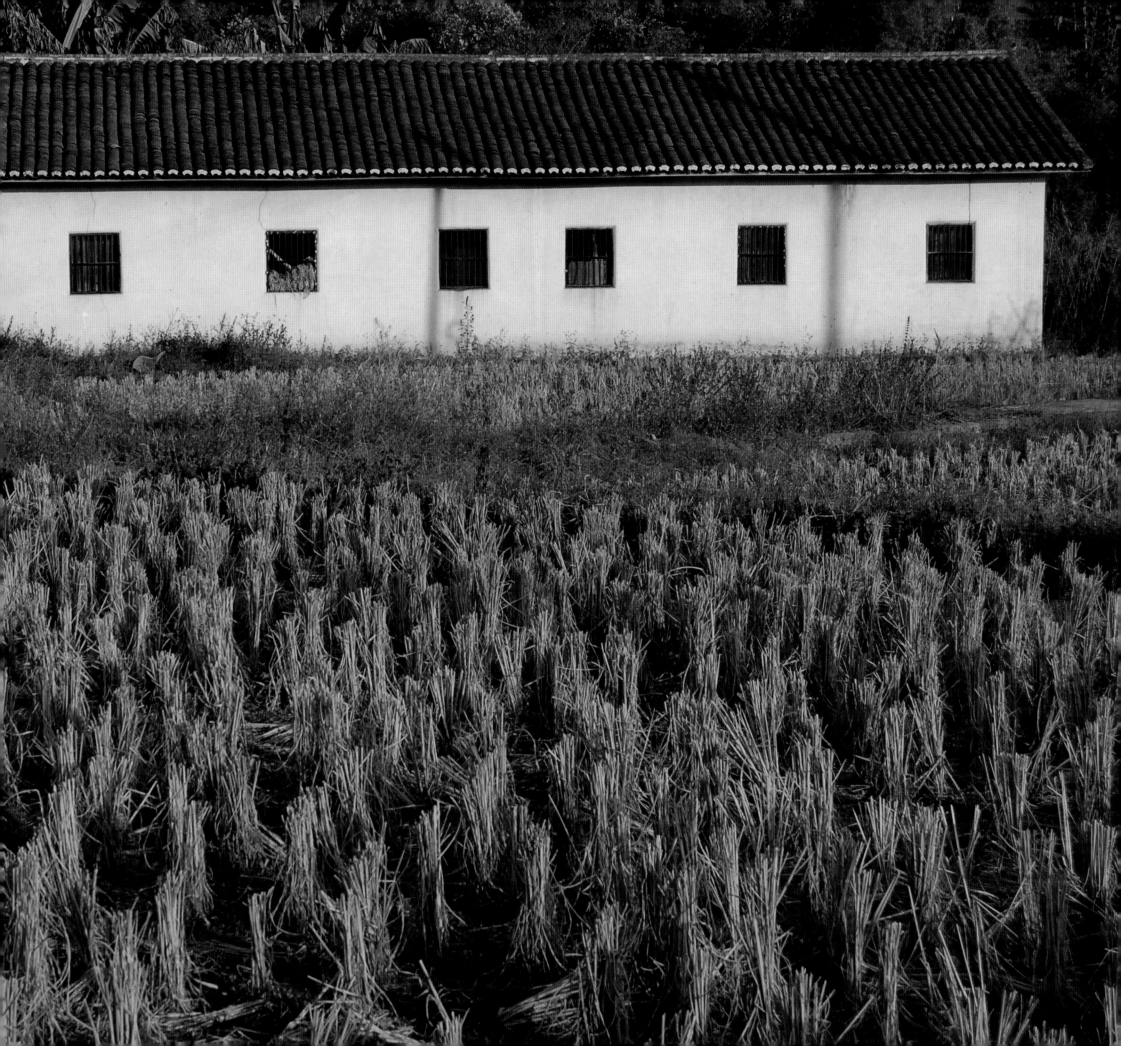

Historic preservation as an economic development strategy is consistent with all five principles of twenty-first-century economic development: globalization, localization, diversity, sustainability, responsibility.

以保存歷史文物作為經濟策略，並不牴觸全球化、地區化、多樣性、可持續性和責任這五個二十一世紀經濟發展的原則。

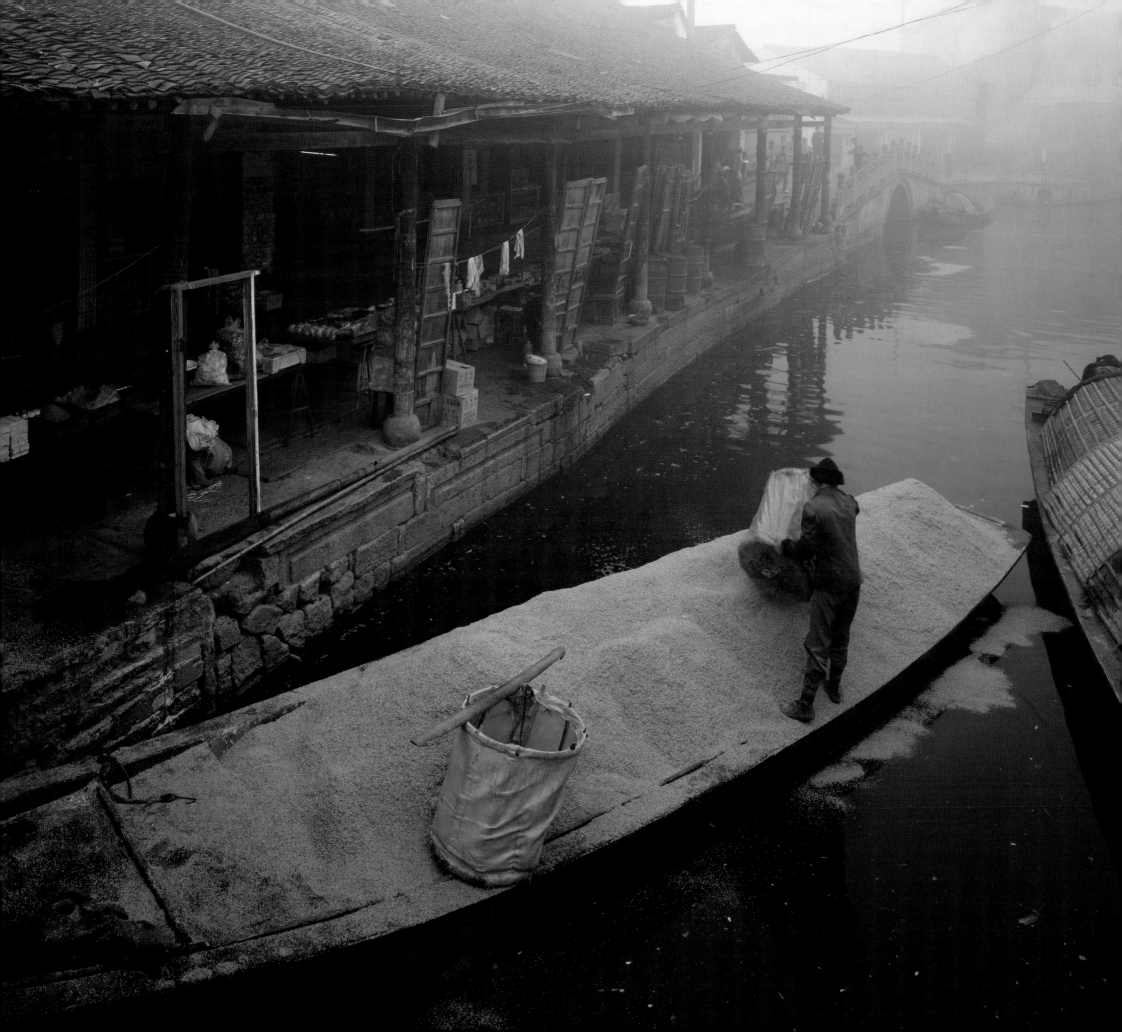

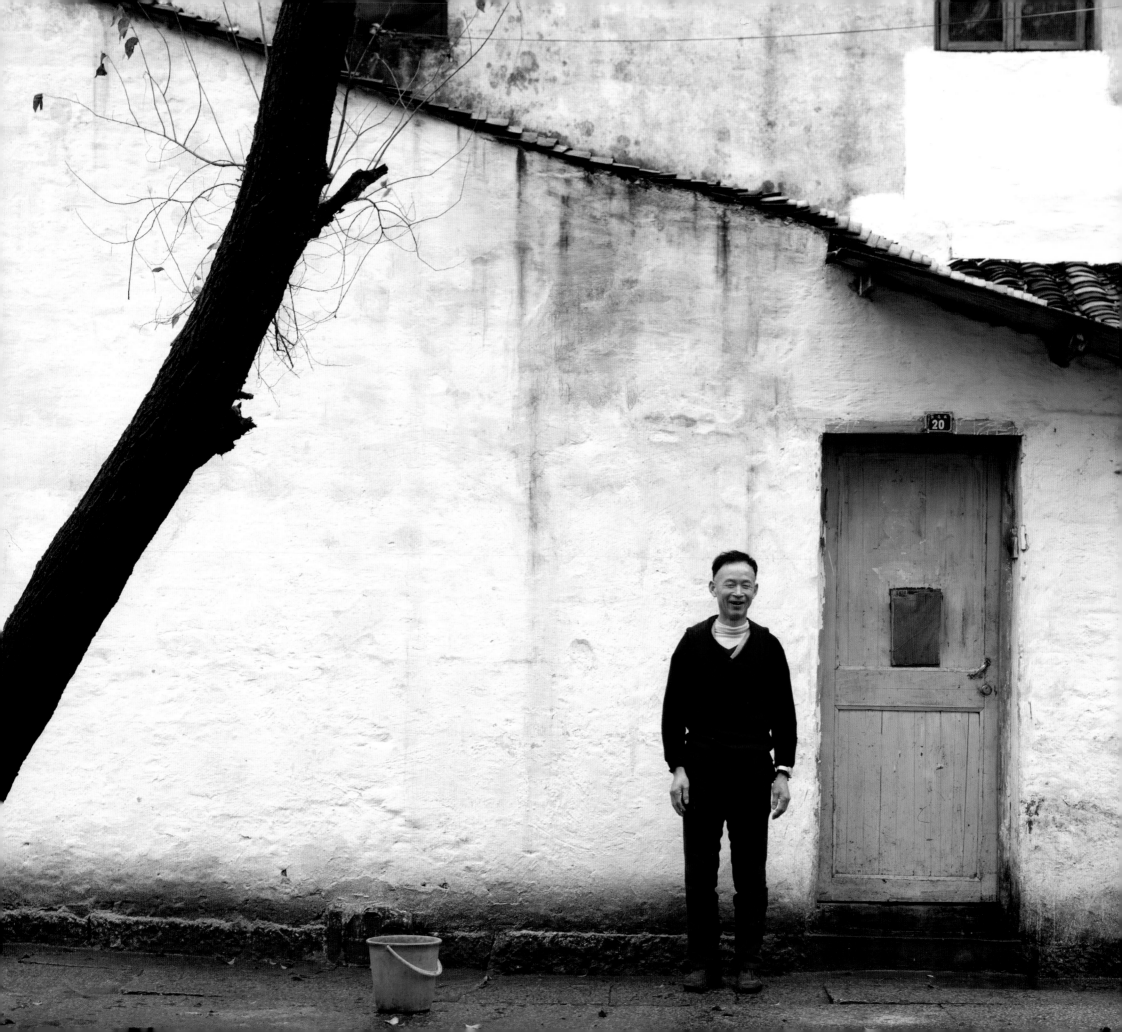

As the world quickly passes into the twenty-first century, the context and environment of local economic development is rapidly evolving. . . . The preservation of the historic built environment, far from being a hamper to economic growth, can be a critical vehicle to make it happen.

世界快步走進二十一世紀，地區經濟發展的範圍和環境急速蛻變…歷史建築環境的保存絕非經濟成長的障礙，反而可以是促成其出現的關鍵媒介。

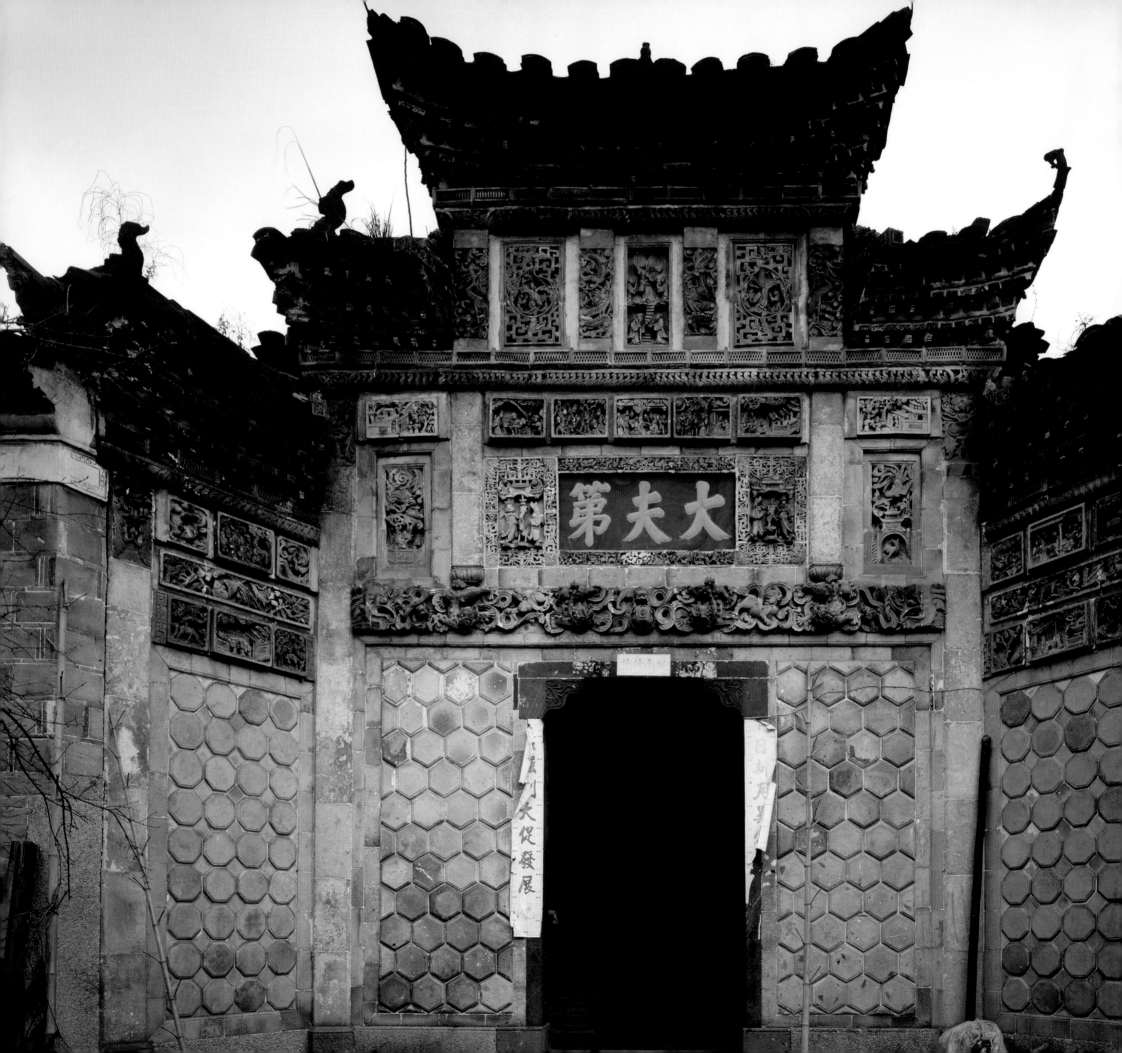

Many local economic development yardsticks in the twenty-first century will be qualitative rather than quantitative. Localization will always necessitate identifying local assets . . . that can be utilized to respond to globalization. Those assets need to be first identified, then protected, then enhanced.

二十一世紀很多地區經濟發展的衡量標準，將以質而非量來釐定。地區化始終不得不識別每地的財產...可加以利用以應付全球化。這些財產首先需要被識別，然後加以保護及強化。

The cultural assets of a community—dance, theater, music, visual arts, crafts, and others—are inherently influenced and enhanced by the physical context within which they were created and evolved over the centuries. If cultural resources are to become and remain an economic asset for a community, then the physical context . . . needs to be maintained. Otherwise more than just the physical buildings are at risk; the quality, character, differentiation, and sustainability of the other assets are in jeopardy as well.

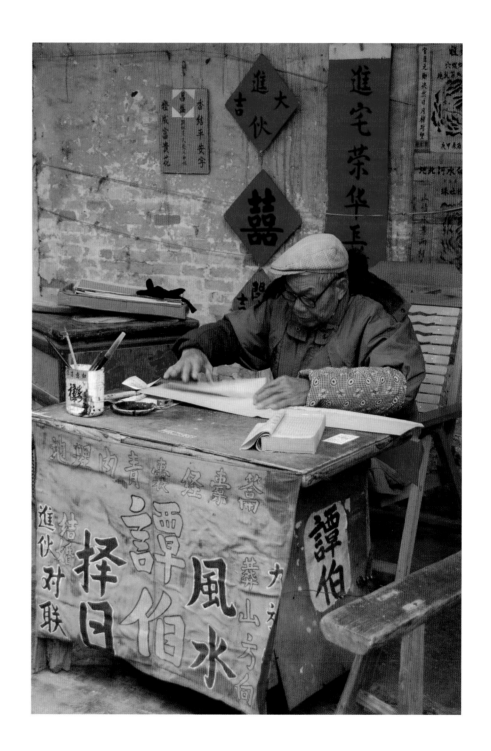

社群的文化財產，如舞蹈、戲劇、音樂、視覺藝術、工藝等等，千百年來在一個實質的環境內創造及演變，自然受這個環境的影響和提升。文化資源要成為社群永久的經濟財產，這實質的環境…必須保存。否則，不但實質的建築物有危險，其他財產的素質、特性、區分和可持續性都一樣會處境不妙。

the receptive

k'un

PUAY-PENG HO
何培斌

生

活

living environments
shenghuohuanjing

環

境

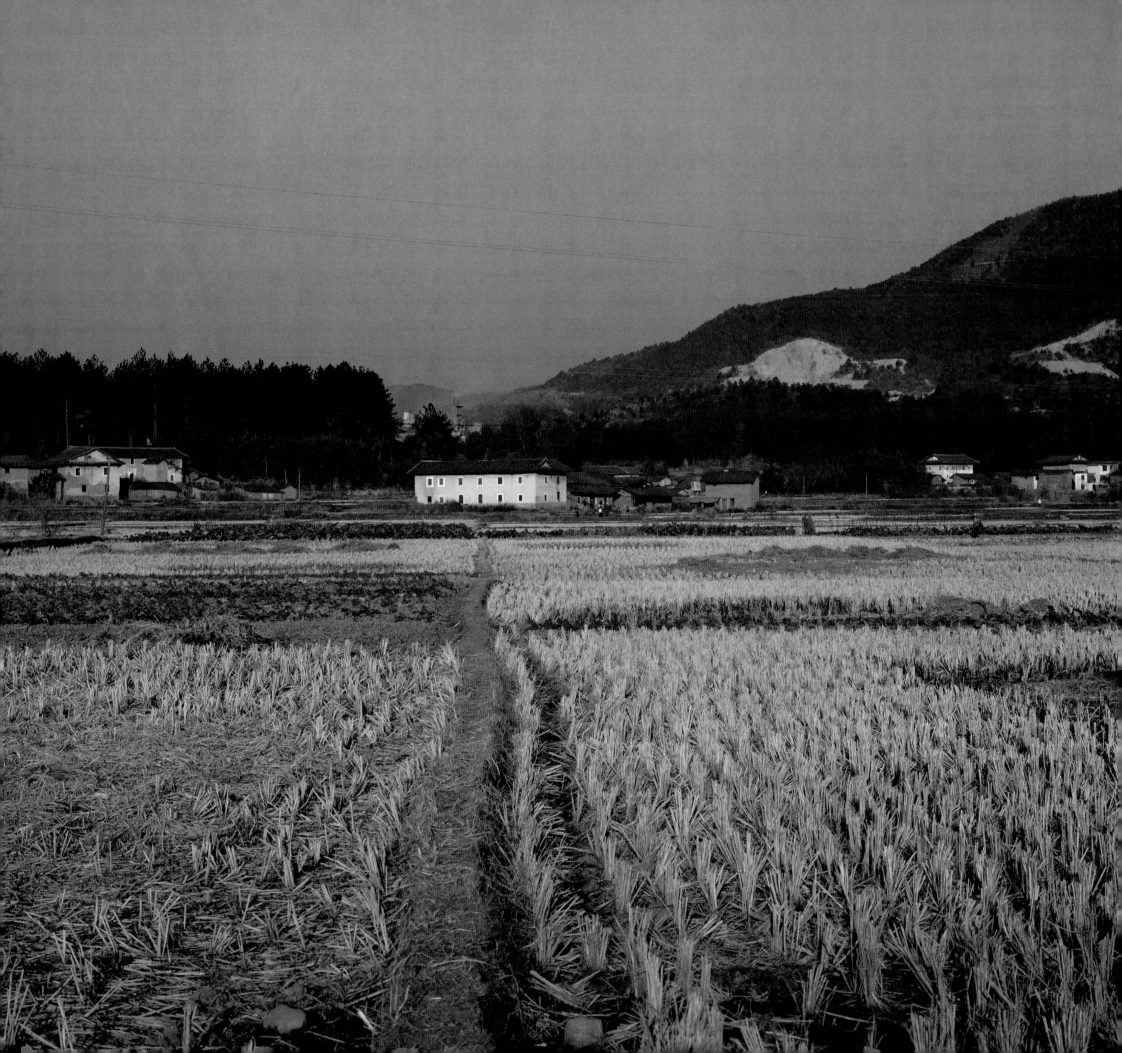

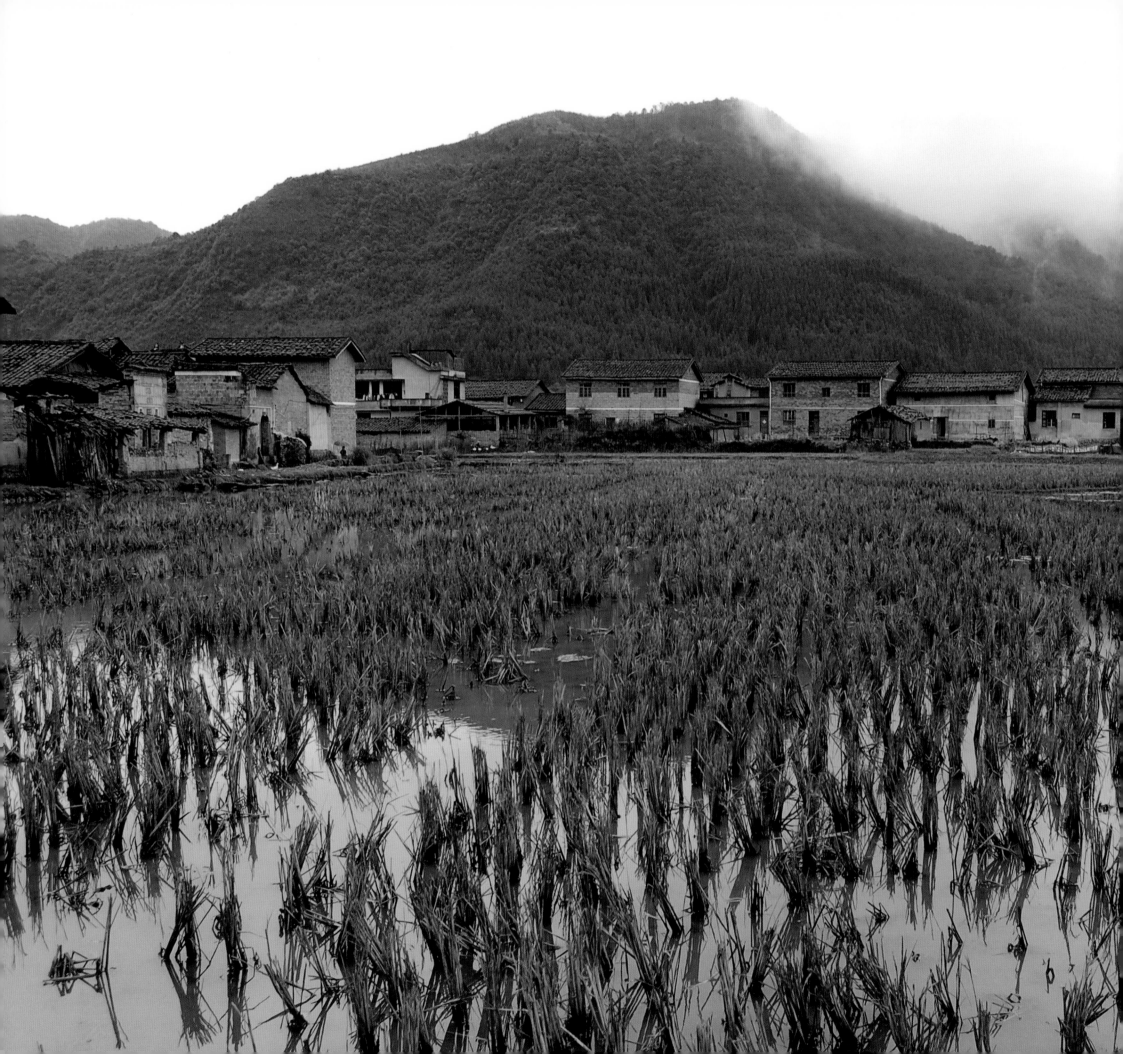

In conservation practice merely preserving a building is not enough. The most important aspect in the preservation of heritage buildings is in maintaining their connection with the past, with nature, and with the people living in them.

文物保護單單保存一座建築物並不足夠。保存文物建築最重要的是保留房子與過去，與自然，以及與生活其中的人的連繫。

In cities and villages throughout China it is the saddest sight when one sees heritage buildings being left vacant and in total disrepair. Much can be done to rehabilitate these traditional structures for modern use while retaining their character.

在中國的城市和農村，最令人難受的是目睹文物建築荒廢失修。要修復這些傳統建築物，作現代用途而不損其特色，可以做的事情有很多。

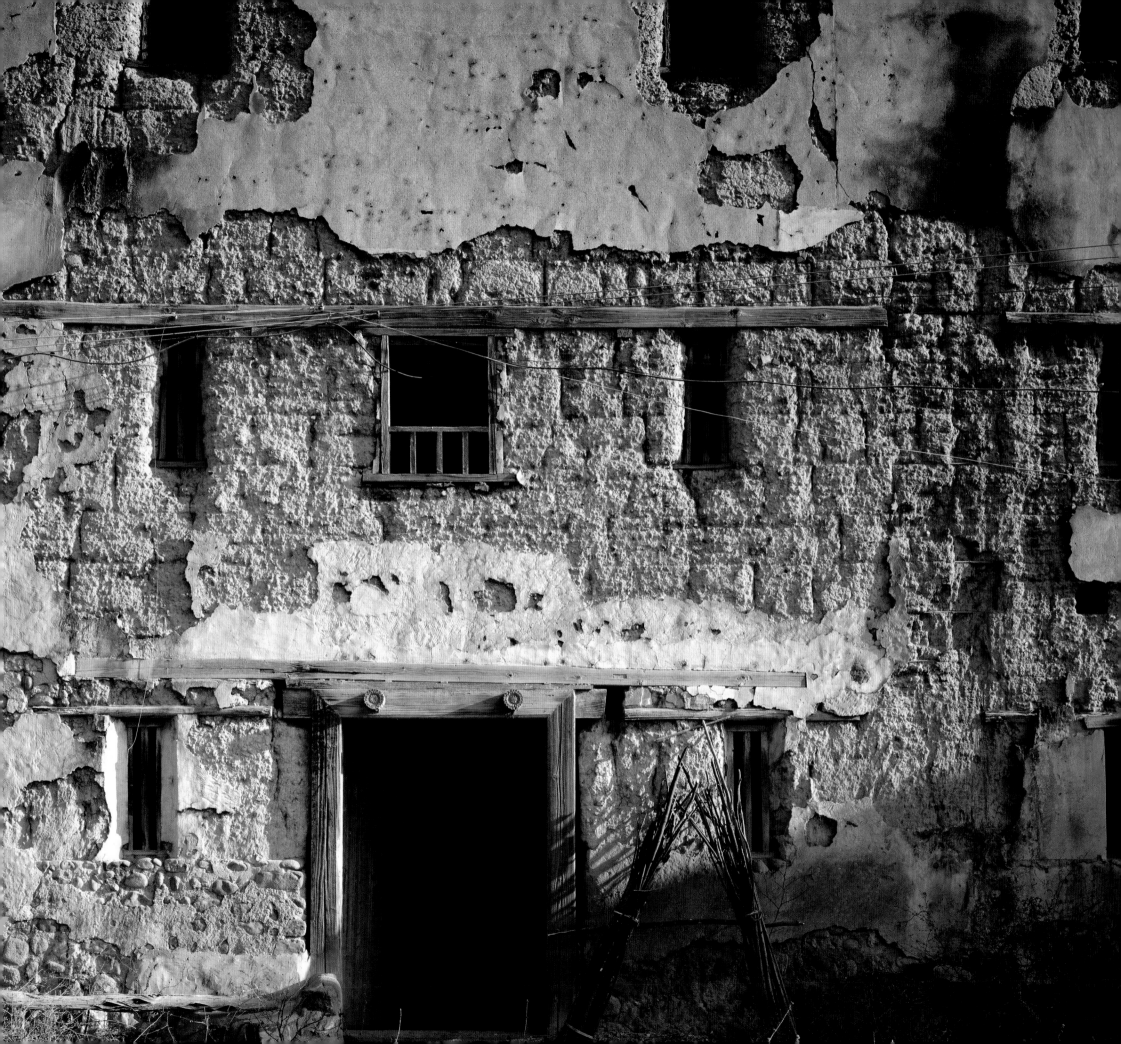

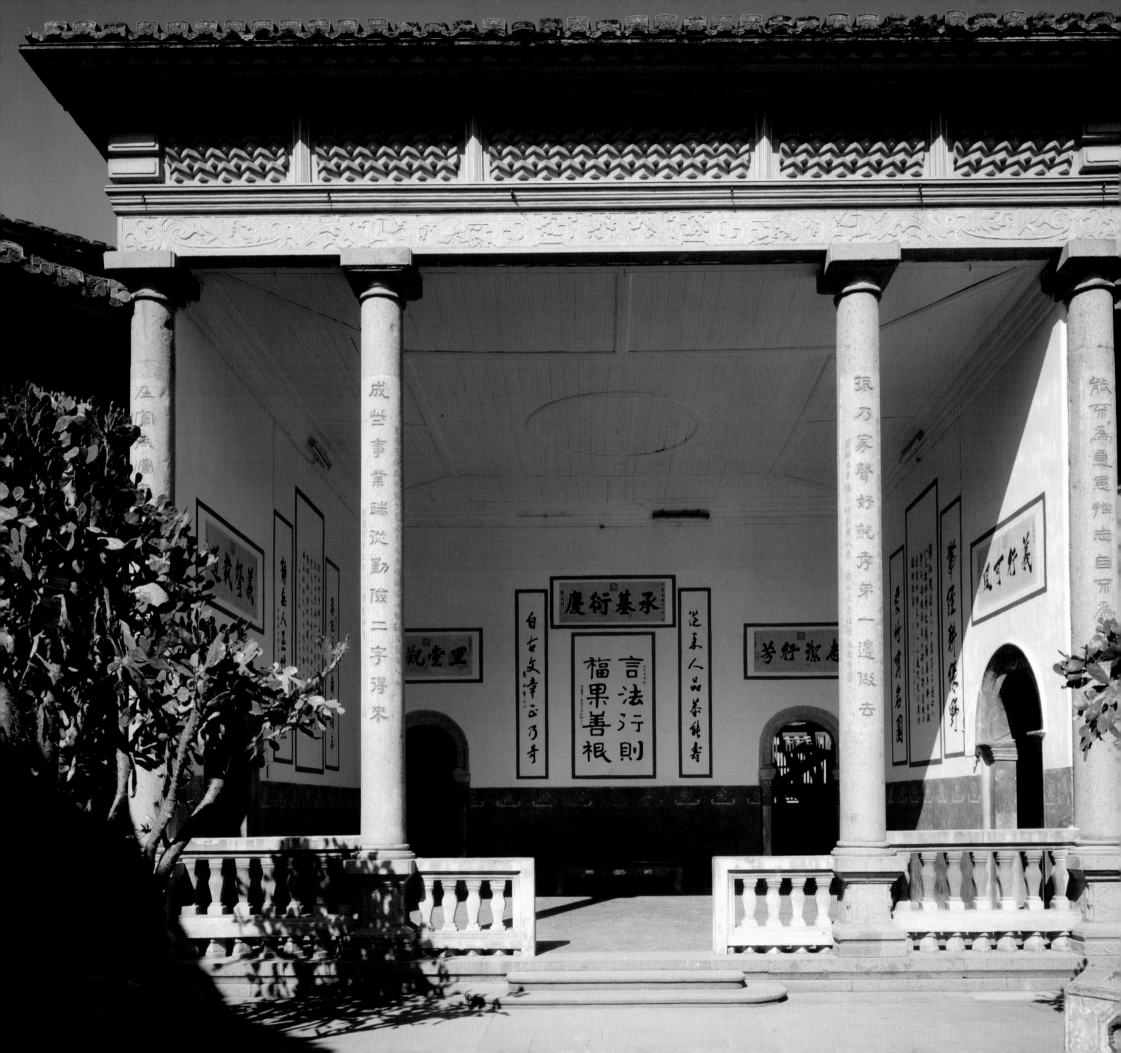

These buildings are steeped in history. Embedded in the building fabric, this historical record provides an essential element of Chinese cultural heritage, enabling the buildings and the environments that surround them to be meaningful to people visiting them today. Even more importantly, the people who inhabit and use the buildings give the architecture meaning as a living environment.

這些房子都歷史悠久，是深植於建築結構的歷史紀錄，組成中國文化遺產的一個重要部份，圍繞四周的建築物和環境，亦因此對今天來訪的人饒有意義。尤有甚者，住在房子裡及使用房子的人令建築物成為一個生活環境，從而賦其予意義。

Villages throughout China are traditionally located in carefully selected locales that reflect a deep respect for the land. Regrettably this connection with the land is often lost through modern development and overbuilding. Our ability to appreciate and truly preserve the unique qualities of heritage buildings would be seriously marred if this connection with the land is severed.

中國各地的農村傳統上座落小心挑選的地點，反映出對土地的虔敬。可惜這種與土地的連繫，往往隨着現代發展和過度興建而消失。與土地的連繫要是被切斷了，我們欣賞和忠實保存文物建築特質的能力，也將會受到嚴重的窒礙。

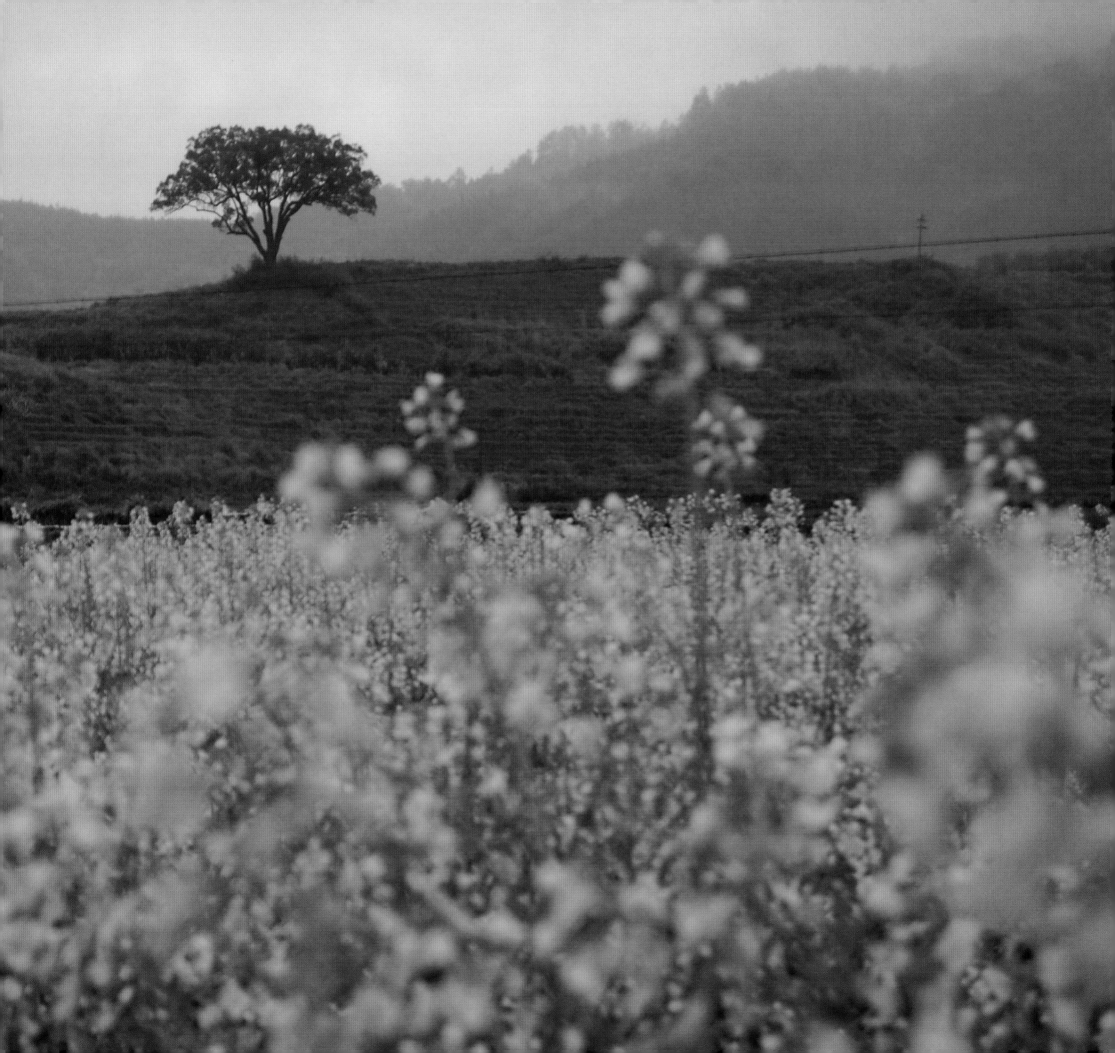

THE ROCKEFELLER BROTHERS FUND

洛克菲勒兄弟基金會

human advancement

renleijinbu

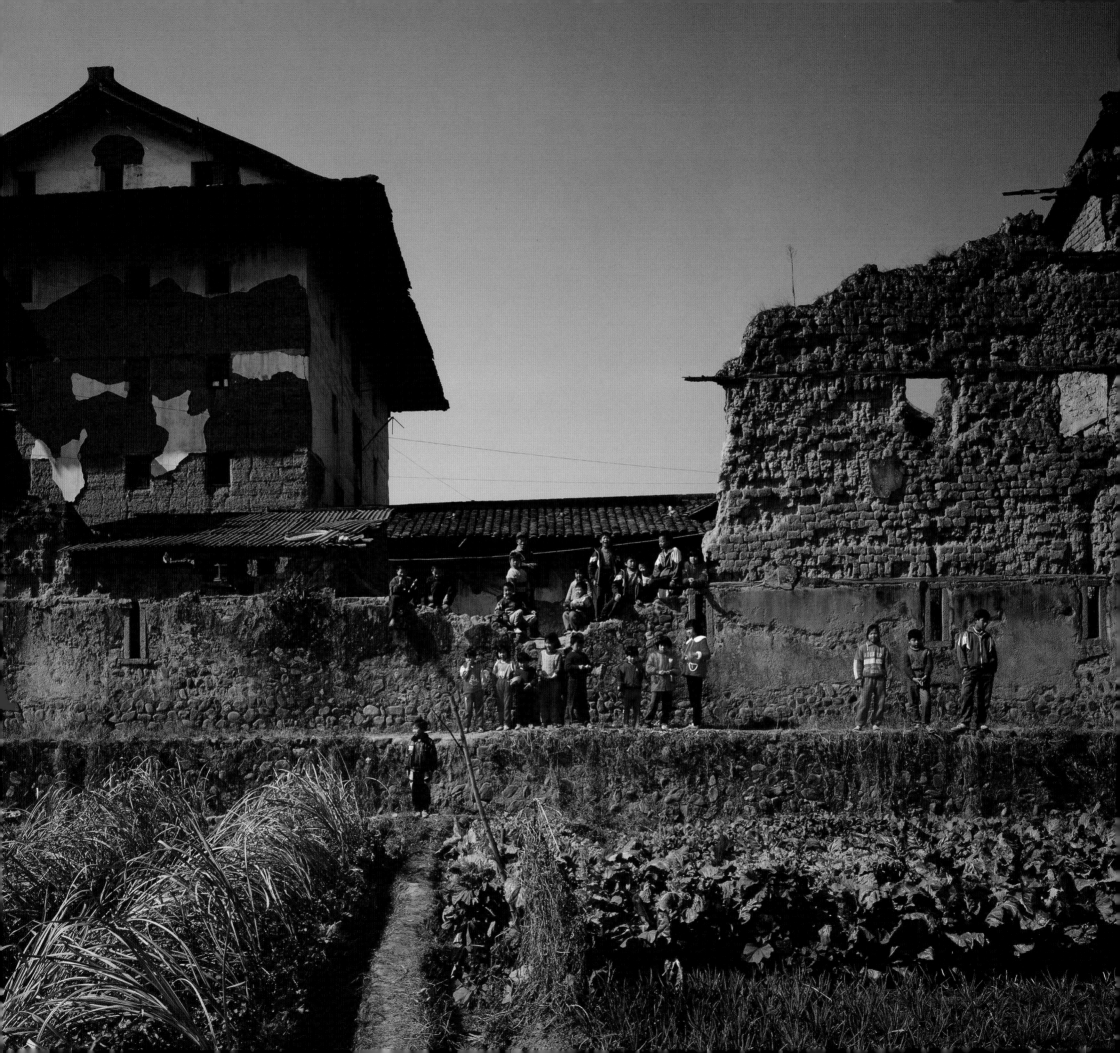

China has experienced extraordinary progress over the last twenty-five years, progress which includes, among many achievements, the elevation of over four hundred million people out of extreme poverty and the growth of China's economy into the fourth largest in the world.

中國在過去二十五年突飛猛進，進步的除多項成就外，還有令四億人民脫貧，以及把中國經濟發展成全球第四大的體系。

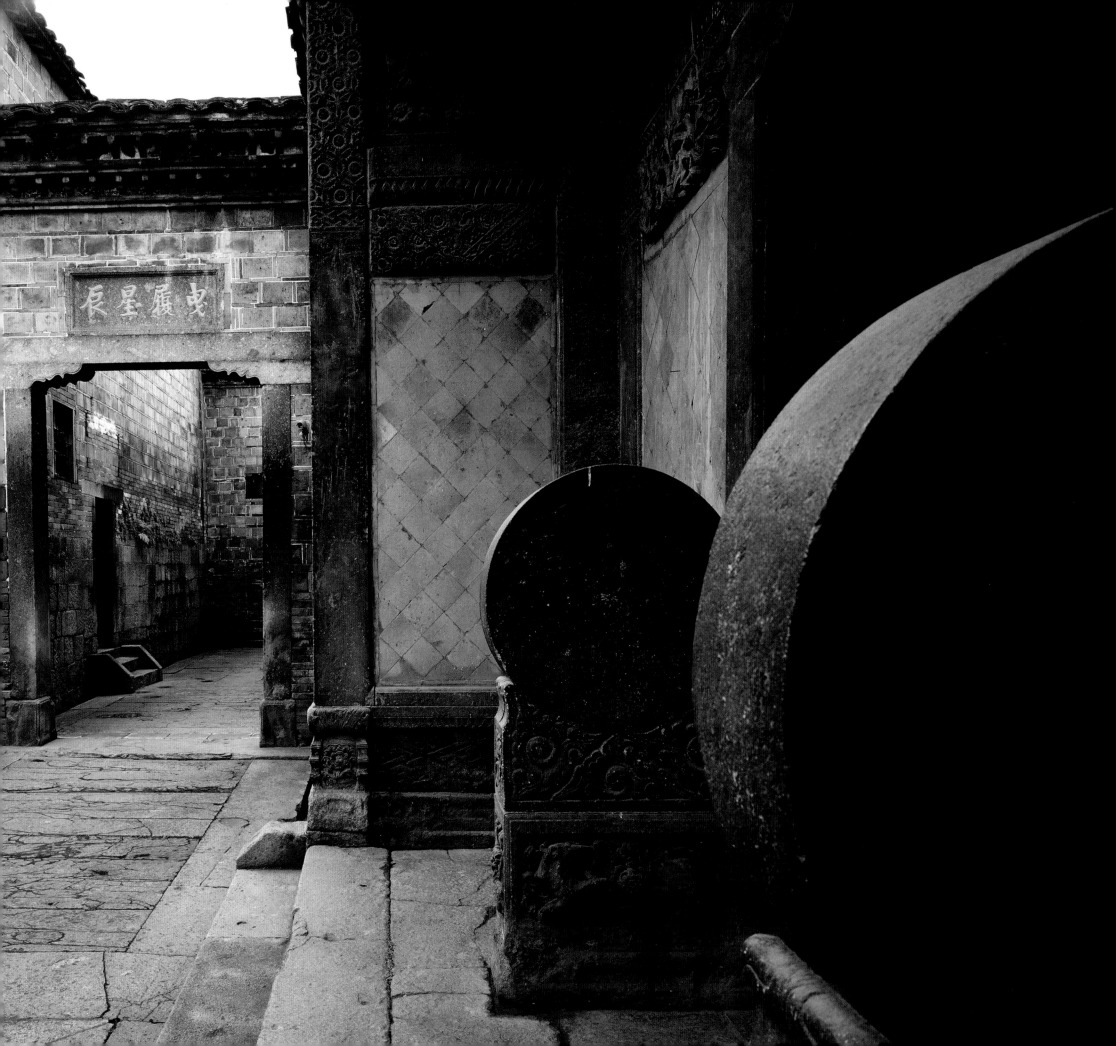

China's rapid development, however, has been accompanied by profound challenges, including environmental degradation and growing disparities between rich and poor, urban and rural, which, if not addressed, threaten the sustainability of development in the region, the country, and the world.

不過，伴隨中國　南部急速發展的是巨大挑戰，包括環境受破壞及污染、貧富懸殊和城鄉差距愈來愈大，這些問題如不處理，地區、國家和全世界發展的可持續性會大受影響。

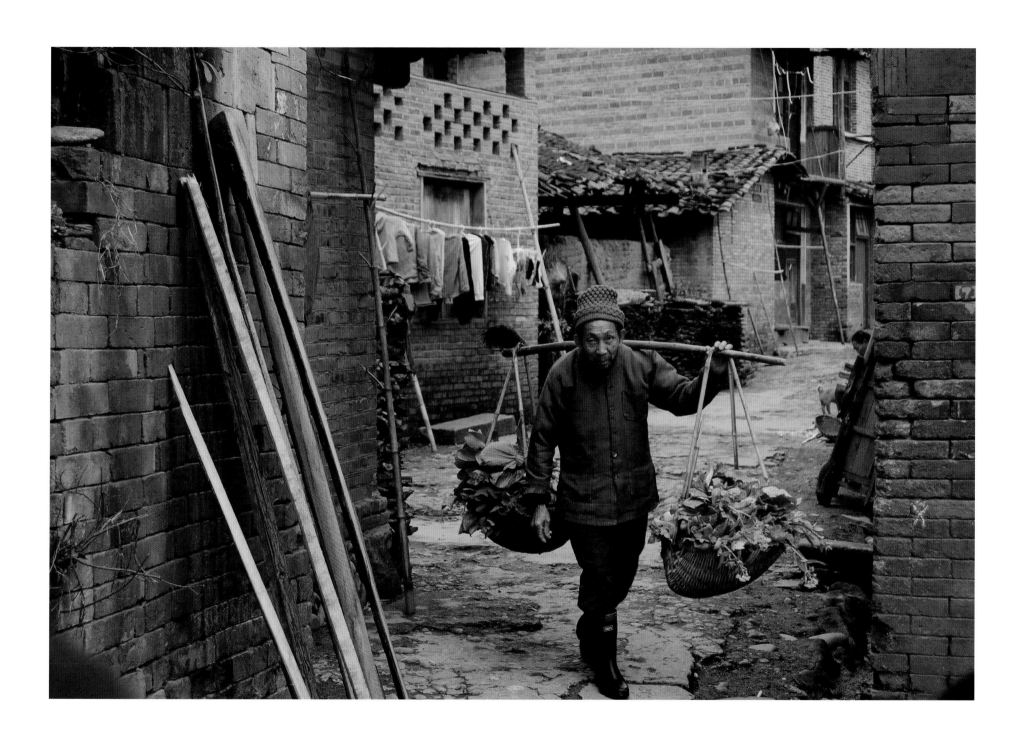

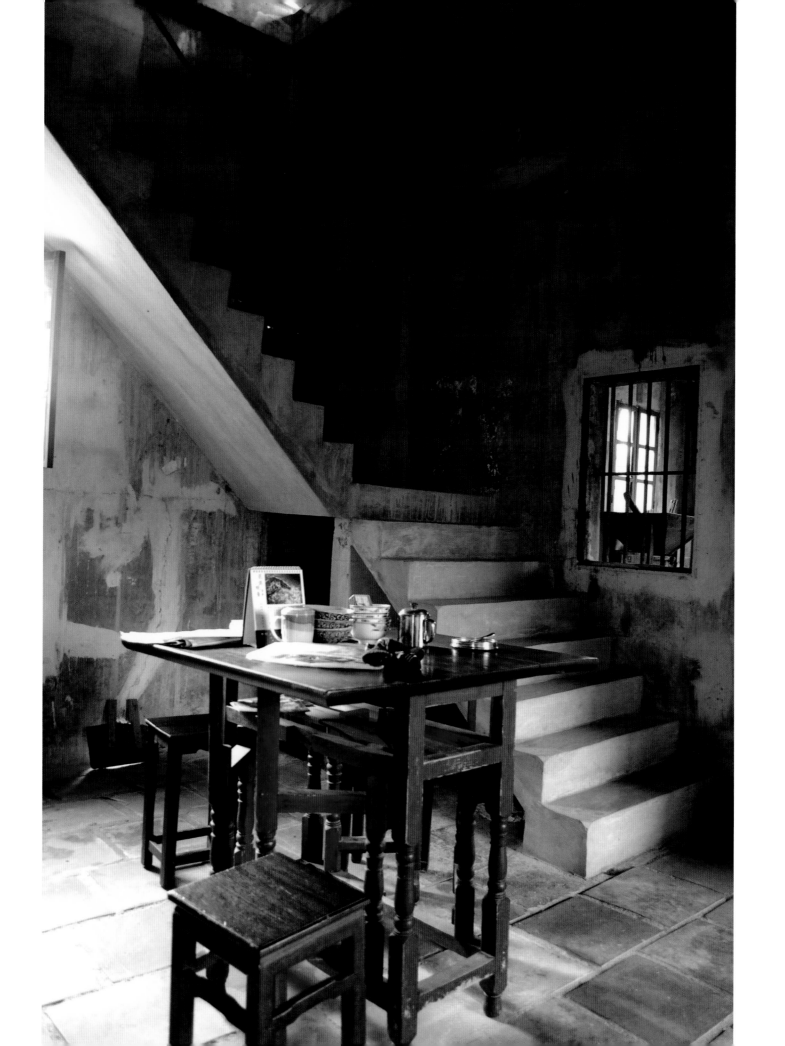

The Chinese government and people have been responding vigorously to these complex challenges. Central to the concerns for the future are the implementation of sustainable development and human advancement. Initiatives that actively engage communities in integrating traditional wisdom and culture with development goals will be essential to the success of these efforts.

中國政府和人民一直以充沛的精力應付這些複雜挑戰。對未來的關注則以貫徹可持續發展和人類進步為中心。成功與否，關鍵在積極鼓勵社群參與，把傳統智慧及文化與發展目標結合。

before completion

wei chi

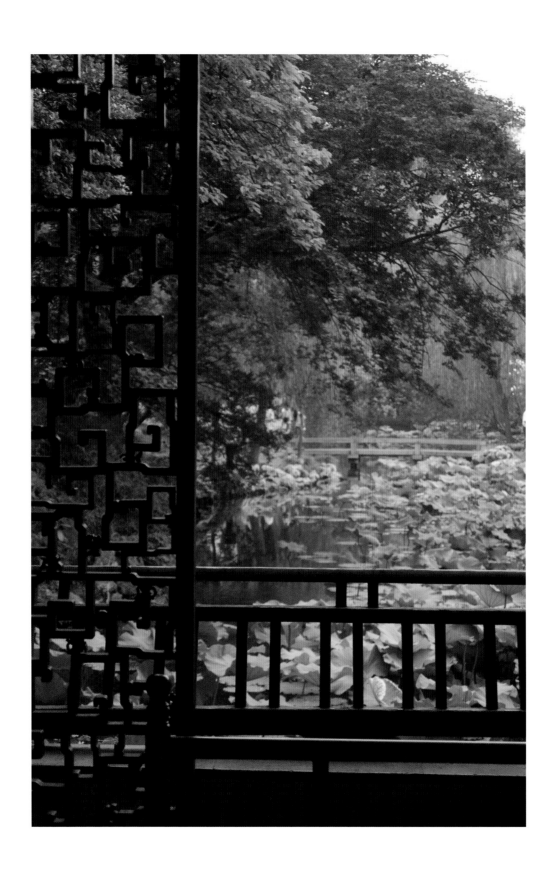

biyu ji hanyi

meaning and metaphor 比喻及含義

CHAN YUEN-LAI, WINNIE

陳婉麗

Traditional Chinese garden design is a very volatile thing that adheres not so much to form but rather to meaning. It is sometimes referred to as the fourth element besides the "three perfections" of poetry, calligraphy, and painting in Chinese art. A diversity of approaches to garden layout bridges the orthodox based on imitation of the past to a more interpretive and direct observation of nature. What is important in either case is the preservation of the total setting of the garden. It is in its totality that Chinese design is imbued with meaning and metaphor.

傳統中國庭院設計變化無限，注重意境多於執著形態，有時被視為中國藝術裡詩書畫三絕以外的第四元素。庭院佈局以多種多樣的手法，把以模仿過去為基礎的傳統和對自然比較抽象及直接的觀察連接起來。兩者最重要的都是要保存庭院的整體環境。中式設計的以全局為重有其豐富的比喻及含義。

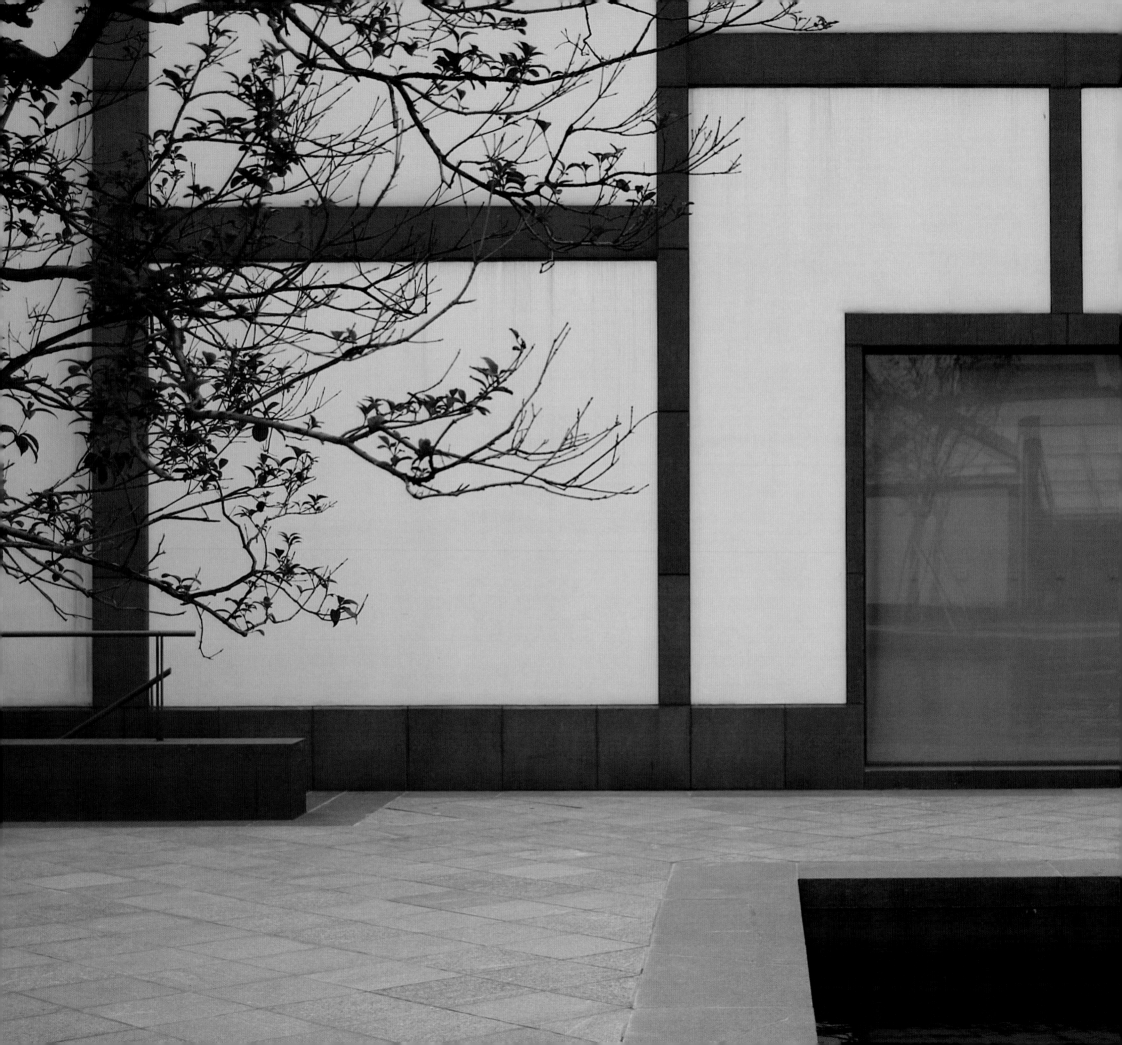

epilogue
THE COMMON GOOD

I. M. Pei

When we speak of culture and cultural memory, I feel that we can only activate that knowledge when we interact with the world within which we live and have experience. With architectural practice this could be the role that context plays when we talk about finding the right solution for any given design challenge. The deep insights that may exist within the human spirit about cultural heritage are only made evident when sparked by direct experience and observation. This applies to any place and time.

I left China when I was seventeen and do not claim to know the country well. My higher education and career have been in the West, and although I have strong memories of China from my childhood, I do not feel that I speak as an authority on all things Chinese.

When I observe the realities of China in this accelerated age of great transformation, I believe that, like anywhere else, there is never one answer and one solution that can be applied universally. China is a vast and diversified country, in both physical topography and ethnic identity. Therefore, you cannot generalize about what should be done to set the nation on the path of sustainable growth and development. It is a reality that much has been lost of the actual historic landscape. Yet it must be recognized that the way of life in China changed radically over the last century and continues in this transformation today. The brick and mortar may remain, but the way of life has changed. The best that can be done now is to save some of what is left of that former time. From my perspective I would say that it is not enough to save a single building. What is essential is to preserve areas that encompass a broader context of habitat, lifestyle, and relationship to nature. For preservation to be meaningful, what is saved must be coherent, allowing it to continue to exist as a living organism.

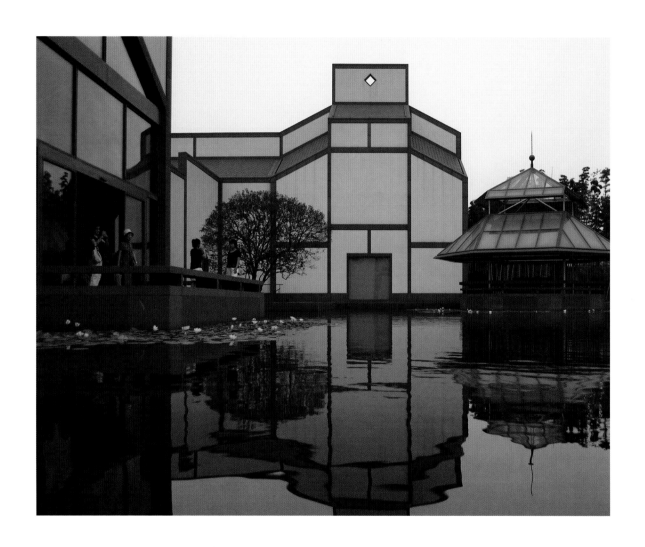

I was recently honored to be asked to return to my ancestral home of Suzhou to design a museum. Suzhou is a unique place that is considered a national treasure. The museum was to be built in the context of the many classical gardens of this ancient town, once home to the literati of the classical dynastic period. To find the appropriate design for this project, I felt strongly that I should use as inspiration the elements of lifestyle, nature, and history that are of such high importance to the Chinese. Water, trees, and rocks were my building blocks, just as they once were for the renowned gardens of Suzhou. This project was indeed a collaborative effort that aspired to achieve a successful cultural transformation. In this effort, to bridge the vernacular language of the past with new architecture, respect for the classical foundations of China's great art and culture was paramount.

We cannot impose our values or our solutions on China, yet as a global society many people from around the world are now actors there. In architecture, as with all types of projects of mutual interest, to appeal to what is most important to your partners is the only way in which one will achieve successful collaboration. The Chinese are especially proud of their cultural heritage, and it will be on this foundation that their continually evolving cultural narrative will stand. Were the world to come respectfully to China with this understanding, the Chinese would be inspired to place even greater value on their rich legacy.

I am hopeful for the future of China.

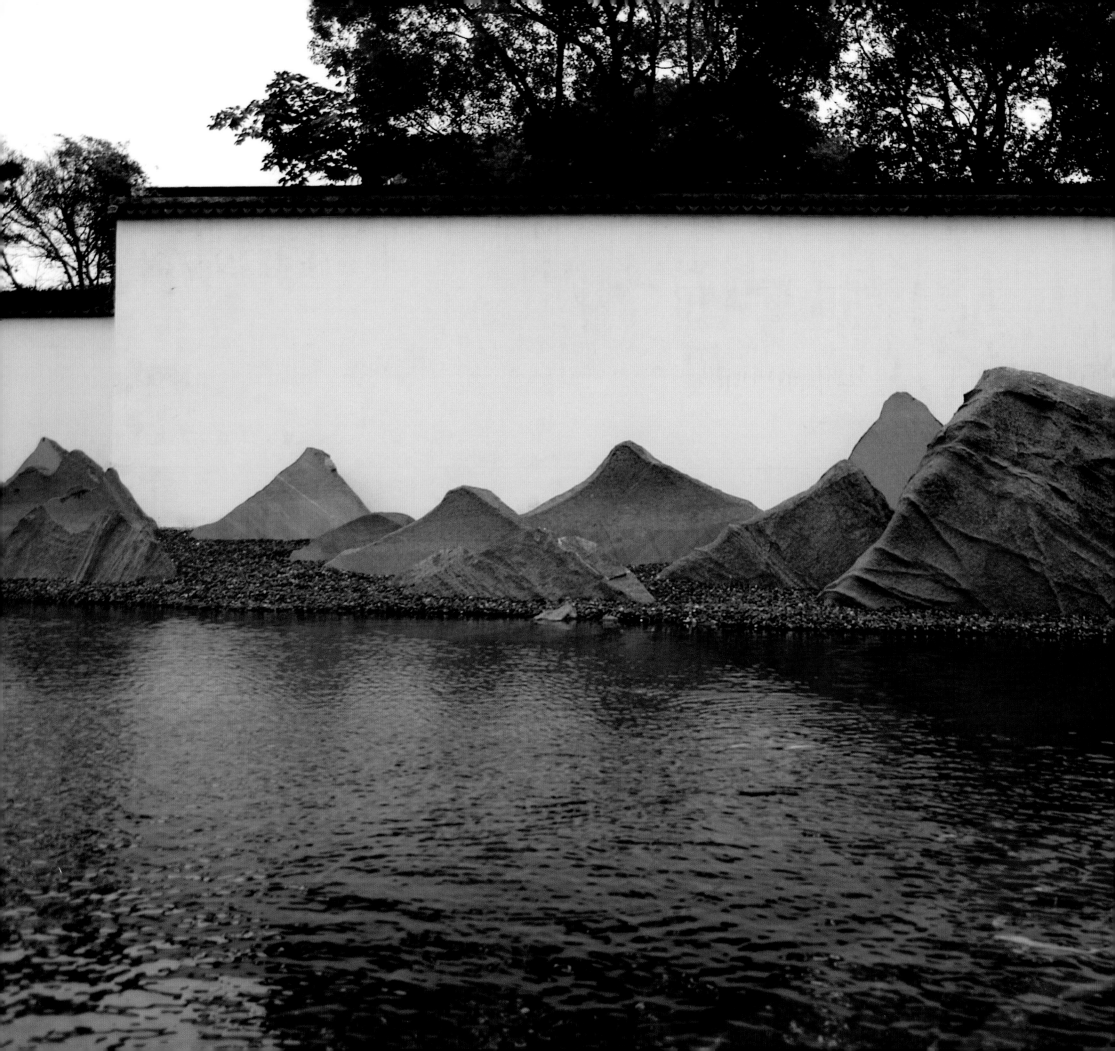

跋
共善共益

貝聿銘

我們談文化和文化記憶的時候，我覺得首先要和我們在其中生活及體驗的世界溝通，才可以活化那些知識。這正如我們研究解決建築設計的問題時，應該從整個設計的背景脈絡上著手一樣。人類在心靈上對文化遺產可能有很深的領悟，但只有親身體驗和觀察才可以拼出火花。這在任何地方和時間都適用。

我十七歲離開中國，不敢說很了解這個國家。我在西方上大學和發展事業，雖然我在中國的童年歲月仍歷歷在目，但我不覺得自己是談中國事物的權威。

我觀察中國在這個急速大變革時代的現狀時，深覺天下間並沒有一個普世適用的答案和解決辦法。中國幅員遼闊，民族眾多，如何令國家走上可持續增長及發展的道路，實在很難一概而論。歷史景觀已面目全非，這是既成事實。但須知中國人的生活方式在過去百多年來改變得很厲害，到了今天仍然在變。磚瓦木石可以依舊，生活方式卻已大不相同。現在可以做的，至多是把從前留下來的一些東西好好保存。以我的看法，單保存一座建築物並不夠。重要的是保存那些環境更豐富的整個地區，其中包含的是廣闊的生態、生活方式和與自然的聯繫。文物保存要有意義，被保存的東西便必須完整連貫，俾其可以作為活的有機體生存下去。

最近我很榮幸獲得邀請，回到故鄉蘇州設計一座博物館。蘇州是一個被視為國寶的獨特地方。這個古城歷代文人輩出，典雅園林甚多，博物館就選址在這樣的環境之中。要恰如其份地設計這座博物館，我深切體會到必須從中國人非常重視的生活方式、自然和歷史中吸取靈感。水、樹和石是我的設計元素，與著名的蘇州園林從前所用者並無分別。這項目的確是一次達致文化成功轉型的協作。在這一次的努力裡，要把過去的民間語言和新建築結合，首要的是尊重中國偉大的藝術和文化的傳統基礎。我們不可以把自己的價值觀和解決辦法強加諸中國，可是社會已全球一體，從世界各地而來的人現在都在那裡參與工作了。建築和所有關乎相互利益的項目一樣，成功合作的唯一方法是在夥伴至感重要的地方上打動他們。中國人特別以他們的文化遺產而自豪，他們不斷演變的文化敘述亦以此為基礎。如果世人能夠在這個理解之下尊重中國，中國人也會受到鼓舞去更重視他們豐富的遺產。

我對中國的前途抱有希望。

gathering together

ts'ui

ACKNOWLEDGMENTS

PUAY-PENG HO
Foremost among many to whom I owe much for the realization of this body of work is Puay-Peng Ho, my mentor and host on my travels in China. Since 1992 Dr. Ho has been leading annual research trips to remote areas of rural southeastern China. In recent years he has concentrated his research on the fluidity of aesthetic migration patterns in Fujian, Zhejiang, Jiangxi, and Guangdong provinces. Taking upward of forty students and faculty from the Chinese University of Hong Kong's Department of Architecture, he has made an invaluable contribution to preserving a record of a fast-changing—and, in many cases, disappearing—cultural landscape and way of life. The detailed documentation that he and his students have created provides an archive and historical record of numerous indigenous cultural environments, classical villages, courtyard houses, and the decorative art and craft that grace so many of these structures.

THE CHINESE UNIVERSITY OF HONG KONG
At the invitation of Dr. Ho, I went on my first field trip in 1995 and over the next decade continued my trips with him in the capacity of visiting artist in the department. These expeditions have provided access to worlds I would never have been able to see on my own, making my photographic documentary on this subject possible. I feel that my experiences have been an exceptional privilege. My gratitude to Dr. Ho, Chung Chi College, and the Department of Architecture at the Chinese University of Hong Kong is inexpressible.

MY STUDENTS
I have formed many enduring friendships with my students over the last decade. They have enriched my life in immeasurable ways. As is often the case in the educational world, students teach teachers as much as the reverse. I feel in many ways that my personal growth as an artist, teacher, and photographer has been a gift from my Hong Kong students. Shooting with a large-format camera in remote locations is as much about carrying the equipment as it is about making photographs. And to my many students who acted as my *sherpas*, I must express a deep gratitude! Although naming one student is an injustice to all the rest, I hope I am forgiven, but I must thank Henry Lo, who, with his eternally positive attitude and professionalism, helped make these arduous trips seem effortless and joyful.

ASIAN CULTURAL COUNCIL (ACC)
An extended residency at the Chinese University of Hong Kong in 2005–6 was made possible through a grant from the Rockefeller Brothers Fund Asian Cultural Council, Hong Kong. I extend my appreciation to the Hong Kong architect Robert Shum, who is the benefactor of this annual grant, the Cypress Group Art Fellowship, which uniquely supports both art and architecture. For sponsorship of my exhibition at UMA G Gallery, Wanchai, I thank both Mr. Shum and Wallace Chang, the gallery's director, for making this work publicly available in Hong Kong. With special affection I thank Michelle Vosper and her staff at the ACC for their sincere interest and support of my residency, both on a professional and personal level. With humor and levity Michelle helped me navigate the challenges of my tenure, and I will forever cherish her friendship.

PETER H. Y. WONG
A photographic documentary is one thing, but bringing it to fruition as a book is something entirely different. To one person alone I owe the credit for having had both the vision and generosity that made this book a reality. A respected member of the Hong Kong business and cultural community, Peter Wong is a man of conviction who has long been committed to the values of heritage preservation and sustainable development. He has championed these initiatives throughout his long career in both the public and private sectors. As a leader, he has spoken out boldly to protect Chinese cultural identity. He has created invaluable networks of like-minded people who are in positions of influence and do what they can to hold back the tide of unthinking development. For Peter Wong's financial support I am indeed grateful, yet to an even greater degree I am in debt to him for his introduction of many of the contributors who have written for the book, and his own intellectual engagement in discussions on these issues, which led me to greater clarification and focus in framing the book's content. I hope that the product of our efforts will give back to him even a small return on the magnitude of the opportunity he has afforded me.

CONTRIBUTORS
An extensive collection of photographs can become many books, and in the case of this documentary, there are over two thousand images. The form that *Open Hearts Open Doors* takes, and the convictions it expresses, are the gift of the people who lent me their thoughts and their words. My good fortune is to have found many people concerned about the issues raised in this volume who were willing to share their reflections with me. I am as grateful to each of them as I am hopeful that our book may become a platform that empowers an awareness of the concerns they have so generously expressed herein.

DESIGN AND EDITORIAL TEAM
I thank my graphic designer, Jessica Yoon, a graduate of Art Center College of Design in Pasadena, for her intelligence, superb design skills, patience, and sense of humor. My editor, Greg Dobie, has been invaluable in bringing his exacting talents to the editing of this book. He raised the bar for me throughout the two years of production, and not only did I learn from him, I am humbled by his skill. I also thank my proofreaders: Michael Collum, Keya Keita, and Liu Xiaoguang. For the translation of the text I am thankful to Chor Koon-Fai, who did not merely change words from one language to another, but provided invaluable input on the nuances of my writing that I believe was possible only because of his sincere appreciation for the book's intent. Sandy Ding converted the traditional text into simplified Mandarin. For his meticulous work and technical help I am truly grateful.

OPEN HEARTS OPEN DOORS
And finally, when I have had time to reflect on this great adventure, I always return to my cherished memories of the Chinese people, who allowed me to photograph them, their homes, and their environment. Wonder is not lost on me when I realize I was given access to worlds otherwise inaccessible had it not been for the hospitable nature of the Chinese people. An open door is a hallmark of village life in China and became for me a metaphor for the hearts of its people, to whom I owe much.

鳴謝

何培斌

這本書得以面世，我第一位要致以衷心謝意的是何培斌，我的良師和招呼我到中國旅遊的東道主。自 1992年起，何博士每年都領隊到中國東南部的農村考察。他近年專注研究福建、浙江、江蘇和廣東省建築模式的轉移。考察隊有四十多位香港中文大學建築學系的學生和人員，為一個急速轉變—很多時候是消失—的文化面貌和生活方式保存紀錄，貢獻甚大。他和他的建築系學生所做的詳盡文獻資料和檔案，紀錄了無數鄉土文化環境、傳統村莊、四合院，以及和這些建築有關的裝飾藝術及手工藝。

香港中文大學

應何博士的邀請，我1995年踏上首次考察之旅，而其後十年間，我以學系客座藝術家的身份多次參與考察。這些遠征讓我接觸到以我個人能力無可能看得到的天地，我以此為主題的攝影紀錄亦得以實現。我覺得這些經驗是我莫大的榮幸。我對何博士、崇基學院和香港中文大學建築學系的感激，非筆墨所能形容。

我的學生

過去十年，我和很多學生結下不解之緣。他們大大充實了我的生命。教學相長，教育世界裡往往就是這樣。我作為藝術家、老師和攝影家的個人成長上，我的香港學生在很多方面都給我極大啟發。在偏僻的鄉野使用大幅照相機，攜帶器材和拍攝相片同樣是考驗。對多位做我嚮導和扶持我的學生，我必須致以萬分謝意！我不得不提一位學生，雖然這其他人不公平，但我懇請大家原諒，我要謝謝羅嘉裕，他永遠積極的態度和專業精神，令艱辛的旅程變得輕鬆愉快。

亞洲文化協會

我以特別的感情來謝謝亞洲協會的Michelle Vosper和她的同事，他們在公在私都真誠的開心和照顧我。Michelle的幽默感和舉重若輕助我度過了不少難關，我會永遠珍惜這段友誼。

黃匡源

攝影紀錄是一回事，輯之成書是完全不同的另外一個問題了。這本書全因一位人士的眼光和慷慨而得以成事，我萬分感激。黃匡源先生在香港的商界和文化界備受尊敬，多年來在公共和私人領域都不遺餘力，提倡保護文物和可持續發展的價值。他以在這方面的領導身份，無畏地公開呼籲保護中國的文化認同。他建立了非常寶貴的網絡，聯繫志同道合而居於有影響力地位的人士，盡力遏止輕率發展的狂瀾。對黃先生的資助我固然感激不盡，更令我感到無以為報的，是他對我的工作極有信心，還推薦了不少人士為本書撰稿，而他的不吝賜教，使我在構想本書內容時有更清晰的方向和重心。他給我一個極大的機會，我希望我們努力的成果怎樣也是一個小小的回報。

參與者

相片數量相當的話可以編很多書，以這一次的紀錄為例，我們有超過二千張圖像。《明心啟扉》的形式和所表達的信念，來自那些把想法告訴我和執筆撰文的人。我有幸找到眾多人士，都是關心本書所提問題的有心人，他們都樂意和我討論所思所想。我對他們每位都心存感激，希望我們這本書可以成為一個平台，喚起對大家在本書所熱切關注問題的覺醒。

設計隊伍

我要謝謝我的美術設計，帕薩迪納藝術中心設計學院畢業的Jessica Yoon。她聰明、天份高、設計技術超凡、有耐性和幽默感。本書每一頁都見到她的心思和才情。我也要謝謝我那幾位一絲不苟的校對高手：Michael Collum, Greg Dobie, Keya Keita, 劉曉光。文字翻譯我要謝謝左冠輝。他不單把一種文字轉換成另一種，還在我寫作上的微細處提出了寶貴意見，我相信因為他由衷欣賞本書的意義才做得到。本書的簡體字版由丁昕負責，把繁體字轉換為簡體。對他一絲不苟的工作和技術協助，我致以衷心謝意。

明心啟扉

最後，我每次回味這段了不起的經歷，總會想起容許我拍攝他們的中國人民，他們的家，他們的環境，都攝進了我的鏡頭。要不是中國人好客的本性，我根本不可能接觸到這些天地，我體會到的時候，仍是覺得不可思議。中國農村的特色是家家門戶長開，對我來說是比喻住在四壁以內者的心胸。我應向他們致以無盡的感激。

221

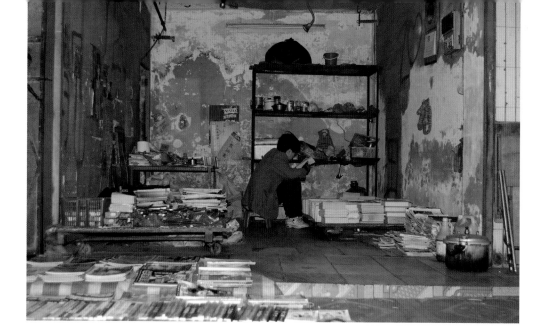

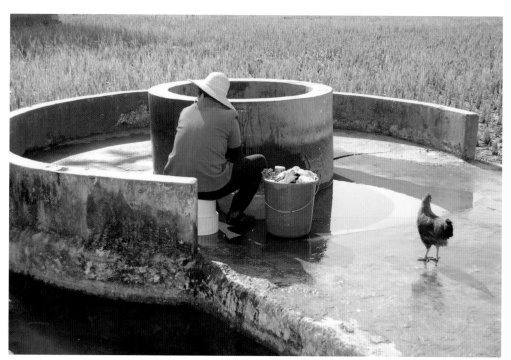

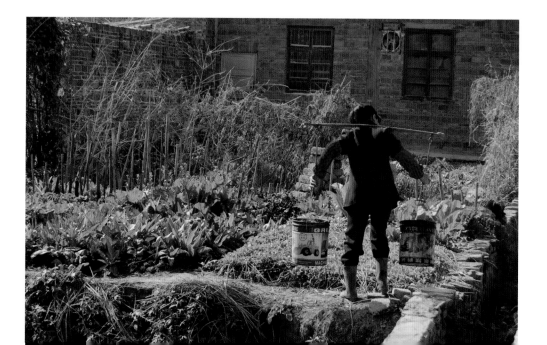

BIOGRAPHIES
人物小傳

ELIZABETH GILL LUI (born 1951) is an internationally recognized fine art photographer and educator. With a degree in comparative religion from Colorado College (Colorado Springs), she pursued graduate work in American Indian studies at the University of Denver and architectural photography at the Graduate School of Design at Harvard University (Cambridge, Massachusetts). She has been a visiting artist, lecturer, and juror at the schools of architecture at the Chinese University of Hong Kong, the University of Colorado at Denver, and the Southern California Institute of Architecture (Los Angeles), as well as at the United States Air Force Academy (Colorado Springs), the Illinois Mathematics and Science Academy (Aurora), and Phillips Exeter Academy (New Hampshire).

Lui's work in fine art photography has been recognized with grants from the Ford Foundation and the Graham Foundation for Advanced Studies in the Fine Arts, which supported the publication of her book *Closed Mondays* (Nazraeli Press, 1999), a photographic interpretation of twentieth-century art museums as architectural icons and cultural symbols. In 2004 she published *Building Diplomacy: The Architecture of American Embassies* (Cornell University Press), a photographic monograph shot in over fifty countries worldwide. With an extensive exhibition record, her most notable conceptual work is photographic collage investigating the bridge between human consciousness, spirituality, and scientific theory in physics and fractal geometry.

In 2005–6 Lui was the recipient of a Rockefeller Brothers Fund Asian Cultural Council Fellowship, which supported her as an artist-in-residence and visiting scholar at the Chinese University of Hong Kong's Department of Architecture and allowed her to expand her work on Chinese vernacular architecture in rural areas of southeastern China. Begun in 1995, this body of work took the artist to Hong Kong to accompany students on several trips to mainland China to record traditional environments in a fast-changing cultural landscape.

ELIZABETH GILL LUI （1951年出生）是國際知名的藝術攝影家和教育家。她畢業於科羅拉多學院（科羅拉多州斯普林斯），獲比較宗教學位，其後往丹佛大學深造，研究美洲印地安文化，以及往哈佛大學研究院修讀建築攝影。她曾在香港中文大學建築學系、丹佛的科羅拉多大學建築學院、南加州建築學院（洛杉磯），以及美國空軍學院（科羅拉多州斯普林普）、伊利諾斯數及科學學院（芝加哥）和菲利普斯．埃克塞特學院（新罕布什爾州埃克塞特）任客座藝術家、講師和評審員。

Lui的藝術攝影作品曾獲福特基金會和格雷姆藝術深造基金會資助，出版了*Closed Mondays* (Nazraeli Press, 1999)，以攝影闡釋博物館在二十世紀如何作為建築學偶像和文化象徵。2004年出版的 *Building Diplomacy: The Architecture of American Embassies* (Cornell University Press) 則是專題攝影集，在全球五十多個國家取景。Lui曾舉行多個攝影展覽，她最為人樂道的概念作品，是以攝影拼湊探討人的意識、靈性和物理學及分形幾何的科學理論這兩者之間的聯繫。

2005至06年，Lui獲洛克菲勒兄弟基金亞洲文化協會獎學金，資助她到香港中文大學建築學系出任駐校藝術家及訪問學人，她得以擴大在中國東南部農村對民間建築的研究。這項始於1995年的工作把藝術家帶到香港，幾次與學生一起到中國大陸旅行，在快速轉變中的文化面貌裡，把傳統環境紀錄下來。

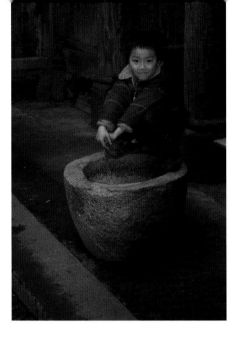

CHAN YUEN-LAI, WINNIE, received her MA in philosophy and MA in architecture from the Chinese University of Hong Kong (CUHK). She will pursue her PhD in Chinese studies at Oxford University's Oriental Institute beginning in 2008. Her ongoing research has focused on traditions in Chinese garden design in the early Qing dynasty. She has provided research and support services to the Chinese Architectural Heritage Unit at CUHK since 2004.

CHOR KOON-FAI is a freelance translator in Hong Kong. He was on staff at the Chinese University of Hong Kong (CUHK) from 1986 to 2007, where he served as editor and executive officer at Shaw College, with responsibility for publications; was founding editor of *Shaw Link*, the college newsletter; and was editor and writer for the CUHK Information Services Office. He has provided translation services for *Reader's Digest* (Chinese edition,1980–present), *Literary Portraits of China* (Shell Oil Company, 1994), *Over Hong Kong* (1988), and *Open Hearts Open Doors: Reflections on China's Past & Future* (2008).

JEFFREY CODY earned his MA in historic preservation at Cornell University in 1985, followed by a PhD in 1989, his research focused on the American architect Henry Murphy, who worked in China in the early twentieth century. Cody has served on the faculties of Cornell and the Chinese University of Hong Kong. He is a noted expert and published author on Chinese architectural history and urbanism. His works include *Exporting American Architecture 1870–2000* (2003). He joined the Getty Conservation Institute's Education Department in 2004, holding the position of senior project specialist.

MARTHA DEMAS received her MA in classics at Duquesne University (Pittsburgh) and PhD in archaeology from the University of Cincinnati, specializing in Aegean archaeology of the Late Bronze Age, with extensive fieldwork in Cyprus. She later received an MA from Cornell University in historic preservation planning. She joined the Getty Conservation Institute in 1990 and currently holds the position of senior project specialist. Since 1997 she has served as comanager for the China Principles project, aimed at developing professional guidelines for conservation practice in China. Her other international project work and publications have focused on conservation and management of archaeological sites.

ENRICO D'ERRICO received his Dottore in Archirenura from the Università degli Studi di Firenze (Florence) in 1970. He is a practicing architect living in Pistoia, Italy, and an internationally renowned restorer and conservator of antiquities, with extensive projects in Iran, Egypt, and Oman. He has provided consultative services to UNESCO throughout the Middle and Near East. Among his major works are an extended survey of Omani historic buildings and the restoration of several forts in the Omani capital of Muscat. He has been a frequent participant and lecturer at international symposia on heritage preservation and historic restoration practices, most recently at the international symposium "Archaeology of the Arabian Peninsula through the Ages" in Muscat and the seminar on Omani heritage and culture, held in Paris, sponsored by the government of Oman and UNESCO. In 1974 he received the Ordine al Merito della Repubblica Italiana with the title of Cavaliere al Merito from the Italian government.

ANGUS FORSYTH is a practicing solicitor and founding partner with the Hong Kong firm Stevenson, Wong & Co. He has served as adviser in the legal, accounting, and arts communities of Hong Kong, for such organizations as the Hong Kong Arts Festival, Friends of the Hong Kong Museum of Art, and Friends of the Art Gallery, the Chinese University of Hong Kong. He serves as trustee of the Hong Kong Arts Festival Trust and the Association of the Friends of the Shanxi History Museum Trust. He is a published author on Chinese jades and the chairman of China Heritage Arts Foundation Limited, the conserver of Ming dynasty buildings in the Huizhou area, Anhui Province, China.

THE GETTY CONSERVATION INSTITUTE (GCI), a part of the J. Paul Getty Trust, began operation in 1985. The GCI works internationally to advance the field of conservation through scientific research, field projects, education and training, and the dissemination of information in various media. In its programs, the GCI focuses on the creation and delivery of knowledge that will benefit the professionals and organizations responsible for the conservation of the visual arts. Advancing conservation practice is the organizing principle for all of the GCI's work—which includes identifying activities that improve the way conservation treatments are carried out, pursuing research that expands conservation knowledge, and increasing access to information on conservation subjects.

HE SUZHONG is founder and chairman of the board of the Beijing Cultural Heritage Protection Center (CHP), an environmental rights organization aimed at building awareness of the importance of cultural heritage in Beijing and throughout China. To date this is the only registered non-governmental organization in the field of cultural heritage protection in mainland China. He also serves as the director of the Division of Legislation and Policy, National Administration of Cultural Heritage, Beijing, and is the recipient of awards from the government of the People's Republic of China and the Archaeological Institute of America.

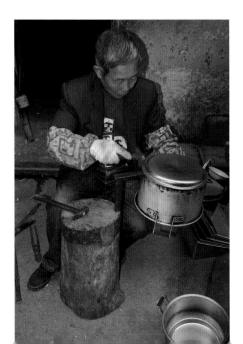

PUAY-PENG HO is currently dean of students, chairman, and professor, Department of Architecture, and honorary professor of fine arts at the Chinese University of Hong Kong (CUHK). He received architectural training at the University of Edinburgh and practiced in both the United Kingdom and Singapore. He received a PhD in Chinese art and architecture from the School of Oriental and African Studies, University of London. His research interests include Chinese architectural history, vernacular architecture, Buddhist art, architectural theory, and architectural conservation. His publications include books on Chinese vernacular architecture, conservation reports, and many papers in the area of Chinese art and architecture. He is founder and director of the CUHK Department of Architecture's Chinese Architectural Heritage Unit, a group of graduate students engaged in a wide range of heritage and preservation initiatives and archival documentation of heritage sites throughout Hong Kong and mainland China.

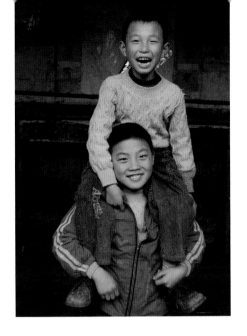

陳婉麗　為香港中文大學哲學碩士和建築學碩士，並將於2008年往牛津大學東方學院修讀中國研究的博士學位。陳氏現時的研究以清初中國庭院設計傳統為主，且自　2004年起即為中文大學的歷史建築研究組提供研究及支援服務。

左冠輝　是香港的自由翻譯員及作家，1980至86年在中文版《讀者文摘》編輯部工作，1989至2003年任香港中文大學逸夫書院事務助理及編輯，2005至07年5月為中文大學資訊處編輯／撰稿員，是逸夫書院通訊《逸林》創刊編輯，其後任榮譽編輯。左氏近年曾為《讀者文摘》翻譯文稿，其他譯作有《飛越香港》（1988）、《中華文影錄》（1994），以及《明心啟扉─鏡看中國的過去與未來》（2008）。

JEFFREY CODY 於1985年獲康奈爾大學史蹟保存碩士學位，並後於1989年獲博士學位，其研究以二十世紀初在中國工作的美國建築師Henry　Murphy為主。Cody曾任教康奈爾大學和香港中文大學。他是著名中國建築史和都市化專家及作家，著作有Exporting American Architecture 1870–2000 (2003)。他於2004年加入蓋提文物保護中心的教育部，擔任高級項目專家一職。

MARTHA DEMAS 獲迪尤肯大學（匹茲堡）古希臘與古羅馬文化研究碩士學位，以及辛辛納提大學的考古學博士學位，專長希臘青銅器時代晚期考古，在塞浦路斯有極豐富的實地研究考察經驗。她其後在康奈爾大學攻讀史蹟保存規劃，獲碩士學位。她於1990年加入蓋提文物保護中心，現為高級項目專家。自1997年起，她出任中國文物保護準則計劃的聯合經理，致力在中國發展一套文物保護工作的專業指引。她的國際工作項目和著作以考古遺址的保護及管理為主。

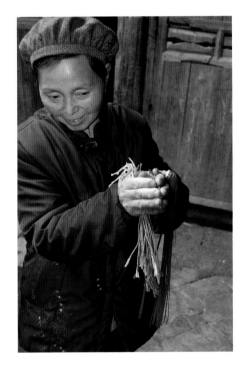

ENRICO D'ERRICO 於1970年獲佛羅倫斯大學建築學士學位，現居意大利皮斯托亞，為執業建築師，是國際知名的古蹟修復及保護專家，參與的計劃遍及伊朗、埃及和阿曼，並為聯合國教科文組織提供整個中東和近東的顧問服務。他的大型計劃有多個，其中一個是詳盡調查了阿曼的歷史建築，以及修復阿曼首都馬斯喀特的幾個城堡。他經常出席有關文物保存和古蹟修復工作的國際研討會，並發表演講，最近參加的有在馬斯喀特舉行的「歷年來的阿拉伯半島考古」國際研討會，以及由阿曼政府和聯合國文教組織贊助，在巴黎舉行的阿曼遺產及文化會議。他於1974年獲意大利國家勳章，由意大利政府頒授騎士榮銜。

ANGUS FORSYTH 為執業律師，是香港史蒂文生黃律師事務所的合夥人。他是一位香港法律、會計和藝術界的顧問，服務的組織如香港藝術節、香港藝術館之友和香港中文大學文物館館友會，並為香港藝術節基金會和山西歷史博物館基金會館友協會委員。他曾出版有關中國玉的著作，現為中國文物藝術基金會主席，更致力在中國安徽省徽州地區保護明式建築。

蓋提文物保護中心　隸屬保羅．蓋提信託基金，成立於1985年。中心在國際間利用科學研究、實地項目、教育及培訓，以及以不同媒介傳播資訊等途徑推動文物保護。中心的計劃，以創造及傳遞專業知識為主，對專責保護視覺藝術的專業人士和組織極有助益。中心所有工作都以推動實踐文物保護為組織原則，包括改善文物保護的處理方法；進行研究，以增加對文物保護的認識，以及讓受保護文物的資訊更公開。

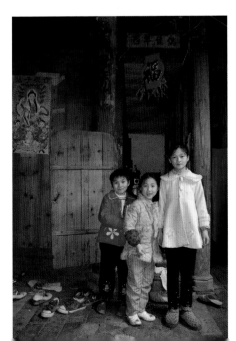

何戍中　為北京文化遺產保護中心創辦人和董事會主席。這個中心是環境權益組織，宗旨為在北京以至全中國建立保護文化遺產的意識，是迄今唯一註冊的中國大陸文化遺產保護非政府組織。何氏亦為北京的國家文物局法規處處長，曾獲中華人民共和國政府及美國考古學院頒發獎狀。

何培斌　現為香港中文大學輔導長和建築學系教授及系主任，也是藝術系榮譽教授。何氏獲倫敦大學亞非學院中國藝術及建築博士學位，研究興趣包括中國建築史、民間建築、佛教藝術、建築理論，以及建築文物保護，出版作品有中國民間建築專著、文物保護報告，以及有關中國藝術及建築的多篇論文。他是中文大學中國歷史建築研究組的創辦人和主任，該組成員為研究生，在中國大陸和香港展開多個文物保護計劃及為歷史遺跡做檔案紀錄。

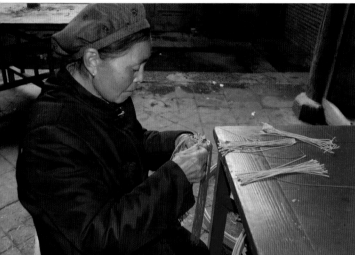

HU XINYU, MATTHEW, is managing director of the Beijing Cultural Heritage Protection Center (CHP) and formerly director of the educational and nonprofit department for Wild China Company Limited. Actively involved in community service in support of heritage and environmental protection, he has worked with the 2008 Beijing Olympic Games Bid Committee, World Wildlife Fund China, Friends of Nature, and the Nature Conservancy.

HUI MEI KEI, MAGGIE, is a PhD candidate in the Department of Architecture at the Chinese University of Hong Kong (CUHK). Her dissertation, "Mapping Religious and Secular Space: A Case Study of Tibetan Vernacular Architecture at Labrang," has involved her in extensive travel and field research in southern Gansu Province, northern Yunnan Province, and Tibet. She acted as project coordinator, researcher, and designer at the CUHK Department of Architecture's Chinese Architectural Heritage Unit for the creation of a database of 150 Chinese buildings for the Hong Kong government's Antiquities and Monuments Office. She received her MA in architecture at the University of Melbourne (2002) and is a registered architect, Royal Australian Institute of Architects (2000).

ETHEL EMERSON HUTCHESON attended Middlebury College and the University of Houston. Her BA in History and French formed the foundation for an international scope of interests in cultural diversity, sociology, and the historical impact of global development. She is engaged in socially responsible nonprofit philanthropy and public service. She serves on several boards of directors that span education, culture and the arts, child advocacy, environmental education and protection, and global poverty and hunger. Her professional background in restaurant ownership and management, coupled with a passion for gardening, is currently manifest at the North Star Ranch in Stonewall, Texas, where she and her husband, Chap, raise longhorn cattle and cultivate sustainable organic gardens. She is a practicing sculptor.

KEYA KEITA is a 1999 screenwriting graduate of the School of Cinema-Television at the University of Southern California (Los Angeles). A published author, journalist, and documentary filmmaker, she is currently living in Kauai, Hawaii. As partner in the production of *Building Diplomacy* (Cornell University Press, 2004), she created the film *Looking for America*, which earned first place in the Gaffers International Film Festival, USA (2005). Her solo film credits include *Waves of Compassion* (2005), commissioned by the East-West Center at the University of Hawaii and Habitat for Humanity, on issues of post-tsunami long-term humanitarian aid in Sri Lanka, and *In a Sea Change* (2008), a documentary on the challenges of progress, preservation, and land rights on the island of Kauai. For *Access Denied* (Cinema Libre, 2007), she provided research production assistance on global poverty initiatives.

LIU XIAOGUANG earned his bachelor's and master's degrees in architecture from Beijing's Tsinghua University School of Architecture in 1987 and 1989, respectively. He received a second master's in architecture from the University of Southern California (Los Angeles) in 1992. A member of the American Institute of Architects and a vice president with RTKL Associates in Los Angeles, he has designed a number of high-profile projects throughout China. Specializing in public and cultural projects, Liu was the lead design architect in Beijing for Phase II of the National Art Museum of China, the China Science and Technology Museum, the Chinese Museum of Film, the National Museum of China renovation and expansion, and Phase II of the National Library of China. In Shanghai his nota clude the Natural History Museum and the Science and Technology Museum. His extensive portfolio includes work throughout Southeast Asia, India, and North America.

VINCENT H. S. LO is founder, chairman, and chief executive officer of Shui On Group, Hong Kong, and developer of Shanghai Xintiandi, an award-winning mixed-use preservation and adaptive reuse project. In 1999 he was made an honorary citizen of Shanghai. He has been awarded recognition by the Chinese, Hong Kong, and French governments, most recently being named Businessman of the Year at the Hong Kong Business Awards (2001), Director of the Year by the Hong Kong Institute of Directors (2002), and Chevalier des Arts et des Lettres by the French government (2005). Active in community service, he serves on the Shanghai-Hong Kong Council for the Promotion and Development of the Yangtze and is honorary life president of the Business and Professionals Federation of Hong Kong, among his other positions.

CHRISTINE LOH is founder and chief executive officer of the nonprofit public policy think tank Civic Exchange in Hong Kong. She is a lawyer by training, a commodities trader by profession, and a former member of the Hong Kong Legislative Council. Currently she does policy work that relates to climate change and environmental issues in China and internationally and is a director of the Hong Kong Stock Exchange, a member of numerous nonprofit boards, and a published author on politics, political economy, and the environment. Her most recent publications are *Being Here: Shaping a Preferred Future* (2006) and *Idling Engine: Hong Kong's Environmental Policy in a Ten Year Stall 1997–2007* (2007).

I. M. PEI was born Pei Ieoh Ming in Suzhou, China, in 1917. At age seventeen he came to the United States to study architecture. He received a bachelor's in architecture from the Massachusetts Institute of Technology in 1940 and a master's in architecture from Harvard's Graduate School of Design in 1946. He became a naturalized citizen of the United States in 1954. Pei has designed some of the most iconic and beloved architectural masterpieces in the world. He gained acclaim for his designs of the East Building of the National Gallery of Art in Washington, D.C. (1978), the John F. Kennedy Library in Boston (1979), the Grand Louvre in Paris (1989), and Miho Museum in Shiga, Japan (1997). He completed three projects in his native China: the Fragrant Hill Hotel in Beijing (1982), the Bank of China Tower in Hong Kong (1989), and the Suzhou Museum in Suzhou (2006), each designed to graft advanced technology onto the roots of indigenous building and thereby sow the seeds of a new, distinctly Chinese form of modern architecture. Pei has been recognized internationally with the highest honors in architecture, arts and letters, and public service, among them the AIA Gold Medal (1979), the Grande Médaille d'Or of the Académie d'Architecture de France (1982), the Pritzker Architecture Prize (1983), and the Japanese Art Association's Praemium Imperiale (1989). He is a Fellow of the American Institute of Architects, a Corporate Member of the Royal Institute of British Architects, and a member of the American Academy of Arts and Sciences, the National Academy of Design, and the American Academy and Institute of Arts and Letters.

胡新宇 為北京文化遺產保護中心執行主任，前為野性中國有限公司的教育及非牟利部門主任。胡氏積極從事文物及環境保護工作，服務的組織有2008奧運申辦委員會、世界自然基金會中國分會、自然之友，以及自然保護協會。

許美琪 為香港中文大學建築學系博士生，為撰寫其論文Mapping Religious and Secular Space: A Case Study of Tibetan Vernacular Architecture at Labrang，跑遍了甘南、滇北和西藏。許氏在中文大學建築學系的歷史建築研究組身兼項目協調員、研究員及美術設計職務，為香港政府的古物及古蹟辦事處建立一個紀錄一百五十座中國建築的資料庫。她於2002年獲墨爾本大學建築學碩士學位，為澳洲皇家建築學院2000年註冊建築師。

ETHEL EMERSON HUTCHESON 肄業於米德爾貝里學院和休斯敦大學。她的歷史及法文學士學位為她打下國際視野基礎，培養了她對文化多樣性、社會學和全球發展的歷史性影響的興趣。她現時從事非牟利慈善和公共服務的社會公益工作，參與董事會的機構包括了教育、文化及藝術、兒童權益、教環教育及保護，以及全球貧窮及饑饉等範疇。她有專業餐飲經營及管理背景，加以熱愛園藝，近年便與丈夫在得克薩斯州石牆鎮北極星牧場飼養長角牛和耕種有機農作物。她也是位創作不斷的雕塑家。

KEYA KEITA 肄業於南加州大學洛杉磯校電視電影學院，1999年劇本創作班畢業，現居夏威夷考愛島，是有著作出版的作家、新聞工作者及紀錄片製片。她是製作Building Diplomacy (Cornell University Press, 2004)的合夥人，因此而創作的電影Looking for America 在美國加弗斯國際電影節獲2005年冠軍。她的個人電影作品包括由夏威夷大學東西文化中心和人類家園委託製作的Waves of Compassion (2005)，內容為講述海嘯後在斯里蘭卡的長期人道援助問題，以及In A Sea Change (2008)，為描寫考愛島的發展、保存及土地權益問題的紀錄片。Access Denied (Cinema Libre, 2007)則由她作資料搜集，協助提供全球反貧窮活動的訊息。

劉曉光 畢業於北京清華大學建築學院，分別於1987及1989年獲建築學學士和碩士學位，1992年在南加州大學獲第二個碩士學位。劉氏為美國建築師學會會員，RTKL建築事務所洛杉磯公司副總裁，曾在中國設計多個知名的建築項目，專長公共和文化建築設計，為北京中國美術館第二期工程、中國科學技術館、中國電影博物館、中國國家博物館擴建工程，以及中國國家圖書館第二期的主建築設計師，在上海的傑作則有自然歷史博物館和上海科技館。劉氏經驗豐富，工作遍及東南亞、印度和北美洲。

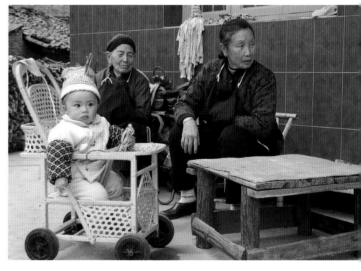

羅康瑞 為香港瑞安集團創辦人、主席及行政總裁，亦為上海新天地發展商，該發展項目以揉合文物保護和可適性再利用而獲獎，1999年獲授上海榮譽市民之銜。羅氏屢獲中國、香港和法國政府頒授榮銜，2001年即獲香港商業獎的「商業成就獎」，2002年獲香港董事學會的該年度「傑出董事獎」，2005年則獲法國政府頒授藝術與文學騎士勳章。羅氏熱心社區服務，身兼多職，為長江開發滬港促進會理事長與香港工商專業聯會終身名譽會長。

陸恭蕙 為思匯政策研究所創辦人及行政總監，該所是香港的非牟利公共政策研究組織。陸氏所習為法律，專業則為商品交易，曾任香港立法局議員，現時從事的政策工作，以中國以至國際的氣候改變和環境問題為主。陸氏現為香港交易所及多個非牟利組織董事，出版著作範圍涵蓋政治、政治經濟及環保，最新作品為Being Here: Shaping a Preferred Future (2006) 和 Idling Engine: Hong Kong's Environmental Policy in a Ten-Year Stall 1997–2007 (2007).

貝聿銘 貝聿銘於1917年在中國蘇州出生，十七歲往美國攻讀建築，1940年獲麻省理工學院建築學士學位，1946年獲哈佛大學設計研究所碩士學位。貝氏於1954年成為美國公民。貝聿銘不少傑作都是劃時代的建築設計，世所稱道的作品有華盛頓國立美術館東翼(1978)、波士頓肯尼迪圖書館（1979）、巴黎大羅浮宮(1989)，以及日本滋賀縣美秀美術館（1997）。貝氏在中國有三項作品：北京香山飯店（1982）、香港中國銀行大廈，以及蘇州的蘇州博物館（2006）；三者都是把先進技術與當地建築接枝，播下嶄新鮮明的中國現代建築形式的種子。貝氏在國際享負盛名，屢獲建築、藝術及文學和公共服務上的殊榮，其著者有美國建築師學會金獎（1979）、法國建築學會大金章（1982）、普利茲克獎（1983）與日本藝術協會帝賞獎（1989）。貝氏為美國建築師學會資深會員及英國皇家建築師學會會員，以及美國藝術與科學學會、國家設計學院和美國藝術暨文學學會會員。

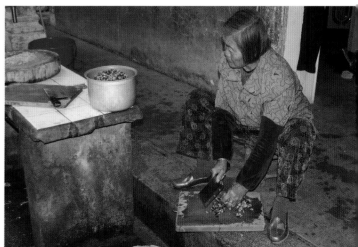

THE ROCKEFELLER BROTHERS FUND (RBF) was founded in 1940 and is dedicated to the philanthropic ideals of the Rockefeller family. The RBF's grant making is organized around four themes—democratic practice, sustainable development, peace and security, and human advancement—and four pivotal places—New York City, South Africa, the western Balkans, and southern China. In March 2004 the RBF decided to concentrate its Asian grant making in southern China, one of the fastest-growing and most dynamic regions of the world. This focus builds on the RBF's history of philanthropy in east and southeast Asia and continues over a century of Rockefeller family philanthropy in China, which dates back to the founding of the Peking Union Medical College in 1921. The RBF's current president, Stephen B. Heintz, assumed office in February 2001. In 1999 the Charles E. Culpeper Foundation of Stamford, Connecticut, merged with the RBF.

DONOVAN RYPKEMA established the Real Estate Services Group, a recognized industry leader in the economics of preserving historic structures, in South Dakota in 1975. He is a noted advocate for economic and preservation projects that integrate rehabilitation, community development, and commercial revitalization. His book *The Economics of Historic Preservation: A Community Leader's Guide* (2005) is widely used by preservationists. Other books include *The Economics of Rehabilitation* (1997) and *The Investor Looks at an Historic Building* (1996). He lectures widely on issues of urban redevelopment, revitalization, and sustainable historic preservation.

ALEXANDER STILLE is the Sao Paolo Professor of International Journalism in the School of Journalism at Columbia University. He is author of *The Future of the Past* (2002), which chronicles efforts in Italy, Egypt, and China to preserve historical monuments and documentary evidence of ancient times. His writings on Italy and Italian Mafia culture include his first book, *Benevolence and Betrayal: Five Italian Jewish Families under Fascism* (1991), which received both a New York Times Literary Supplement Best Books Award and a Los Angeles Times Book Award in 1992. He continues to write for the *New Yorker*, the *Boston Globe*, and the *New York Times*.

PETER H. Y. WONG is a chartered accountant practicing in Hong Kong. He retired in 2003 as senior tax partner at Deloitte Touche Tohmatsu, Hong Kong. He formerly served as a Hong Kong legislator and has long been a leader for sustainability and preservation initiatives in Hong Kong and China. He is a member and former chairman of the Hong Kong Society of Accountants (now the Hong Kong Institute of Certified Public Accountants), former chairman of the Hong Kong Social Welfare Advisory Committee and the Advisory Council on the Environment, and founder and deputy chairman of the Independent Schools Foundation Academy. His broad leadership in health, social welfare, civic, political, educational, and environmental initiatives earned him the Order of the British Empire (1993) and the Gold Bauhinia Star (1998). He was appointed the district grand master of Hong Kong and the Far East (1992), making him the most senior Freemason in southeast Asia.

BENJAMIN T. WOOD, AIA, heads Ben Wood Studio Shanghai, a firm specializing in architecture, development, and urban planning through-out China. Wood is director of design for Shanghai Xintiandi, a project of Shui On Group, Hong Kong. He earned his master's in architecture at the Massachusetts Institute of Technology in 1984. Before establishing his practice in Shanghai, he was a principal with Wood and Zapata, Cambridge, Massachusetts. He has worked throughout the world on a wide range of commercial, residential, private, and public sector projects. His efforts to establish a conservation ethos among the Chinese direct his architectural practice throughout China.

JESSICA H. YOON studied design, art, and art history at the Corcoran College of Art (Washington, D.C.). She received a BA in graphic design in 2004 from the Art Center College of Design (Pasadena) and is a member of the American Institute of Graphic Designers. She is currently a senior graphic designer in Los Angeles, providing a broad range of printing and Web design services to clients in advertising, publishing, and telecommunications. She is the designer of the book *Open Hearts Open Doors*.

ZHENG SHILING is an architect and scholar and the director of the Institute of Architecture and Urban Space, Tongji University, Shanghai. He obtained his PhD in history and theory of architecture from Tongji University in 1993. He serves as director on the Committee for the Preservation of Historical Areas and Heritage Architecture and the Committee of Urban Space and Environment, Shanghai Urban Planning Commission. He is an elected member of the International Committee of Architectural Critics, the Architecture Society of China, the Chinese Academy of Sciences, and l'Academie d'Architectur of France and is an honorary fellow of the American Institute of Architects. Many of his architectural works have won national and Shanghai architectural design awards. Widely published, he has authored several books, including *On the Rationality of Architecture: The Value System and Symbolism of Architecture* (1997), *The Evolution of Shanghai Architecture in Modern Times* (1999), and *Architecture Criticism* (2001); he was a contributor to *Tracing Back: The Excellent Architecture of Modern Times in Shanghai* (2001).

PAUL ZIMMERMAN received an MBA from Erasmus University in Rotterdam, the Netherlands. He was founder and director of Bridge Design, an identity and corporate literature design company in Hong Kong from 1987 to 1998. In 2000 he founded The Experience Group, a consultancy advising business leaders on strategy and policy development. In 2003 he was appointed executive director of MF Jebsen International, an investment holding company, and to date has direct responsibility for MF Jebsen Automotive (Aston Martin and Triumph Motorcycles), Jebsen Travel, and Pacific Aviation Marketing. Active in public service, he has been instrumental in a range of initiatives aimed at responsible urban planning and growth for Hong Kong, including Designing Hong Kong Harbour District, the Coalition on Sustainable Tourism, Heritage Watch, and Designing Hong Kong.

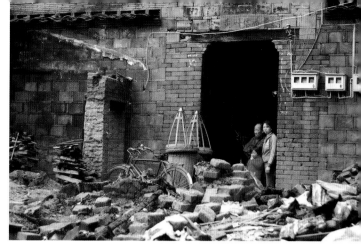

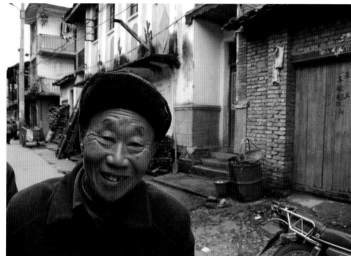

洛克菲勒兄弟基金會 成立於1940年，以推動洛克菲勒家族的慈善事業為宗旨。基金會捐贈的領域有四個主題，分別為民主實踐、可持續發展、和平及安全與人類進步，而以紐約市、南非、西巴爾幹半島和中國華南為重點活動地區。基金會於2004年3月確定，把對亞洲的捐贈集中在全球發展最快速及活躍的中國華南，此舉為基金會在東亞及東南亞多年活動的里程發展，亦為洛克菲勒家族在中國超過一個世紀的慈善事業之延續，洛氏家族在中國的捐贈可追溯至成立於1921年的北京協和醫科大學。基金會現任主席為Stephen B. Heintz，2001年2月履任。1999年，康涅狄格州的Charles E. Culpeper Foundation併入洛克菲勒兄弟基金會。

DONOVAN RYPKEMA 於1975年在南達科他州成立的Real Estate Services Group，為公認的歷史建築保存經濟學行內龍頭。他為人熟悉的是提倡結合修復、社區發展和商業復興的經濟及保存計劃，所著的*The Economics of Historic Preservation: A Community Leader's Guide* (2005)廣為文物保存人士引用，其他著作有*The Economics of Rehabilitation* (1997) 與 *The Investor Looks at an Historic Building* (1996)。他到處發表演說，主題為都市重建、復興及可持續的歷史文物保存。

ALEXANDER STILLE 為哥倫比亞大學新聞學院國際新聞學聖保羅講座教授，其著作*The Future of the Past* (2002)記錄了意大利、埃及和中國在保存歷史遺跡及古代文獻方面的工作。他講述意大利和意大利黑手黨文化的作品，包括他的第一本著作*Benevolence and Betrayal: Five Italian Jewish Families under Fascism* (1999)於1992年同時獲得紐約時報副刊最佳書獎和洛杉磯時報書獎。他亦為《紐約客》、《波士頓環球郵報》和《紐約時報》撰稿。

黃匡源 是香港執業的特許會計師，2003年退休前是德勤‧關黃陳方會計師行高級稅務合夥人，曾為香港立法局議員，是在中國及香港倡議可持續發展和文物保存的領導人物。黃氏為香港會計師公會會員，曾任公會主席，亦為香港社會福利諮詢委員會與環境諮詢委員會前主席，以及弘立書院創辦人及副主席。黃氏在衛生、社會福利、市政、政治、教育和環境範圍領導倡議，貢獻傑出，故於1993及1998年分別獲 OBE 勳章和金紫荊勳章。1992年，黃氏獲委任為共濟會的香港及遠東區最高代表，成為東南亞最高級別的共濟會會員。

BENJAMIN T. WOOD, AIA, 領導的Ben Wood上海工作室，是專門在中國進行建築、發展和都市規劃項目的公司。Wood是上海新天地的設計總監，這個上海地標是香港瑞安集團的發展項目。他於1984年獲麻省理工學院的建築學碩士學位，在上海開設工作室前是麻薩諸塞州劍橋市Wood and Zapata的合夥人，工作經驗遍及全球，範圍涵蓋商業、住宅、私人及公共項目。他致力於在中國提高文物保護意識，工作亦因而擴及中國其他地方。

JESSICA H. YOON 在華盛頓哥倫比亞特區的可可然美術學校修讀設計、美術和美術史，2004年獲加州帕薩迪納藝術中心設計學院文學學士學位，是美國平面設計師協會會員，現為資深平面設計師，在洛杉磯工作，為廣告、出版及電訊業客戶提供印刷與網頁設計服務，《明心啟扉》的美術設計就是她的傑作。

鄭時齡 是建築師，亦是學者，為上海同濟大學建築與城市空間研究所所長，1993年獲同濟大學建築歷史與理論博士學位，是上海市規劃委員會歷史文化風貌區與優秀歷史建築保護專家委員會和城市空間與環境專業委員會主任，並為建築評論家國際委員會成員、中國建築學會會員、中國科學院和法國建築科學院院士，以及美國建築師協會榮譽院士。鄭氏多個建築作品曾獲國家及上海的建築設計獎，而且著述豐富，出名的著作有《建築理性論—建築的價值體系與符號體系》(1977)、《上海近代建築風格》（1999）與《建築批評學》(2001)；撰稿的則有《回眸—上海優秀近代保護建築》(2001)。

PAUL ZIMMERMAN 是荷蘭鹿特丹伊拉斯姆斯大學工商管理碩士，為香港的企業形象及宣傳刊物設計公司Bridge Design （1987-98）創辦人及總裁，2000年成立歷豐諮詢集團，為商界領袖提供策略及政策發展顧問服務，2003年獲委任為投資控股公司捷成馬國際執行董事，現直接負責捷成馬汽車（阿斯頓．馬丁及凱旋摩托車）、捷成旅遊和太平洋航空拓展有限公司的業務。他熱心公共服務，積極推動多個監察香港城市規劃及發展的計劃，如「共創我們的海港區」、「可持續旅遊發展聯盟」、「文化傳承監察」與「創建香港」。

SHOOTING LOCATIONS AND PHOTO IDENTIFICATION
拍攝地點及圖片引索

FUJIAN	1995, 1996	福建	1995, 1996
	Xiamen		廈門
	Hukeng		湖坑 40, 59, 86, 89, 90, 92, 196
	Regional villages		當地鄉村 117

ZHEJIANG	1997, 1998	浙江	1997, 1998
	Hangzhou		杭州 West Lake: cover, 26; 65, 80
	Shaoxing		紹興 29, 36, 97, 139, 182
	Anchang		安昌 18, 181
	Dongyang		東陽 Lu Family Mansion: 17, 34, 99, 100
	Longmen		龍門 6, 142, 191, 195, 201
	Water canal villages		水鄉

HEBEI	2001	河北	2001
	Beijing		北京
	Regional villages		當地鄉村

JIANGXI	2004, 2005	江西	2004, 2005
	Meipi		渼陂 2, 20, 22, 55, 57, 68, 75, 79, 112, 122, 154
	Regional villages		當地鄉村 166
	Ji'an City		吉安市 149, 169

GUANGDONG	2004, 2005, 2006	廣東	2004, 2005, 2006
	Guangzhou		廣州
	Shamian Island		沙面
	Meizhou		梅州 127
	Xiyangzhen		西陽鎮 8, 44, 105, 111, 115, 131, 179; Qiu Family Mansion: 10, 25, 48, 50
	Zili village		自力村 32, 146, 152, 158, 206
	Kaiping		廣東開平 160, 163, 187, 204

FUJIAN	2006	福建	2006
	Wuyishan		武夷山 12, 119, 121, 125, 132, 184, 192, 199, 238
	Taining		泰寧 Li Chunye Mansion: 30, 53, 62, 102, 203
	Xiamei		下梅
	Regional villages		當地鄉村 124, 134, 205

| SHANGHAI | 2007 | 上海 | 2007 141, 156, 157, 173; Shanghai Science and Technology Museum, 164 |

| JIANGSU | 2007 | 江蘇 | 2007 |
| | Suzhou | | 蘇州 106, 165, 210; Suzhou Museum, 212, 214, 216 |

| HONG KONG | 1995–2007 | 香港 | 1995–2007 |
| | Hong Kong and New Territories | | 香港及新界 front matter, 4, 15, 70, 72, 174, 204 |

Please Note: A select number of the small photos presented in the book are not included as captioned thumbnails.

注：為數有限的一些小圖片不在附錄解說之中。

front matter

The joyful laughter of a group of children is as universal in China as in cultures all over the world.

Regional village, Wuyishan, Fujian

童真歡笑，在中國如此，普世也相同。
福建武夷山當地鄉村

front matter

A banner proclaiming the word *Fate* flanks an elaborately carved doorknocker.

Meipi, Jiangxi

童真歡笑，在中國如此，普世也相同。
江西渼陂

front matter

Devotional shrines are commonly found throughout China.

New Territories, Hong Kong

中國各地常見的神庵。
香港新界

p. 2

The triple-arched gateway to the village of Meipi honors both the town's history and its prestigious place in the modern era, as the location of the meeting on February 7, 1930, at which Mao Tse-tung strengthened his leadership of the Red Army.

Meipi, Jiangxi

渼陂村口的三拱牌坊，紀念的是該鎮歷史和現代的特殊地位；1930年7月8日，毛澤東在此地鞏固了他的紅軍領導權。
江西渼陂

p. 4

A waterspout in the shape of a carp is a widely used motif expressing good fortune through personal effort.

New Territories, Hong Kong

排水口作鯉魚形狀是常用的圖案，喻意財富靠個人努力得來。
香港新界

p. 6

A young child plays by the edge of a rice paddy that lays fallow in winter while his mother works in the courtyard beyond pressing heating bricks from coal dust, the most widely used form of heating throughout rural China.

Longmen, Zhejiang

小孩在冬天休耕的稻田旁玩要，他的母親在另一邊的院子裡正用煤灰壓製取暖磚。煤磚是中國各地農村最普遍使用的取暖物料。
浙江龍門

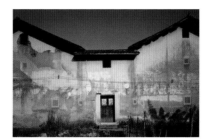

p. 8

Hand-formed and sun-dried adobe bricks, widely used as a building material when kiln firing is not available, can be seen beneath the sheared-off clay surface of the front elevation of a residence.

Xiyangzhen, Guangdong

房子正面牆壁泥灰剝落，露出手造曬乾的土磚，是無窯可燒時最常用的建築材料。
廣東西陽鎮

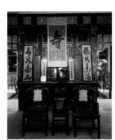

p. 10

A prominent feature in homes is an ancestral altar that shows respect for past generations and is a place for the display of family memorabilia, plaques, and genealogical records. Offerings of food and other tangible forms of reverence are often displayed on these altars.

Qiu Family Mansion, Xiyangzhen, Guangdong

家庭內最顯眼的地方是向先輩表示敬意的祖先神櫥，也是陳列祖傳物品、神牌和族譜的地方。神櫥上經常供奉著食物和其他祭品。
廣東西陽鎮丘家(譯音)大宅

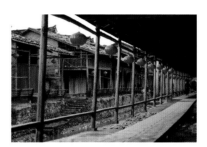

p. 12

Decorated for the New Year with red lanterns and proclamations of good wishes, freshly poured concrete walkways straddle a stream and shop fronts.

Regional village, Wuyishan, Fujian

慶祝新年的紅燈籠和春帖，跨在小溪和店前的是剛鋪設的混凝土行人道。
福建武夷山當地鄉村

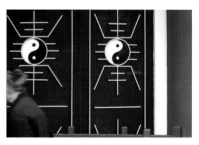

p. 15

At Fung Ying Seen Koon Temple, a visitor passes in front of doors adorned with the traditional Daoist symbol of yin and yang, an expression of the balance of opposites.

Fanling, New Territories, Hong Kong

蓬瀛仙館內，一名遊人在飾以傳統陰陽圖案的門前過。陰陽和而萬物得也。
香港新界粉嶺

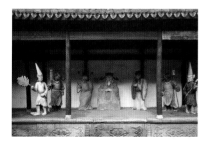

p. 17

These full-scale wooden figures were once used in performances of traditional folk tales. Rarely preserved, here they are displayed on a small, protected stage in an inner courtyard of a residence. The elegantly carved finials of the roof tiles are indicative of the exceptional quality of the property.

Lu Family Mansion, Dongyang, Zhejiang

這些真人大小的木偶曾用作演出傳統民間故事，少有保留，現陳列在一間宅子內院的小型有蓋戲台上。屋頂瓦片雕刻典雅的尖頂飾足證房子品質上乘。
浙江東陽魯家（譯音）大宅

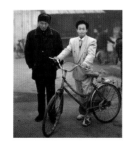

p. 18

Two generations reflect the change in personal style that has come to be the norm. The young man's attire, and a small gift tied up with a flower on the bicycle rack, are clues to his destination.

Anchang, Zhejiang

兩代反映個人風格的改變，現已成標準。年輕人的衣著，還有自行車架上包得好好飾以花朵的禮物，是他將會赴甚麼約會的提示。
浙江安昌

p. 20

Light filters down from a skylight to play on the simple beauty of a latticework screen decorated with glass beads and origami cranes.

Meipi, Jiangxi

從天窗透進來的陽光照射在簾子上，簾子飾以玻璃珠子和紙鶴，簡約而美。
江西渼陂

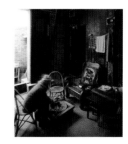

p. 22

The Liang family's daughter, lovingly known as Rabbit, warms her hands on a charcoal brazier in the early morning chill. This type of heating, in widespread use throughout rural areas, is a grave source of interior air pollution.

Meipi, Jiangxi

大清早天氣寒冷，小名兔子的梁家閨女用炭爐暖手。這種農村地區各處普遍使用的取暖方法，是內陸空氣污染的主要根源。
江西渼陂

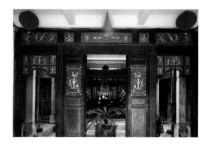

p. 25

A delicately restored room divider frames an inner courtyard that is open to the sky. In the room on the far side of this "skywell" the family's ancestral altar can be seen.

Qiu Family Mansion, Xiyangzhen, Guangdong

巧手修復的屏門，框着後面的露天院子。天井遠處的房間內是這家人的祖先神櫥。
廣東西陽鎮丘家大宅

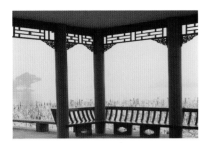

p. 26
A deep wintry mist envelops the lake beyond as seen from a viewing pavilion at water's edge.
West Lake, Hangzhou, Zhejiang

湖旁觀景亭眺望，重重冬霧籠罩遠處水面。
浙江杭州西湖

p. 29
Sandwiched between stone walls, a small open-air shop is composed of moveable wood flooring and door panels that provide both structural support and protection from fire.
Shaoxing, Zhejiang

夾在石牆中間的露天小店，由可移動的木地板和門板組成，既作結構支撐，亦作防火。
浙江紹興

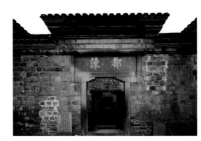

p. 30
Kiln-fired bricks create a solid structure yet must be maintained. Patches of new mortar show the intermittent restoration necessary for the perpetuity of a classic building.
Li Chunye Mansion, Taining, Fujian

窯磚砌成的堅實結構，有待保存。塊塊新灰泥是定期維修時補上去的，要永久保存一座典雅子維修工作不可少。
李春燁大宅

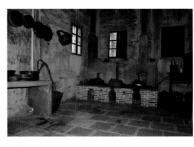

p. 32
The layout of a traditional kitchen is preserved in this exceptional example of a *diaolou*, a home built by the Overseas Chinese who had immigrated to Western countries. Many returned to China with wealth and a commitment to create a better quality of life in the areas from which they had originally come.
Zili Village, Guangdong

典型碉樓內保存的傳統廚房佈局。碉樓是移居西方國家的海外華僑修建的房子。不少衣錦還鄉的華僑都一心落葉歸根，在祖家享福。
廣東自力村

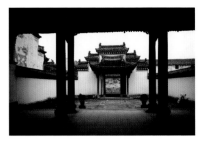

p. 34
The shadow and diffused light in a spacious side courtyard lead to an alleyway beyond.
Lu Family Mansion, Dongyang, Zhejiang

影重重光漫漫的寬敞側院，外面是一條深巷。
浙江東陽魯家大宅

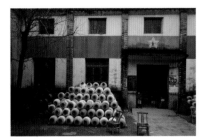

p. 36
Precariously stacked wine vessels dwarf a child who looks out from a merchant's shop.
Shaoxing, Zhejiang

危如纍卵的酒罈子，在店內往外張望的孩子相比下顯得更加細小。
浙江紹興

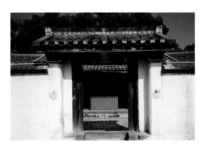

p. 40
An ancient tree revered by villagers stands as a gateway to the Hakka village beyond.
Hukeng, Fujian

村民敬拜的古樹，在客家村子的村口屹立，有如大門。
福建湖坑

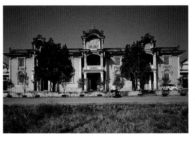

p. 44
A combination of flat, concave, and convex tiles creates a rhythmically ordered pattern on the roofline of the entrance to a walled residential compound.
Xiyangzhen, Guangdong

築有圍牆的住宅大院入口，屋頂輪廓線上的瓦片或平或凹或凸，組成有韻律感的井然圖案。
廣東西陽鎮

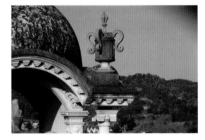

p. 48
This mansion is the central manor house of a village on the outskirts of Ji'an City. The facade features mixed Western design elements; the interiors were laid out in a traditional courtyard style. The builder's grandson is now committed to the full restoration of the property.
Qiu Family Mansion, Xiyangzhen, Guangdong

這座大宅是吉安市近郊一條村子的中央莊園大廈。大宅正面混合了西式設計元素，內部格局是傳統的院子形式。屋建者的孫子現承諾把房子全面修復。
廣東西陽鎮丘家大宅

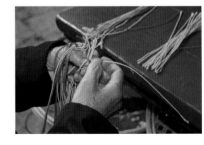

p. 50
From the rooftop's airy perch, the eclectic cupola, showing Western architectural influences, frames the view of hillsides that embrace the valley in which the village is sited.
Qiu Family Mansion, Xiyangzhen, Guangdong

高高在上的圓屋頂不拘一格，但西式建築影響明顯可見，背景襯托的崗巒環抱着村子所在的山谷。
廣東西陽鎮丘家大宅

p. 53
The ornately carved stone pedestal base of a wooden pillar provides both structural support and protection from water damage.
Li Chunye Mansion, Taining, Fujian

木柱子是建構性支撐，雕琢華麗的石柱腳則保護柱子免受水侵。
李春燁大宅

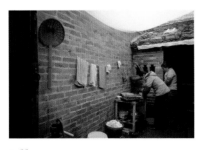

p. 55
An outdoor kitchen is shielded with a translucent tarp that protects the women from the elements while preparing meals. Beyond and to the back are wood-burning ovens that support huge woks.
Meipi, Jiangxi

戶外廚房，以半透明油布遮擋，做飯的女人可免受風吹雨打。後面是燒柴的爐灶，可以放很大的鑊。
江西渼陂

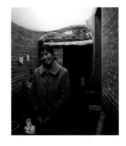

p. 57
An openhearted smile and an open door are the cornerstones of village life.
Meipi, Jiangxi

燦爛的笑容和敞開的門口是農村生活的基礎。
江西渼陂

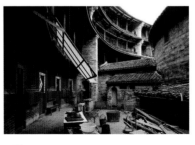

p. 59
The interior of a four-story Hakka round house is the home to more than two hundred villagers, often members of an extended familial lineage. Living in vertically delineated dwellings, each family has its own areas on the ground level for keeping livestock and for cooking, while living quarters are maintained above.
Hukeng, Fujian

四層的客家土樓內部，住了二百多個村民，多半是同一血脈。每家人住垂直的一棟樓，底層有自己養牲口和煮食的地方，居所在樓上。
福建湖坑

p. 61
Patient and meticulous, the hands of an elderly woman braid the cords for small prayer beads. It is hoped that the shift to mechanization does not cause the diminution of these traditional practices.

耐心而細緻，老婦人的雙手在編織穿念珠用的繩。但願機械化不會令這些傳統的作業縮減。

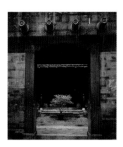

p. 62
Ornamentally capped stone lintels act as both functional and decorative elements marking the doorway to an open-air bay. A dramatic minimalist impact is achieved with the placement of a single potted tree in the center of the "skywell," where it can thrive in sunlight, fresh air, and occasional rainfall.
Li Chunye Mansion, Taining, Fujian

末端飾以花紋圖案的石過梁，作為露天小院子出入口的標誌，既實用亦美觀。天井中央小樹一盆，在陽光、新鮮空氣和偶爾的雨水裡成長，達到令人驚喜的極簡抽象派藝術效果。
李春燁大宅

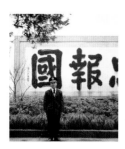

p. 65
A public official serves as a guide and security guard at a botanical garden in a popular tourist destination in the West Lake District.
Hangzhou, Zhejiang

在西湖區遊客熱點一個植物公園充當嚮導和保安員的政府人員。
浙江杭州

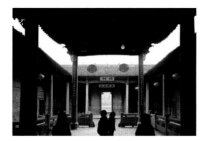

p. 68
Friends spend leisurely time visiting with one another at the village's largest ancestral hall. Villages can have multiple halls of varying sizes, built by families during the dynastic era who gained prestige by having one of their children pass the imperial exams based on the Chinese classics, thus earning official status and employment in the imperial bureaucracy. A high number of halls in a given locale would bring honor to the village.
Meipi, Jiangxi

朋友在村內最大的宗祠見面，消磨閒暇。村子可以有大小不同的多個祠堂，舊時王朝年代，有子弟考取到功名後踏上青雲路的家庭都可以建祠。一條村內有多個祠堂是闔村光彩。
江西渼陂

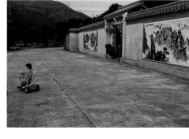

p. 70
Reflecting the convergence of past and present, electrical power lines and a plastic tricycle are juxtaposed with the restored landscape murals on the facade of a traditional residence.
New Territories, Hong Kong

電力線和塑膠三輪車與傳統房子外牆修復好的風景壁畫並列，反映了過去和現在的會合。
香港新界

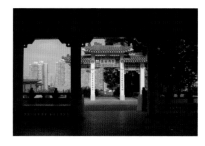

p. 72
A view from the Daoist temple, Fung Ying Sin Kuan, frames massive apartment towers that are commonplace in Hong Kong and the mainland.
Fanling, New Territories, Hong Kong

道觀蓬瀛仙館外望，框住了香港和大陸普遍不過的高樓大廈。
香港新界粉嶺

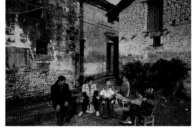
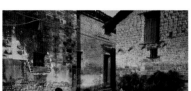

p. 75
The Liang family gathers for relaxation in the late winter sun.
Meipi, Jiangxi

梁家在冬末的陽光下休息。
江西渼陂

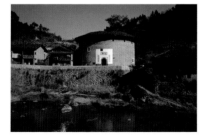

p. 79
An open channel and strategically placed cisterns are the means of collecting precipitation that drips from the eaves of the sloped roof above the "skywell."
Meipi, Jiangxi

一條露天渠道和位置剛好的貯水盆子，是收集天井上斜面頂屋檐水滴的工具。
江西渼陂

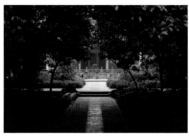
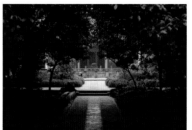

p. 80
To dramatic effect, a pathway emerges from the shadows into the open space of a public garden.
Hangzhou, Zhejiang

小徑從蔭處出來，逕自通往公園的空地，效果出人意表。
浙江杭州

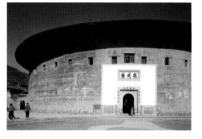

p. 82
An aesthetic relationship is achieved through the casual placement of a round threshing basket between the two wheels of a well-worn bicycle.
Regional village, Wuyishan, Fujian

一輛舊自行車，一個圓竹箕，隨便一放，竟然別具美感。
福建武夷山當地鄉村

p. 86
This four-story round house of massive proportions is an outstanding example of a unique architectural form indigenous to southeastern regions of China. People of Han ancestry, who migrated from the Central Plains of China in the earliest years of the Common Era, populated these areas, and were later to become known as the Hakka people.
Hukeng, Fujian

這幢四層高巨大土樓是中國西南地區所有的獨特建築類型。中原漢人在公元初移居到這些地區，緜緜世代之後被稱為客家人。
福建湖坑

p. 89
A doorway frames the view of another round house that sits across the stream from the village's largest residential complex.
Hukeng, Fujian

門口框住的風景，是坐落溪流對岸的另一幢土樓，上游是村子最大的民居建築群。
福建湖坑

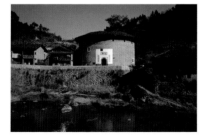

p. 90
A retaining wall buttresses the roadway that fronts a series of residences, including a three-story Hakka round house.
Hukeng, Fujian

擋土牆支撐著道路，路旁是這幢三層土樓在內的一列房子。
福建湖坑

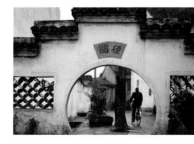

p. 92
Solid fortifications, thick walls, and an arched doorway show the stability of the building style in a Hakka round house.
Hukeng, Fujian

堅實的土木、厚牆和拱形門口，客家土樓的穩固建築風格於此可見。
福建湖坑

p. 97
The characters above a moon gate read "Peaceful Way."
Shaoxing, Zhejiang

月洞門外，曲徑通幽。
浙江紹興

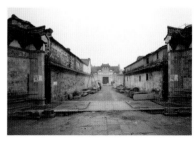

p. 99
A road leading to the Lu Family Mansion is flanked by the materials of stonemasons working on the restoration of the residence.
Dongyang, Zhejiang

通往魯家大宅的路，兩旁都是石匠修復房子用的材料。
浙江東陽

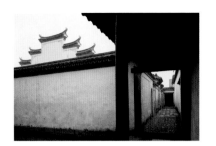

p. 100
A stepped gable roofline in the *matouqiang* style looms above the exterior facade and the walkways that circle the residence.
Lu Family Mansion, Dongyang, Zhejiang

山牆高低有致的馬頭牆風格屋頂輪廓線，俯視着內牆和環繞房子的走道。
浙江東陽魯家大宅

p. 102
An elaborately carved wooden balustrade is indicative of the superior quality of what was once the residence of a high official.
Li Chunye Mansion, Taining, Fujian

雕欄猶在，昔日顯貴官邸之講究可見一斑。
福建泰寧

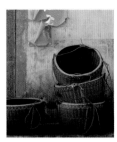

p. 105
The perfect weave of baskets reflects an ancient craft that is as functional as it is beautiful.
Xiyangzhen, Guangdong

編織完美的籃子，是既實用亦美觀的古老手工藝品。
廣東西陽鎮

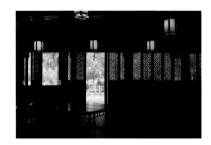

p. 106
Located on the grounds of the Humble Administrator's Garden in the culturally historic city of Suzhou, a wooden pavilion, bathed with subtle light, provides a cool reprieve from the heat of a summer day.
Suzhou, Jiangsu

位於文化歷史名城蘇州的拙政園，園內隱約透進陽光的木閣，是避開炎夏熱浪的陰涼好去處。
江蘇蘇州

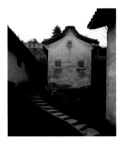

p. 111
A gracefully curving stairway leads to a small storage hut that sits atop a hillside of solid rock. Above its roofline can be seen the village pagoda.
Xiyangzhen, Guangdong

優美蜿蜒的階梯，通往位於磐石山坡上的簡陋儲物小屋。屋頂後上方巍然可見的是村內高塔。
廣東西陽鎮

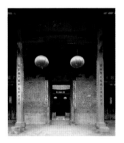

p. 112
The entrance to an ancestral hall is marked with the poems and pronouncements that celebrate a family's achievements in competitive imperial examinations.
Meipi, Jiangxi

宗祠門口的對聯標榜子弟在科舉時代的成就。
江西渼陂

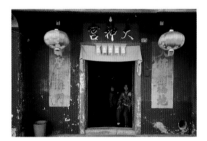

p. 115
Peering out from a temple's open doorway, children are participating in a family gathering that is going on within.
Xiyangzhen, Guangdong

廟門大開，家人在廟內聚會，孩子乘空在門口往外張望。
廣東西陽鎮

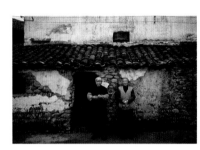

p. 117
A combination of earth and clay, stone, and kiln-fired brick shows evidence of a long history of repairing and restoring an old building using a variety of materials and techniques.
Regional village, Fujian

泥、黏土、石和窯磚的結合，足證以各種物料和技術維修及復原一座古老房子的悠悠歲月。
福建當地鄉村

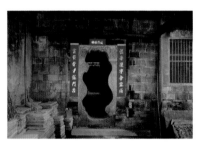

p. 119
Evoking the shape of a plume of smoke, this unique, intricately carved doorway is the portal to the inner courtyard garden of a village home.
Environs of Wuyishan, Fujian

造型為一縷煙雲的獨特石門，雕琢精緻，是一所村居的內院園圃入口。
福建武夷山附近地方

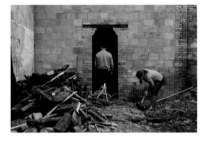

p. 121
The refuse left behind by the decay or destruction of historic buildings has an environmental and economic impact that needs to be factored into the decision-making process of transforming the rural and urban landscapes.
Regional village, Wuyishan, Fujian

歷史性建築物崩塌或拆毀後的頹垣敗瓦，對環境和經濟都有影響，必須在重新發展農村和市區的決策過程中加入這些考慮因素。
福建武夷山當地鄉村

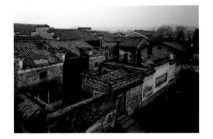

p. 122
Seen from the third-floor terrace of a home, an expanse of rooftops provides a view that is one of the most iconic from China's vernacular environments.
Meipi, Jiangxi

從一處居所的三樓陽台眺望，煙瓦鱗次，典型中國鄉郊環境的如畫風光。
江西渼陂

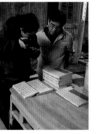

p. 125
Dr. Puay-Peng Ho and Hui Mei Kei document family genealogy records.
Regional village, Wuyishan, Fujian

何培斌博士和許美琪其在紀錄族譜。
福建武夷山當地鄉村

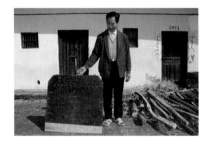

p. 127
A rare and well-preserved architectural plan showing the layout of a Hakka *weilongwu* hillside dwelling is the proud possession of a village inhabitant.
Environs of Meizhou, Guangdong

罕有而保存得好好的客家圍龍屋佈局圖是這位村民的得意收藏。
廣東梅州附近地方

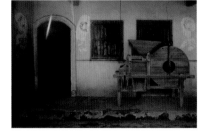

p. 131
Traditional hand methods of harvesting rice are still practiced throughout China, including the use of rice threshers, which separate the grain from the stalk.
Xiyangzhen, Guangdong

中國各地仍採用傳統人手收割稻米的方法，脫穀機把米粒和禾稈分開。
廣東西陽鎮

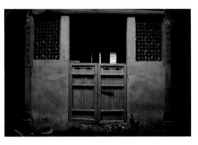

p. 132
An ornamental wooden gate, carved window screens, and structural posts show the vulnerability of unprotected wood in traditional environments.
Regional village, Wuyishan, Fujian

裝飾用的木柵欄、雕花的窗格子，以及結構性支柱，傳統環境木材欠缺保護時的脆弱於此可見。
福建武夷山當地鄉村

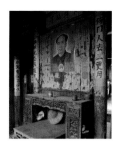

p. 134
The widespread display of images of Mao Tse-tung reflects the Chinese people's respect for his lasting influence.
Regional village, Wuyishan, Fujian

無處不在的毛澤東畫像，反映中國人對他持久的影響心生敬意。
福建武夷山當地鄉村

p. 139
The genteel caretaker of a historical property looks out from well-preserved window screens composed of interlocking rectangles with paper backings.
Shaoxing, Zhejiang

彬彬有禮的看門人，守著一幢歷史性建築物，窗格子的長方形圖案交疏連結，背後糊紙，保存得很好。
浙江紹興

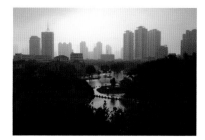

p. 141
A midday view of Shanghai's skyline contrasts the beauty of man-made gardens with the polluting effects of a rapidly developing industrialized and car-dominated metropolis.
Shanghai

上海日正方中的城市輪廓，人工花園之美對比著大都會因急速工業化和汽車充斥所帶來的污染惡果。
上海

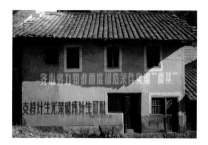

p. 142
Slogans are written on the sides of buildings as a means of delivering information to the public. In this case the words communicate the spirit of national unity and the value of family planning.
Longmen, Zhejiang

建築物外牆壁上的標語是向公眾發放訊息。這裡宣傳的是國家團結的精神和家庭計劃的價值。
浙江龍門

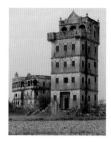

p. 146
An eclectic combination of Western and Chinese architectural design, the *diaolous* of Guangdong Province served the purpose of both defense and habitation for many Overseas Chinese who had returned to their ancestral homes in the early decades of the twentieth century to reestablish their patrimony.
Zili Village, Kaiping, Guangdong

中西合璧的折中建築風格，廣東省的碉樓可作防衛，也是二十世紀二三十年代不少海外華僑回鄉處理祖產時居住的地方。
廣東開平自力村

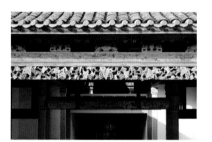

p. 149
Multiple layers of decoration are rendered in exquisite detail on this residential building. A wooden crossbeam features carved grapevines with scampering mice, while the lintels are painted with representations of human figures, architectural spaces, and floral and songbird motifs.
Ji'an City, Jiangxi

多層次的細緻雕刻裝飾。木橫梁雕刻了葡萄藤和老鼠，過梁繪上分別代表人、建築空間，以及花卉和鳥兒的圖案。
江西吉安市

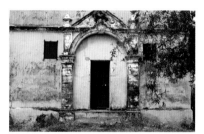

p. 152
The decorative elements on an archway and columns show Western influence on the facade of a *diaolou*.
Zili Village, Kaiping, Guangdong

拱門和柱子上的雕飾顯示碉樓正面所受的西化影響。
廣東開平自力村

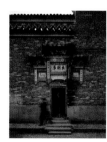

p. 154
A bas-relief ornamental crown tops the side entrance to a residence constructed with kiln-fired bricks.
Meipi, Jiangxi

房子是磚砌的，側門入口上端是裝飾性的王冠淺浮雕。
江西渼陂

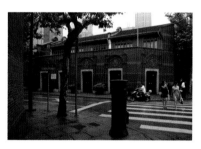

p. 156
A masterful restoration of the landmark First Congress Hall of the Communist Party forms the centerpiece of an adaptive reuse project amid the dramatically changing urban landscape of Shanghai.
Xintiandi, Shanghai

精心修復的中國共產黨開第一次代表大會場址，成為劇變的上海都市面貌裡改造性再利用項目的最引人注目例子。
上海新天地

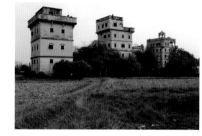

p. 158
Sited in fallow winter fields, multistoried watchtowers, *diaolous*, are topped with varying degrees of decorative roofing, generally seen as reflective of the wealth of their owners. An international mixing of Chinese, Byzantine, Romanesque, Gothic, and Islamic stylistic motifs make this style of building completely unique.
Zili Village, Kaiping, Guangdong

坐落冬日休耕的農田裡，這些名為碉樓的數層高崗塔屋頂裝飾各有不同，一般認為是反映了樓主的家財。碉樓的建築風格國際化，融會了中國、拜占庭、羅馬、哥德和伊斯蘭特色，自成一派。
廣東開平自力村

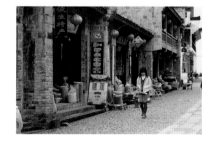

p. 160
A traditional district, adapted to modern commercial use, attracts a young woman who is as modern as the storefronts are old.
Kaiping, Guangdong

已作現代商業用途的舊區，年輕女郎信步徐行，佳人摩登，門面古老，互相映照。
廣東開平

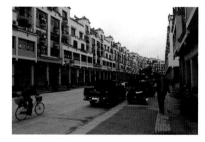

p. 163
Storefronts on the ground level, with residential spaces above, is a common way of taking a classical model and restating it in a contemporary vernacular.
Kaiping, Guangdong

底層作店舖，樓上是住宅，古老建築物舊貌賦新顏，現代鄉鎮常見。
廣東開平

p. 164
Articulating traditional design motifs on a scale made possible using the engineering capability of modern technology, windows and skylights expand the openness and light that define this monumental public space.
Design by Liu Xiaoguang, RTKL Associates.
Shanghai Science and Technology Museum

利用現代技術工程令傳統設計特色表達得更淋漓盡致，窗子和天窗把光和紀念性的公共間擴展得更寬敞明亮
劉曉光－RTKL Associates 設計。
上海科技博物館

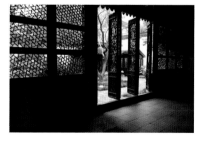

p. 165
A device that served both the circulation of light and air, intricate cracked-ice latticework is exquisitely preserved on windows and hinged doors in a building on the grounds of the Humble Administrator's Garden, one of Suzhou's most revered classical gardens.
Suzhou, Jiangsu

蘇州名園拙政園的窗子和鉸接門，精心保存了錯綜交結的窗格子冰裂圖案，這種設計既透光亦有利空氣流通。
江蘇蘇州

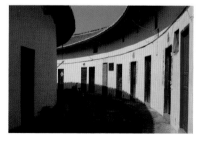

p. 166
The arch of the rear of a *weilongwu* sits on the gentle slope of a hillside. The specific relationship between the built environment and nature is the fundamental basis for the practice of feng shui, believed to align the harmonies of man with the universe.
Regional village, Jiangxi

圍龍屋後邊的弧形結構，坐落山腰的緩坡之上。建築物環境與自然的關係是風水的基本原理。風水被視為可助人與宇宙調和。
江西當地鄉村

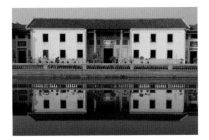

p. 169

A pond is sited on the front side of a building for it to take advantage of the positive energy of water. This practice is rooted in feng shui, which influences the construction of individual structures as well as the location of entire villages.
Ji'an City, Jiangxi

房子前是一湖清水，因為門前水能聚氣。蓋房子以至整條村的選址都要看風水。
江西吉安市

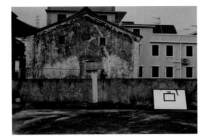

p. 173

The tight-fitting patterns of urbanization are often witness to the merging of older structures with new buildings, an example of the loss of the larger context of a traditional environment even when particular structures may survive.
Shanghai

密密麻麻的都市化造成舊房子混合新建築，房子雖然可以幸存，但已失去一大部份的傳統環境。
上海

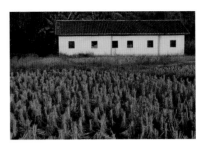

p. 174

The juxtaposition of the traditional and the contemporary is an ever-present reality in China's urban landscape.
Fanling, New Territories, Hong Kong

傳統與現代並列，今日中國城市風景的不變寫照。
香港新界粉嶺

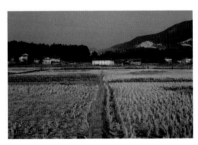

p. 179

A barn sits on the edge of a fallow winter field.
Xiyangzhen, Guangdong

冬日休耕田旁的穀倉。
廣東西陽鎮

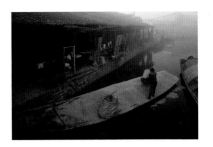

p. 181

A network of waterways provides the means for transporting goods and supplies to storefronts that line the canals' boardwalks.
Anchang, Zhejiang

水道縱橫，是運河邊木板人行道旁小店運輸貨物和必需品的交通網絡。
浙江安昌

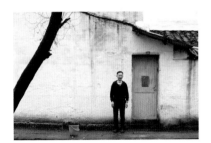

p. 182

The harmonies of blue on blue match this sprightly gentleman's smile.
Shaoxing, Zhejiang

調和的藍色，輕鬆的笑容，正好相襯。
浙江紹興

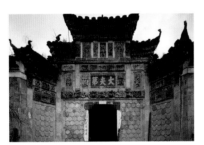

p. 184

An intricate stone-carved facade features exacting bas-relief depictions of human, animal, and floral designs.
Environs of Wuyishan, Fujian

正門外牆上複雜精細的石刻全是人物、動物和花卉設計的淺浮雕。
廣東西陽鎮

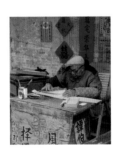

p. 187

Against the backdrop of commercial activity a fortune-teller practices his craft.
Kaiping, Guangdong

商業社會裡，算命先生仍然有他的生意。
廣東開平

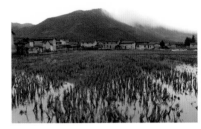

p. 191

A well-worn path wends its way through dried winter fields to the village beyond. A concrete factory and its hillside excavations lay further on.
Longmen, Zhejiang

飽受踐踏的小路越過乾枯的冬日禾田，進了遠處的村子。村後的山上是水泥廠和廠方開鑿的山坡。
浙江龍門

p. 192

The rolling fog of the Wuyi region in southeastern China contributes to the legendary beauty of this area.
Wuyishan, Fujian

中國東南武夷區，霧聚雲舒，添上山水傳奇色彩。
福建武夷山

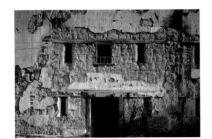

p. 195

Crumbling plaster exposes the clay-and-stone underbelly of a once-proud building.
Longmen, Zhejiang

灰泥剝落，磚土外露，昔日朱樓今成頹垣。
浙江龍門

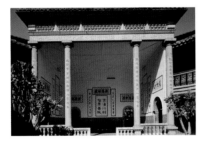

p. 196

Standing in the central courtyard of the largest Hakka round house in Hukeng (see p.86), this ancestral hall proudly displays calligraphy that records the accomplishments of those family members who passed imperial exams, bringing honor to their family and village.
Hukeng, Fujian

湖坑（看參86頁）最大的客家土樓中庭，祖先堂上，滿壁翰墨紀錄了子弟的功名，光耀門楣，闔村與有榮焉。
福建湖坑

p. 199

A sculptural tree that sits atop a hill provides an iconic landmark in a rural setting.
Wuyishan, Fujian

山崗上姿態優美的一棵樹，成為郊野別有風格的地標。
福建武夷山

p. 201

Winter greens and a bevy of village children provide a sharp contrast of vitality and life to the backdrop of old and decaying building facades in a traditional village.
Longmen, Zhejiang

冬日的綠意和一群孩子，是活力和生命，與背景傳統村子裡古老破落的房子是強烈的對比。
浙江龍門

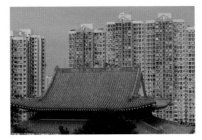

p. 203

The design and ornamentation of gates were strictly dictated by protocol and provided clear expressions of the owner's social status and official rank. Here, massive drum-style pedestals anchor the front doorway of the impressive stone-and-brick residence of a high-ranking official.
Li Chunye Mansion, Taining, Fujian

大門設計和裝飾有一定規格，清楚顯示屋主人的社會地位和官階。大官的堂皇府第是石構磚砌，正門入口鎮以巨型石鼓墩。
李春燁大宅

p. 204
Signage and commercial activity mask the traditional buildings that line the streets in contemporary cities.
Kaiping City, Guangdong; third from top, Hong Kong

現代城市內街道兩旁的傳統建築物，被招牌和商業活動淹沒。
廣東開平 上面下圖3: 香港

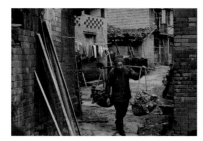

p. 205
An elderly man carries his fresh picked produce using a shoulder yoke–an age-old device known to peasants the world over.
Wuyishan, Fujian

老翁挑着新鮮採摘的菜蔬，他肩上的扁擔是全世界農民都使用的古老工具。
福建武夷山

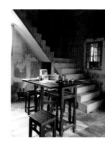

p. 206
Ground floor interior living space of a *diaolou* is washed by the soft light of late afternoon.
Zili Village, Kaiping, Guangdong

碉樓底層內的起居間，浴在午後黃昏前的柔和陽光裡。
廣東開平自力村

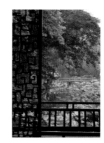

p. 210
A pavilion on its grounds frames a view of the Humble Administrator's Garden, considered one of the most exceptional gardens in the renowned city of Suzhou.
Suzhou, Jiangsu

拙政園內亭子外望的景色。拙政園被視為名城蘇州的第一園。
江蘇蘇州

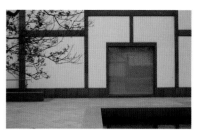

p. 212
Drawing on traditional design motifs, the Suzhou Museum, designed by I. M. Pei, is the modern expression of an ancient aesthetic.
Suzhou, Jiangsu

貝聿銘設計的蘇州博物館，靈感來自傳統特色，是古代美學的現代演繹。
江蘇蘇州

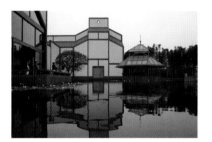

p. 214
A lotus pond reflects the modern lines of the Suzhou Museum's timeless geometry.
Suzhou, Jiangsu

蘇州博物館永恆外形的現代線條，倒映在蓮花池水面上。
江蘇蘇州

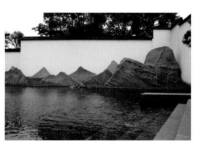

p. 216
The coming together of mountain and water symbolizes the classic concept of *shan shui*, the balance of intelligence and a forgiving heart.
Suzhou, Jiangsu

智者樂水，仁者樂山，山水相合，智仁相融。
江蘇蘇州

p. 220
Students, faculty, and friends of the Department of Architecture, the Chinese University of Hong Kong, go on annual field trips to the mainland under the tutelage of Professor Puay-Peng Ho. The purpose of these trips is to study and document rural traditional environments in the changing landscape of twenty-first-century China.
Fujian 1995, 1996

香港中文大學建築學系的學生、老師和友好人士在何培斌教授領導下，每年到中國進行考察之旅。二十一世紀的中國，風景面貌變化不斷，這些旅程的目的，就是研究和紀錄這種演變下的傳統鄉郊環境。
福建 1995, 1996

p. 220
Zhejiang 浙江 *1997, 1998*

p. 221
Jiangxi 江西 *2004, 2005*

p. 221
Guangdong 廣東 *2004, 2005, 2006*

p. 221
Class members in a course entitled Visual Thinking, taught by the author.
Hong Kong 香港 *2006*

作者教授的視覺思考課程班上學員。
香港2006

p. 238
The whimsical shadows cast by fish drying in the sun draw attention to a straightforward rural practice of food preservation.
Regional village, Wuyishan, Fujian

陽光下曬曝的魚乾，投影奇特，這種土法食物保藏方法直接簡單。
福建武夷山當地鄉村

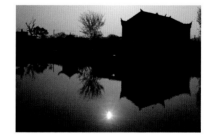

Endpapers, front
A sunset captures the silhouetted reflection of a building in the pond that fronts the entrance to the village of Meipi.
Meipi, Jiangxi

渼陂村口的池塘，夕陽剪影，綽綽投在水面。
江西渼陂

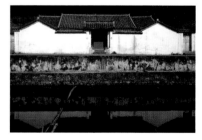

Endpapers, back
A courtyard house in the village of Meipi has an elongated front facade that is illuminated in the evening's last light.
Meipi, Jiangxi

渼陂村的一座莊園，長長的正面外牆，夕陽餘輝映照其上。
江西渼陂

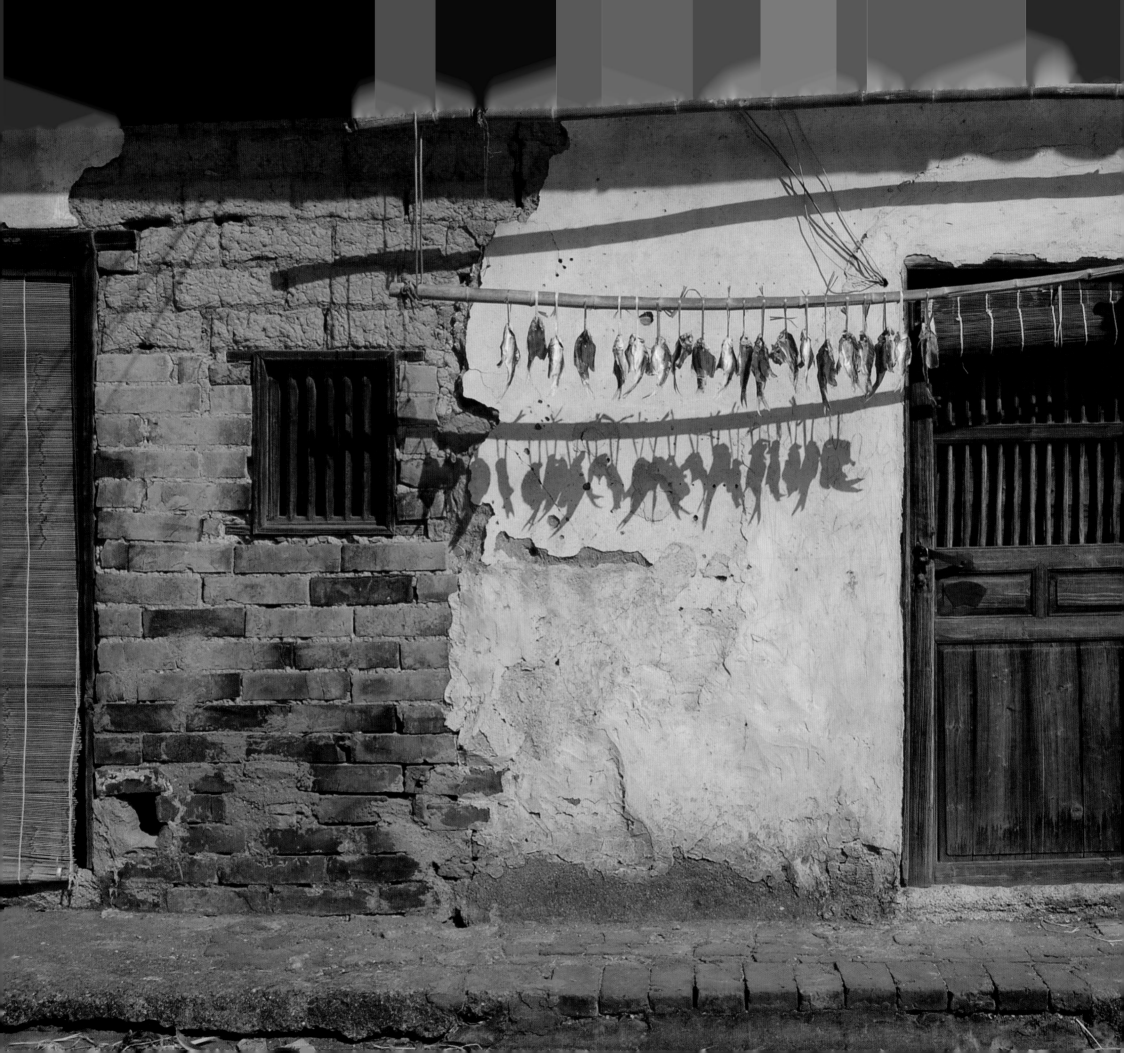

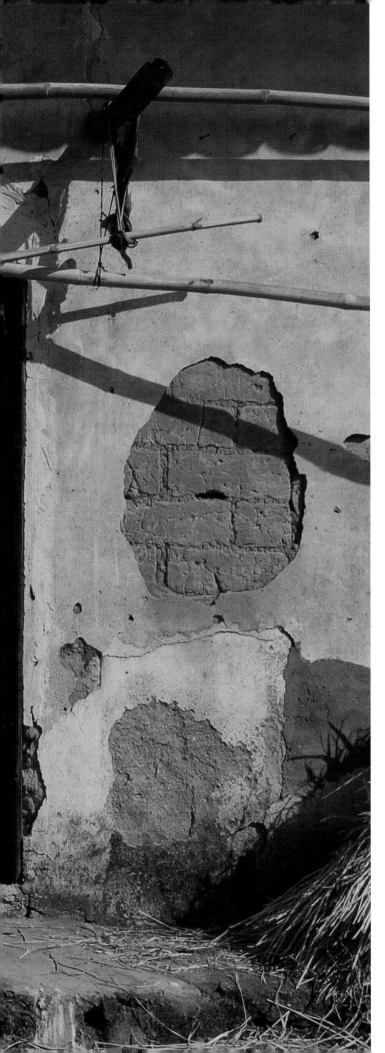

NOTATIONS
Cited Works
注解

I CHING CHARACTERS
The I Ching or *Book of Changes*, trans. Richard Wilhelm and Cary F. Baynes (Princeton, New Jersey: Princeton University Press, 1977; first edition 1950). Characters used as chapter headings throughout.

DESIGN MEDIUM
Adobe Creative Suite InDesign CS2, Photoshop CS2, Illustrator CS2
Typefaces–Bembo, Adobe Garamond Pro, Sabon, News Gothic, SimSun, Kai

BIBLIOGRAPHY
參考書目

ART OF LINGNAN GARDENS.
BEIJING: China Architecture and Building Press, 2003.

BAKER, BARBARA, ED. *CHINESE INK, WESTERN PEN: STORIES OF CHINA: AN ANTHOLOGY.*
OXFORD: Oxford University Press, 2000.

BARD, SOLOMON. *TRADERS OF HONG KONG: SOME FOREIGN MERCHANT HOUSES, 1841–1899.*
HONG KONG: Urban Council of Hong Kong, 1993.

BOOTH, MARTIN. *GWEILO: MEMORIES OF A HONG KONG CHILDHOOD.*
LONDON: Doubleday, 2004.

BOSCO, JOSEPH, AND PUAY-PENG HO. *TEMPLES OF THE EMPRESS OF HEAVEN.*
HONG KONG: Oxford University Press, 1999.

CARPENTER, FRANCIS ROSS; ILLUSTRATED BY DEMI HITZ. *THE OLD CHINA TRADE: AMERICANS IN CANTON, 1784–1843.*
NEW YORK: Coward, McCann & Geoghegan, 1976.

CHAN, BERNARD. *NEW ARCHITECTURE IN CHINA.*
LONDON: Merrell, 2005.

CHEN, GUIDI, AND WU CHUNTAO. *WILL THE BOAT SINK THE WATER?: THE LIFE OF CHINESE PEASANTS.* TRANSLATED BY ZHU HONG.
NEW YORK: Public Affairs, 2006.

CODY, JEFFREY W. *EXPORTING AMERICAN ARCHITECTURE, 1870–2000.*
LONDON: Routledge, 2003.

FAHR-BECKER, GABRIELE, ED. *THE ART OF EAST ASIA.*
COLOGNE: Könemann, 1999.

GARRETT, VALERY M. *HEAVEN IS HIGH, THE EMPEROR FAR AWAY: MERCHANTS AND MANDARINS IN OLD CANTON.*
OXFORD: Oxford University Press, 2002.

HAYES, JAMES. *SOUTH CHINA VILLAGE CULTURE.*
OXFORD: Oxford University Press, 2001.

HESSLER, PETER. *ORACLE BONES: A JOURNEY THROUGH TIME IN CHINA.*
NEW YORK: HarperCollins, 2007.

HONG KONG MUSEUM OF ART AND PEABODY ESSEX MUSEUM. *VIEWS OF THE PEARL RIVER DELTA: MACAU, CANTON AND HONG KONG.* EXH. CAT.
HONG KONG: Urban Council of Hong Kong, 1996.

HONG KONG MUSEUM OF HISTORY AND HONG KONG MUSEUM OF ART. *IMPRESSIONS OF THE EAST: THE ART OF GEORGE CHINNERY.* EXH. CAT.
HONG KONG: Hong Kong Museum of History, 2005.

HU, CHUI. *THE FORBIDDEN CITY: COLLECTION OF PHOTOGRAPHS.* TRANSLATED BY YANG AIWEN AND WANG XINGZHENG.
BEIJING: China Photographic Publishing House, 1998.

HU, SHENG. *FROM THE OPIUM WAR TO THE MAY FOURTH MOVEMENT,* 2 VOLS. TRANSLATED BY DUN J. LI.
BEIJING: Foreign Languages Press, 1991.

I. M. PEI AND SUZHOU MUSEUM.
SUZHOU: Guwuxuan Publishing House, 2007.

INFORMATION OFFICE OF THE STATE COUNCIL, PEOPLE'S REPUBLIC OF CHINA. *COLLECTIONS OF TIBETAN FOLK WORKS OF ART.*
BEIJING: China Intercontinental Press, 2002.

JOHNSON, IAN. *WILD GRASS: THREE PORTRAITS OF CHANGE IN MODERN CHINA.*
NEW YORK: Vintage Books, 2004.

KNAPP, RONALD G.; PHOTOGRAPHY BY A. CHESTER ONG. *CHINESE HOUSES: THE ARCHITECTURAL HERITAGE OF A NATION.*
NORTH CLARENDON, VT: Tuttle, 2005.

LEECE, SHARON; PHOTOGRAPHS BY A. CHESTER ONG. *CHINA MODERN.*
SINGAPORE: Periplus, 2003.

LEECE, SHARON; PHOTOGRAPHS BY MICHAEL FREEMAN. *CHINA STYLE.*
SINGAPORE: Periplus, 2002.

LI, SUI-MEI. *OLD FASHIONS OF GUANGZHOU.*
BEIJING: People's Fine Arts Publishing House, 1998.

LO, KAI-YIN, AND PUAY-PENG HO, EDS. *LIVING HERITAGE: VERNACULAR ENVIRONMENT IN CHINA.*
HONG KONG: Yungmingtang, 1999.

MACKERRAS, COLIN, ED. *SINOPHILES AND SINOPHOBES: WESTERN VIEWS OF CHINA.*
OXFORD: Oxford University Press, 2000.

MAH, ADELINE YEN. *FALLING LEAVES: THE TRUE STORY OF AN UNWANTED CHINESE DAUGHTER.*
LONDON: Penguin, 1997.

MITTER, RANA. *A BITTER REVOLUTION: CHINA'S STRUGGLE WITH THE MODERN WORLD.*
OXFORD: Oxford University Press, 2004.

MUDGE, JEAN MCCLURE. *CHINESE EXPORT PORCELAIN IN NORTH AMERICA.*
NEW YORK: Riverside Book Company, 2000.

REED, MARCIA, AND PAOLO DEMATTÈ, EDS. *CHINA ON PAPER: EUROPEAN AND CHINESE WORKS FROM THE LATE SIXTEENTH TO THE EARLY NINETEENTH CENTURY.* EXH. CAT.
LOS ANGELES: Getty Research Institute, 2007.

SHAN, DEQI. *CHINESE VERNACULAR DWELLING.* TRANSLATED BY WANG DEHUA.
BEIJING: China Intercontinental Press, 2004.

STILLE, ALEXANDER. *THE FUTURE OF THE PAST.*
NEW YORK: Farrar, Straus and Giroux, 2002.

XU, YUANXIANG, AND YIN YONGJIAN. *LAO TZU: THE ETERNAL TAO TE CHING.*
CHINA: Intercontinental Press, 2007.

YANG, SHENCHU. *THE ARCHITECTURE AND CULTURE OF YUELU ACADEMY.*
CHANGSHA: Hunan Science and Technology Publishing House, 2003.

YANG, XIAGUI; PHOTOGRAPHS BY LI SHAOBAI. *THE INVISIBLE PALACE.* TRANSLATED BY CHEN HUANG.
BEIJING: Foreign Languages Press, 2003.

ZHENG, PING. *CHINA'S GEOGRAPHY: NATURAL CONDITIONS, REGIONAL ECONOMIES, CULTURAL FEATURES.* TRANSLATED BY CHEN GENGTAO.
BEIJING: China Intercontinental Press, 1998.

OPEN HEARTS OPEN DOORS
Reflections on China's Past & Future

明心啟扉
鏡看中國的過去與未來

© 2008 4STOPS PRESS

Library of Congress Control Number: 2007907411

ISBN 978-0-9796165-0-1

EDITORIAL DIRECTOR
Elizabeth Gill Lui

TRANSLATOR
Chor Koon-Fai

GRAPHIC DESIGNER
Jessica H. Yoon

EDITOR
Gregory A. Dobie

SIMPLIFIED MANDARIN EDITION
Text Conversion
Sandy Ding

SEAL CARVING
Fung Ka Yee

PRODUCTION ASSISTANT
Sandy Ding

EDITORIAL ASSISTANTS
Michael Collum, Keya Keita, Liu Xiaoguang, Peter H. Y. Wong

PRINTER
Midas Printing International Limited, China, PRC

4STOPS PRESS
Museum Tower, No. 2003
225 South Olive Street
Los Angeles, California 90012 USA
www.4stopspress.com

With Distribution by

CORNELL UNIVERSITY PRESS
Sage House
512 East State Street
Ithaca, New York 14850 USA
www.cornellpress.cornell.edu

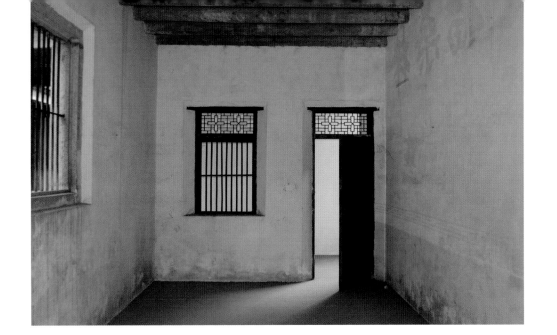

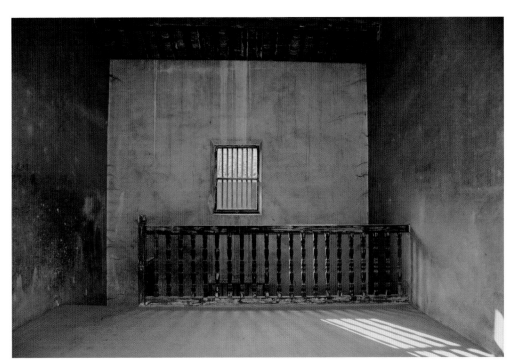

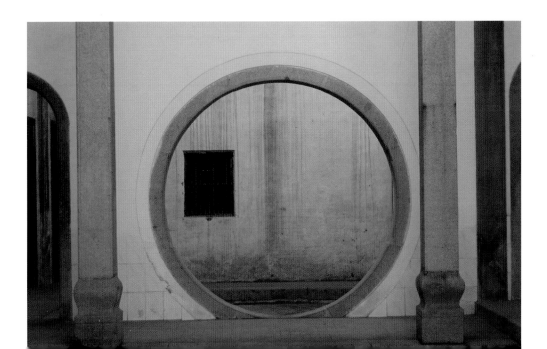

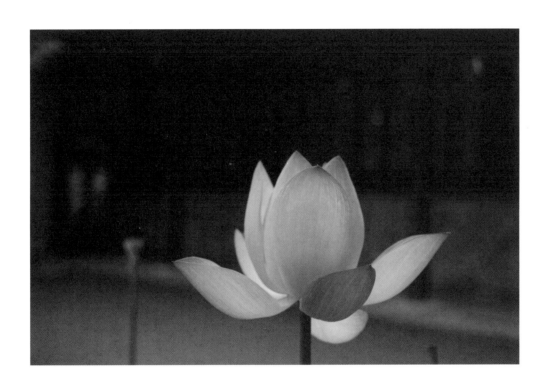

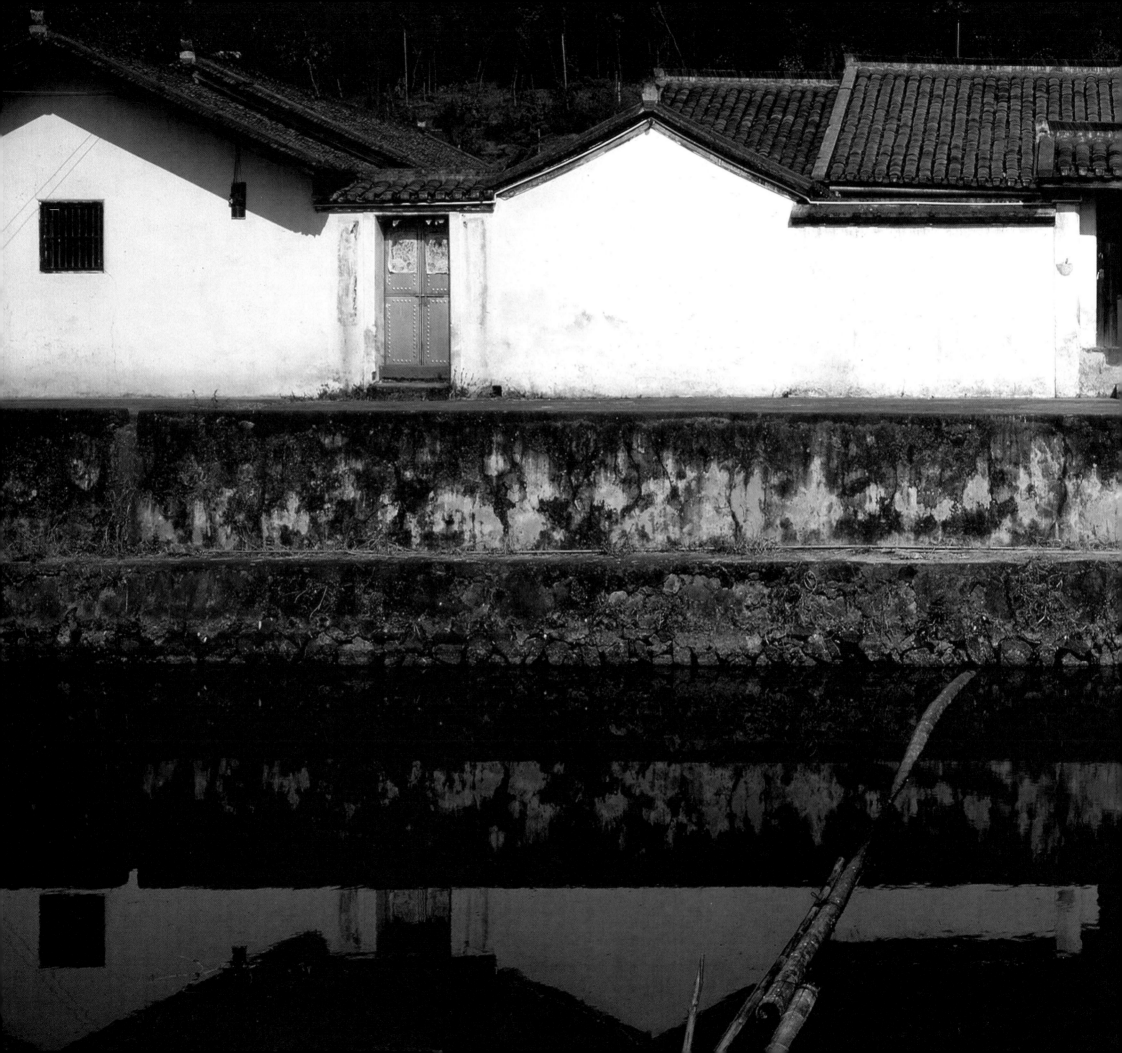